WITHDRAWN

St. Louis Community
College

Library

5801 Wilson Avenue
St. Louis, Missouri 63110

American
Master Drawings
and Watercolors

Published in association with The Drawing Society, Inc.

American Master Drawings and Watercolors

THEODORE E. STEBBINS, JR.

WITH THE ASSISTANCE OF JOHN CALDWELL AND CAROL TROYEN

A History of Works on Paper from Colonial Times to the Present

HARPER & ROW, PUBLISHERS

New York, Hagerstown, San Francisco, London

Library of Congress Cataloging in Publication Data
Stebbins, Theodore E
 American master drawings and watercolors.
 Bibliography: p.
 Includes index.
 1. Drawing, American—History. 2. Water-color
painting, American—History. I. Title.
ND1805.S73 1976 759.13 75-37156
ISBN 0-06-014068-2
ISBN 0-06-014069-0 pbk.

76 77 78 79 10 9 8 7 6 5 4 3 2 1

Contents

For Susan, Sam, and Michael

Foreword

Although The Drawing Society has previously published monographs on such eminent American artists as Charles Burchfield, Edwin Dickinson, Morris Graves and Jackson Pollock, never before has it attempted a project of this magnitude. In spite of the many fine publications on various aspects of American drawing, the Society felt that a major survey of American draftsmanship from Colonial times to the present had not been undertaken for many years, and would be an important contribution to the knowledge and appreciation of American drawing.

The Drawing Society was fortunate enough to persuade Professor Theodore E. Stebbins, Jr., Curator of American Painting and Sculpture, Yale University Art Gallery, to agree to undertake this major project. Professor Stebbins, as fine a writer as he is an art historian, spent more than two-and-a-half years on this project.

On the occasion of this publication, Professor Stebbins is serving as the guest director of an exhibition based upon the book; this exhibition has been organized by The American Federation of Arts and generously supported by a grant from the National Endowment for the Arts. The exhibition will be presented at The Minneapolis Institute of Arts, the Whitney Museum of American Art in New York, and The Fine Arts Museums of San Francisco during 1976–1977. For their work on both the exhibition and the publication, The Drawing Society would like to particularly thank Wilder Green, Director, and Konrad G. Kuchel and Anne Sharkey, of The American Federation of Arts staff.

The Drawing Society also wishes to thank Cass Canfield, Jr., of Harper & Row, for his personal encouragement and enthusiasm in helping to make this project a reality.

<div align="right">

David Daniels, President
The Drawing Society, Inc.

</div>

Acknowledgments

This book was conceived by The Drawing Society as the way in which, during the Bicentennial year, the achievements of American draftsmen could be given the serious attention they deserve. I joined their discussions early in 1972, and since then David Daniels has been the guiding spirit for this project. No author could ask for greater kindness and understanding than he has given; to him and to the other members of The Drawing Society I owe a great debt of thanks. Moreover, we have been fortunate in finding others who believed in the project and aided production of the book in innumerable ways, particularly Wilder Green and Konrad Kuchel of The American Federation of Arts, who asked me to plan a major exhibition in conjunction with the publication, and Cass Canfield, Jr. of Harper & Row, who has been the most skillful and patient of editors.

Collectors, scholars, and dealers in the field have responded to my time-consuming requests and visits with great generosity. Especially helpful have been Arthur G. Altschul, James T. Callow, Leo Castelli, Edward H. Dwight, Stuart P. Feld, Lawrence Fleischman, George Fitch, Daniel Fraad, Jo Ann and Julian Ganz, Jr., Lloyd Goodrich, Margaret and Raymond Horowitz, Philip Johnson, Ellsworth Kelly, Roy Lichtenstein, Peter C. Marzio, Paul Mellon, Stephen D. Paine, Eleanor Sayre, Jonathan D. Scull, Robert Scull, Joan Washburn, Nelson C. White, Rudolf G. Wunderlich, and Betsy and Andrew Wyeth. In addition, literally hundreds of institutions have responded to my queries. Special thanks are due the curatorial and photographic staffs at the Museum of Fine Arts, Boston, and the Metropolitan Museum of Art, as well as those at the Abby Aldrich Rockefeller Folk Art Collection, Addison Gallery of American Art, Albany Institute, Art Institute of Chicago, Brooklyn Museum, Cincinnati Art Museum, Clark Art In-

stitute, Columbus Gallery of Fine Arts, Delaware Art Museum, Detroit Institute of Arts, Fogg Art Museum, Library of Congress, Museum of Modern Art, New-York Historical Society, Philadelphia Museum of Art, Museum of Art of the Rhode Island School of Design, National Collection of Fine Arts, Shaker Community, Inc., Pittsfield, Mass., The Museums at Stony Brook, N. Y., Whitney Museum of American Art, Worcester Art Museum, and the Yale University Art Gallery.

Elaine Dee has taken much time from her busy schedule at the Cooper-Hewitt Museum in order to help me; Sherman E. Lee generously and courageously lent me his doctoral thesis on American watercolor; and Dianne Pilgrim has shared with me her researches on American pastels. And William H. Gerdts has once again been the best of colleagues, kindly reading the manuscript in order to correct some of its more egregious errors and omissions.

I have also been aided by many people at Yale, including the members of a graduate seminar on American drawings which I taught in 1973: Louise Bloomberg, Marylyn Brown, Susan P. Casteras, Helen Cooper, Mary Alice Hinson, William Howze, Martha Landesberg, Anne McCauley, William T. Oedel, Christina Orr, Oswaldo Rodriguez, and Richard Saunders. Two other members of this group became my colleagues in writing this book: John Caldwell researched and prepared the initial drafts for Chapters 5 and 10, and Carol Troyen did the same for Chapters 13 and 14. They made completion of the book possible, and they have my everlasting gratitude.

I benefited also from the concern and insight of Kathleen Foster and Michael Quick, two other able young scholars, as well as from the aid of Catherine Lorraine and of Susan Thalmann, who worked long hours with the bibliography and index. Joseph Szaszfai brought great skill to the making of many photographs. Galina Gorokhoff once again saw the work through from beginning to end, typing, editing, and proofreading with enormous skill and dedication.

T.E.S., Jr.

Introduction

This book represents the first attempt to survey the whole field of American drawings and watercolors from the late sixteenth century depictions of Indian life by John White and Jacques Le Moyne to the rich and eclectic products of our own day, some four hundred years later. Our effort has been to examine the major American draftsmen with some care, while also bringing to light many astonishing accomplishments by little-known artists; stylistic and formal developments are analyzed, as are the collecting and exhibition of drawings, and the artistic milieu in which they were produced.

Moreover, I have been convinced since the beginning that, for the book to be most useful, its net must be widely thrown. Thus, "American" is understood to include both foreign-born artists who produced significant work on these shores, as well as expatriate Americans whose art played a role here. Always using quality as our guide, we have included works of those in the "mainstream" and those out of it. One will find the drawings of well-known painters, and works by others who only drew. There are drawings by folk and country artists, by professionals and amateurs, by naturalists and explorers, and by illustrators. Having to stop somewhere, we have *not* included architectural drawings—another whole field in itself—children's drawings, or cartoons.

We include here the finished watercolor, the gouache, the pastel, and even the collage (briefly), believing these mediums to be generically related to pure drawing, and finding the extraordinary beauty of American work in these modes simply too compelling to leave to another occasion. In doing so, we follow the practice of today's artists, who consider a drawing to be almost anything on paper (and many things that are not), as well as that of The Drawing Society, which has half-seriously debated calling itself "The Works of Art on Paper Society."

There is also strong historical evidence for this inclusion. For example, John Ruskin in his influential *Elements of Drawing* describes the progress of the draftsman as he moves from the basic techniques of sketching in pen or pencil to more complex shading and the use of charcoal and chalks, and finally to the creation of finished wash drawings and watercolors. This attitude—of regarding watercolor as simply a more advanced kind of drawing—is increasingly widespread today. One sees evidence of this as one museum after another reclassifies its watercolors, placing them under the care of their graphics departments. And surely the old bias that the only true drawings are sketches has been similarly discarded; this attitude can now be seen as a product of the nineteen forties, when the sketch's autographic, linear qualities so closely paralleled the achievements of then-current abstract expressionist painters and draftsmen.

Drawing is still misunderstood, as suggested by a recent writer's comment that "drawings are frequently direct notations made by the artist for himself alone."[1] This is simply untrue; drawings are made for myriad reasons, almost always including practical purposes involving a wider audience than simply the artist. Even a highly personal (and finished) work such as the great *Self Portrait* by Copley (Fig. 16) was made not only to please the artist and his family, but undoubtedly also to hang prominently in his house, demonstrating to colonial Boston the artist's amazing abilities in the difficult pastel medium. Indeed, a major aim of this book is to examine the purposes of drawings. Even within the work of one artist, such as Thomas Cole for example, one finds a wide variety of aim: among the drawings illustrated here are a plein-air sketch of trees, made for later use in a painting; a finished ink drawing of a tree-trunk, possibly made for exhibition; a compositional sketch from imagination; a topographical landscape drawing, perhaps meant for later reproduction as an illustration; and a highly finished pencil and wash landscape, apparently made as a gift. All are landscapes or landscape-elements, yet as with every artist the specific intention dictates choice of medium, size, manner, and style.

A drawing in any medium is indeed a "direct notation," due largely to its being normally on paper. Whether long-lasting and good quality, or fragile and pulpy, paper is enormously demanding. Few mistakes are tolerated, whether the artist works in pure line or heavy gouache. He must *care* about drawing whether his technique is rapid and calligraphic or painstaking and detailed; the sense of touch must be sure, while compositional ability, iconographic originality, and the like, matter less than in oil painting. Drawing is not necessarily easier or more difficult than painting, or purer or more self-revealing; it is simply very different.

Drawings and watercolors have been neglected in America, per-

haps because of their lack of ostentation, their often small size, or their fragility; or another reason may be that the bulk of material has been so great that drawings may have seemed to lack rarity or value. Though they have been collected and exhibited for two hundred years, works on paper have traditionally been thought less complete and less desirable than oil painting or sculpture. Thus the great public collections and the major body of scholarship are of relatively recent origin.

Watercolors gained public acceptance first, and one finds them included in private collections by the mid-nineteenth century. Their popularity increased after the founding of The Water Color Society in 1866, and they were bought by Thomas B. Clark, Evans, and other major collectors late in the century. In the first decades of the twentieth century the watercolor was being collected seriously both privately and publicly, with large groups of works by Homer, Sargent, La Farge and others having entered museum holdings at Brooklyn, Worcester, Boston, and New York (The Metropolitan). And though earlier critics had paid some attention to the medium, it was only in 1922 with A. E. Gallatin's *American Water-Colourists* that the first book on the genre was written. Noteworthy in the following decade was Lloyd Goodrich's treatment of Homer's watercolors in his great monograph on that artist —and indeed, Goodrich's contributions have continued to the present day. The first scholarly treatment of the whole field of American watercolor occurs in Sherman E. Lee's remarkable doctoral thesis of 1941, unfortunately never published, while a lesser though still useful effort is found in Albert Ten Eyck Gardner's over-titled book of 1966, *A History of Water Color Painting in America.*

Drawing similarly lacks anything like a definitive survey. The first notable book appeared in 1923, just one year after Gallatin's work on watercolor; it was Theodore Bolton's *Early American Portrait Draughtsmen in Crayons.* This was followed in 1947 by Slatkin and Schoolman's *Treasury of American Drawings*; it includes no useful text, but the selection of visual material is excellent, and in fact seventeen of the works illustrated there are also included in the present volume. Exhibition catalogues in the meantime have added significantly to the literature, particularly in the contemporary area. Similarly, a number of useful monographs have been devoted to the drawings of current draftsmen, including de Kooning, Johns, Kelly, Lichtenstein, and Wyeth, while major figures of past eras have been less well treated. Winslow Homer, for example, is a superb talent both as a pure draftsman and a watercolorist, yet there is still no serious and useful study in book form of any aspect of his graphic work.

Illustration and folk art have received considerable attention, but the major figures in the "mainstream" have not: among watercolorists, only John Marin has been the subject of a catalogue raisonné, while of

the draftsmen, John Singleton Copley, George Caleb Bingham, and Martin J. Heade are among the few whose work has been analyzed and published by recent scholars. Thus an important aim of this book is to guide the reader through both the general and specific bibliography in this field, hoping at the same time to suggest the vast number of areas where work is needed. It goes without saying that the paucity of scholarly writing has inhibited the present effort to survey the field: we have been sorely tempted to subtitle this volume "Materials Toward a History," given the thinness of the foundation.

The two great collections of drawings and watercolors—as with American paintings—are those of the Metropolitan Museum of Art and of the Museum of Fine Arts, Boston. The latter is probably preeminent, and it is surely the best published, for the watercolors were presented in a 1949 catalogue (along with the European collection) and many of the drawings were included in the best catalogue in the field, *M. & M. Karolik Collection of American Water Colors and Drawings, 1800-1875* (1962). These collections resulted from the energies of individuals, including Gallatin in New York and Maxim Karolik at Boston, and other equally venerable institutions which have lacked such far-sighted patrons (the Corcoran, the National Gallery, or the Pennsylvania Academy, for example) lack significant holdings in these fields. The drawings particularly have been scattered at the whim of artists' heirs and museums' moods. Some artists' drawings were broken up early, and are hardly known today (Homer Martin, Whittredge); with others, large bodies of material were placed at institutions just now becoming appreciative of their good fortune and their responsibility (Sargent at the Metropolitan, Church at the Cooper-Hewitt, Cole at Detroit); while the work of still others remains in private hands and is presently being "discovered."

The organization of this book is generally chronological, with some allowance made for unity within a specific medium. The first four chapters, for example, deal with successive periods in all mediums up to about 1830; chapters five and ten respectively take up the discrete traditions of the folk artist and the professional illustrator; and the intervening chapters deal with landscape and the academic figure (two areas in which pure drawing dominates) and then separately with the watercolor and pastel up to 1900. The final four chapters take up the twentieth century, first distinguishing between the early "realist" tradition and then the "modernist," the first generally using a linear mode, the second watercolor, and then bringing the reader from the Second World War to the present essentially chronologically. Whatever is lost here in the way of logical consistency is made up for, I trust, in usefulness, for this is the way the material seems most clearly understood.

The single great problem in such a work is that of selection: what artists, and what works? Like any such choice, this selection can be completely satisfactory for only one person. Certainly a book of the same title might consider only a dozen artists, devoting a chapter to each; the masters, from Copley to Church, from Homer and Bellows to de Kooning, unquestionably stand out. Yet it has seemed to me that to devote a book only to them would be to lose the extraordinarily rich fabric of the American graphic tradition. Americans have expressed themselves through drawings for centuries, and with a primary eye to quality, the effort has been made to illustrate the major works, styles, mediums, and individuals over the whole range of our history. It goes without saying that one can include virtually all of the earlier people, and that the problem of selectivity becomes more and more agonizing as one approaches the present day. The work of two hundred forty-eight people is illustrated herein, and many others are discussed; yet doubtless many readers will find their favorite draftsman mistreated or neglected altogether. For this, as for all errors, the author can only apologize, hoping to do better next time.

<div style="text-align: right">T.E.S., Jr.</div>

New Haven
April 8, 1976

1

The Beginnings:
Early Colonial Draftsmen

Great numbers of drawings were made in the colonies almost from the time of the first settlements. The artists included explorers and naturalists, amateurs and professionals, visitors and settlers—and despite the perishability of their work and the low esteem in which their efforts have been held, enough early drawings survive to suggest that American artistic life in the colonies was far richer than has been generally believed.

The early drawings are stylistically eclectic; they are American only in their subject matter. Among the ablest of the explorer-naturalists was Jacques Le Moyne de Morgues (c. 1533–1588), a French-born Huguenot, who has rightly been considered "the first serious student of nature and the first artist of quality" to work in what is now the United States.[1]* In 1564 Le Moyne traveled to Florida with a French expedition under the command of René de Laudonnière, and as its official artist he produced a series of watercolors on vellum depicting that exotic and unknown region. Of the forty-two works which he took to France in 1566 after a massacre of most of the colony, only one is known to survive: *Laudonnière and King Athore at Ribaut's Column* (Fig. 1). However, the whole set of watercolors is known from the often-embellished engravings which were published, together with Le Moyne's account of the expedition, by Théodore de Bry in 1591.[2] De Bry had produced his volume dealing with explorations of Virginia in 1590, and followed it closely with the volume by Le Moyne on Florida, commenting accurately in his Foreword to the latter that it was "a Historye doubtless so Rare, as I thinke the like hath not been heard nor seene."[3]

* Notes begin on page 411.

1

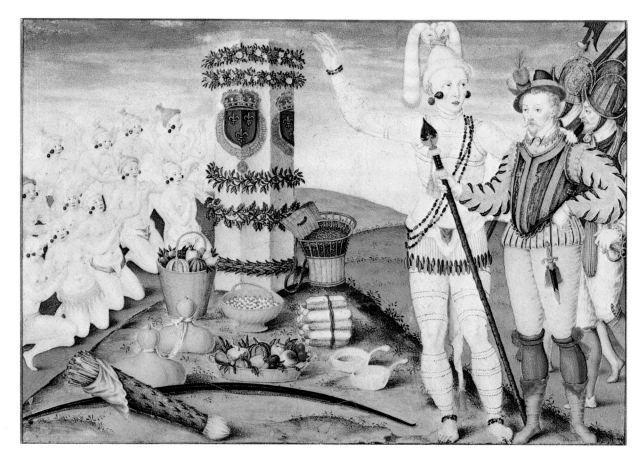

Fig. 1. JACQUES LE MOYNE DE MORGUES, *Laudonnière and King Athore at Ribaut's Column*, 1564. Watercolor on vellum, 7 x 10¼".

There exist, in addition, a number of later drawings and watercolors by Le Moyne, including over one hundred carefully detailed botanical watercolors of fruits and flowers seen in the gardens of England (where the artist had fled for religious reasons in 1572)[4] and a recently discovered finished watercolor called *A Young Daughter of the Picts*.[5] Together, these compositions establish Le Moyne as a capable and imaginative craftsman who was a founder of the watercolor tradition in England, France, and in a sense in America as well. Particularly in *Laudonnière and King Athore*, the artist reports both what he sees and what he feels. Though his ability at handling perspective is limited, this linear, colorful drawing expressively reflects the wonderment felt by a sixteenth-century visitor to the New World.

Le Moyne's travels were followed shortly by those of John White (fl. 1577–1593), the second major recorder of America. As early as 1577, White may have traveled as recording artist with Sir Martin Frobisher's second expedition to Baffin Island, and he is also thought to have been with a party which explored the Outer Banks of the Carolinas in 1584. More important, White accompanied Sir Richard

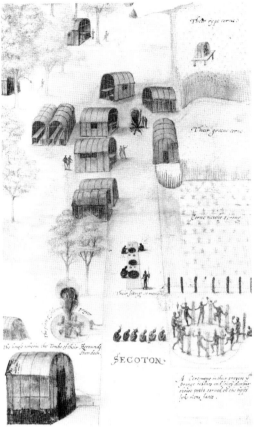

Fig. 2. JOHN WHITE,
The Village of Sekotan, c. 1585–1590.
Watercolor, 12¾ x 7¾″.

Fig. 3. JOHN WHITE,
A Warrior of Florida, c. 1585–1590.
Watercolor, 10⅝ x 5⅜″.

Grenville's expedition of 1585–86 to Roanoke Island, off the coast of North Carolina, in an ill-fated attempt to establish a permanent British colony there. Like Le Moyne before him and innumerable men to follow, White's role was that of official artist to the expedition.

As was true even through the nineteenth century, the most talented artists seldom went on these explorations. The artist-reporter needed to have only minimal artistic competence combined with considerable courage, strength, and adventurousness. White exemplifies this tradition, and his watercolors are charming and able visual records of an unknown continent. They include maps, studies of individual Indians as well as views of their villages and flat botanical images of flowers and fishes (see Figs. 2, 3). Moreover, White's personal qualities are suggested both by the integrity shown in his journal and in his leadership of a new expedition in 1587 which again settled on Roanoke Island. White's granddaughter, Virginia Dare, was born there in the summer of 1587, and White sailed for England shortly thereafter, seeking badly needed supplies. When he finally returned three years later, he dis-

covered no trace of the settlers. The mystery of this "Lost Colony" remains unsolved to this day.

Seventy-five of White's watercolors survive today—though in somewhat damaged condition—in the British Museum. The artist employs colored washes, primarily browns and reds with blue and green details, on untreated paper. Figures are outlined in pencil or brown ink, and pure colors are applied with a brush quickly and directly. White had a sharp eye for detail, a spontaneous manner, and his results were often delightful. Apparently less highly trained than Le Moyne, his view was more acute and he seems less overwhelmed than Le Moyne at the total strangeness of the new land. A possible explanation for this, and also for similarities in their approach, is that White may have known Le Moyne's work; indeed, a recent scholar has suggested that White may have been apprenticed to him.[6] In any case, twenty-three of White's watercolors were engraved and published by Théodore de Bry in 1590 in Part I of his great compendium, *America*; this first volume, on Virginia, thus actually preceded by one year de Bry's publication of Le Moyne's earlier Florida watercolors.

Le Moyne and White were the founders of watercolor drawing in America, and of the English watercolor tradition as well, for as Graham Reynolds notes, "The first appearance of the word 'watercolour' recorded in the *Oxford English Dictionary* comes from Shakespeare and is contemporary with the work of John White and Le Moyne de Morgues."[7] Circumstances were such that it was some time before artists of the same caliber came again to America. Le Moyne and White were followed over the succeeding two centuries by a variety of trained and untrained reporters who drew for specific scientific, military, or other useful purposes—but very seldom intended chiefly to create works of art. One remarkable figure was Samuel de Champlain (1567–1635), the first governor of French Canada, who made extensive visual and verbal records of his voyages across the Atlantic. Unfortunately, the original manuscript and drawings exist only for his 1599 voyage to the West Indies; these pen and ink drawings (in the John Carter Brown Library, Brown University) are crude renderings of topography, natives, and animal life, and they are frequently more imaginative than reportorial. Later trips to Canada resulted in the elaborate 1632 edition of *Les Voyages de la Nouvelle France Occidentale,* which includes many engravings that, although bearing his name, are often so inaccurate that scholars now doubt whether Champlain actually conceived them. In any case, no original drawings for the North American illustrations have survived.

French explorers and artists were increasingly active in America during the following century. One was the Franciscan, Louis Hennepin

Fig. 4. Jean-Baptiste Michel Le Bouteux, *View of the Camp of Mr. Law's Concession at New Biloxi, Coast of Louisiana,* 1720. Watercolor, 19½ x 35⅜".

(c. 1640–after 1701), who accompanied La Salle to the Great Lakes and the upper Mississippi area in 1679–80. His illustrated books about these explorations were immensely popular, being quickly translated from the French into Dutch, English, Italian, and other languages. Though no original drawings are known, and the engravings, like Champlain's, appear to be highly imaginative, Hennepin remains an important figure for his early verbal and visual description of some of the great sights of North America, including Niagara Falls. Shortly afterward, Baron Louis Armond Lahontan (1666–after 1735) traveled in much the same area, commanding various forts as a professional soldier. Lahontan's engravings are diagrammatic and scientific, and as with Hennepin, none of the original work has survived.

The French were naturally particularly concerned with holdings in Louisiana, and many efforts were made to make visual records of this area. Jean-Baptiste Michel Le Bouteux[8] for example, was an early settler at New Biloxi (in present-day Mississippi); this area had been granted by the French government to the Scottish-born financier John Law, who by 1717 had gained a monopoly on commercial privileges there. Bouteux's only known watercolor is a rather sophisticated panoramic rendering of 1720, the *View of the Camp of Mr. Law's Concession at New Biloxi, Coast of Louisiana* (Fig. 4). This artist shows a rare understanding of perspective for the period, along with the ability to render clearly trees, dwellings, and the inhabitants of the camp itself

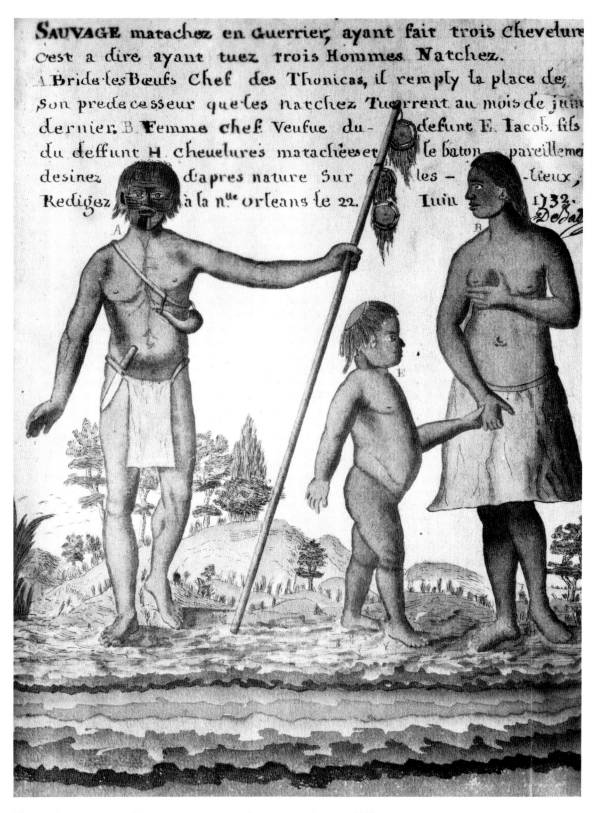

Fig. 5. ALEXANDER DE BATZ, *Buffalo Tamer, Chief of the Tunica,* 1732.
Pen and ink with watercolor, 9½ x 13".

as they went about their daily activities. Yet despite Bouteux's obvious ability, little is known about his later career.

A second Louisiana artist of this period was Antoine Simon Le Page Du Pratz (1689–1775), who lived there from 1718 to 1734. His *Histoire de la Louisiane* was published in Paris in 1758, and contains many engravings after what were apparently relatively crude pen-and-ink sketches of the flora and fauna of the area. In the case of yet another visitor to Louisiana, Alexander de Batz (d. 1759), about half a dozen original drawings of Indians are preserved today at the Peabody Museum, Harvard University. De Batz was an interesting figure: active in New Orleans beginning in 1732, he was one of the first architects in America, making maps and plans of existing structures, and recording as well the appearance of native tribes in the area. His watercolor *Buffalo Tamer, Chief of the Tunica* (Fig. 5) shows the warrior-chieftain with his wife and child; while stylistically reminiscent of White's work (which had a lasting impact on America's vision of the noble savage), it is at the same time a carefully observed, rare view of an Indian family.

The Dutch also had an interest in America, particularly during the better part of the seventeenth century when they controlled New Amsterdam (later the city of New York). A wash drawing in sepia and color on paper entitled "Novum Amsterdamum" and inscribed in Dutch "In the ship Lydia [or Lyden?] by Laurens Block, son of Herman, in the year 1650," in the collection of the New-York Historical Society, has often been considered one of the earliest views of the New World. However, even when publishing it in 1915, I. N. P. Stokes noted that its authenticity had been disputed and that no record could be found of either the artist or the ship. Given these uncertainties and the fact that its inscription is apparently of the eighteenth century, this drawing must remain in the doubtful category.

Less sophisticated, more conceptual—and also far more believable than the "Block" drawing—are the pen-and-ink depictions of New York by Jasper Danckaerts (1639–c. 1702–04). Danckaerts was a leader of the Labadist sect who in 1679–80 traveled to New York and elsewhere in the company of Peter Sluyter, seeking a site suitable for colonization. The seven known drawings were made by Danckaerts to illustrate Sluyter's journal, and are preserved today at the Long Island Historical Society. Most are extremely simple, unadorned topographical sketches; they are taken from a bird's-eye view in which the artist looks down on the foreground and straight out at the horizon. Now eschewing flora and fauna in favor of recording details of harbor and village, Danckaerts' efforts are naïve while being both useful and realistic. Most impressive is the so-called *Labadist General View of New York* (Fig. 6), a broad, panoramic view of the city from Brooklyn Heights which—as Kouwen-

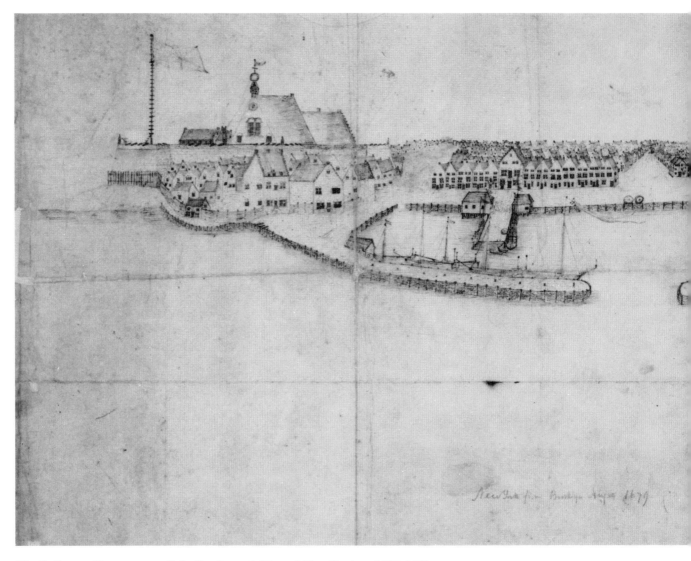

Fig. 6. JASPER DANCKAERTS, *Labadist General View of New York*, c. 1679–1680.
Watercolor, 12⅞ x 32⅜".

hoven points out—showed that fortifications and military matters were now of secondary interest compared to the expanding commerce seen in the new docks and Marat House.[9]

In addition, a number of men are thought to have made topographical drawings or watercolors of the New World, judging from existing engravings after their work, but little can be said about their styles in the absence of the originals. William Burgis, for example, was active in the years from 1716 to 1731, and the views of New York and Boston that he published are important in the history of early American prints, yet no drawing by him is known today.

Those who drew America in the sixteenth and seventeenth centuries were explorers or naturalists first and artists second. The prime value of their work—as they undoubtedly intended—was reportorial rather

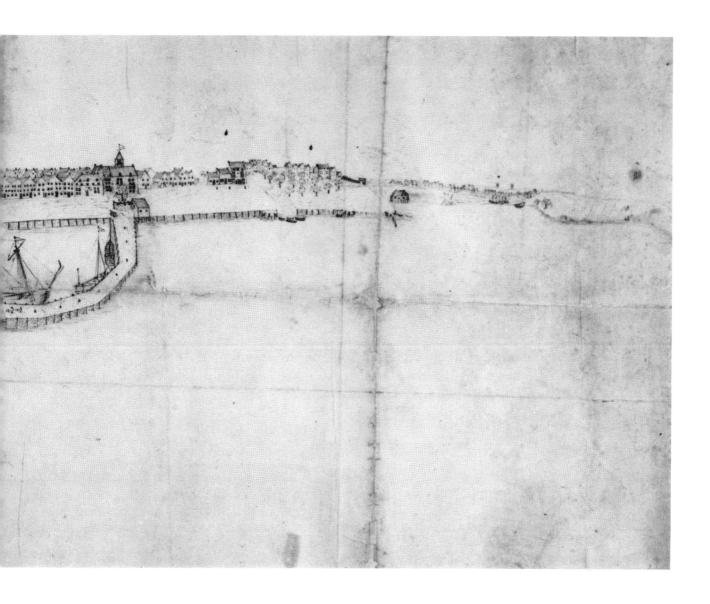

than aesthetic, and they were either lower-rank professional artists or, perhaps more commonly, amateurs who had had some training with a master. Their medium was usually watercolor on paper, applied with a brush after outlining in ink—the traditional tools of the scientific observer. Pure linear drawings, made with quill or reed pens, graphite, silverpoint, or chalks or crayons, were seldom executed by our early artists, though all these mediums were well known to the contemporary Mannerist and Baroque artists of Europe. Watercolor must have been thought appropriate for making visual records, while other means were not. Certainly this medium was convenient for the traveler: paper and brushes and small tins of powdered color were light and easily transported; and watercolors could be made rapidly, for the pigment dries quickly and needs no fixing, varnishing, or glazing. Indeed, it may well

have been considered the simplest of drawing techniques, for it was only with the coming of resident American masters in eighteenth-century colonial cities that other ways of drawing became popular.

The eighteenth century saw the transformation of many variegated, multinational colonies into a single English-speaking nation. At its beginning, the stable, professional artist was unknown; one hundred years later, academies were being formed, exhibitions held, and drawings of all kinds—including some of high quality—were being made. This artistic transition—far from complete even in 1800—was accomplished very slowly, as the arts progressed along a tortuous route. Each new, aspiring artist had to make his own way, fighting and refighting the same battles against public indifference and neglect of his skills.

The first resident professional artist who regularly made and sold drawings in the colonies was Henrietta Johnston (?–1728/29) of Charleston, South Carolina. Apparently of Irish origin, she and her husband, the Reverend Gideon Johnston, arrived in Charleston about 1706 or 1707. The couple found themselves in a state of "miserable poverty," and Henrietta quickly took up the making of portraits in pastel, an art in which she had had some early training at home. Her career does not fit the later, clichéd image of the amateur woman artist who made pictures for her own amusement during carefree leisure hours. Rather, her efforts literally enabled her family to survive, for as her husband noted in his journal after eighteen months in the colony: "Were it not for the Assistance my wife gives me by drawing Pictures (which can last but a little time in a place so ill peopled) I should not have been able to live. . . ."[10] Yet the Reverend's pessimism with regard to demand appears to have been ill-founded, for Henrietta Johnston's talent was almost unique in that period and there are signed pastels by her dating up to 1725, when she executed several portraits during a trip to New York. This is not to suggest that her talent was prodigious, for it was not: her portraits are a far cry from the elegant, airy productions in the same medium by the French and Italian masters of the time such as the well-known Rosalba Carriera (Venetian, 1675–1757) and even from the more mundane works of the leading English practitioners such as Edmund Ashfield (act. 1675–1700). Johnston used her powdery, colored chalks in a repetitious manner: the portraits are nearly always bust length, of small size (often about 9 x 11 inches), with the sitter's head turned slightly, eyes abnormally large, and no hands, jewelry, or other details shown. Moreover, the artist's method of binding paper to board was apparently faulty, and many of the drawings are stained or damaged. Nevertheless, her portraits at their best (see Fig. 7) are pleasant and direct likenesses.

A second artist active at this time was John Watson (1685–1768), a Scot who emigrated to Perth Amboy, New Jersey, in 1714 or 1715. A Court of Common Pleas complaint lists him as a "limner" in the latter

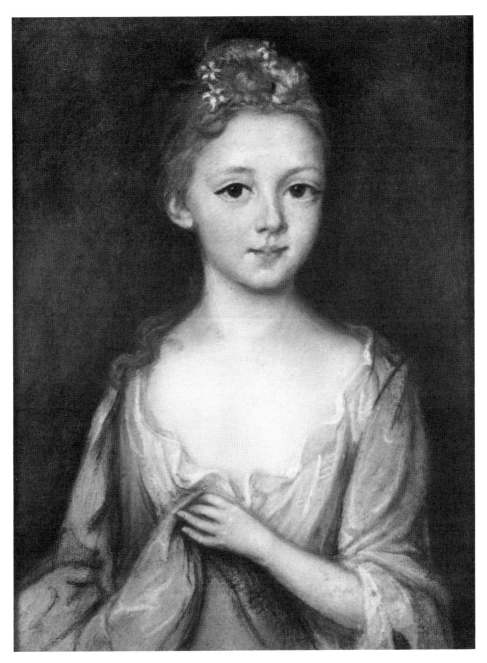

Fig. 7. Henrietta Johnston, *Frances Moore*, c. 1720.
Pastel, 11½ x 8½″ (sight).

year. Watson was, among other things, the earliest known art collector in America, for by 1725 he had amassed a considerable group of European paintings on a trip home; however, his collection lasted only until 1776, when it was tragically destroyed by a group of militia shortly before the Battle of Princeton. Watson apparently prospered through his art and other means (William Dunlap notes his reputation as a "miser and usurer"); and unlike his contemporary, Henrietta Johnston, he executed both oil paintings and drawings. The latter are either

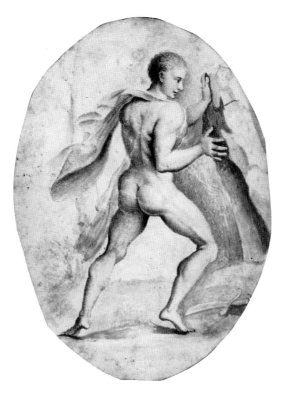

Fig. 8. JOHN WATSON, *Hercules*, c. 1750.
Pencil and wash on vellum, 4$\frac{1}{16}$ x 3$\frac{1}{16}$".

graphite or wash on vellum, and they consist of small portrait drawings
(such as the rather elegant, Knelleresque *Governor William Burnet*
at the New-York Historical Society) and depictions of ideal or allegori-
cal subjects in the same mediums and scale.

Portrait drawings probably appealed to Watson's sitters because
they could be made quickly, were easily transportable, and were inex-
pensive in comparison to oil paintings, for the artist's account book of
1726 shows that commissions in oil cost at least two pounds, five shil-
lings, while those "on Black and Whait" were apparently priced at six
shillings. The uses of the "ideal drawings" are more difficult to guess,
though one can presume they were either copies of engravings meant to
display the artist's talents to prospective customers or studies for now-
lost compositions. In any case, outstanding among them is the so-called
Hercules (Fig. 8), of which a nineteenth-century historian wrote: "The
writer has a small pencil sketch of a nude athlete, drawn by Watson,
which shows remarkable skill in depicting anatomical developments."[11]
The nude was an unusual subject in America even a century and a half
later; Watson's figure is thus truly astonishing. This is one of only a
handful of his drawings that exist today—though over seventy lasted
into the late nineteenth century—thus suggesting once again the
fragility of works of art on paper, and the fact that our knowledge is

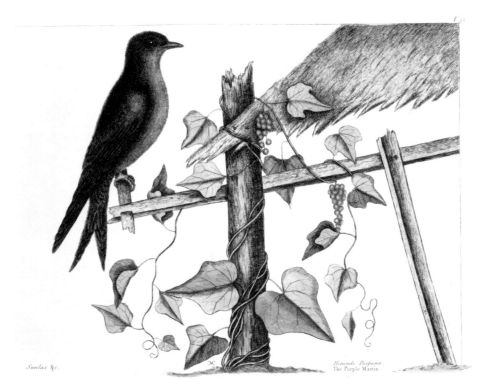

Fig. 9. MARK CATESBY, *The Purple Martin*, 1731.
Engraving after watercolor.

based only on a tiny fraction of the drawings executed over past centuries.

Mark Catesby (1679?–1749) is a third artist who was active during the early decades of the eighteenth century. Following the tradition of the early explorer-naturalists rather than the resident professionals such as Johnston and Watson, Catesby is nonetheless an important figure who is rightly considered "the father of American ornithology." Born in Suffolk, England, he studied natural science in London and then in the years 1712 to 1719 he traveled to visit relatives in Virginia. Upon his return to England, he was encouraged by Dr. Hans Sloane and other leading botanists to go back and make a more serious study of the southern colonies' natural history. He then took a second journey, arriving in South Carolina in May 1722 and traveling up and down the coast making many watercolors of flora and fauna before departing for England, via the Bahamas, in 1726. The result of these two extensive trips was Catesby's great publication of 1731, *The Natural History of Carolina, Florida, and the Bahama Islands: Containing the Birds, Beasts, Fishes, Serpents, Insects and Plants: Particularly the Forest-trees, Shrubs, and other Plants, not Hitherto described, or very incorrectly figured by Authors. . . .*

Unlike other naturalists, Catesby had learned the art of engraving

and was able to cut his own plates and then hand-color the prints himself. The usual practice, followed from the time of John White (fl. 1577–1593) to that of John James Audubon (1785–1851), was for the publisher to hire a professional engraver who copied—and sometimes modified—the artist's original drawings. Catesby's illustrations are flat and detailed: they show colorful birds, fish, crabs, and plants in profile, with little attempt to suggest depth, weight, or background habitat. His simple compositions (see Fig. 9) are nonetheless successful in their genre, for as Catesby modestly noted in his Preface: "As I was not bred a Painter I hope some faults in Perspective and other Niceties may be more readily excused, for I humbly conceive plants and other things done in a Flat, tho' exact manner, may serve the purpose of Natural History, better in some measure than in a more bold and Painter-like way."[12]

John Smibert's arrival at Newport, Rhode Island, in 1729 signaled a new professional status for the artist in America. Smibert (1688–1751) was a well-known, competent master of the Baroque manner of portraiture; the fact that he chose to stop at Newport, and then settled permanently in Boston, suggests that the time had come when a trained, full-time painter could look forward to making a decent living in the colonies. Smibert brought with him not only a knowledge of the fashionable styles of English art, but also a collection of paintings including copies after Raphael, Poussin, and other masters, casts of classic sculpture, mezzotints, books, and indeed all of the painting and drawing materials a professional artist might need. He had been, after all, appointed professor of "drawing, painting, and architecture" in Bishop Berkeley's proposed college for Bermuda, and presumably he took for granted the role of drawings in the fine arts. In the famous painting *Bishop Berkeley and His Entourage* of 1729 he included at the far left a portrait of himself holding what is clearly a landscape drawing in red chalk (see Fig. 10). Smibert's recently discovered Notebook mentions no drawings, but it does record his purchase in Italy in 1720 of "6 figurs in pastills."[13] Moreover, it is apparent from the artist's correspondence with his London agent that the artist's shop that he operated in Boston carried lead pencils and red chalk. Thus there is every reason to think that he drew as a matter of course, though none of the drawings which have been attributed to him at various times can now be accepted as authentic.

Moreover, newspaper notices and advertisements confirm the growing role of the draftsman at this time. Artist's supply shops were in operation in several cities by the 1730s and 1740s: in 1732 Richard Fry of Boston gave notice of his operation as "Stationer, Book-seller, Paper-Maker, and Rag Merchant"; Smibert advertised his own color and frame shop in 1734; and in 1737 "Mrs. Mary Sewall, Widow" ad-

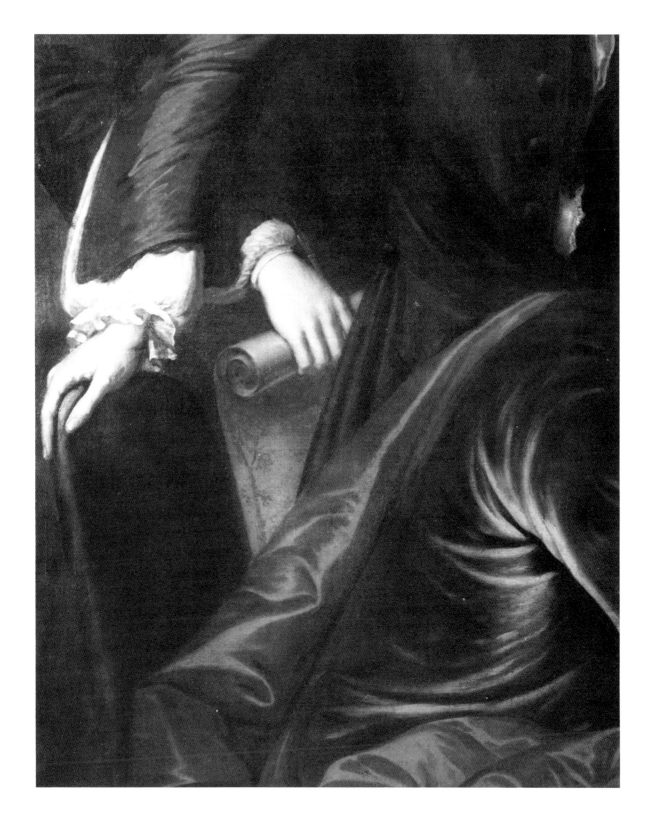

Fig. 10. JOHN SMIBERT, *Bishop Berkeley and His Entourage*, 1729.
Detail of oil painting.

vertised "All sorts of Drawing for Embroidery, Children's quilted Peaks, drawn or work'd."[14] Jeremiah Theus (c. 1719–1774)—like Smibert, well known today for his oil portraits—made notice in 1744 that he was teaching the art of drawing in Charleston, just as the now-unknown Peter Chaffereau had done a decade before.[15] And in New York, such newspaper notices began to appear in 1746, when Gerradus Duyckinck noted that, besides limning, painting, varnishing, and gilding, "he will also teach any young Gentleman the art of Drawing." Finally, in the same year in New York, Obadiah Wells advertised that he sold "Paints, and Oyl, drawn Lead, Chalk fine or corse."[16]

There was little notion of art as *art* at this time in America. Rather, it was a useful craft, and the artist had to be a jack of all trades; he was an artisan, and by midcentury drawing was rapidly becoming one of his tools. A 1740 advertisement by Gustavus Hesselius (1682–1755) —again an artist who must have made drawings for his ambitious compositions, though none survive—and his new partner, John Winter (act. c. 1739–1771), suggests the varied nature of their work:

> Painting done in the best Manner, by GUSTAVUS HESSELIUS, from Stockholm, and JOHN WINTER, from London, viz: Coats of Arms drawn on Coaches, Chaises, &c, or any other kind of Ornaments, Landskips, Signs, Shewboards, Ship and House Painting, Gilding of all sorts, Writing in Gold or Colour, old Pictures clean'd and mended, &c.[17]

In 1750 Winter became a landscape painter, and his notice of that year specified also that he taught "drawing in perspective, as building, figures, landskips, &c."[18]

Few drawings survive from the first half of the eighteenth century, either from the hands of the leading painters (such as Smibert, Theus, Hesselius, or Robert Feke) or from the men who began to appear as teachers of drawing. In some cases, artists are known from a single work only—such as Le Bouteux above or Bishop Roberts (d. 1739) in the period now being discussed. Roberts, for example, gave notice in the July 23, 1737, issue of the *South Carolina Gazette* that he would supply "Land-scapes for Chimney Pieces of all Sizes: Likewise Draughts of their Houses in Colours or Indian Ink."[19] This ad suggests that "draughts," or drawings, were not uncommon; that Roberts specialized in pictures of houses, presumably commissioned by their proud owners or by prospective house builders; and that both watercolor and "Indian ink" (India ink, a waterproof, black carbon ink) were in general use. Moreover, his one surviving work—a watercolor view of Charleston, later engraved by Thomas Leitch—is a competently rendered panorama of the waterfront with a high sense of detail and an interest shown in human activities, judging from the foreground genre scene; it makes us regret again that so much has been lost.

2

The Revolutionary Period, 1755–1780:
Drawing Flourishes

America before the Revolution provided unfertile soil for the artist. The extent of Puritan fear of the arts may have been overstated, but it is nonetheless true that the artistic profession had an arduous time gaining a foothold on this continent. Reverend Jacob Duché undoubtedly spoke for a large part of the nation when he declared the hope (in a sermon delivered in 1755) that the Revolution would "banish the syren LUXURY with all her train of fascinating pleasures, idle dissipation, and expensive amusements from our borders," while he looked forward to the restoration of "honest industry, sober frugality, simplicity of manners, plain hospitality. . . ."[1]

The artistic impulse developed nonetheless, and it found outlets in unlikely places. Thus the major American draftsman of the 1750s—and in fact one of the most important artists of his time—was Benjamin West (1738–1820), who was the youngest of ten children from a stern Pennsylvania Quaker family. West first showed artistic inclinations when he began to draw before the age of seven, and despite the general Quaker stricture against pictorial images, his parents apparently encouraged these efforts. An early biographer reported that the "colours he used were charcoal and chalk, mixed with the juice of berries," and continued, "with such colours *laid on* with the hair of a cat drawn through a goose quill, when about nine years of age he drew on a sheet of paper the portraits of a neighboring family, in which the delineation of each individual was sufficiently accurate to be immediately recognized by his father."[2]

None of these juvenile efforts seems to have survived, but we do

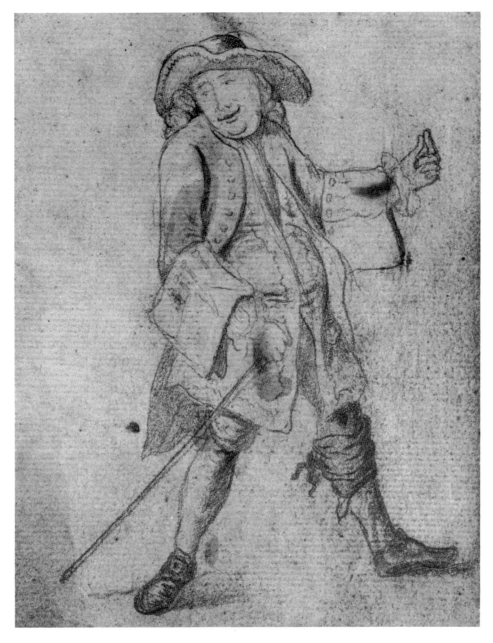

Fig. 11. BENJAMIN WEST, *Man With a Walking Stick, Gesturing,* c. 1759–1760.
Pencil, 6 x 3⅞".

have a small sketchbook (at the Historical Society of Pennsylvania) which probably dates from West's early career as a professional portraitist in Philadelphia, circa 1756–58. This book contains thirty sheets, each 6½ inches high and 3⅞ inches wide, which bear about seventy pencil sketches altogether. All of them portray human figures, both men and women; some are apparently studies for miniatures (showing an oval frame), while others may have been studies of sitters for full-size portraits. The drawings examine pose rather than likeness. Most confidently handled are two drawings which tend toward caricature, one of

a man with a walking stick, seen in profile, the other (Fig. 11) possibly of the same subject, now turned out and gesturing toward the viewer. The humorous attitude of this figure suggests that West must have known—undoubtedly from prints—the tradition of English satiric art which was flourishing at that time in the hands of William Hogarth (1697–1764). These drawings show the American artist groping toward the artistic mainstream, making a book of drawings primarily for his own use and pleasure, drawing figures as they looked rather than as they wanted to be seen. Even as a youth, West had come to feel—through the reading of Jonathan Richardson's *Works* and other treatises—that draftsmanship lies at the foundation of the painter's profession.

It is well known that West went on from this beginning to become the first American to gain a significant position in the international art world. Leaving Philadelphia and the colonies forever, he traveled to Rome in 1760 and thence to London in 1763. An early exponent of neoclassicism, he was appointed historical painter to the king of England in 1772 and president of the Royal Academy in 1792. During the same years, West played an important role in the American arts as well, for his London studio became in effect the first American academy. Almost every aspiring American artist for three generations went to London to study with him, and so his students included Copley, Stuart, Trumbull, Charles Willson Peale and later his son Rembrandt Peale, as well as Allston and Morse.

West always loved to draw, unlike many of his contemporaries in England (such as Sir Joshua Reynolds); his mature drawing style therefore deserves brief discussion, for although few of the American students copied it exactly, their exposure to West's drawings was an influential part of their training. Thus, while close derivations of West's style were carried on only by relatively minor figures such as his son Raphael West (1769–1850) and Mather Brown (1761–1831), the fact that men like Trumbull and Copley became able and prolific draftsmen in their own right is more telling.

Interesting in showing West's stylistic transition is a drawing of 1765–69, *The Indians Delivering up the English Captives to Colonel Bouquet* (Fig. 12). Now employing an ink line and washes, West demonstrates his new abilities. His neoclassic composition is well-conceived, and his purpose—here depicting an event which had occurred during a 1764 expedition against the Ohio Indians—clearly foreshadows his important American history paintings such as *The Death of Wolfe*, 1771.

As a developing draftsman in England, West naturally sought his model in the Baroque masters of seventeenth-century Italy, particularly Guercino (1629–1666), rather than in the burgeoning English school of landscape watercolorists. P. J. Mariette had noted as early as 1768, "Les Anglois sont passionnés pour les desseins [sic] du Guerchin,"[3] and indeed his drawings were collected by many notable Englishmen, includ-

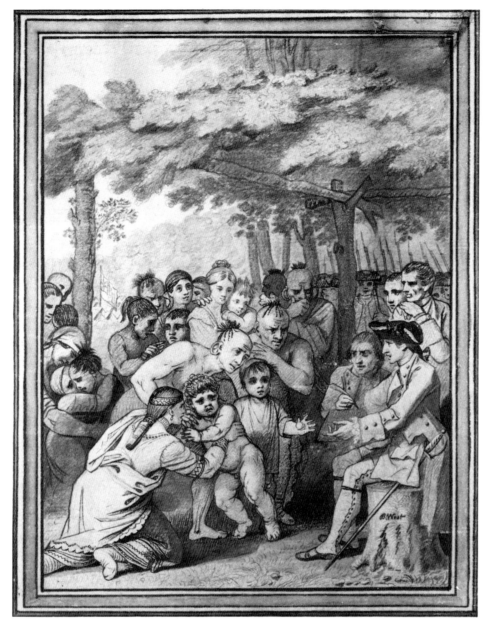

Fig. 12. BENJAMIN WEST, *The Indians Delivering up the English Captives to Colonel Bouquet*, c. 1769. Ink and wash, 10 x 8¼".

ing Reynolds and George III himself. West was on good terms with the king, and one can surmise that he had easy access to the drawings of Guercino and other Italian masters, which existed in great quantity at Windsor Castle. Following this example, West usually drew in brown or black inks over pencil, though occasionally in chalks, particularly during his early years in London. Often the drawings are compositional studies, representing ideas taken from mythological or literary sources, rather than observation of specific figures or scenes. They are like the earlier American drawings in being figure studies for possible paintings,

but otherwise are quite different in being conceptual rather than realistic. And, of course, their style has completely changed. As in *The Blind Belisarius* (Fig. 13), West's line is now easy and even, his touch quick and broad, and his hand certain as he follows the mode of an earlier period.

One finds among West's many drawings occasional landscapes and genre or family scenes, but very few of the types of drawings that became most popular with his students, such as the quick portrait study which Trumbull practiced; the careful study of a figure or group of figures for a larger composition, as in Copley's oeuvre; or the close, detailed drawings of specific parts of the body or costume, which Allston made. Thus the young Americans learned from West that drawing itself was an art, but they did not carry back with them a dogmatic approach or the notion of a single correct style of draftsmanship.

A drawing boom of sorts occurred in America during the 1760s, and it had nothing to do with West, who had just left, or with his students, who began to return only during the 1770s. Rather, the teaching and making of drawings seems to have sprung up all over the colonies almost at once, a symbol and a product of the growing economy and culture of America. Advertisements for drawing teachers, for classes

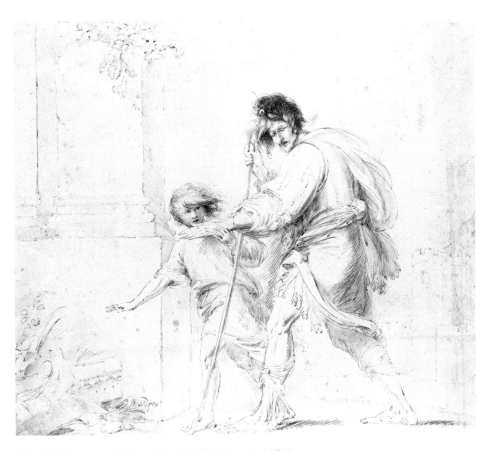

Fig. 13. Benjamin West, *The Blind Belisarius*, 1784.
Pen and ink, 17⅛ x 19¾".

now of both men and women, for drawing in all mediums, appeared regularly in the newspapers of the major cities after 1760. One Lawrence Kilburn, "Limner, from London," offered to instruct "in the Art of drawing Landskips, Faces, Flowers &c. on very reasonable Terms," while another artist offered to teach either "crayons or water colors." Inks, books, native-made and imported paper, "drawing and copy books"—all were being sold, with an emphasis on those supplies which were the "latest from London." These notices demonstrated that almost every kind of drawing medium was known: for example, Stephen Dwight of New York stated in 1762 that "He also will teach drawing in Crayon, black and white chalk, Indian Ink, and black Lead Pencil, in the quickest and best Manner."[4] It is difficult to guess the *reasons* for all of this drawing. Certainly few of the students could have aspired to be artists; rather, drawing appears to have been increasingly recognized as both a useful and proper craft for gentlemen who might use it in planning farms, houses, or fortifications, and ladies, who could be amused by viewing or even making likenesses of their loved ones.

Drawing masters apparently flourished, beginning in this decade, in New York, Boston, Philadelphia, Charleston, and to some extent in Baltimore, for dozens of them advertised in these cities. Yet their work and that of their students has largely disappeared, and that which does remain is often unsigned and unidentifiable. And some artists' work, even though known, is essentially irrelevant to this study: for instance, the dozen or more sketches by John Greenwood (1727–1792) all appear to have been executed after he left the colonies for good in 1752, and they play no such role as West's in later American art.

Nevertheless, fine pre-Revolutionary drawings from a number of hands do exist. To take one example, the tradition of scientific drawing was continued in the work of William Bartram (1739–1823), whose father, John Bartram (1699–1777), was a correspondent of Linnaeus and had cultivated the first botanical garden in the colonies. William Bartram was an almost exact contemporary of West, was also a Quaker, and like West showed a talent for drawing as a very young man; Benjamin Franklin offered him an apprenticeship after seeing drawings he had made for his father at sixteen, and two of his watercolors were reproduced as engravings in George Edwards' *Gleanings from Natural History* three years later, in 1758.

Bartram's extensive, poetic writings about his explorations and observations are generally considered more important than his art, for their influence is seen in the work of Coleridge, Wordsworth, and others and thus they helped shape the early nineteenth century's attitude toward nature. His drawings and watercolors are nevertheless of more than passing interest, for they present a fascinating mix of accurate observation and romantic imagination. Some are watercolors that are simple, realistic depictions of birds, flowers, and fish following generally

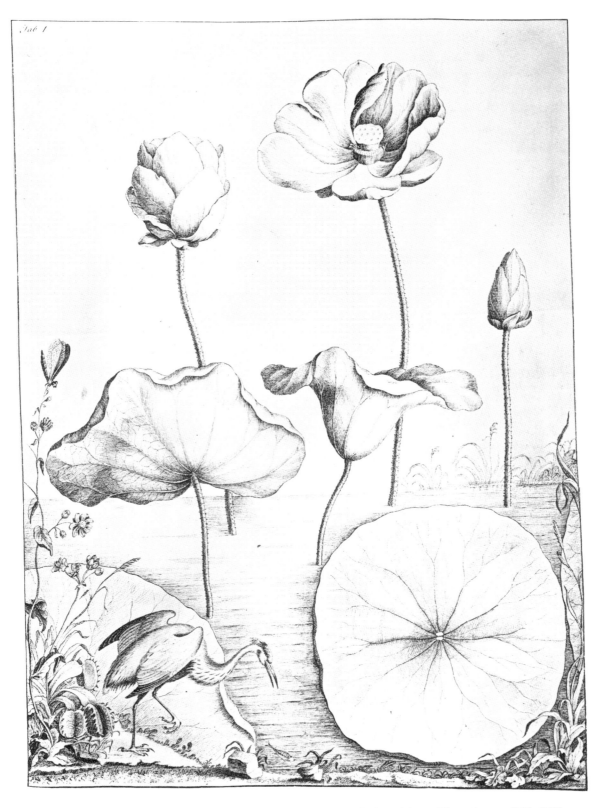

Fig. 14. WILLIAM BARTRAM, *A Drawing of the Round Leafed Nymphia as Flowering*, c. 1761–1762. Pen and ink, 14⅞ x 10⅝″.

in the tradition of Catesby. Others, however, are nothing short of extraordinary: these are highly detailed pencil drawings that are both scientific and surreal; though meant as illustrations, their creator's unique artistic vision is often dominant. One entitled *A Drawing of the Round Leafed Nymphia as Flowering* (Fig. 14) depicts the American lotus which the artist observed on the Cape Fear River, North Carolina, in 1761–62. The drawing itself was sent to London, where it was purchased by one of his important patrons, Dr. John Fothergill. An observer in London wrote upon viewing this work, "So great was the deception, it being candle-light, that we disputed for some time whether it was an engraving, or a drawing. It is really a noble piece of pencil-work."[5] Working with extraordinary control, Bartram illustrates the lotus flower first from above (lower right), and then in profile in five successive stages of growth from the bud to the full blossom. At the lower left of the sheet he includes a touch of realistic landscape in a different scale, showing a great blue heron, and in the lower left corner appears the first known sketch of what Darwin later called "the most wonderful plant in the world," the Venus's-flytrap. The balance between the two parts of the drawing is an uneasy one; the seemingly gigantic lotus flowers seem to waver threateningly in this wondrous vision of nature in the New World. There is no doubting the quality of Bartram's achievements. His work stands out for its technical excellence and for its imaginative qualities; while it continues the botanical tradition, it must also be considered a precedent for the later romantic naturalists in America, such as John James Audubon and Martin J. Heade.

The most extraordinary accomplishment among colonial draftsmen, however, is that of John Singleton Copley (1738–1815). While his contemporary Benjamin West departed from the colonies after showing youthful promise, Copley remained in his native Boston until he had reached full artistic maturity, and had become by far the greatest of American colonial painters. As Jules Prown has suggested, without exaggeration, "The unexpected blossoming of a major eighteenth-century artist in colonial Boston . . . is one of the most remarkable episodes in the history of art."[6]

Copley's stern, insightful, handsomely painted oil portraits of Boston's gentry are well known, but his excellent drawings in various mediums have received less attention. Even as a youth, his drawings were both more incisive and more ambitious than West's. In 1754, when he was sixteen, he made a small pen-and-ink drawing called *Unknown Subject, Battle Scene,* now at the Addison Gallery, Andover; it is somewhat reminiscent of Callot, and is probably a copy from a French or Italian Baroque source. At about the same time, he made two chalk drawings of a *Figure from the Battle of the River Granicus*

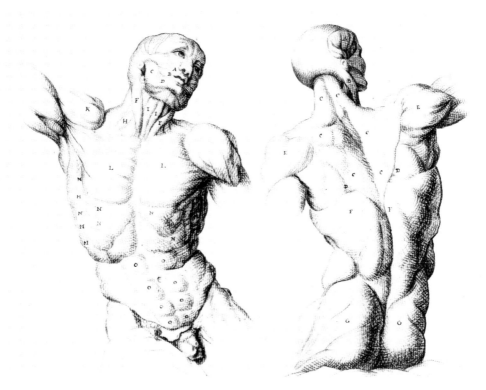

Fig. 15. John Singleton Copley, *Two Torsos* (*Anatomy Book*, Plate VI), 1756.
Pen and ink with black and red crayon, 10¾ x 17 1/16″.

after Charles Le Brun, the seventeenth-century French master, whose
work later inspired both Trumbull and Vanderlyn. The Andover draw-
ing shows him using an ambitious historical composition, practicing
light and dark pen lines and cross-hatching in trying to create an illusion
of light and space while in the chalk drawings he is sensitive to a
different medium as he seeks to draw the plastic form and expression of
a human torso.

In 1756 Copley made for himself a small "anatomy book," which
consists of eight anatomical drawings and three pages of handwritten
text.[7] These drawings (see Fig. 15) are unusual in many ways. For
one thing, they demonstrate Copley's intense artistic ambition and his
desire—common in European academies but unique in America at that
time—to probe beneath appearance in order to teach himself the realities
of human form and musculature. They also show, once again, the key
role that books and prints then played for the aspiring artist, in the
absence of museums, exhibitions, and institutions of formal instruction,
for Copley's drawings are adapted from several Italian and Dutch
books. It is also significant that the final drawing in the book is a meas-
ured line drawing of the Medici *Venus*, possibly taken from a
French drawing book: here Copley employs an ink outline only, in a
sense looking forward to the neo-classic style. While in the others he

ambitiously uses inks as well as black and red crayon in a successful attempt to reproduce the subtle transitions and shading of the original engravings, they are not simplistic copies but vary significantly from their sources, often using two or three plates in a single drawing, altering the composition of the sheets, and emphasizing their expressive qualities and their value range. Plate VI in Copley's book (Fig. 15), for example, combines Tables X and XII from *Anatomy Improv'd and Illustrated* . . . (London, 1723; first ed. Rome, 1691) by Bernadino Genga and Giovanni Maria Lancisi; this expressive drawing curiously prefigures the work of William Rimmer in Boston over a century later.

Copley's anatomy book is remarkable, but it is still rather more craft than art. For the latter, one looks to his majestic pastel portraits, surely the most sophisticated drawings made in America before the Revolution. Bolton notes with classic understatement that "Copley was the first important American portrait draughtsman in pastel."[8] In fact, his pastels are unprecedented in America, and it is difficult to conceive how he acquired the necessary skill and vision to make them. Henrietta Johnston, as noted, did rather crude pastel portraits much earlier in the century, and Joseph Blackburn (act. 1753–63), a secondary English-born painter who came to Boston in 1754, is said to have worked in the medium—but certainly Copley must have had other inspirations than this. The medium itself has been misunderstood in recent times, as Watrous points out, having become mistakenly "associated with the soft, powdery effects produced in broad, coloristic drawings of the late nineteenth and the twentieth centuries."[9]

The term "pastel" properly refers to fabricated chalks "made from pastes which are prepared by mixing dry pigments with binding media," the paste ordinarily then being "rolled into a colored stick of cylindrical shape and then dried."[10] Every imaginable variation of hue, value, texture, and hardness is possible, and it is misleading in the extreme to consider pastel either easy to use, incapable of linear effects, typified by pale, soft ("pastel") colors, or a "woman's medium." Pastel was employed in Europe in the sixteenth century, and its use flowered during the seventeenth and particularly the eighteenth century. Treatises on art included sections on the pastel; recipes for making the materials were published; and by the eighteenth century art suppliers were manufacturing prepared pastels. Volumes devoted solely to the medium, published during the period that it reached its height of popularity, included one by John Russell published in Dublin in 1733 and another (*Traité de la peinture au pastel*) in Paris in 1788. As indicated by the latter title, the medium was used in increasingly "painterly" ways, with the result that artists began replacing smooth paper with textured or prepared grounds which would better hold the strokes of the chalk.

Copley had begun to make pastels at least by 1758, the date of the

powerful portrait *Hugh Hall* (Kennedy Galleries, New York). The medium is not yet used with an easy touch, though the subject's head is well modeled and the composition is effective in pressing the figure forward while showing little space around it. Even here, there is none of the bland, decorative quality of a Blackburn. To have produced it Copley must have seen an original pastel by a European master, for although pastels were widely engraved, the medium is simply not one that can be understood through the black-and-white line engraving or mezzotint. Yet there exists no evidence that there *were* fashionable pastels then in Boston, and sadly there has been no study of the pastel in America in general or of Copley's use of the medium in particular which might shed light on his sources.

We know from Copley's stylistic development in his oil paintings that ambition and sensitivity, felicitously combined in his character, could lead him to ever greater artistic heights. Moreover, there is one important clue regarding his continuing interest in pastels, for on September 30, 1762, he wrote the pastelist Jean-Étienne Liotard (1702–1789) in Geneva, asking him to send "one sett of Crayons of the very best kind such as You can recommend [for] liveliness of colour and Justness of tints." In the same letter he expressed the hope that Liotard's pastels would become the models for American art, but went on, "not that I have ever had the advantage of beholding any one of those rare peices [*sic*] from Your hand, but [have] formd a Judgment on the true tast of several of My friend[s] who has seen em."[11]

Copley's growth continued apace. In 1764 he executed a fine pair of pastels of Mr. and Mrs. John Scollay (Collections, Mrs. Edward W. Kimball and Fogg Art Museum); both are bust-length portraits, confident, richly shadowed. Between 1765 and 1770 he used the medium frequently, increasingly gaining freedom of stroke, coloristic impulse, and liveliness of pose. Consistently limited to head and shoulders, without accessories, often on dark backgrounds, the portraits are both brilliant and convincing. Interestingly, even Benjamin West in London had heard about these accomplishments of the far-off Bostonian, for in 1766 he wrote reminding Copley of the superiority of oil painting and suggesting that he stick to that. Copley replied, asking for more specifics as to "why You dis[ap]prove the use of them, for I think my best portraits done in that way."[12]

Copley's judgment was vindicated, for many of his best portraits were indeed done in the quicker, less expensive, chalk medium. He reaches his peak in a series of drawings made during the late 1760s, including *Jonathan Jackson, Governor John Wentworth,* and *Joseph Barrell* (the latter at the Worcester Art Museum), all elegant, haughty young men. Particularly outstanding is his *Self-Portrait,* c. 1769, at Winterthur (Fig. 16), in which he gives a new vision of the artist in America: he is totally at ease, in pose, attitude, and in the demonstrable

use of a difficult medium; and the elegance of his informal damask robe and lightly powdered wig give perfect proof of the social heights which Copley envied, then achieved.

Where did Copley learn about pastels? Where could he have seen one which made possible his own development in this medium? We know from the letter quoted above that he was knowledgeable enough to order materials from Liotard, a Swiss-born, Paris-trained master whose work was much admired in England. But we also hear from Copley that he had heard about, but never seen, Liotard's pastels. In any case his modeling of faces, with a strong light source coming from one side (often the left, as in the *Self-Portrait*), is close to Liotard's technique,[13] but the latter artist normally employed a greater range of colors as well as quite different formats and poses than the simple bust-length formula. Moreover, Copley's wiry, linear method of depicting human hair is closer to that of a French pastelist, Jean-Baptiste Perroneau (1715–1783), while the directness of his sitter's gaze and his increasing interest in colorful costume recall the approach of another French master, Louis Vigée (1715–1767). (However, Copley never tried to imitate the very lively expressions favored by Maurice Quentin de La Tour [1704–1788], who was perhaps the major French pastelist.) Thus, Copley's pastels relate directly to the Continental tradition, rather than to English or Irish work in the medium; lacking documentation, one can only guess that he may have seen French drawing books and probably actual pastels as well, brought to Boston by one of the immigrant drawing masters of the 1750s.

Copley left the colonies in 1774 seeking the company and the inspiration of the English and Continental masters whom he admired, and in a sense failing to realize the quality of his own miraculous achievement in America. Here he had been a portrait painter, a trade he had learned to disparage: "Was it not for preserving the resembla[n]ce of perticular [sic] persons, painting would not be known in the plac[e]."[14] Aside from the anatomy book, his drawings in America had been finished portraits (the pastels), and he evidently found no need to make drawings for his oil portraits. In England the situation was reversed: he gave up pastels, and made a great many drawings which are compositional or detail studies for portraits and for the large history paintings he began to undertake.

Copley had gone first to Italy and then to London, where he quickly came into close contact with Benjamin West. The latter by then was a leading force in the English art world, while Copley came only with high ambitions. Nevertheless, Copley did not emulate West's generalized, Italianate drawing style when he set about preparing his own history pictures; rather, his graphic sensibility led him once again to adopt a "French" style used only rarely by West. These drawings (see Figs. 17, 18) typically employ black and white chalks on blue or gray

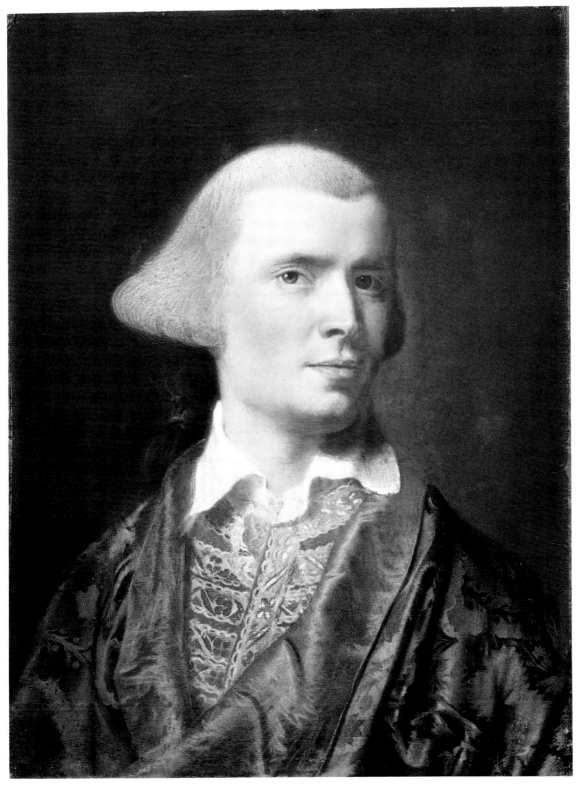

Fig. 16. JOHN SINGLETON COPLEY, *Self-Portrait*, c. 1769.
 Pastel, 23⅛ x 17½".

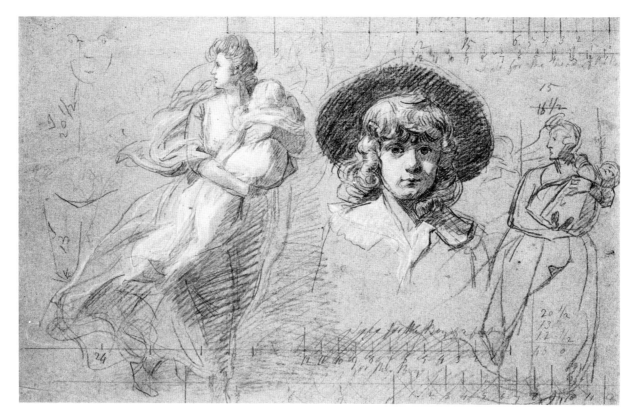

Fig. 17. John Singleton Copley, *Fleeing Woman and Child, and Boy in a Hat*, 1783. Black and white chalk on gray-blue paper, 13⅞ x 22¼″.

paper (though on occasion one finds red chalk, pencil, and ink on white, tan, olive, or pink paper). They demonstrate the artist's concern with placement and pose of figures, with analysis of particular forms of costume or anatomy, and occasionally with individual portraits to be used in larger composition; his aims are like those of the Renaissance draftsman, while his style and technique are closest to early eighteenth-century artists such as Watteau or Rigaud.

Copley consistently made drawings throughout his career in England, from 1775 until his death in 1815. He developed his sketch style by 1777–78, when he did a series of studies in black and white chalk for an ambitious group portrait of 1778, *Sir William Pepperrell and His Family*. There was little change over the years, and late drawings for *George IV as Prince of Wales* of 1804–1809 are similar to the earlier ones in technique and appearance. Many studies were made for the large history paintings which were so important to his career, particularly *The Death of the Earl of Chatham* (1779–81) and *The Death of Major Peirson* (1782–84). Both were developed from many drawings which show his graphic style at its best. *Fleeing Woman and Child, and Boy in a Hat* (Fig. 17) is a study for the right-hand group of fleeing figures in *Death of Peirson*, and it was evidently posed by members of the artist's family—John Singleton Copley, Jr., being the boy with the hat, the in-

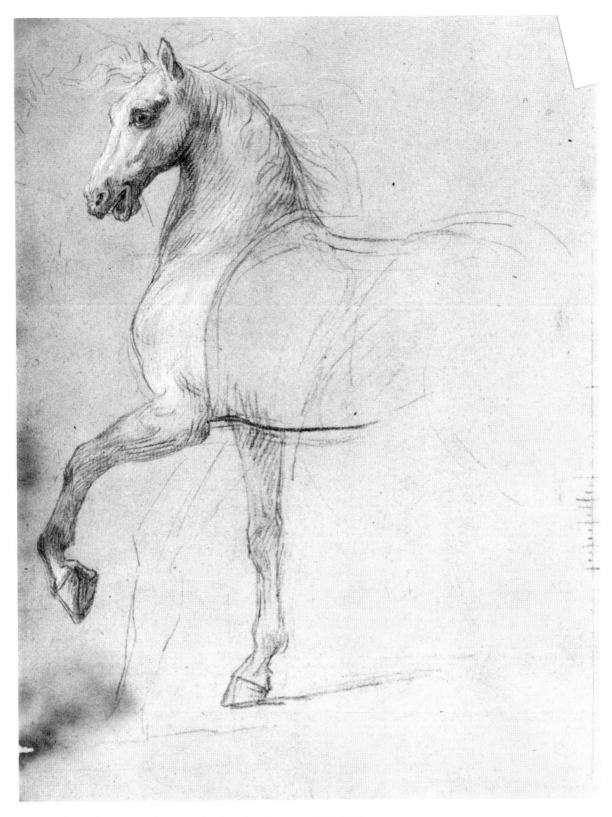

Fig. 18. JOHN SINGLETON COPLEY, *Study of a Horse*, c. 1797–1798.
Black and white chalk on gray-blue paper, 13⅜ x 11¼″.

fant Jonathan Copley the babe in arms, and the family nurse the fleeing woman.[15] The drawing is marked with Copley's calculations, as he carefully planned the placement and gesture of every figure. Its style is linear and energetic, the figures outlined quickly in black chalk, with hatching used to create darks and shadows: the mother and child on the left worked up in medium-length dark strokes, with white then applied for the child's long robes and the mother's shawl; an appealing, straightforward portrait sketch of his son in larger scale, more carefully worked particularly in the light and shadows on his face; and on the right a quicker outline sketch of the mother holding the child in a different pose with its head turned back.

An even greater number of sketches have survived for *The Siege of Gibraltar* (1783–91), many of very high quality, and Copley also did drawings for both single and group portraits, and for biblical scenes such as *Saul Reproved by Samuel for Not Obeying the Commandments of the Lord*, 1798. Drawings for the latter picture included the simple, expressive *Study of a Horse* (Fig. 18), where again the artist used black and white chalk on gray-blue paper.

It seems surprising in our own time of almost instant visual communication that Copley's pastels—the great achievement in drawing of his American career—did not have a greater impact upon his artist contemporaries. Yet news about works of art could only travel then as the works themselves traveled, and Copley's pastels were concentrated in a small area of New England; moreover, the best ones were executed on the eve of the Revolution, when the time and energy of the people were directed elsewhere. Nevertheless, his pastels did influence some draftsmen, such as Benjamin Blyth (1746–after 1786) of Salem, Massachusetts, who by the late 1760s was advertising his skill, "Limning in Crayons" in order to produce "good Likenesses."[16] His only signed pastel is the portrait *George Cabot*, dated 1771 (Collection of Henry Lee Shatuck, Boston), which utilizes Copley's basic format while being poorly modeled and rather crude in color and handling. He also did a pair of portraits of John and Abigail Adams (Massachusetts Historical Society). Blyth remained in Salem at least until 1777, and was last heard of working in Richmond, Virginia, in 1786.

Copley's work did have considerable influence a decade or more after his departure. For example, painters of the "Connecticut School" including Ralph Earl, Winthrop Chandler, and the "Beardsley Limner" prospered during the 1780s and 1790s, doing some oil portraits based clearly on Copley's compositional mode. Similarly, a number of pastelists, evidently knowledgeable about Copley's work, were active at the same time doing bust-length portraits of varying quality and occasionally great charm (see Fig. 19); though research and attribution are far from complete in this area, it is worth noting at least that competent pastels were made by Abraham Delanoy (1742–1795), Sarah Perkins

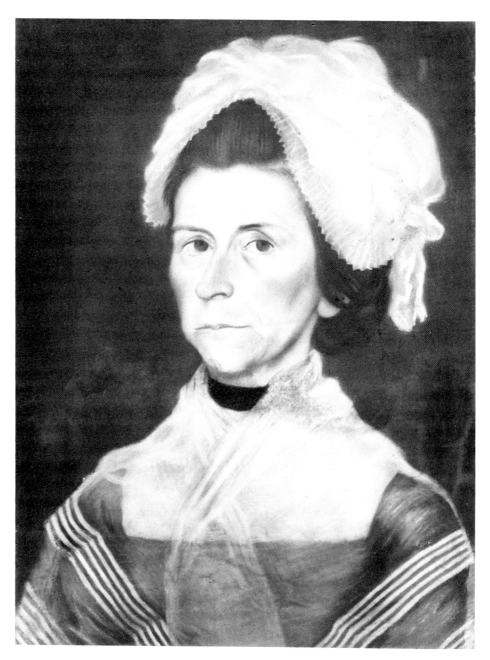

Fig. 19. UNKNOWN ARTIST, *Portrait of a Lady*, 1790.
Pastel, 21 x 15½".

(1771–1831), and Joseph Steward (1753–1802).[17]

Other draftsmen in the colonies carried on the tradition of the journeyman drawing master, paying little heed to Copley's example. Many were foreign-born and brought with them what passed for the latest technique and fashionable style; though usually artists who at home were second-rank at best, they played a key role in expanding America's notion of the arts. John Durand, for example, probably of French birth or parentage, was active in New York and elsewhere be-

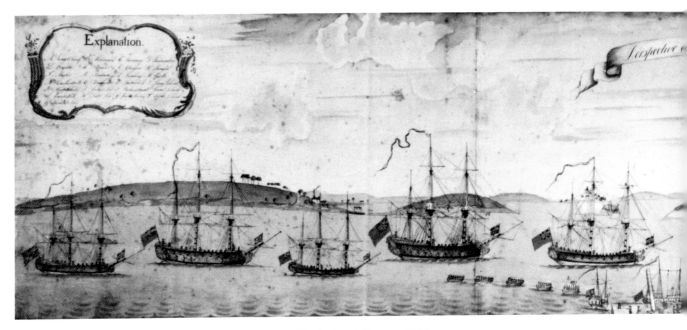

Fig. 20. CHRISTIAN REMICK, *Perspective View of the Blockade of Boston*, 1768. Watercolor, 13 x 61″.

tween 1766 and 1782; in the late sixties he taught drawing and water-color, and later sought support for a projected series of historical paint-ings—a genre then practically unknown in the colonies. Durand was primarily a portraitist, while others specialized in even more "practi-cal" areas. Thus Pierre Charles L'Enfant is best known as the designer of Washington, D.C., yet his watercolor landscape *A View of West Point on the Hudson River*, c. 1782 (Library of Congress), suggests the breadth of his interests and is an interesting forerunner of the Hudson River School. In contrast, the native-born Christian Remick (1726– after 1783) was a professional sailor. In 1769 he published a notice that, "lately from Spain," he stood ready to perform "all sorts of Drawing in Water Colours, such as Sea Pieces, Perspective Views, Geographical Plans of Harbours, Sea-Coasts, &c.," and in addition that he "Colours Pictures to the Life, and Draws Coats of Arms."[18] Today Remick is best known for having hand-colored Paul Revere's famous engraving *The Boston Massacre*, 1770; however, six finely detailed watercolors are also known, each one a "Perspective View of Boston Harbor," (see Fig. 20), in addition to the more loosely washed *Perspective View of Part of the Commons* (Concord [Mass.], Antiquarian Society) and a number of coats of arms in watercolor.

It would be many years before the artist could feel comfortable in America, and longer still before the draftsman was considered an artist. The fact is that draftsmen were able to make a foothold, and then to flourish in a limited way in the eighteenth century, only because their craft was felt to be a useful one. The American attitude toward drawing

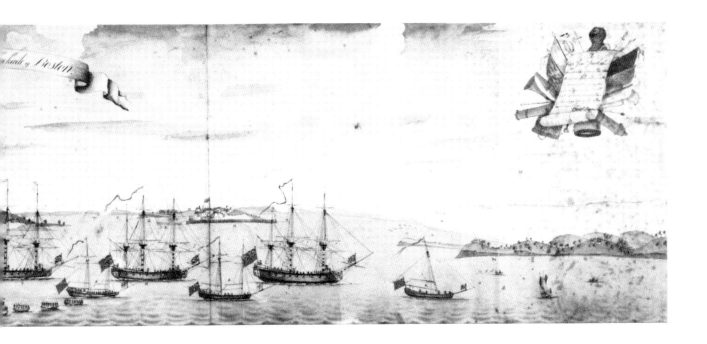

was perhaps best expressed in 1769 by James Smither of Philadelphia, who wrote:

> Drawing is a most ingenious, interesting, and elegant art, and the study of it ought to be encouraged in every youth . . . its utility being so extensive, that there are few arts or professions in which it is not serviceable.

> All designs and models are executed by it—Engineers, architects, and a multitude of professions, have frequent occasion to practice it; in most stations it is useful, from the general who commands an army, to the mechanic who supports himself by handicraft. A young gentleman possessed of an accomplishment so exceedingly desirable, both for amusement and use, is qualified to take the sketch of a fine building— a beautiful prospect of any curious production of art, or of any uncommon and striking appearance in nature, especially to persons of leisure and fortune, it affords a most pleasing entertainment, and enables them to construct and improve plans to their own taste, and judge of designs, &c. with propriety.

However, in the same advertisement Smither goes on to suggest the beginning of an aesthetic view of drawing as well, in words that are meaningful even today:

> Of all others this art has the greatest number of admirers, and no wonder, since in a kind of universal language, or living history understood by all mankind, it represents to our view the forms of innumerable objects, which we should be otherwise deprived of, and helps us to the knowledge of many of the works of nature and art, by a silent communication.[19]

3

Neoclassic Drawings:
The Figure and the Land

John Trumbull (1756–1843) was well equipped, given his ambition, education, and family background, to become the leading American painter of his generation. He was the best-educated artist of his time, having graduated from Harvard in 1773; by the time of the Revolution he had read Hogarth, had studied Piranesi's prints, and had been influenced by Copley's recent portraits. Through his father's connections as governor of Connecticut, Trumbull became an officer in the Continental Army and, for a short time, aide-de-camp to General Washington. In 1780 he went to London, where West accepted him as a student, and there he remained (with trips to Paris and elsewhere) for almost a decade. Encouraged by West and by Thomas Jefferson, in 1785 he began his series of oil paintings of the Revolutionary War, hoping to become the history painter for the new republic.

In fact, Trumbull found patronage wanting; the nation had its mind on things other than art. Moreover, his abilities as a painter began to decline almost as soon as he had begun. Even the canvases done late in the London years are inferior to the first, sophisticated composition, *The Battle of Bunker's Hill* (1785). As he grew older, his irascibility and the fact that he almost never could paint well on a large scale (perhaps due to a childhood injury which deprived him almost totally of the use of his left eye) led to increasing bitterness and decline.

Despite his problems with painting, Trumbull was nevertheless the most gifted draftsman of late eighteenth-century America. Anomalously, he deserves to be remembered as much for the small pencil and chalk sketches he made only for his own use as for the historical paintings which he hoped would guarantee his immortality. Trumbull drew from

the beginning, his aim at first being primarily to teach himself about art. He recorded in his *Autobiography* that in 1772–73, while still at Harvard, he had painted *The Crucifixion* "in water colors, from a print by Rubens."[1] Later in the same decade, in 1778, Trumbull was working in Smibert's old studio in Boston, still struggling to learn the higher forms of art through drawing books and engravings. It was probably at this time that he prepared a sketchbook, now at Yale, which includes many laborious pencil sketches, copies from Charles Le Brun's influential treatise *Méthode pour apprendre à dessiner les passions*, first printed in 1698.[2] Le Brun in his own time had controlled the French Academy, and for two centuries afterwards his drawings of human expressions, "Attention," "Rapture," "Joy," and so on, had been considered definitive by young painters. Trumbull laboriously copied each of the engraved plates (see Fig. 21), as well as the accompanying inscriptions.

Drawing did not come easily. In 1784 Trumbull was enrolled in the Royal Academy School, and as part of his training he made a number of pencil and black-chalk drawings of casts of classic sculpture, including the *Dancing Faun* and the *Venus de Medici*. There is hardly great sureness of line or articulation of form in these works; outlines are often erased and reworked, planes seem flat and arbitrary, and there is little understanding of human proportions (the heads often seeming too small for the bodies).

Yet by late 1785 Trumbull had embarked on his series of "national history" paintings, beginning work on *The Death of General Warren at the Battle of Bunker's Hill* and *The Death of General Montgomery in the Attack on Quebec* (both at Yale). At this point, his pencil sketch style was nearly developed—astonishingly—as seen in a small study of two heads, *Generals Warren and Montgomery* (Yale). Despite the fact that both paintings were planned and executed in West's studio, and relate closely to his work, of the drawings only Trumbull's pen-and-ink compositional sketches show any relationship to West's style. His more numerous portrait sketches are quite different, being carefully realistic and linear, and have little to do with West's graphic manner. Trumbull did emulate Copley in planning his paintings and—following Copley's approach in pictures such as *The Death of Chatham*—in making both compositional drawings and portrait studies of the individual participants. However, the similarity between them is one of working method rather than style: Copley's chalk portraits are gently modeled, nonlinear, almost painterly in effect, while Trumbull's sketches show the artist's delight in every clear, curving stroke of his pencil.

The majority of Trumbull's small portrait drawings appear to have been executed between 1789 and 1794, after he had left London and was traveling up and down the eastern United States making studies for the historical paintings. Typical of his delicate sketches is *Reverend Enos*

Fig. 21. JOHN TRUMBULL, *Attention*, after Charles Le Brun, c. 1778.
 Pencil, 7¾ x 6¼".

Hitchcock (Fig. 22). Made as a visual record for later use in the painting *The Surrender of General Burgoyne at Saratoga*, the drawing captures Hitchcock's likeness with deft, sensitive pencil strokes; it is subtly modeled, with light cross-hatching and stumping giving texture to the fleshy cheeks and chin. On the verso the artist noted: "A very light and florid complexion/Dark blue eyes/light flaxen hair—/2 Sept. 1791." In his *Autobiography*, Trumbull records that during 1791, "In September I went into the country, passed some time with my family, then went on to Boston and New Hampshire, [and] obtained heads of several statesmen and military officers for my great work";[3] one of these was un-

doubtedly Hitchcock, who had been chaplain to the 10th Massachusetts Regiment and was with General Horatio Gates at Saratoga.

A related drawing of the same period is *Hopothle Mico*, the Talasee King of the Creeks (Fig. 24), which was sketched in New York in 1790. Trumbull is usually admired more for his technical facility than for deep observation of character, but this sketch (for an unknown project) conveys something of both the strength and pathos of the Creek chieftain. Drawing even more quickly than in *Reverend Hitchcock*, the artist uses wiry line alone to suggest the richness of his sitter's jacket and medals, combined with remnants of feathered headdress and beads. Trumbull's drawing style is seen here at its freshest: certainly his manner was taken not from West or the English school but rather relates directly to French neoclassicism, and particularly to the portrait drawings of Jacques Louis David (1748–1825). The artist had been to France on numerous occasions (six trips between 1780 and 1797) and came to know many artists, including Mme. Vigée Le Brun and David himself; during a visit in 1786 he had made a pen-and-ink copy of the latter's *Grief of Andromache over the Body of Hector*. Even more

Fig. 22. JOHN TRUMBULL, *Reverend Enos Hitchcock*, 1791.
Pencil, $2^{15}/_{16}$ x $4^5/_8''$.

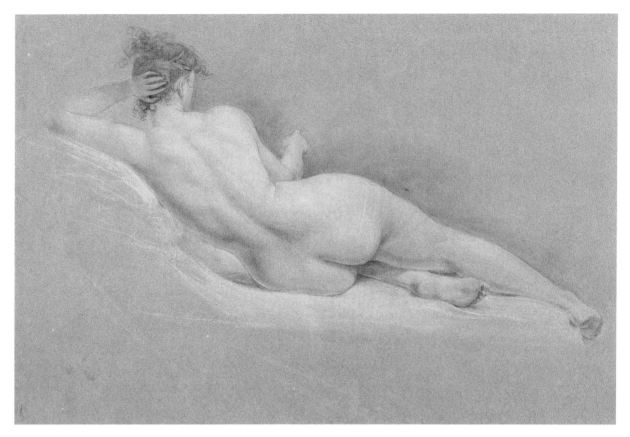

Fig. 23. JOHN TRUMBULL, *Reclining Female Nude*, c. 1795–1796.
Chalks on blue paper, 14 x 22½".

remarkable is the fact that Trumbull's masterful, linear manner actually
anticipates the style of David's pupil J. A. D. Ingres (1780–1867), one
of the master draftsmen of the nineteenth century.

Trumbull also mastered a different mode of drawing in which he
used black and white chalks on blue paper for delicate tonal figure
studies. The best known of this series, *Reclining Female Nude* (Fig. 23),
is remarkably sensuous; its companion piece, *Female Nude, Front View*
(also at the Yale University Art Gallery), is slightly awkward in the
handling of legs and arms but is even more explicitly sexual, showing as
it does the bare breasts and pubic hair of a girl sleeping rapturously.
Trumbull's first biographer, Theodore Sizer, believed these to be
Royal Academy figure studies, dating from Trumbull's training there in
1784. However, there is no evidence that the Academicians were work-
ing in this manner at the time, and Trumbull's own drawings of that
year are vastly less well handled than the nudes. Moreover, these draw-
ings again are extremely French both in style and mood, recalling par-
ticularly the nudes done in the same medium on similar blue paper by
Pierre Paul Prud'hon (1758–1823). While it is clear that Trumbull knew
the chalk technique by the time of his 1789 study *Sir Thomas Lawrence*

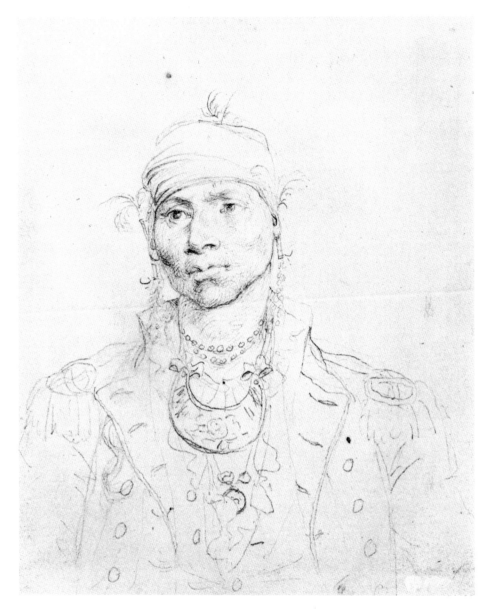

Fig. 24. JOHN TRUMBULL, *The Indian Chief Hopothle Mico*, 1790.
Pencil, 4⅞ x 4".

as "The Dying Spaniard" (Boston Athenaeum), it seems likely that the subtly modeled, rhythmically outlined nudes date from a later trip to Paris, perhaps the lengthy stay of 1795–96. These drawings are apparently not preparatory studies for later paintings; they are too finished to be academic exercises, and thus it seems likely that John Davis Hatch was correct in suggesting that they were probably done purely for the artist's pleasure.[4]

Trumbull's drawings give evidence of what was possible if a talented young gentleman took James Smither's philosophy to heart (see p. 35). Drawings for Trumbull could be both beautiful and use-

ful, designed for use in future paintings or simply to bring joy. He was a draftsman of great range, of which Smither would have approved; besides the work already discussed, he did landscape studies in both pen and wash; finely wrought maps, prepared for military purposes; landscape designs for Yale College; a wide variety of architectural subjects, including a volume of drawings presented to Alexander Jackson Davis, "his pupil and friend"; and drawings for the Trumbull Gallery at Yale (built in 1832) and for a mahogany sarcophagus.

A less accomplished but nonetheless interesting contemporary of Trumbull's was St. John Honeywood (1763–1798), an orphan who grew up in Lebanon, Connecticut, and later attended Yale. At that institution he became well known for his poems and his Latin orations, and was a favorite of President Ezra Stiles. He was a gentleman-artist, an amateur whose graphic facility was employed to amuse his friends rather than provide a livelihood; nonetheless, his wash drawings—such as that of Stiles (Fig. 25)—demonstrate an artistic ambition and an intellectuality that sets him apart from his contemporaries.

Trumbull's chief rivals in painting during the Federal period were Gilbert Stuart (1755–1828) and Charles Willson Peale (1741–1827), and though both may have exceeded him at times in the quality of their oils, neither one drew often or particularly well. This is understandable in Stuart's case, for although he also was trained in London by West, he developed a marvelously quick technique in oil portraiture that was quite his own. Seldom attempting historical compositions, he had less need than Trumbull or Copley for the careful studies they made; moreover, he saw little need for the graphic medium, once telling Matthew Harris Jouett that "drawing the features distinctly & carefully with chalk [is a] loss of time. All studies [should] be made with brush in hand."[5] However, Stuart's good friend Dr. Benjamin Waterhouse reported that Stuart "was patient and even laborious in his drawings,"[6] suggesting that the artist did indeed draw on occasion. In any case, only one drawing by him is known today, the fine but somewhat faint pencil sketch *Seated Baby* (Fig. 26); according to a notation on the verso, it was "drawn on a visit to Dr. Waterhouse," presumably in the years before 1787 when both he and Stuart were living in London.

Quite different in his approach to drawing was Charles Willson Peale, the young nation's leading portraitist in the years between the departure of Copley in 1774 and Stuart's arrival in 1793. One of the last great colonial geniuses, Peale was a painter-craftsman who was equally at home with art, science, natural history, politics, or museology. He was also the father of seventeen children, many of them later important artists and draftsmen in their own right. Peale always encouraged his children, and other students, to learn drawing; in fact, the combined need for a drawing school and a place for exhibitions encouraged Peale to found America's first art academy, the short-lived Columbianum in

Fig. 25. St. John Honeywood, *Ezra Stiles*, 1786.
Pen and brush with wash, 5¾ x 4⅜".

Fig. 26. Gilbert Stuart, *Seated Baby*, c. 1785.
Pencil, 7 x 4½" (sight).

Philadelphia. Peale's biographer, Charles Coleman Sellers, even suggests that his "insistence on anatomical drawing from the living model may have caused the rift"[7] that shortly broke up this early institution. Unfortunately, no early life drawings by Peale or his family can be identified today. In any case, it is surprising that Peale was not a more able draftsman, for he made many drawings over his long life; these consist mostly of quick pen sketches (often in his diaries or letters) which record or convey the appearance of a landscape view or a scientific apparatus with a minimum of artistic style or personal touch. Perhaps most interesting are the twenty-six watercolors he made in 1801 of scenes along the Hudson River; they are charming and well observed, if also unsophisticated in their limited color and repetitive compositions.

Peale's position in the Columbianum nevertheless makes his role an important one, for at least two dozen drawings, watercolors, and pastels were exhibited with the paintings at the 1795 Columbianum exhibition. Included were a "*Portrait in Crayons*" (e.g., a pastel) by "Copeley of Boston"; an "*Allegorical Picture in Crayon*" by "A Lady of Philadelphia"; watercolor landscapes by George Barrett, William Birch, and

a Mr. Beynroth; as well as architectural drawings, maps, and ship designs by Samuel Lewis, Joshua Humphreys, William Williams, and others.

Drawing flourished in the Federal era, with the vast bulk of graphic work of the period coming from the hands (and sometimes the machines) of professional draftsmen. Typical of these practitioners—in his foreign birth and his use of repetitive profile designs—was Pierre Eugene du Simitière (c. 1736–1784), who was active primarily in Philadelphia. Working in chalks and sometimes in pastels, he had sitters that included Americans from Benedict Arnold to George Washington; however, one of his best-preserved likenesses is the *Unidentified Gentleman* (New-York Historical Society).

Closely related, though more sophisticated in modeling, are the small pastel portraits in which James Sharples (1752–1811) and his family specialized. After training in France for the priesthood, he returned to England to study art. By 1782 he had moved to Bath, where he taught drawing, and in the following year he moved to London, where on several occasions his work was exhibited at the Royal Academy. About 1793 the family—including his artist-wife Ellen Wallace (1769–1849) and three sons whom he also trained—moved to America; over the next eight years they made a great many small pastels, primarily in New York and Philadelphia. Eventually the family returned to England; however, the popularity of their work enabled James in 1811 to leave an estate of £35,000, and a large collection of the family's output makes up the Sharples Collection at Bristol, England.

Even the fine study of 1930 by Katherine McCook Knox, *The Sharples*, failed to unravel completely the problem of trying to separate the hand of James Sharples from that of his wife, from his sons' work, and from later imitators; so uncertainty still abounds in this area. Sharples himself portrayed Washington from life on several occasions (see Fig. 27); and there are dozens of duplicates and replicas of this basic composition. Working on grainy, gray paper (usually sheets 9 by 7 inches), Sharples used a brush to apply powdered pastels, which he kept in bottles; for Washington and other subjects as well, he favored a rich Prussian-blue background. A pastel normally took about two hours, and the artist charged fifteen dollars for profiles—his most successful mode—and twenty for full-face views. Mrs. Sharples appears to have been as able as her husband, judging from the fine *Washington* at the National Portrait Gallery, London; her works are distinguished from her husband's chiefly by their lighter, more "painterly" backgrounds. Though the work of the Sharples family is repetitive, it can also be elegant and decorative.

A third exponent of the neoclassic likeness was the French-born

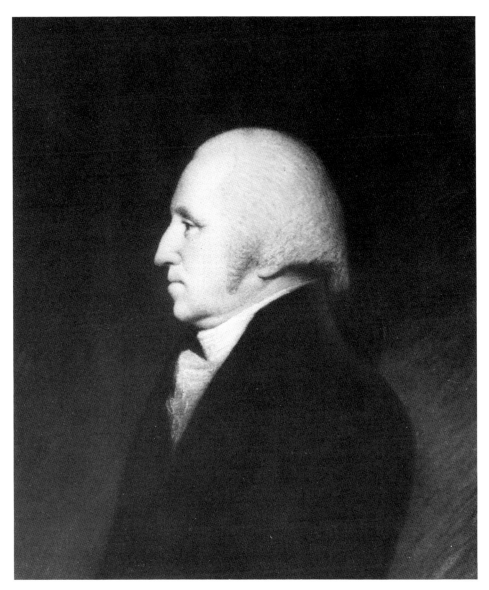

Fig. 27. JAMES SHARPLES, *George Washington*, c. 1795.
Pastel, 9½ x 7½".

artist Charles Balthazar Julien Fevret de Saint-Mémin (1770–1852),
who was even more prolific than the Sharples. Saint-Mémin began his
artistic career in America in 1796 with highly detailed engravings of
New York and other cities, but he soon turned to making profile portrait
drawings (see Fig. 29), which became highly popular, over eight
hundred of them now being known. He portrayed men, women, and
children—including three Presidents and a great many national leaders
—in the same format, always using black and white chalk on tinted
(often pink) paper of about twenty-two by sixteen inches.

Like the Sharples, Saint-Mémin made use of a machine called the
physiognotrace, by means of which the human profile could be copied

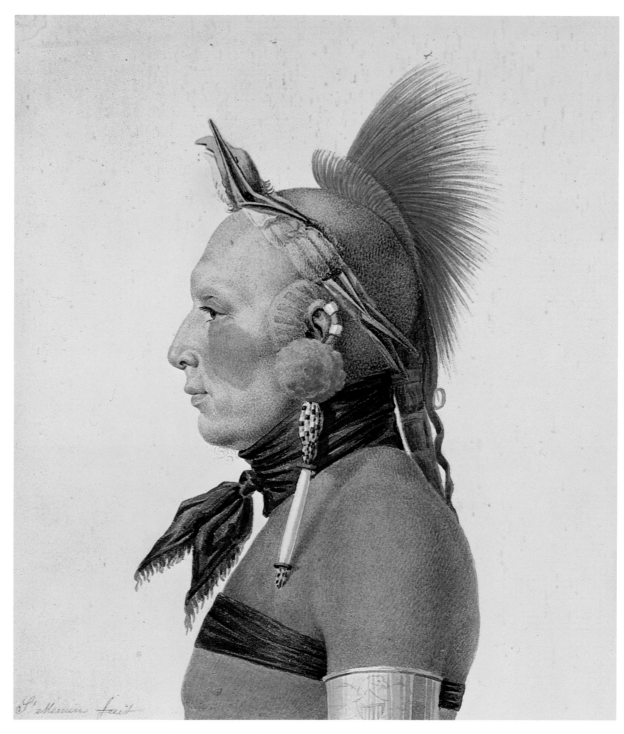

Fig. 28. CHARLES BALTHAZAR JULIEN FEVRET DE SAINT-MÉMIN, *An Osage Warrior*, c. 1804. Watercolor, 7½ x 6¾".

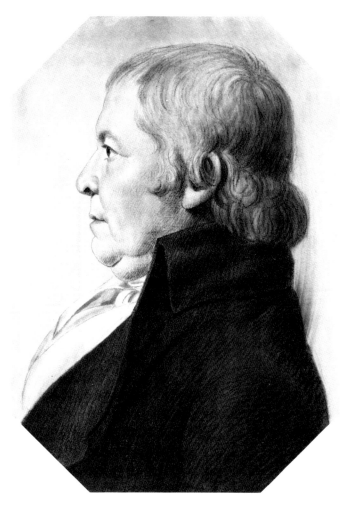

Fig. 29. Charles Balthazar Julien Fevret de Saint-Mémin, *Paul Revere*, 1800.
Black and white chalk on pink prepared paper, 20¼ x 14¼".

quickly and accurately; the artist then added modeling and detail using the chalks by hand. He often went on to reduce the portrait (again using mechanical aids) to the small size of two inches in diameter, which he then engraved for thirty dollars; his sitter received the original life-size drawing as well as the copper plate and a dozen engravings—which had great appeal in those days long before the advent of photography.[8] The technique was not a new one, having already proved popular in France since its invention by Gilles Louis Chrétien in 1786. Nevertheless, Saint-Mémin's portraits are more than mechanical, for the chalk portraits often show quick, bold use of the medium for line and in modeling, and the artist's watercolors, such as *An Osage Warrior*, 1804 (Fig. 28), are subtle and forceful. After working successfully in every city from New York to Charleston, the artist finally returned to Dijon, France, in 1814, leaving behind a large number of elegant portraits in a pure neoclassic mode.

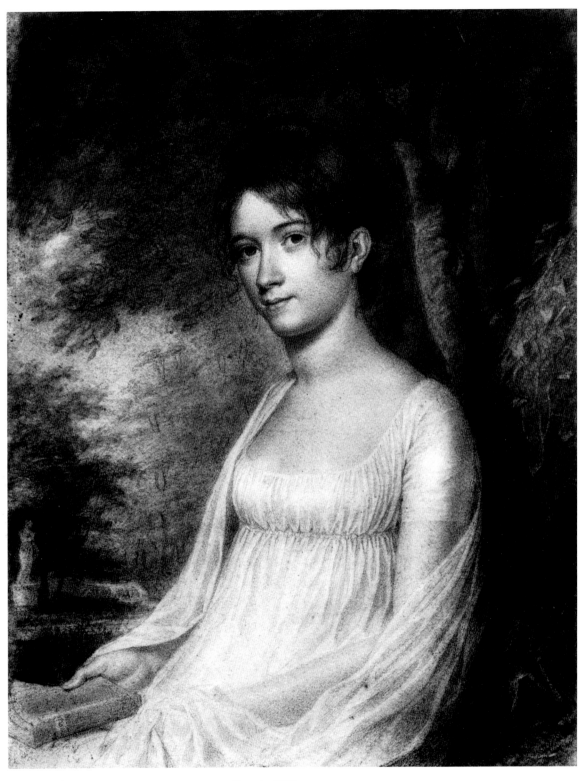

Fig. 30. JOHN VANDERLYN, *Sarah Russell Church*, 1799.
 Crayon, 8⁷⁄₁₆ x 6³⁄₈″.

The ablest of the neoclassic draftsmen following Trumbull was John Vanderlyn (1775–1852), a history and portrait painter who clashed with the older "patriot-painter" on many occasions. Vanderlyn spent three years in training with Archibald Robertson of New York; then in 1796 his patron, Aaron Burr, arranged for him to study for five years in Paris. After two years back in New York, he returned to Europe until 1815, spending most of his time in France. It was there that he painted two of the masterpieces of American neoclassic painting, *The Death of Jane McCrea* (1804) and *Ariadne Asleep on the Isle of Naxos* (1814). Despite these successes, Vanderlyn's career was full of frustration; though he was well trained and had considerable abilities, he failed to find patronage or understanding in his own country, and grew increasingly embittered, finally dying in poverty.

Like Trumbull, Vanderlyn paid little heed to his own drawings after using them, yet they show his genius more clearly than his often-labored oil paintings. Interestingly, he began to draw just as Trumbull had, by making a sketchbook (1791–92, Albany Institute of History and Art) which included four physiognomic studies based on engravings after Charles Le Brun—including "Admiration," "Attention," "Hatred," and "Honor." These early drawings, in pen and ink, are more controlled and more consciously linear than Trumbull's. Continuing to draw, he executed male nudes in pencil and charcoal, a copy after Poussin, and other studies. His first fully developed drawing is a portrait of Robert Fulton, who in 1798 was himself living in Europe as a practicing artist (he later made watercolor studies of his inventions). In the following year, while still in Paris, Vanderlyn executed a series of small drawings of the Church family, including *Sarah Russell Church* (Fig. 30). Alert and intelligent, she is wholly at ease in her fashionable Empire gown, seated outdoors with a classic sculpture in the background and a book in her hand. Vanderlyn here used hard black crayon with a graphite-like appearance; he modeled Sarah Church's face and form with utmost subtlety, moving carefully from the folds of her light-toned dress to the sharpness of her eyes, the light reflecting off her dark hair to the adjacent trees. The drawing is a tonal study, and line is almost totally absent.

His pencil drawing *Washington Irving* (Museum of Fine Arts, Boston) of 1805 is able enough, but shows by comparison what Vanderlyn had lost even in a few years—for he is now a quick and clever draftsman rather than the painstaking yet easy master of his medium. Other drawings of greater and less facility followed, including some sensitive studies for his *Ariadne* of 1814 (Pennsylvania Academy of Fine Arts). Perhaps significantly, however, Vanderlyn reached another peak as a draftsman some forty years later when after years of frustration he was finally awarded a commission for a large painting for the Rotunda of the Capitol. This work, *The Landing of Columbus*, which he worked on

from 1839 to 1846, was a disaster in many ways. Yet to prepare its composition, Vanderlyn returned once again to Paris where he executed a large series of drawings, most in charcoal and colored chalks on gray, blue, or cream-colored paper. There are small studies of poses (both dressed and nude) and also full-scale cartoons for almost every figural detail in the painting. One of the earlier studies for the *Costume of Columbus* (Fig. 31) is in pencil with white-chalk highlights; using a tense, varied stroke, creating volume and form as Copley did, Vanderlyn here carries on history painting and the tradition of neoclassic drawing long past their supposed demise. As with West, Copley, and Washington Allston, Vanderlyn felt artistically more at home in Europe than America, and like them produced many of his finest drawings while abroad.

American neoclassic drawing style was essentially French, as demonstrated by artists from Copley to Vanderlyn; yet even in the last decade of the eighteenth century, American artists were *speaking* as if the only possible source of artistic style or knowledge was London. Though increasing numbers of French names began to appear among the drawing masters and suppliers who were advertising, the greatest status a teacher could claim was that his mode was "the latest from London." This seems strange in view of what was actually happening stylistically, and in light of the bitterness caused by the Revolution, but it was nevertheless the case: the drawings of Romney, Fuseli, and Gainsborough, the watercolors of Sandby and Cozens—in other words, the work of the leading English draftsmen of the time—had relatively little impact on Americans, who were turning instead to French models. Thomas Jefferson's example was archetypal: as a statesman and writer, he relied heavily on British constitutional and philosophical precedents, but as an architect and draftsman, he turned to French sources (and particularly to Charles Louis Clérisseau).

Advertisements again testify to the growing popularity of drawing of all types. In New York alone, several dozen draftsmen advertised their own work and their classes in the years 1777–99. The practical uses of drawing were still being pointed out, for architectural, military, and such uses; but one also senses an increasing sensitivity toward style. Messrs. Casella and Corti, for example, noted in 1797 that they were: "Italians, Just arrived from London . . . have brought . . . a very large assortment of Italian Paintings and Drawings, superior in point of elegance to anything of the kind ever imported."[9] Women teachers were found in greater numbers, and ladies now were sought as students by teachers of both sexes (though their classes were normally held separately from the gentlemen's). Philadelphia's artistic scene was even more active, with "Drawing Academies" run by "Demillier and Delavanne"; John Drinker, assisted by Matthew Pratt; Duvivier & Son; Hugh Reinagle; and William Williams. In Baltimore was the school ad-

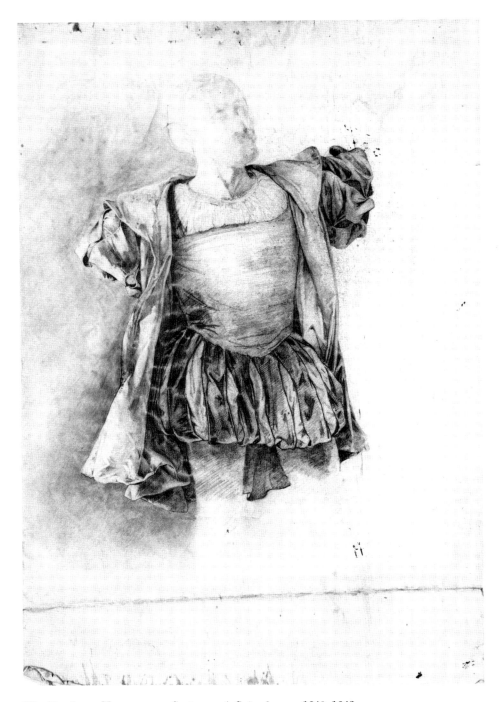

Fig. 31. John Vanderlyn, *Costume of Columbus*, c. 1840–1842.
Pencil and chalks, 18½ x 13″.

vertised in 1793 by Charles Peale Polk, nephew of Charles Willson Peale, and another operated by Frederick Kemmelmeyer. Increasing numbers of drawing books, inks, papers, and other supplies became available. Advertisements listed both pocket-size and larger camera obscura, for sale and lease; and engravings after old masters were offered for study by those who wanted to learn drawing without a teacher. Finally, the predecessors of dealers and museums began to appear, in

Fig. 32. ARCHIBALD ROBERTSON, *West Point and the Narrows of the Hudson River,*
c. 1799. Pen and ink, 9 x 11⅜″.

such ads as the one in New York of John and Michael Paff claiming
"the greatest collection of the most curious caricatures and drawings."[10]

Little of the work of these masters and their students has survived;
perhaps best-known today of the work of the early schools is that of
Archibald (1765–1835) and Alexander Robertson (1772–1841) in New
York. Beginning in 1791, "Ladies and Gentlemen" at their Columbian
Academy were "instructed in drawing and painting in water colours,
chalks, &c., on paper, tiffany, silks, &c.; history devices, heads, figures,
landscapes, flowers . . . architecture and perspective, &c."[11] Like so
many of this generation of artists in America, the Robertson brothers
were born abroad (in Scotland), and both had studied painting in
London before emigrating to New York.

Despite the variety of subjects and mediums advertised, the existing
work of the Robertsons (outside of miniature portraits) consists largely
of landscapes either in pen and ink or watercolor. In both modes,
Archibald seems to have been the leader—understandably enough, as he
was his brother's teacher—and after 1802 the business was organized
to allow Archibald to paint and draw while Alexander took responsi-
bility for teaching. Typical of their ink drawings of the 1790s is Archi-
bald's *West Point and the Narrows of the Hudson River,* c. 1799 (Fig.
32), which was discovered bound with the original manuscript of his

Fig. 33. ARCHIBALD ROBERTSON, *The Highlands of the Hudson River*, c. 1805–1810. Watercolor, 14½ x 19¼".

book "On the Art of Sketching."[12] This is a formal, neoclassic sketch which makes practically no concession to the three-dimensional reality of landscape or to the possibility of a viewer's emotional response to it. Rather, the view is diagramed schematically and competently; using tight pen strokes half an inch in length, Robertson first makes a basic topographical outline, then uses heavy, dark strokes to fill in the foreground, lighter ones for the middle distance, and faint ones for objects on the horizon. Alexander's pen style was very similar, though at its best (as in *Poughkeepsie*, 1796; Kennedy Galleries, New York) perhaps slightly more calligraphic and more varied.

The Robertsons traveled frequently, recording views of rivers and hills, towers, great estates, and small houses in New York State and surrounding areas. They also did watercolors, though here Archibald's hand seems far more inventive than his brother's. Their drawing style remained quite static, while their watercolor technique advanced. Thus, Archibald's watercolor *Drawell at Morrissania* of about 1798 (Museum of the City of New York) resembles the pen drawings both in its simplistic composition and in its technique; he used a small brush to lay on almost-hatched lines, to give texture, over large areas of wash. In a watercolor of perhaps a decade later, *The Highlands of the Hudson* (Fig. 33), remnants of the tight, hatching style remain, but now one

finds a wide variety of treatment: the flat washes of the sky, the tight execution of details such as horses and coach, and the long sweeping strokes in the water. Moreover, the artist's point of view is higher than before, his handling of perspective both more ambitious and more successful.

Archibald Robertson's work helped to introduce the topographical watercolor tradition from England, where it had flourished since early in the eighteenth century. His own watercolor style is close to that of some of the later English practitioners such as Michael "Angelo" Rooker (1743–1801) or John "Warwick" Smith (1749–1831), whose work he could well have known there. Moreover, Robertson was far from being alone in this process of transmittal: also active during the 1790s were William Birch (1755–1834) and his son Thomas (1779–1851). Some of William's watercolors were engraved and published by himself and his son as a book, *Views of Philadelphia* (1800), and in 1808 others were used in a series on the country seats of the United States. From Ireland came John James Barralet (c. 1747–1815); settling in Philadelphia, he worked as a book illustrator and made watercolor views which are among the most sophisticated of the day. Michel Felice Corné (c. 1752–1845) escaped the Napoleonic counterrevolution by coming to Salem in 1799 at the suggestion of the important early patron, Elias Hasket Derby, Jr.; he became best known for his elegant gouache and watercolor views of ships, and particularly naval encounters of the War of 1812. A stiff but finely detailed example, largely of gouache, with

Fig. 34. MICHEL FELICE CORNÉ, *Sailing Ship "Charles" of Boston*, 1802. Gouache, 13½ x 19¾".

Fig. 35. WILLIAM STRICKLAND, *Waterworks, Fairmount Park, Philadelphia*, c. 1815–1820.
Gouache, 14¹⁄₁₆ x 19 ³⁄₁₆″.

very little evidence of individual brush strokes, is the *Sailing Ship
"Charles" of Boston*, 1802 (Fig. 34).

The watercolor tradition gained strength in the first decades of
the nineteenth century, as increasing numbers of well-trained artists
went out to make accurate views of country and city scenes. John
Rubens Smith (1775–1849), for example, became one of the leading
drawing masters of New York and Philadelphia and was the author of
several drawing books; having received advanced training in London,
he exhibited frequently at the Royal Academy before emigrating to
America in 1809. He was in New York by 1814, where he did the care-
fully representational but relatively loosely worked watercolor of *St.
George's Church, after the Fire of January 5, 1814* (Fig. 36).

Quite different in formal structure and in density of the watercolor
(here, heavy "gouache," or opaque watercolor, is substituted for the
transparent strokes), and possessing a strong yet somewhat naïve
appearance are William Strickland's works such as *Waterworks, Fair-
mount Park, Philadelphia* (Fig. 35). Strickland (1788–1854), a Phila-

Fig. 36. JOHN RUBENS SMITH, *St. George's Church, after the Fire of January 5, 1814,* 1814. Watercolor, 20½ x 25″.

delphia architect who was trained with Benjamin Latrobe, portrayed a pure classical scene in early America, a geometrically defined park, with the evidence of his engineering abilities; architecture and decoration are seen in properly classic style, and the hand of the artist at work is never felt. Strickland's formal, nontransparent watercolor technique was similar to that used by Corné and others: their views were studio products, perhaps made on the basis of outdoor sketches; these pictures were regarded as finished and ready to hang. They are thus part of a different tradition than the quick watercolor sketch as practiced by C. W. Peale (see Fig. 37) or Dunlap, for those traveling artists had less time and fewer choices at hand in terms of paper, pigments, various brushes, and so on. Apparently it was normal practice for the sketcher to use watercolor rather freely, brushing one hue over another, with little use of "body color" or gouache; while for the artist making a *finished* work, it was necessary that the watercolor look more dense and solid—indeed, more like an oil painting.

As in England and the Continent, topographical sketches varying widely in quality and technique were made by travelers, both native and

foreign. Though we had no Grand Tour, the eastern part of the continent was of great interest, especially to the many Europeans at home who had still only heard of America's wonders. Travelers kept journals or sketchbooks either to preserve their own memories or for possible publication; their efforts, both literary and visual, are usually of primary interest for their content rather than their aesthetic merit. One of the most interesting of visitors was the Baroness Anne-Marguerite-Henrietta Hyde de Neuville (c. 1779–1849), who accompanied her husband in exile from Napoleon's France, and made her home in New York City and New Brunswick, New Jersey until 1814. Traveling up the Hudson to Albany, they proceeded west to see Niagara Falls; another time they traveled from Connecticut to Tennessee. After two years in France, her husband became Minister to the United States, and the Baroness lived in Washington until 1822. Making figure studies in both pencil and charcoal and landscapes in watercolors, the artist produced a clear and often charming record of the places she saw and the people she met during both visits. Of equal interest are the observations of a Russian diplomat and traveler, Pavel Svinin (1788–1839), whose work demonstrates a free but sure hand, particularly in his architectural watercolors; moreover, his written description of his travels (*A Pic-*

Fig. 37. CHARLES WILLSON PEALE, *View of West Point from the Side of the Mountain*, 1801. Watercolor, 6¼ x 7¹⁵⁄₁₆″.

turesque Voyage in North America, 1815) was published in German, French, and Dutch, and presents an insightful view of America by an educated and sympathetic observer. In addition, an English-born artist of considerable skill in depicting city scenes both in watercolor and in finely detailed drawings was John J. Holland (c. 1776–1820), who had arrived about 1796, in the same decade that saw so many other artists drawn to these shores.

A final traveler who is worthy of mention is William Dunlap (1766–1839), whose major achievement remains not his art but his massive, perceptive survey of the American arts up to his own day (*History of the Rise and Progress of the Arts of Design in the United States*, New York, 1834). Dunlap wrote with a critic's natural bias, favoring his friends and sometimes dealing cruelly with his enemies; the book nevertheless remains his great work of art. He was also a versatile artist, though like Trumbull he had one bad eye and worked best on a small scale, and miniatures on ivory make up his finest work. He made pastels not unlike those of the Sharples, including one of Washington dated 1783. He also often drew informally, apparently placing little value on such things, for his voluminous handwritten diaries are sprinkled with rough sketches in brown ink along with occasional watercolors: his subjects are heads and figures, rough landscapes, and copies after Canova and others. In addition, in 1815–16 he did a sketchbook (now broken up) on his travels to the Hudson River Valley, Niagara, Lake Champlain, and elsewhere in New York.[13] Dunlap records its making in his *History*: "I practiced more than ever I had done before, sketching scenes from nature in watercolors, and making faithful portraits of places which appeared worthy of my attention."[14] Despite these efforts, Dunlap's watercolors are slight, often faded "portraits of places" he had thought worth recording; in their blue-green tonality and their thin washes, they represent almost no advance over C.W. Peale's travel sketches of 1801. It is worth noting parenthetically that Dunlap's *History* pays very little attention to drawings or watercolors, either by himself or others: he himself fully believed in the scale of values proposed by West and Reynolds, wherein history painting was ranked as the highest art, and portraiture and other modes followed—and drawing was for him a simple amusement or a preparatory discipline.

4

Romanticism and the
Early Nineteenth Century

Washington Allston (1779–1843) was a major founder of American romantic art. Renowned as a giant in his day, his reputation rested equally upon his grand, richly-colored paintings with their "Titian-esque" glazes and upon the stature and dignity which he as an individual brought to the arts. He was perhaps the first American artist to capture public imagination *qua* artist, rather than as a craftsman. He devoted his life to the pictorial expression of "those intuitive powers," as he put it, "which are above and beyond both the senses and the understanding."[1] That he failed in a sense, having for his last twenty years struggled with the huge, never-finished canvas *Belshazzar's Feast*, only confirms the nature of what Wordsworth had called the artist's "Romantic agony."

Well born and well educated, Allston began to draw (like so many other painters) at a very young age. Even before entering Harvard, he made "a lively series of satirical drawings, 'The Buck's Progress,' a spirited attempt in the vein of Hogarth."[2] These well-composed works of 1796 were executed with pen-and-ink outlines and simple watercolor washes; they demonstrate an already remarkable facility and an urbane wit. He continued to draw, toward a variety of ends, for the rest of his life, seldom returning to this early vein but in fact exploring almost every medium and style. Allston's drawings never show the regularity of purpose and evenness of style of a Copley or Trumbull; rather, they are the work of a new kind of artist who uses the drawing to explore both himself and the world without. Of course, the intellectual world was changing rapidly as Allston came to maturity. The "fantastic and gloomy" novels of Charles Brockden Brown and the penetrating essays

and novels of Washington Irving represented the forthcoming reign of imagination, fantasy, and identification with nature that replaced the orderly and rational world of Franklin and C. W. Peale, as Romanticism overcame the dominant classical tradition.

By early 1801 Allston had graduated from college and left for London, where he studied with West, like so many before him, and attended classes at the Royal Academy. He first exhibited in London in 1802, and in 1803 he toured the Continent with John Vanderlyn; then from 1804 to about 1808 he lived in Rome where he particularly admired the work of the Venetian painters and of Raphael and Michelangelo. He drew frequently, and formed a lifelong taste for Italian master drawings. Later in life, on receiving a gift of drawings attributed to Raphael, Tintoretto, and others, he commented that "these drawings . . . not only satisfy you with their own beauties, but they set the mind to work, in conjuring up visions of its own, a true test of genius in art."[3] Thus he understood clearly that the drawing could be a work of art in itself, that apart from its possible utility as a likeness, a study, or whatever, it could provoke the mind with its own beauty and vision. This new attitude was crucially significant, for with Allston and his successors the drawing slowly began to gain the recognition it deserved.

In Rome and later in London (1811–18), Allston was a member of the international *literati*: his circle included Thorwaldsen, Coleridge, Wordsworth, Fuseli, and West, and when he finally returned to Boston in 1818 he naturally came into contact with the leading writers and painters of America. He was a poet, a novelist (*Monaldi*, 1822), and an aesthetic philosopher who gave articulate expression to sensual romanticism as he understood it. Though he was trained in the history-painting tradition, Allston's theories were in opposition to the traditional neoclassic ideal: dismissing the idea of art as imitation, he emphasized "personal, intuitive, . . . metaphysical apprehension."[4]

Allston's drawings are of many types. They vary from the illustrations he made for Washington Irving's *Knickerbocker's History of New York*[5] to quite classical outline drawings such as *Study for Jacob's Dream*, 1818. The latter, in the Dana Collection now housed at the Fogg Art Museum, Harvard, brings to mind the simple contours and lack of modeling of the Englishman John Flaxman (1755–1826). His sketchbooks are full of experiments, repetitions, tracings, reworkings; and the pencil sketches are always vigorous, and occasionally inspired. For some of his paintings, including the climactic *Belshazzar's Feast*, Allston made a series of studies of close details such as hands, heads, and ears, often using black or red chalk with white highlights on gray paper as in *Belshazzar's Left Hand* (Fig. 38). Copley had studied groups of figures and Trumbull individual faces in seeking to perfect their compositions. One feels that Allston had another motivation: that he drew the hand both as a tribute to great Italian drawings he had seen

Fig. 38. Washington Allston, *Belshazzar's Left Hand*, c. 1820–1830.
Charcoal heightened with white chalk on gray-green paper, $9\frac{1}{8}$ x $12\frac{3}{8}''$.

and—in its clenched, muscular quality—as a symbol of man's condition. Whatever the purpose, this study and larger ones such as *Three Men Talking* (Dana Collection), of a great many years before, confirm the the artist as a master of drawing style: his sense of mass and volume is brilliant, with a sensitivity for texture and attitude, and outline is sparingly but well used.

A quite different drawing, almost unique in American art, is Allston's *Ship in a Squall* (Fig. 39), perhaps dating from the 1830s. This is a large chalk outline on canvas, presumably preparatory to a painting and thus meant only for the artist's purposes. Only by chance did the painting remain unfinished, and the drawing visible. Allston's sketch becomes a memorable work of art on its own: with a quick, confident hand, he gives body to the rolling sea, the towering clouds, the thunderstorm sweeping down from the right, the rigged ship heeling before the wind. Though no detail is seen, the artist suggests a complete, dramatic confrontation between man and the elements simply through the use of an expressive, varied, and energetic white line.

Allston's later years in London found him no longer the protégé of the aging West, but a teacher and example in his own right. His friend and early traveling companion Edward Malbone (1777–1807) was now dead, after a short career as one of America's most brilliant miniaturists and draftsmen (as seen in his earlier pencil and wash drawing,

Fig. 39. WASHINGTON ALLSTON, *Ship in a Squall*, c. 1820–1830.
White chalk on canvas, 48⅛ x 60″.

Fig. 41). Among Allston's later students were the Americans Charles
R. Leslie (1794–1859) and Samuel F. B. Morse (1791–1872). Both be-
came competent draftsmen, and indeed Leslie was for a short time
professor of drawing at West Point. Morse followed Allston's manner
most closely: his pencil drawings for *The Judgment of Jupiter*, at Yale,
reflect some of his master's Michelangelesque sympathies, but at the
same time they are more timid, more purely linear, and far less muscular
than Allston's work. Morse drew often in later years, making sketch-
books during his travels, joining the Sketch Club, and so on, but his
letters show that he never felt fully confident in the graphic medium.

More successful than these men—in a worldly sense—was their
contemporary John Wesley Jarvis (1780–1840), who was the best-
patronized portraitist of the first quarter of the nineteenth century in
New York. Though born in England, Jarvis did not have the benefit
of London training but rather served an apprenticeship to the engraver

Edward Savage (1761–1817), himself a fine draftsman. Jarvis also drew often, in an unpretentious but able neoclassic manner—as seen in the small wash drawing of his friend *Washington Irving*, done in 1800 (Fig. 40). Well known as a wit and raconteur, Jarvis was at the center of New York's intellectual world and played something of the role that Allston did when abroad and later in Boston.

Our arts were maturing together: at the same time that the professional careers of an Allston or a Jarvis became possible, writers such as Cooper and Irving were making pioneer efforts in increasingly sophisticated and consciously American literature. Writers and artists knew each other, and the importance of their interaction is just beginning to be explored. To cite one example: a great many American draftsmen are illustrators in some sense, and a number—from Allston to the present day—have been close to the literary tradition. This is true both of Allston and Jarvis. The latter, for example, contributed several illustrations to James Kirke Pauling's *The Diverting History of John Bull and Brother Jonathan* (Philadelphia, 1827), and like Allston, he shows a wry sense of humor, though his drawings are linear (probably originally pen and ink) rather than watercolor.

Edward G. Malbone was one of the ablest miniaturists of the Federal period, and an excellent pencil draftsman as well—and in both mediums his work was much admired by his friend Washington Allston,

Fig. 40. John Wesley Jarvis, *Washington Irving*, 1800. Wash, 3⅝ x 5¼″.

Fig. 41. EDWARD G. MALBONE,
Portrait of a Young Man, c. 1800–1805.
Pencil over wash, 7⁹⁄₁₆ x 6¼″.

Fig. 42. THOMAS H. WENTWORTH,
Portrait of a Man, c. 1815.
Pencil and wash, 4⅞ x 3¹⁵⁄₁₆″.

among others. The small drawing in the Karolik Collection, *Portrait of a Young Man* (Fig. 41), is sensitive and fine: line is controlled perfectly as it describes the head and shoulders, the long hair and broad collar, of the subject. Moreover, it makes an interesting comparison to a drawing of about ten years later, *Portrait of a Man*, c. 1815 (Fig. 42) by Thomas H. Wentworth (1781–1849). Wentworth worked as a miniaturist and an itinerant oil portraitist, and his drawing reveals a fine hand; though lacking Malbone's ultimate touch, his use of pencil and shading is forceful and direct indeed.

More significant as draftsmen in the same years are several of the sons of the venerable Charles Willson Peale. Rembrandt Peale (1778–1860) played a conscious role in the coming to maturity of American art, particularly American drawing. From the very beginning of his life he had watched his father, working beside him in order "to arrange and examine a curious collection of old engravings which my father had bought of itinerant Italians," later looking on enviously as an older sister took a course in drawing (Rembrandt's father being perhaps the first American to think of men and women as having equal potential in the arts). After her lessons, Rembrandt "rushed to her room and watched every movement of her pencil [and] . . . copied the drawings she had made." He reports that his father gave him only very general directions, letting him develop on his own but stressing the necessity "to

acquire correctness in drawing before I should attempt the use of the brush. This I endeavored to accomplish by the aid of anatomical engravings and plaster casts.'"[6] In this practice he followed the method already used by Trumbull and others, and subsequently employed by some artists even up to the present day.

The Peales made the most of their unique opportunities, Rembrandt noting that "as a preparatory step to my artistic studies, I went through a course of chemistry, under Dr. Woodhouse.'"[7] This must have been in 1802–03, when he had been sent to study with West in London, like many before him. Rembrandt's training equaled Allston's: in 1805 he helped found the Pennsylvania Academy of the Fine Arts, and he traveled to Europe for further study in 1808 (painting both David and Houdon from life) and again in 1809–10, spending much time in Paris, where he came to know J. L. David and François Gerard (1770–1837). Gaining a reputation for his oil portraits and for such West-influenced history paintings as *The Court of Death*, Peale succeeded Trumbull as president of the dying American Academy (in New York) and was a founder of the National Academy of Design.

Peale produced the greatest portrait drawings of his time. They range considerably in medium and style, beginning with the 1810 pencil drawing done in Paris of the French actor François Joseph Talma (Walters Art Gallery, Baltimore), a superb, closely detailed work which makes elegant, formal use of line. A less formal but no less expressive drawing is *Robert Owen* (Fig. 43), which is inscribed "a study from Life—London 1833," where the background is left unworked and line is used more economically. This was made on Peale's fifth and final trip abroad; it represents the long, intelligent face of the Welsh, Utopian Socialist, known also for his Utopian experiment in New Harmony, Indiana. Peale uses black crayon on light brown paper in a quick, graceful way, lightly hatching the cheekbones and jaw in modeling the face. Yet this drawing must have been made for the artist's own use, for it remained in his possession until his death; it was included in the 1862 auction of his estate, when it brought the sum of $1.75.

It is astonishing but nonetheless true that Theodore Bolton omitted reference to Rembrandt Peale in his important book of *Early American Portrait Draughtsmen* of 1923, for if Peale was not the most prolific he was certainly one of the ablest of such artists. Each drawing seemed to represent an experiment both in capturing likeness and in using various graphic mediums with maximum effect. Among other things, he was the first American to master the chiaroscuro drawing, in which he used a medium-toned brown paper and then built up lights with white chalk and darks with black and brown chalks. The fine portraits *Dr. John Warren* (Fig. 44) and *E. I. Du Pont* (Winterthur Museum, Delaware) show this technique used strongly: black and white lines, some quite calligraphic, define costume and cravat, while more smoothly applied

Fig. 43. REMBRANDT PEALE, *Robert Owen*, 1833.
Black crayon on light brown paper, 15⁷⁄₁₆ x 11⅞″.

and hatched strokes, with subtle use of stumping and some graphite,
model the face and features. Such portrait drawings were evidently
used both as preparatory studies for oil paintings (themselves often less
successful than the drawing) or as finished portraits in themselves.

Peale tried most of the drawing mediums and many subjects, though
in none did he reach the heights of his portraits. His drawings range
from those done in a linear, detailed manner, to tracings after Leonardo,
to a variety of landscape drawings and watercolors. Typical of the latter

Fig. 44. REMBRANDT PEALE, *Dr. John Warren*, c. 1820.
Colored chalks on dark brown paper, 14⅛ x 11″.

is the *Cascade of Tivoli* (formerly Adelson Gallery), dating from about 1830, where predominantly green hues are heavily washed over and over, with lozenge-shaped strokes in white gouache used to represent the falling water; clearly Peale never had the feeling either for water-color or for landscape that he did in his chalk portraits.[8] Similarly awkward are his compositional studies in the manner of West, such as the pen-and-wash study for *The Court of Death* (Collection of Charles Coleman Sellers), his most successful allegorical subject.

Peale was also a highly articulate spokesman for the arts and particularly for drawing. Following his father's lead, he loved museums and had very specific and indeed quite modern notions as to what a public museum should be.[9] He was also a pioneer lithographer—which he saw as a tool to make "drawings" more widely available. Most important for this study, he wrote a highly successful drawing book called *Graphics*, first published in 1834, which went through nineteen editions before 1866.[10] He was a strong advocate of "art for the people," and his book was aimed at a wide audience: he believed that it would make possible the teaching of drawing to all high school students, even by totally inexperienced teachers. Angrily defending art against still-widespread charges of its frivolity, he pointed out the practical contributions that painters had made to society, mentioning Fulton and the steam engine, Morse and the telegraph, C. W. Peale and his invention of porcelain teeth, and himself, who "though a portrait painter, lighted the first city [Philadelphia] with gas."[11] He was one of the chief "art crusaders" (as Peter Marzio has called them) who succeeded in the first half of the nineteenth century in bringing art to the nation as a whole. As he wrote in *Graphics*: "Drawing, the natural and universal language of man, should be cultivated as the first guide to all that can be done by hand, and taught in every school as preliminary to all other instruction."[12]

Books about art had from the beginning been a key means by which the American could learn. For many years the libraries of American artists and architects were far more sophisticated than their own styles, and books and engravings supplied a constant source of inspiration. As Prown points out, Copley while still in America was familiar with such wide-ranging titles as Francesco Algarotti's *Letters Upon Painting*, Charles du Fresnoy's *De Arte Graphica*, and books by Roger de Piles, Horace Walpole, James Gibbs, and so on.[13]

Drawing books published in America began to appear by the end of the Revolution, and increased in numbers as the nineteenth century went on. The first comprehensive manual designed to teach the student how to draw was Archibald Robertson's *Elements of the Graphic Arts* (1802), which pays homage to du Fresnoy's work and—as seen in Robertson's drawings—preaches a classic style. Robertson's work was still aimed at the potential professional, while a book of just two years later, published by John Low in New York, was "the first nineteenth century American art instruction book for the people at large" according to Carl W. Drepperd, the pioneer bibliographer of this field.[14] Other books by many authors followed. Aimed at a variety of audiences, advocating a slowly changing style as artists turned from the figure to the landscape, these books have in common a belief that the best way to learn to draw is through copying engravings (and later, lithographs). Some books included recipes for inks and colors; some concentrated on perspective, others on the figure, landscape, or flower painting; some

were aimed at amateurs, some at professionals, others at children.

Besides Peale's book, noted above, among the most important works are Fielding Lucas, Jr.'s *The Art of Colouring and Painting Landscapes in Water Colours* . . . (Philadelphia, 1815), the earliest manual for this increasingly popular medium; John Rubens Smith's *A Key to the Art of Drawing the Human Figure* (Philadelphia, 1831); and John Gadsby Chapman's *The American Drawing Book: a manual for the amateur and basis of study for the professional artist* . . . (New York, 1847). The last followed a theme which had been proposed by Peale and which became increasingly popular as the arts boomed at midcentury: as stated on the title page, "Anyone who can learn to write, can learn to draw." While Peale's and Smith's books look primarily to French sources, Chapman's—at a somewhat later date—invokes the English model. His book is typical of all that preceded it, however, in being directed to those "who have in view more than mere pleasure and amusement in the pursuit of the art of Drawing," and the author justifies the art by pointing to its "most practical purposes."[15] Art for art's sake remained for the future: these draftsmen were urged on by the promise that drawing could help them make straighter furrows and neater fences!

Drawing books rarely suggest innovations in style or medium; rather, they commonly present wisdom accumulated over several generations. Chapman's book is typical of those of the early nineteenth century; even though it was written in 1847, it retains a traditional, classic approach and thus has little relationship to the most advanced work actually being done at the time. Chapman's reader is taught to "distill the best from nature" while seeking ideal forms, rather than momentary or individual manifestations; the author recommends drawing "after the Antique," and considers accuracy and precision among the highest values.

Chapman's book, like many of its predecessors, suggests that students use the pen for its qualities of discipline, rather than the "slovenly" pencil. The beginner is taught first to draw simple, straight lines, then diagonals, then shading and cross-hatching; he advances to curves, and then to the copying of geometric shapes from engraved diagrams in the book, and finally to simple forms such as drinking glasses and pitchers. The artist's materials are discussed in detail, from pencils, charcoal, chalks, watercolors, to papers of various kinds. Depiction of the face and body is taught; the eye, nose, foot, are all explained in geometric terms, with illustrations still looking rather like Le Brun's. Succeeding chapters discuss penmanship, geometry, and perspective. Chapman, like his predecessor, had taste and a sound knowledge of European art; yet he was more a technician than an aesthetician, a promoter of past ideals (who eventually moved to Rome) rather than a harbinger of new ones. Nevertheless, the role that he and Peale played in making the arts acceptable in America cannot be overestimated.[16]

Fig. 45. Raphaelle Peale, *A Deception*, 1802.
India ink and pencil, 16 x 10¾".

At the same time, many drawings were made in the early nineteenth century which did not conform to rules laid down in the drawing books. Even in the Peale family itself there was no homogeneous style, for each artist sought his own vision of the world. For example, Rembrandt Peale's talented older brother, Raphaelle (1774–1825), had received his father's training, in fact working as his chief assistant for several years; he had also collaborated with Rembrandt in running a museum in Baltimore. Yet his temperament was quite different from his brother's: having little urge to follow the great history-painting tradition, he neither studied in London nor painted Washington, but rather turned to the then unknown and unappreciated genre of still-life painting. While Rembrandt was becoming a leading figure in the art world, Raphaelle became increasingly depressive and alcoholic. Nevertheless, if one can judge from the one drawing which surely comes from his hand, he too became a great draftsman, if a very idiosyncratic one.

Raphaelle's drawing *A Deception*, 1802 (Fig. 45), is a still life—and indeed Raphaelle was the founder of American still-life painting—and it is a trompe l'oeil rack picture, a mode of still life which fully matured in America seventy years later, in the hands of Harnett and Peto. The pen-and-ink and pencil medium used by Raphaelle was consistent with contemporary practice, as are his French stylistic sources. Moreover, the drawing at once looks back to neoclassicism in its planar, rational qualities, while in its introspection and personal iconography it looks ahead to romanticism. There is no sign of the artist's hand here: in a carefully balanced, subtly constructed composition, the artist uses his technical skill in reproducing various crafts, particularly the different types of printed surfaces seen in *A Deception*.

Other members of the Peale family also drew, though not so spectacularly as the two eldest sons of Charles Willson Peale. The latter's brother, James Peale the elder (1748–1831), was a magnificent miniaturist, but his sketchbooks are rough and practical. *His* son, James Peale, Jr. (1789–1876), was a prolific though undistinguished landscape watercolorist of the mid-century. Perhaps most distiguished of the younger generation was Titian Ramsay Peale (1799–1885), a son of Charles Willson, who became an outstanding naturalist and illustrator. Just as his father had been interested in the natural sciences and had made fine small drawings of flora and fauna brought back by the Lewis and Clark Expedition, so Titian made this type of realistic, observed sketch his specialty. He accompanied the Long expedition to the upper Mississippi in 1818–21, and from 1838 to 1841 went to the Pacific with the Charles Wilkes party. Titian was an explorer and a scientist, and his art is—in the tradition of the artist-naturalist before him—essentially styleless, a means of visual record-keeping more than anything else. Still, the small watercolors made on the Long expedition are quick, loosely washed, and often show considerable innate sense about color, as in the dark blue

Fig. 46. TITIAN RAMSAY PEALE, *The Mastodon*, 1821.
 Wash, 14¼ x 19″.

hills and the red shawl on an Indian mother in *Sioux Lodges*, 1819 (Collection Miss Ida Edelson, Philadelphia).[17] This is the first known depiction of a Plains Indian teepee, just as another watercolor is the earliest depiction of grazing buffalo on the Plains—making clear Peale's importance as forerunner to the many Western artists to follow.

Titian Peale also executed drawings in pure wash, on one occasion, in 1822, finishing a work begun by his father, *The Long Room* (Detroit Institute of Arts), depicting that gallery at the Peale Museum: one sees in close detail the various stuffed birds, habitat groups, and other specimens as they were exhibited side by side with the Peales' paintings and busts of American revolutionary heroes. On another occasion he executed the fine black-wash drawing *The Mastadon* (Fig. 46), after the Peale Museum's famous specimen which had been exhumed in 1801.

Despite the traditional leadership of Boston and the burgeoning growth of drawing schools and other arts in New York, the arts flourished uniquely in Philadelphia during the first quarter of the century. The long alliance of the arts with the sciences—typified in the lives of the Bartrams, of Franklin, and of the Peales—produced a particularly fortuitous environment for the draftsman with a scientific bent. One notable example was Alexander Wilson (1766–1813), a Scottish-born contemporary of the Peales, who emigrated to the United States in 1794.

Fig. 47. ALEXANDER WILSON, *Red Tailed Hawk*, c. 1812.
Pencil, pen and wash, 18½ x 11¼".

After teaching school for almost a decade, he met William Bartram in about 1802 and was inspired to begin making sketches and collecting material about American birds. In 1804 he wrote: "I am most earnestly bent on pursuing my plan of making a collection of all the birds of this part of North America."[18] He took a walking trip to Niagara in the fall of that year, sketching birds and landscape as well; engravings of the Falls and surrounding scenery appear with his poem *The Foresters.*

Wilson's career received important encouragement when Meriwether Lewis gave him the new species of birds brought back from his expedition and asked him to make drawings of them. The first two volumes of his great work *American Ornithology* had appeared by 1810 when Wilson met John James Audubon (1785–1851) in Louisville, Kentucky. Audubon had scarcely begun to make his own bird drawings at the time, and certainly must have been influenced by Wilson's work. Wilson continued to travel widely, north and south, and had the eighth and final volume of his book at the press before his sudden death in Philadelphia in 1813.

Wilson's achievement both as naturalist and artist was great, though his drawings and watercolors of hundreds of species of birds suffer inevitably by comparison with Audubon. Wilson's watercolors are truthful, rather than romantic; his sense of composition was not as original as his powers of observation were sharp. Realism of background, niceties of scale or dramatic treatment all were of little interest: he sought out the American bird with the eyes of a true naturalist (Fig. 47).

All this is quite different in the work of John James Audubon, the most illustrious of American naturalist-artists. Audubon's name is well known today, but this is often because of the "Audubon Societies" or the prints made at third or fourth hand after his work, rather than a knowledge of his own productions. Audubon in fact was the first major American watercolorist, and indeed one of our chief Romantic artists.

Audubon was born in 1785 in Haiti, the natural son of a French father and a Creole mother. Brought up and educated in France, he studied briefly with Jacques Louis David sometime before his first journey to America in 1803. Interestingly, his own art comes closest to the neoclassicism of David and of contemporary Americans such as John Vanderlyn only some years later (about 1819–25), when he turned to the making of pencil-and-charcoal portraits for twenty-five dollars apiece. These drawings are the direct descendants of the portrait drawings of Sharples, Saint-Mémin, and especially Vanderlyn: of nearly uniform size (about 10 by 8 inches), often in profile, they are skillful examples of the craft while at the same time going beyond the earlier drawings in variety of execution. *Nicholas Augustus Bertroud* (Fig. 48), Audubon's brother-in-law, was drawn in Shippingport, Kentucky, in 1819.

Audubon has gained deserved fame for his ornithological com-

Fig. 48. JOHN JAMES AUDUBON, *Nicholas Augustus Bertroud*, 1819. Pencil and charcoal, 10 x 8″.

positions, 435 of which were reproduced in his magnificent book *The Birds of America*, published in the years 1826 to 1838. However, the original watercolors, now in the New-York Historical Society, are far less well known today than either the original hand-colored "elephant folio" engravings made after them by Robert Havell, Jr., in London or the many later editions in various sizes that have appeared. The prints convey something of Audubon's unique sense of design, his ability to bring together science and romanticism; but only the original watercolors show the true range of his expressive and technical genius.

Audubon's earliest bird drawings were done in France in 1805–06, when he returned from America to visit his parents in the Loire Valley. Among the best is *Chat*, 1806 (Harvard College Library), which like

the others was executed in pencil and pastel on paper (and not watercolor). Typical early work represents only a single bird, in profile; there is no attempt at background, and only the beginnings of Audubon's lifelong concern with naturalism in pose and habitat.

The artist's progress was steady, and well before 1810 Audubon broke away from the monotonous profile drawings to much more lifelike ones, the birds now often seen in branches—a development made possible by his new method of posing the freshly killed birds with wires so they could be better observed. The medium now is often pencil, pastel, *and* watercolor, as in the *Ivory-Billed Woodpecker* (Harvard College Library), done in 1812 in Kentucky, where Audubon and his wife lived for over a decade, until 1820. The years following, up to 1826, saw his technique and his vision making great advances as he traveled over the country in search of new species to record. Pastel was now used less often, and more selectively; a sense of rhythm and confidence comes into the compositions, and one feels in these drawings the artist's heightened intensity as he now plans for the book itself.

The pastel-and-watercolor *House Wren* (Fig. 49), dating from about 1824, is particularly charming in its informality. It serves the purpose of the naturalist, showing the male, female, and young of the species; yet even more surely it displays Audubon's art in its perfect placement, leaving so much of the sheet empty; in the accurate, lively depiction of the birds; and in the sense of whimsy shown in the artist's attention to the wonderfully rendered, soft gray hat with all its tears and stains. The birds themselves are executed in pure watercolor, applied with a tiny brush; the branch is outlined with pen, then colored, while the hat is in watercolor heightened with pastel. This is magnificent use of the watercolor medium: tight strokes defining the birds' every detail, broader washes built up to suggest the texture of the felt, some wet staining at the top of the hat implying its frayed quality. Then the tree branch which is supporting this family is simply outlined in India Ink, the artist realizing that further detail could only mar his composition.[19]

Far more complex in design is the equally beautiful *Blue Jay*, about 1825 (Fig. 50), another of the series of drawings for the *Birds of America* owned by the New-York Historical Society. The blue birds are depicted in watercolor mixed with substantial amounts of white; the resulting gouache is brilliant yet opaque, and the birds thus stand out from the tree branch, where more transparent watercolor (applied drily and directly) and pen-and-ink lines were employed. The branch itself is extraordinary with its mottled colors, some in shadow, with wood seen beneath peeling bark—one feels the very texture and touch of the tree. Audubon rhapsodized about the blue jays themselves: "Who could imagine that a form so graceful, arrayed by nature in a garb so resplendent, should harbour so much mischief; that selfishness, duplicity and malice should form the moral accompaniments of so much physical

Fig. 49. John James Audubon, *House Wren,*
c. 1824. Pastel and watercolor, 19⅛ x 11½".

Fig. 50. John James Audubon, *Blue Jay*, 1825.
India ink and watercolor, 23¾ x 18⅞".

Fig. 51. John James Audubon, *Gyrfalcon*, 1833.
Watercolor, 38½ x 25⅝".

perfection!"[20] Clearly excited by this vision, he produced a watercolor that is nervous and energetic even in its high detail. Moreover, the Havell print after this watercolor reproduces it almost exactly—a relatively unusual occurrence, as Havell tended to make the prints more complete and more detailed than the originals, thus adding to their accuracy but detracting from their artistic qualities.

In 1826 Audubon traveled to England, having failed to find either sufficient patronage or an engraver for his project in Philadelphia. In November 1826, William H. Lazars engraved the first ten plates of the book; it was taken over finally by Robert Havell, Jr., the brilliant English engraver who saw it through to completion until the last plate was done in June 1838.[21] Staying in England until 1829, Audubon made oil copies of some of the watercolors while seeking subscriptions for his book, but did little drawing. However, on his return he set off on numerous drawing expeditions, and the habitats of his new watercolors were often the work of George Lehman (?–1870), his traveling companion. He continued to approach his astonishing project with remarkable energy: as Edward Dwight has pointed out, half of the *Birds of America* watercolors were made in the years 1831–38, during which time "Audubon crossed the Atlantic Ocean four times and travelled from the Florida Keys to Labrador, drawing and observing birds."[22] He also wrote and published the first four (of five) volumes of his accompanying text, the *Ornithological Biography*.

Watercolors for the book were being made up until its completion, and some of the finest work dates from the last years of the project. His *Gyrfalcon* (Fig. 51), for example, is unsurpassed in its bold, dramatic treatment. Aubudon had seen the species on a trip to Labrador in August 1833 and was obviously moved by the bird—considered by many the most beautiful of northern predators. He had a special feeling for hawks and other birds of prey, often depicting them in flight, filling his sheet in order to emphasize their size and power, turning perhaps to the Japanese print for his inspired design of line and color and natural drama. Such late work is often primarily in gouache, with little of the painstaking detail of the *Blue Jay*.

Audubon did not stop when the *Birds of America* was completed, and indeed many of his finest watercolors date from the years after 1841 when he was at work on another enormous project, the book called *The Viviparous Quadrupeds of North America*. Before his death in 1851, Audubon had completed seventy-six watercolors for this work, undertaken at the urging of his friend the Reverend John Bachman of Charleston. After his death, the illustrations were completed by his sons, John Woodhouse Audubon (1812–1862) and Victor Gifford Audubon (1809–1860), both able enough watercolorists that their work can be confused with his. The *Quadrupeds* brought out the best in Audubon: with his love of close observation and his particular ability at depicting

Fig. 52. John James Audubon, *Norway Rat*, 1843.
Watercolor and pencil, 24½ x 32⅝″.

the bodies and furs of animals, the small squirrels, rats, and chipmunks made ideal subjects. He now often concentrated solely on the animal, leaving backgrounds to others as in the *Norway Rat*, done in New York City on January 18, 1843. His drawing (Fig. 52) is inscribed: "Norway, Brown, or Common House Rat"; the melon which the rats are eating is only outlined in pencil, as is the beginning of another adult rat on the lower left. In this drawing and its companions, Audubon takes a final step: in portraying a common animal, found at home, he reaches a perfection of composition and delicacy of treatment that place him outside the naturalist's tradition, and demand instead that he be compared with Pisanello and Dürer, the great animal draftsmen of past centuries. Artist-naturalists continued to record their observations through the nineteenth century, sometimes with fine results, as in the work of Louis Agassiz and Louis Agassiz Fuertes, but after Audubon's work the tradition could only decline.

Quite different is both the background and style of one of Audubon's chief Romantic contemporaries, Thomas Sully of Philadelphia (1783–1872). Born in England, he had come to Charleston in 1792, receiving lessons from several masters before going to London in 1809 for a year of study with West. Unlike many others of the period, he practiced a drawing style that was essentially English: whether making landscape,

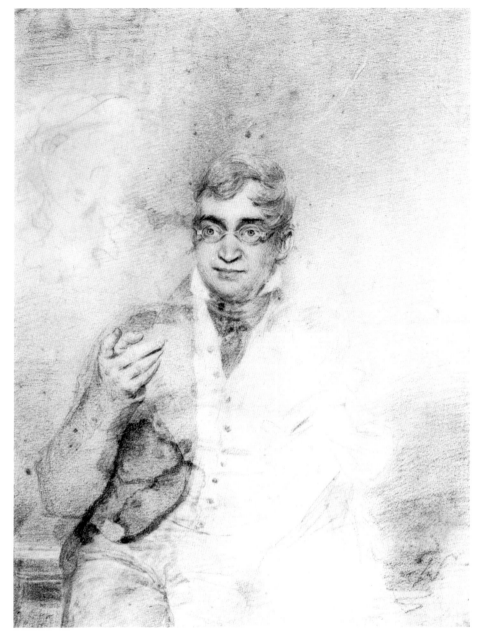

Fig. 53. THOMAS SULLY, *Portrait of Man with Spectacles*, c. 1820–1830.
Pencil, red crayon and watercolor on vellum, $6\frac{5}{8}$ x $5\frac{5}{16}$".

portrait or compositional studies, he normally used a flowing, generalized pen-and-ink outline reminiscent of West, Fuseli, and Romney. Most of his drawings are studies for portraits, and he generally followed the rule laid down in his book of 1873, *Hints to Young Painters*: "The first sitting may be short, as . . . sketches on paper, of different views of the person, will be sufficient to determine the position of the portrait."[23] These preliminary sketches (Fig. 53) often employ simple use of watercolor, to record the sitter's dress, hair color, and so on. In addition, however, Sully did more direct portrait studies, such as the

Sketch of Andrew Jackson (Detroit Institute), about 1815, strongly executed in charcoal on blue-gray paper, or the elegant, late, finished drawing *Lady at Her Writing Desk* (Collection of Rita and Daniel Fraad). He also did able, finished watercolors during the 1830s, as well as landscapes and imaginary romantic subjects in gray and black washes. Like many of his generation, his range was a wide one, for on occasion he worked in making wash vignettes for banknotes and diplomas, as well as illustrations of a variety of works, including *Robinson Crusoe*.

Sully also founded what may have been the first sketch club in America. Next to the drawing *Gertrude of Wyoming* he notes: "Philosophical Hall, Philadelphia, December 1812. The following persons—Remb't Peale, Charles B. King, Krimmel, Gideon Fairman, Wm. Greene of the Virginia Theater, John Clifton and Thos. Sully constituted a club for the purpose of making designs. They met once a week in Mr. Sully's painting room, and from some passage read by one of the club, from the work of some author promiscuously taken up, a design was executed by each one of the company. Two hours were allowed . . ."[24] Sully's companions in this early sketch club were remarkably well chosen: Peale gained a major reputation, as has been seen, and the same is true of King (painter of Indian portraits and still lifes) and Krimmel (an important genre painter and watercolorist). Green and Clifton seem to have disappeared altogether, as artists. Gideon Fairman (1774–1827) was a prominent banknote engraver active in Philadelphia after 1810. Some of his wash drawings also survive, such as the tiny *Atlanta* (Fig. 54), a well-executed work, in Sully's romantic style, which was presumably a design for a banknote engraving.

Fig. 54. GIDEON FAIRMAN, *Atlanta*, c. 1820–1825.
Wash, 2¼ x 3″.

John Lewis Krimmel (1789–1821) was a member of Sully's sketching group but quite unlike that master. In 1810 Krimmel had emigrated to Philadelphia from Ebingen, Germany, in the company of a fellow artist named Alexander Rider; according to Dunlap's admiring account,

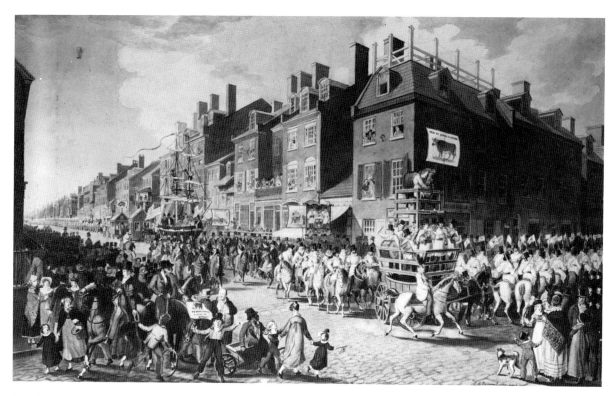

Fig. 55. JOHN LEWIS KRIMMEL, *The View of the Parade of the Victuallers from Fourth and Chestnut Streets, 1821*, 1821. Watercolor, 14½ x 24″ (sight).

he was already trained, having "been well instructed in drawing and the management of colours."[25] Krimmel's great contribution lies in his introduction of genre painting to American art: an admirer of Wilkie and Hogarth, he painted and drew realistic and often humorous pictures of the daily life of Philadelphia. His watercolors particularly are well drawn in fine pen-and-ink outlines and are felicitously colored; typical are *Election Day at the State House* and *Fourth of July at Centre Square* (Historical Society of Pennsylvania). However, outstanding in his watercolor oeuvre is *The Parade of the Victuallers* of 1821 (Fig. 55), which shows his ability at orchestrating the details of a vast urban scene with hundreds of figures. Though drawing upon various European sources as well as the American topographical watercolor, Krimmel's achievement was nonetheless unique in his time. Despite this, he was little appreciated even in Philadelphia. As Dunlap put it, "Notwithstanding his extraordinary talents, Krimmel received no commissions, and had little to do."[26] Like so many artists in similar circumstances, he (and his friend Rider) became teachers of drawing, for some time employed in "a great boarding school for young ladies." However, just as he was reaching artistic maturity at the age of thirty-two, he was tragically drowned.

5

Folk and Country Drawings

The art produced in rural and small-town America during the late eighteenth and early nineteenth centuries has been described in a number of ways, as naïve, primitive, nonprofessional, or folk. None of these terms is wholly satisfactory: for one thing, the objects we attempt to define with a single word vary tremendously in intent, quality, and indeed in degree of "naïveté." Many of the practitioners discussed here were professionals in the fullest sense of the word, and some demonstrated a sophisticated understanding of form, composition, or technique. Although "folk" is the term most often used to describe works from outside the mainstream of academic art in nineteenth-century America, it seems wiser to restrict that term to those works which represent a genuine folk art (*Volkskunst*) in that their creation derived from long-established popular traditions and was only minimally indebted either in form or technique to contemporary "fine" art. Included under this heading, then, are the works of the Pennsylvania Germans, the Shakers, and a few others.

For drawings of a different type—portraits, still lifes, landscapes—that are reactive to the mainstream of academic art, the term "country" or "craft" drawings, with the implied connection to country furniture, seems more appropriate. The creators of these works were not "folk" in the European sense, and lived not in small villages or isolated communities but most often resided in towns that had some connection with the major artistic centers. They were often country artists who knew about and responded to the mainstream of American style.

The earliest true *folk* drawings in America were produced by the Pennsylvania Germans, and represent a survival of the medieval practice of manuscript illumination. Early examples of this genre occur in the illuminated musical and other manuscripts produced in a community

Fig. 56. GEORGE GEISTWEITE, *The 34th Psalm*, 1801.
Illuminated fraktur, 12⅜ x 15⅛″.

of celibate men and women at Ephrata, Pennsylvania, from the 1740s to the 1760s.[1] By far the greater number of these "fraktur" drawings, however, date from between 1790 and 1845. Most of them, like the *Vorschrift* (Fig. 56) by George Geistweite, contain writing in fraktur script, the Gothic typeface developed in the sixteenth century that gave its name to the whole class of such drawings, whether or not they contained written material. Geistweite was a circuit-riding minister in Centre County, Pennsylvania, from 1794 to 1804 and also schoolmaster of the first school in the county; in this drawing can be seen both his roles as teacher and minister. A *Vorschrift* was an example of penmanship and moral lessons made by a teacher for imitation by his students. The words were usually religious precepts, in this case verses from the Thirty-fourth Psalm, beginning (in German) "I will bless the Lord at all times; his praises shall continually be in my mouth."

Geistweite's work is designed with poetic vigor and complexity. He combines men, deer, a lion, peacocks, a hen, the Hapsburg double eagle, flowers, and many other elements into a brilliantly colored, all-over pattern that perfectly complements the Gothic quality of the script. This is true folk art: unrelated to contemporary style, it reflects the wonderment of a European people celebrating their existence in the

Fig. 57. UNKNOWN ARTIST, *Birth and Baptismal Certificate of Alexander Danner*, 1804. Watercolor, 13⅜ x 15⅞".

American Eden. It is an art with its own tradition, which must be seen apart from academic standards. At the same time, many of the animals and figures used here have counterparts in Christian iconography, though efforts to interpret their meaning literally and specifically have not by and large proved successful.[2] It seems likely that the fraktur artist appropriated traditional motifs and combined them with elements in the life around him that took his fancy. For example in the marvelous *Birth and Baptismal Certificate of Alexander Danner* of 1804 by an unknown artist (Fig. 57), the lions and unicorns recall animals depicted in heraldry, in this case suggesting particularly the British royal coat of arms.[3]

Although most fraktur drawings served practical purposes such as aiding the education of children or recording and celebrating births and marriages, occasionally the fraktur artist seems to have produced a drawing for the sheer joy of practicing his skill with an especially difficult or elaborate formal design. An example of this is Johan Henrich Otto's *Fraktur Motifs* (Fig. 59), which probably dates from the 1780s. One of the finest early Pennsylvania-German fraktur artists, Otto apparently came from Ephrata, and worked in Lancaster and Bucks counties from 1772 to 1788.[4] This watercolor exhibits a characteristic

Fig. 58. SHAKER DRAWING, *The Tree of Light*, 1845.
Watercolor, 18⅛ x 22¼″.

symmetry along with a restrained yet richly colored profusion of animal and floral forms. Although there are calligraphic patterns in red ink near the top and right-hand margins, the artist's prime concern is with the colorful depiction of parrots, crowns, peacocks, and flowers in profile and frontal views. Otto has exploited his objects for maximum decorative effect, and in the manner characteristic of fraktur artists he has made no effort to render them three-dimensionally. In the parrot at the left, for example, the artist has combined a sense of literal accuracy, drawing in details with red ink, with a masterful use of pure color and flattened form anticipating the work of Paul Klee in the twentieth century. Frakturs in general are carefully drawn, like this one, the forms and figures first being outlined with inks of various colors, then filled in with flat washes of color.

Fraktur drawings declined in quality in the early nineteenth century, when they came increasingly to be printed rather than hand-made, and they had become infrequent by mid-century, when such firms as Currier and Ives began to mass-produce them. During a brief period around 1850, however, a related type of drawing was being made by members of another, equally isolated segment of American society, the

Shakers. They began to make drawings after the so-called "Era of Manifestations," a period of ecstatic religious revival among the sect that reached its height in the years 1842 to 1845. During this time Shakers would retire on specified days in the spring and autumn to a selected mountain where religious ceremonies were often combined with visionary experiences that included "spiritual gifts" from Mother Ann Lee, the founder of the sect, and other early leaders. One outstanding Shaker watercolor-drawing, *A Type of Mother Hannah's Pocket Handkerchief* (Fig. 60), seems to have served in some sense as a memento of such an occasion. Below the design of trumpets in the center of the drawing is inscribed: "Upon the mountain of my pleasure saith the Lord have I placed fruits of every kind. And from thence will I cause to be planted a chosen seed in the hearts of some of every nation. . . ." The birds are described as "A dove of Peace" and "A dove of Purity," and the lamps are identified as "A type of Jepha's [sic] lamp that lighted him thro' the wilderness of woe during his rejectment."

Other Shaker drawings, such as *Tree of Light* of 1845 (Fig. 58), record an ecstatic vision that occurred apart from the ceremonies on the mountains. The tree is described as "guarded by four angels" and as standing "in the center of the meeting room in the Church, City of Peace," which was the Shaker term for their settlement at Hancock, Massachusetts. Certainly with the fantastic flowers and red, yellow, and purple fruits, the tree resembles none ever seen on earth. Yet the purity of line and color of the drawing reflect the orderliness and simplicity of Shaker design.

Hannah Cohoon (b. 1788?), a member of the Hancock community, inscribed the *Basket of Apples* (Shaker Community, Inc.) as representing a specific vision:

> Sabbath. P.M. June 29th 1856. I saw Judith Collins bringing a little basket full of beautiful apples for the Ministry, from Brother Calvin Harlow and Mother Sarah Harrison. It is their blessing and the chain around the pail represents the combination of their blessing. . . . Seen and painted in the City of Peace by Hannah Cohoon.[5]

The yellowish-brown apples, drawn in watercolor over pencil guidelines, sit in a blue basket that is apparently transparent. (Unlike the apples of usual Christian iconography, to the Shakers apples signified love.)[6] The result—a conceptual rather than an observed still life—clearly demonstrates the otherwordly character of the artist's vision in the magically regular apples that appear to float within their container.

Although the fact that some Shaker furniture styles originated in contemporary work from surrounding communities has recently been demonstrated,[7] the sources of Shaker drawing style remain unclear. Such works as *A Type of Mother Hannah's Pocket Handkerchief* are related to the fraktur drawings and prints of the Pennsylvania Germans

Fig. 59. Johan Henrich Otto, *Fraktur Motifs*, c. 1780–1790.
Pen and watercolor, 13⅛ x 16½".

in their symmetrical combinations of script and flat animal and plant
motifs, and certain subjects, such as birds and flowers, are common to
them both.[8] However, no connection between the two groups has yet
been found, and it appears that the similarities in their work must arise
from common European origins. Other elements in Shaker design, such
as the tree of light, resemble motifs found in needlework pictures and
quilts from as far away as New England and the South. What is certain
is that the Shaker drawings, like the frakturs, represent a genuine folk
art which was essentially uninfluenced by the academic art of the period.

In the last half of the nineteenth century the folk traditions repre-
sented by the Shakers and the Pennsylvania Germans generally became
attenuated and trivial. Although no longer concerned with religious
mysteries or the celebration of great events, later "folk" artists oc-

Fig. 60. SHAKER DRAWING, *A Type of Mother Hannah's Pocket Handkerchief*, 1851.
Watercolor, $14\frac{1}{16}$ x $17\frac{1}{16}$".

casionally compensated for their lack of genuine wonderment or religious passion with a pure technical virtuosity which makes their work of interest. Thus the untitled cutwork picture shown here (Fig. 61), probably made during the late nineteenth century in Pennsylvania,[9] represents a combination of an older, European tradition of ornamental cutout borders which had been continued by fraktur artists, with the practice of making silhouette portraits, which had flourished throughout early nineteenth-century America. The fantastically elaborate border, created from a piece of paper folded once and cut with a sharp knife or scissors, contrasts effectively with the simple, massive figures in the center, which were cut out separately and pasted to the background. The studiously illusionistic flag and flowers, depicted in three dimensions and carefully rendered in watercolor, represent yet another

Fig. 61. UNKNOWN ARTIST, *Cut Work Picture (Family with an American Flag and Pets),*
c. 1861–1863. Collage, 15 x 19″.

level of formal sophistication, making clear the work's identity as both drawing and collage, and giving the entire composition an irresistible, almost humorous, ambiguity.

Related to this work, at least in terms of technical exuberance, are the calligraphic pictures produced by American schoolteachers and penmanship students throughout much of the nineteenth century. Sometimes signed and sometimes not, these drawings were widely produced for almost a hundred years, beginning in the late eighteenth century. Their subjects include patriotic motifs, particularly Washington, the American eagle, and the like, as well as a variety of animals such as horses, stags, and birds. A fine example by an unknown artist is *Young Lion* (Fig. 62), with its rhythmic, cursive pen strokes and its charming, humorous quality. With a sense of whimsy, this artist used interlocking oval flourishes of varying thicknesses to create a two-dimensional image. A later practitioner, L. W. Frink of New York, used a more complex style in his fine *Buffalo of the Plains* of 1871 (Collection of Barbara Johnson). Composed of multitudes of fine strokes made with a steel-tipped pen, the buffalo's shaggy coat is minutely rendered, even though the artist was almost certainly drawing from memory or from an engraving. However, the details are drawn with nearly obsessive precision, and the animal—with its staring eyes in the form of a perfect circle—has a place in the world of pure design. Calligraphic drawings such as these

Fig. 62. UNKNOWN ARTIST, *Calligraphic Picture: Young Lion*, c. 1840–1850. Pen and brown ink on board, 23⅝ x 29⅝″.

can be elegant in their sweeping, linear forms and abstract in the liberties they take with the natural world; they are at once examples of the penman's craft and a form of art, and indeed may be viewed as distant offspring of letter books and teaching drawings, like the *Vorschriften* of the Pennsylvania Germans.

Country Drawings

While the folk draftsmen considered here were concerned essentially with a two-dimensional, conceptual approach to the picture plane and used watercolor primarily as unmodulated local color, the "country" artists discussed below accepted academic conventions of space and perspective, and varied tone both as a modeling device and to record variations in appearance. By and large, they had *some* training in or experience with the traditions of academic art and were attempting in their own work to create similar effects; at times, they were well trained and could be technically adept. Like the makers of American country furniture, however, these artists imitated the high styles imperfectly, but in so doing created new forms or so altered old ones as to achieve an originality and freshness which often surpassed that of their models. Many of these artists were apparently women who had learned watercolor in the drawing academies that began to appear dur-

Fig. 63. UNKNOWN ARTIST, *The Watercolor Class*, c. 1815–1820. Watercolor, 14⅝ x 23⅝″.

ing the last years of the eighteenth century or had received their education in the nineteenth-century seminaries for women, where lessons in drawing became an integral part of the curriculum. The anonymous *Watercolor Class* (Fig. 63) illustrates a scene which must have been a common one in the early ninteenth century: well-dressed young ladies work at watercolors in a pleasant, orderly atmosphere, under the direction of the drawing master seated at the right.

Nineteenth-century parlors were often adorned with "mourning pictures" in watercolor on silk or paper, which—in the days before the photograph—served to keep alive the memory of family members, young and old, who had died. Often created by young women, these works constitute a major genre of country drawings during the first half of the nineteenth century. *Polly Botsford and Her Children* (Fig. 64), which dates from about 1813, is a particularly fine example. Against delicate pink and blue washes of the sky, the regular, abstracted masses of the willow and the church echo each other both in mass and form. The church itself is a remarkable vision that unites the interior of the edifice with its exterior in a bold simplification of reality. The artist has repeated very similar motifs to produce a striking design, as in the identical row of poplars in the background, which is contrasted to the three girls of steadily diminishing size, whose overlapping triangular shapes in turn relate to the five-sided church. Repetition of form and

Fig. 64. UNKNOWN ARTIST, *Mourning Picture: Polly Botsford and Her Children*, c. 1813. Watercolor on velvet, 18 x 23½".

geometric clarity of outline produce a magical, almost surreal quality with enormous appeal for the contemporary viewer.

Mourning pictures created throughout the country follow a set formula that almost always includes a stream, bereaved children or adults under overhanging weeping willows, and a church. Yet there exist a few highly individualistic works such as *Venus Drawn by Doves* (Fig. 65, possibly by Betsy B. Lathrop, c. 1815). The existence of several similar drawings suggests that they were done as exercises in a single drawing class. The goddess, in her Empire dress and hair style, resembles Aurora more than Venus (and was presumably copied from an engraving), and is a strange apparition indeed against the rather stark New England shore.[10] The technique is something of a hybrid as well—consisting as it does of cut paper and watercolor on silk. The pigments are applied in light washes and opaque body colors as well as in delicate dots of stippling, a technique characteristic of miniature painting, and the whole is a sophisticated example of this genre.

Women artists were also responsible for a great many "folk" drawings of still-life subjects. Although some of these were drawn after engravings, and a few actually modeled from life, the largest number were apparently created by using stencils in order to outline the forms of fruits, flowers, and vases. Emma Cady's *Fruit in a Glass Compote* (Fig. 66), drawn about 1820 in New Lebanon, New York, is perhaps the

Fig. 65. UNKNOWN ARTIST, *Venus Drawn by Doves*, c. 1815.
Watercolor on silk with cut gold paper collage, 15¾ x 15½".

masterpiece of this style, and all the more remarkable as it is the only known work by the artist.[11] Because solid outlines of the fruit had been fixed for her by the stencil, effects of perspective and spatial depth were difficult indeed; yet by taking advantage of the tapering shape of the two pears and the fold in the peach at the left and by carefully arranging the grapes, the artist has skillfully and subtly suggested recession in space. The left edge of the table, on the other hand, slants back in exactly the opposite direction from what one would expect! As with other country artists, it is Cady's *instinct* for design and color as much as her training that enabled her to produce a work of art that stands up aesthetically to academic still life of the period.

In other stenciled drawings as well, such as *Apple Still Life* (Abby Aldrich Rockefeller Folk Art Collection) by an unidentified artist, the certainty and grace of the geometric forms are important elements of the work's success. To the modern viewer, acquainted with the drawings and paintings of purists such as Ellsworth Kelly, the clarity of outline

and abstract shape in such works is especially appealing. Abstract design and realistic detail combine to produce an effect intellectually designed while being objectively observed.

In the early years of the nineteenth century there was also an enormous demand for portraits, executed as quickly and cheaply as possible. Since there were at that time relatively few trained artists, especially outside the larger cities, a number of country artists found that they could earn their livelihood as itinerant portrait draftsmen. Deborah Goldsmith (1808–1836) may have received some training in a female academy or drawing school, but her work is not so much that of a genteel amateur as the product of a full-time professional portrait painter, yet one whose work never gained anything like an academic sophistication of form or modeling. Born in North Brookfield, New York, she began her career at about the age of twenty-one, staying at the homes of her patrons until her portraits of the family were completed. Her travels ranged over New York and Connecticut, until she married one of her sitters, George Throop, in Hamilton, New York.[12]

In the *Talcott Family* (Fig. 67) of 1832, the floor appears to be tilted so sharply upward as to pitch the sitters and their furniture out of the picture space; the left arm of the man is bizarrely elongated, and the dog at his feet looks rather like a large mouse. Yet the crisply de-

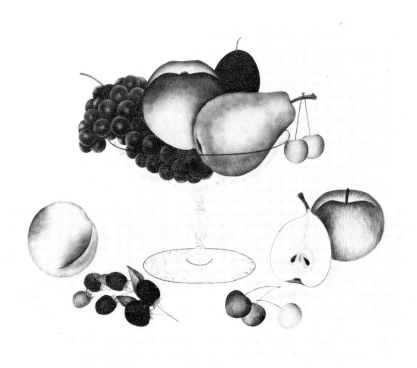

Fig. 66. Emma Cady, attr. to, *Fruit in a Glass Compote*, c. 1820.
Watercolor, 16 x 19½″.

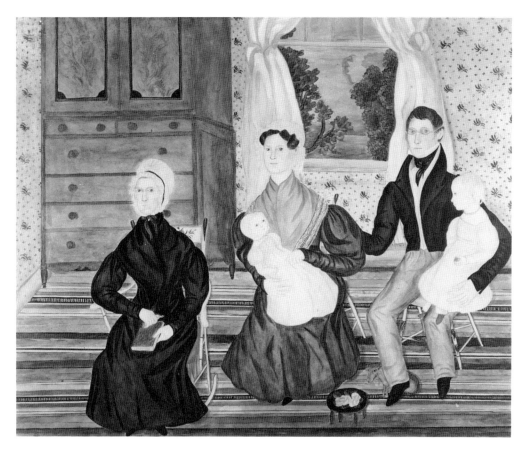

Fig. 67. DEBORAH GOLDSMITH, *The Talcott Family*, 1832.
Watercolor, 14¼ x 17¾".

lineated patterns of the rug and wallpaper combine with the careful
likenesses to produce an intensely real and immediate experience. Since
patrons of country no less than of academically trained portrait painters
were most concerned with likeness, we can assume that the Talcott
family was pleased with Deborah Goldsmith's effort. The modern
viewer is struck by the directness with which she rendered their gazes
and the expressive qualities of their faces, as well as her skill both in
composition and in the bright colors of rug and wallpaper.

Another portraitist of the same decade was Henry Walton (1804?–
1865), who lived most of his life in upstate New York near Ithaca and
began his career as a topographical draftsman and lithographer.[13]
His watercolors of cities and towns, though fantastically detailed, de-
viate relatively little from the mainstream art familiar from hundreds
of nineteenth-century prints. However, his portraits, mostly in water-
colors, are less technically accomplished than his landscapes, and the
sharp outlines and ambiguous space of works like *Frances and Charles
Cowdrey*, about 1839 (Fig. 68), warrant the use of the term "country
art" in connection with his efforts in this field. Walton continues the
precisionism of his topographical watercolors, but on such a small scale

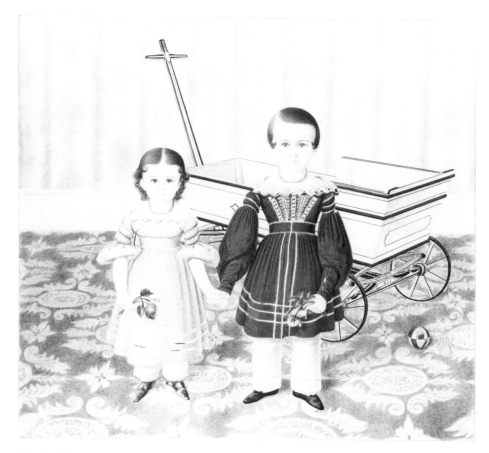

Fig. 68. Henry Walton, *Francis and Charles Cowdrey*, c. 1839.
Pen and watercolor, 11½ x 12⅝″.

as to produce a clarity of vision amounting to a kind of magic realism.
He has lettered the composition in the lower margin, which he de-
liberately left uncolored (as if to emphasize the resemblance of the
drawing to a lithograph—a common practice in country drawings, where
all marks of the artist's hand are suppressed in an effort to reproduce
a more "valuable" or cosmopolitan work).

Recent research has revealed the identities and analyzed the styles
of other artists working in this genre, including J. Evans, Joseph
H. Davis, and J. A. Davis, all of whom worked in related styles
in New England during the 1830s and 1840s. Perhaps the outstand-
ing hand is that of Joseph H. Davis. Though little is known about his
life, a substantial body of work can now be attributed to him, including
the fine watercolor *Page and Betsey Batchelder,* 1836 (Collection of
Mr. and Mrs. Samuel Schwartz). Here a couple sits proudly, each in
profile at opposite ends of a painted country table covered with fruit,
books, and other objects; they float upon a richly stenciled floor, and
their cat stares out from the center of the composition. Like many of
his contemporaries, Davis's abilities did not include the illusion of real
space or three-dimensionality, yet his work is totally captivating.

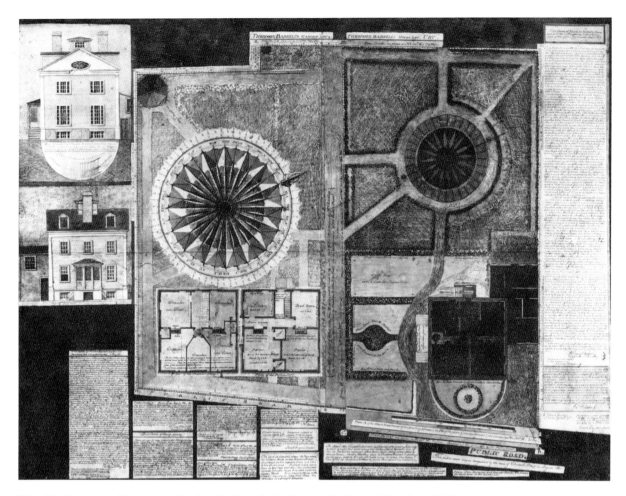

Fig. 69. THEODORE BARRELL, attr. to, *Deed and Architectural Plans: The Barrell House,*
c. 1833. Watercolor, 31 x 41″.

The country portraitist was largely put out of business by the rising
popularity of the daguerrotype during the 1840s and 1850s. Where once
the artist with a box of watercolors and a modicum of skill could charm
a community by producing ingratiating likenesses of one's family, now
came the proprietor of the exotic new technique which could magically
reproduce an *exact* likeness, with no intervention of an artist's hand.

Women did not make up the whole population of country artists.
Indeed, the tradition that some training in draftsmanship was basic to
any "gentleman's" education continued through much of the nineteenth
century. Drawings of high quality by such gentlemen-architects as
Thomas Jefferson, John Trumbull, and Benjamin Latrobe abound at
the turn of the century; later on, one finds equally sophisticated works
by men such as Alexander Jackson Davis. These fall into the tradition
of professional architectural renderings rather than folk or country art;
however, there do exist unsophisticated, "architectural" drawings that
stem from the professional tradition. An intriguing example is seen in

the unusual *Deed and Architectural Plans: The Barrell House* (Fig. 69), a drawing which functioned as a complete written record of a title to land, a plan of the house lot and its adjoining garden lot, an elevation of both the east and south sides of the Barrell house, and as a personal, conceptual work of art as well.

The country and folk drawings that we have been examining come from various traditions and periods; what they have in common is their lack of sophistication in modeling and sometimes in composition, along with a seemingly instinctive linearity of plane and flatness of color areas that recall some forms of primitive art. The country drawing often uses pure color in an apparently naïve—and pleasing—way, and its emphasis on line rather than illusion very well suits modern eyes which have been trained on Cubism and color abstraction.

It should be remembered that a considerable majority of *all* American painters before 1850 began in the folk tradition. Thus if one looks to the early portraits of such disparate artists as Gilbert Stuart and Martin Johnson Heade, or the first landscapes of Benjamin West or Thomas Cole, one finds the young, self-taught artist beginning in this primitive mode. Many artists who later gained academic success presumably also made ''folk'' drawings and watercolors, though relatively few examples of such work have survived (paper being so much more perishable than canvas). One that does demonstrate the tradition, however, is Fitz Hugh Lane's *Burning of the Packet Ship Boston*, 1830 (Fig. 70). This very early watercolor by Lane (1804–1865), later the chief marine painter in mid-century America and a founder of the ''luminist'' style, is bold and direct, with flattened forms, repetitive scalloped waves, and an elemental black and white design. Other artists would have been satisfied with this not inconsiderable accomplishment, but Lane (like the other ''academic'' artists) aspired to a more difficult kind of illusionism and went on from the folk tradition.

An artist who began much as Lane did, and who worked in the less sophisticated mode throughout a long and successful career, was Jurgan Frederick Huge (1809–1878), who was born in Hamburg but came to America as a young man. Although his technique may reflect early training in Germany and his precisionist style and fondness for decorative lettering demonstrate an origin similar to that of fraktur artists, the most direct influence on Huge's style seems to have been the marine and topographical engravings popular in mid-nineteenth-century America. His large watercolor *Bunkerhill* of 1838 (Fig. 71) may even have been intended to serve as the model for a lithograph, as did at least two of his other watercolors of the same year.[14] His desire to imitate prints is evident in his habit of labeling his subjects in large letters in the margin as well as signing them in the right margin below the watercolor. Huge's conception of the watercolor medium is indicated by the signature that appears here, ''Drawn and painted by J. Frederick

Fig. 70. FITZ HUGH LANE, *Burning of the Packet Ship Boston*, 1830.
Watercolor, 19¼ x 27″.

Huge.'' In fact, Huge usually applied watercolor in flat washes with
details executed in pen and ink. His rigidly schematized rendering of
waves and smoke, which are among the most attractive aspects of his
early work, diminished somewhat over the years, but his taste for ab-
stract linear design elements, crisp rendering of figures, and precise
overall approach continued in works dating to 1878, the year of his
death. Although Huge occasionally worked with crayon, pastel, and
pencil, the watercolor with pen and ink was his favorite medium.

Sometimes country artists imitated more or less closely the aca-
demic styles popular in the area around them, such as the Hudson River
School. There are, for example, some remarkable charcoal drawings on
sandpaper after the engravings of W. H. Bartlett. A similar work, *The
Devil's Pulpit* by Thomas A. Ayres (?–1858) (Fig. 72), in pencil, char-
coal, and wash, repeats stylistic and iconographic elements found in
paintings by Asher B. Durand as well as Bartlett's engravings. Ayres
was born in New Jersey, but went to California in 1849, where he
sketched the Yosemite Valley during the first official expedition there.
Although Ayres exhibited his work in New York City during the latter
part of his life, in drawings like *Devil's Pulpit* he appears to be at a
point of transition between the country artist and the academically
trained professional. The treatment of space is ambiguous, with the
rocks protruding forward toward the picture plane, and the figures are

Fig. 71. JURGAN FREDERICK HUGE, Bunkerhill, 1838.
Watercolor, 19 x 32".

conceived as two-dimensional. Though the background trees are depicted with more subtle gradations of tone and texture than are common in country art, the foreground foliage is not far from that in *Polly Botsford and Her Children*.

Also related to the Hudson River School aesthetic, but just as idiosyncratic as Ayres's work, are the paintings and watercolors of Charles Hofmann, a German immigrant who worked in Pennsylvania during the 1860s and 1870s. In his *Berks County Almshouse, Hospital and Lunatic Asylum* 1865 (Fig. 73), the artist—a longtime inmate of this institution—uses a detailed, topographical style in drawing the almshouse and its environs. With the great clarity of vision special to "country" artists, at once he records a detailed, knowable reality which he experienced and a brightly lit, perfect world which he conceived.

An even later work which also reflects the academic mainstream is the pencil and gouache drawing on dark paper, *Entrance to Harbor—Moonlight*, 1881 (Fig. 74) by David Johnston Kennedy (1816/17–1898). The artist was a Philadelphian who made countless pencil and watercolor views of that city (a large collection still existing at the Historical Society of Pennsylvania) despite being employed for most of his life as General Agent of the Pennsylvania and Reading Railroad. *Entrance to Harbor—Moonlight* is crisp and compelling, and is surely based on knowledge of the marine paintings of Heade or James Hamilton.

Fig. 72. THOMAS A. AYERS, *The Devil's Pulpit*, 1857.
Pencil, charcoal and wash, 17 x 11⅜″.

Fig. 73. C. C. Hofmann, *Berks County Almshouse, Hospital and Lunatic Asylum*, 1865.
Ink and watercolor, 23⅝ x 40⅝".

Fig. 74. David Johnston Kennedy, *Entrance to Harbor—Moonlight*, 1881.
Gouache, Chinese white and pencil, 9¼ x 14¹⁵⁄₁₆".

Fig. 75. WILLIAM BROOKS, *Hardware*, 1840.
Pencil, 9⁹⁄₁₆ x 11⅞".

Finally, there are occasional drawings that turn up which are so
idiosyncratic that they fit comfortably into neither country nor city,
primitive nor academic traditions. However, they appear to be the
drawings of trained craftsmen rather than artists, and though they
contain observed elements, their compositions are conceptual rather
than pictorial in intent. One example is William Brooks's drawing of
1840, *Hardware* (Fig. 75), certainly a design for a printed trade card
or advertisement by the firm Charles Brooks & Co., No. 6, Dock Square,
Boston. The artist—perhaps a son of the storekeeper—has rendered the
firm's goods with careful detail, and he ingeniously spells out the word
HARDWARE by adapting a variety of implements and objects to the letters,
a hinge becoming the H, an iron the D.

Even more astonishing is a drawing (Fig. 76) by Cyrus W. King,
who was the only son of a prominent politician who became governor of
Maine. Using a pencil on a sheet of paper only 11¾ by 14¾ inches, King

Fig. 76. Cyrus W. King, *12943 Objects*, c. 1874.
Pencil and black ink, 11¾ x 14¾".

created a vast and complex autobiographical doodle. There are forms taken from a wide variety of nations and cultures, and references to theology, astrology, classical art, and mathematics, among others. There are objects within objects, and obviously many levels of meaning. The drawing can be appreciated for its craftsmanship, admired for its erudition, or studied for its figures, animals, and articles of craft. It can also be read as the product of a tortured mind, for the drawing itself represents the creative obsession of a madman. Other drawings and at least one topographical lithograph by him are known, but there is nothing else of this complexity. In the lower right King noted ''12943 objects on this card in 1853,'' presumably marking his progress to that date; yet the drawing elsewhere is inscribed ''Copyrighted 1874 by C. W. King.'' Shortly after completing this work, the artist apparently died in a madhouse.

6

Drawings of the Hudson River School

It has been said that "the American landscape is the great protagonist of our art,"[1] and it is undeniable that American scenery inspired great pictorial accomplishment in painting, drawing, and watercolor during the nineteenth century. Moreover, many advances and experiments in our landscape style are first seen in drawings or watercolors, thus providing further proof of the phenomenon discussed by Wolfgang Stechow in his analysis of seventeenth-century Dutch landscape painting ("In many periods the art of black and white anticipated discoveries made later in painting").[2] This is particularly germane for the developmental phases of the Hudson River School. During the late eighteenth century the topographical print and the traveler's sketchbook came into being, apparently paving the way for the school itself; the sketches of such men as C. W. Peale (see Fig. 37) and William Dunlap foreshadowed the school's interest in topographical detail and atmospheric particularity.

However, the full story of the development of landscape art in America has not yet been told, and particularly obscure is the relationship of drawings to watercolors. It is clear that existing contemporaneously with the flowering of American landscape painting were two disparate graphic traditions: one, the practice of the school itself, which emphasized creation of pen and pencil sketches, normally in conjunction with *paintings*; and the quite separate watercolor school which flourished at the same time. The Hudson River School painters discussed below viewed drawing and sketching as valuable in themselves; they worked largely in black and white; and their stylistic sources were many, and certainly looked back in part to the Dutch seventeenth-century manner. The watercolorists (described in the following chapter) worked and exhibited beside the Hudson River painters

in New York City, often making use of the same subjects—and indeed at times seeming to lead that school rather than follow it; but they made *finished* works of art, arguing that a watercolor was as complete as any painting; and *their* prime source of inspiration was the English watercolor tradition of the late eighteenth and early nineteenth centuries.

The sketchbooks of the landscapists of the late eighteenth and early nineteenth centuries were likely to be small in scale, and filled with views outlined simply with a pen or with colored washes over pen-and-ink lines. Such were the drawings of the Peales, of Trumbull, and the others. Thus there was very little warning for the revolution in landscape draftsmanship that was accomplished by Thomas Cole (1801–1848). By the early 1820s Cole was making drawings which singlehandedly established the drawing style of the Hudson River School; moreover, his approach to landscape drawing remained dominant up to the Civil War and beyond, and indeed was practiced enthusiastically by some artists throughout the nineteenth century.

Cole was one of the most prolific of draftsmen, leaving behind several thousand sheets; he made many types of drawings, each for a distinct purpose. Basic to his approach, however, was the pencil study of an individual tree, such as that seen in *White Cedars near Niagara* (Fig. 77). That it is necessary for a landscape painter to study trees—in fact, to be able to draw them so that not only their species but their own individuality is clearly recorded—was soon to be taken for granted. However, in America this idea was Cole's, and though there were considerable precedents in the work of German and English romantics such as Caspar David Friedrich and John Constable, no artist anywhere carried it further. The critic William Dunlap recognized the importance of this innovation, the change from generalized sketches of nature to detailed analyses of her parts, writing in 1834 that Cole "began in 1823, to make studies from nature. . . . He made small, but accurate studies of single objects; a tree, a leafless bough—every ramification and twig was studied."[3]

This approach is first evident in a sketchbook (at the Albany Institute) which Cole inscribed "Pittsburg 1823," suggesting that he had begun this kind of study before his arrival in New York two years later. Thus it would appear that Cole's change occurred not from contact with other artists, but rather was self-motivated. As a well-read young man, Cole may of course have been influenced by various English manuals of the period which urged the importance of trees and their individualization.[4] For example, the *Landscape Magazine* (published in London in 1793) emphasized this point: "Unless each tree represented, differ in representation, according to its nature, from others around it, what mortal shall divine its intention?"[5] This new, anticlassical view is found as early as 1786 in Alexander Cozens' *The Shape, Skeleton and*

Fig. 77. THOMAS COLE, *White Cedars Near Niagara*, 1829.
Pencil, 9¾ x 7¹⁵⁄₁₆″.

Foliage of 32 Species of Trees for the Use of Painting and Drawing,
and later is seen in John Martin's *Characters of Trees* of 1817, either
of which could have been seen by the young painter.

The highly detailed sketch from nature of a single tree, with species,
locale, and often the date and even the time of day specified, is the
archetypal Cole drawing. His practice of making such pencil studies in
his sketchbooks was taken up by others, and became the favorite mode
of the school. Yet Cole made many other kinds of drawings as well, for

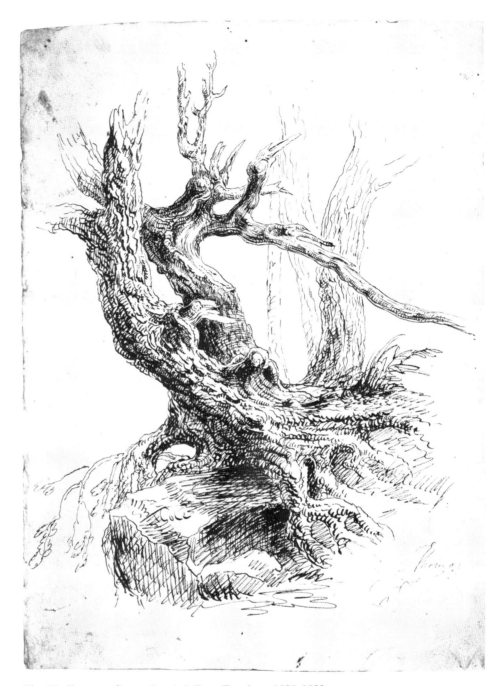

Fig. 78. THOMAS COLE, *Gnarled Tree Trunk*, c. 1825–1829.
Pen and ink, $14^{13}/_{16}$ x $10^{11}/_{16}$".

a wide variety of purposes, and the different categories are often con-
fused. For example, on occasion he would make mannered, finished draw-
ings of trees, using chalks or ink-over-pencil outlines, as in the *Gnarled
Tree Trunk* (Fig. 78). Larger than his normal outdoor sketch, this
drawing must have been conceived as a study of the ideal rather than
the real (so paralleling a similar division in his oil paintings). Elegant
and freely drawn, based generally on nature yet doubtless worked up
in the studio,[6] inscribed with a signature rather than any species or

Fig. 79. THOMAS COLE, *Tranquillity*, c. 1835–1840.
Pen and ink over pencil, 2⅝ x 3¼″.

Fig. 80. THOMAS COLE, *Albany*, c. 1840.
Pen and ink, 10⅛ x 15⁵⁄₁₆″.

place, this work shows Cole in a mood more self-conscious than observant.

Cole also made panoramic landscape drawings of several distinct types. For example, he drew compositional sketches from nature, outlining in pencil a scene in the Catskills or White Mountains which might later be used as the subject of a painting. He also made "record drawings" of most of his completed paintings, recording the appearance of his finished compositions as they were sold; these are usually small, careful works in ink outline. In a third kind of landscape drawing, usually small in size, in ink, he recorded ideas for paintings, as in *Tranquillity* (Fig. 79): here the artist has quickly jotted down, in Rococo style reminiscent of West's, a compositional thought which has occurred to him. A fourth type of landscape drawing was the careful topographical study meant for reproduction as an engraving, rather than as a study for a painting. Here he would normally work in pen in rather *retardataire,* classic fashion, as in a series of views along the Hudson, including *Albany* (Fig. 80).

Still another mode of the landscape drawing for Cole is found in the small round work in pencil and white wash (reproduced to scale in Fig. 81) now called *Romantic Landscape: Indian and a Cross.* Extraordinarily minute in treatment, highly worked in every part, it stands entirely on its own. Howard Merritt suggests its relationship to a painting of 1845, and notes the possibility that the drawing was a study for a never executed lithograph, a medium which Cole attempted twice late in his career.[7] However, one should also note that by this date, the drawing had gained a new level of respect as a work of art in itself. The Sketch Club was prospering; at times drawings were exhibited along with oil paintings and watercolors at the National Academy and elsewhere; the academies now taught drawing rigorously, and indeed some patrons of the Hudson River School were beginning to fill scrapbooks with the drawings of their favorite artists. Thus the *Romantic Landscape* might also be of this new genre, a finished "album drawing" made for a fellow painter or a patron as an intimate view of the artist at his best.

One of the earliest and best of these albums is the John Ludlow Morton Sketchbook, owned by the New-York Historical Society. Morton (1792–1871) occupied an ideal situation for an early collector of drawings: an enthusiastic and able draftsman himself, he was Secretary of the National Academy of Design and thus he knew the New York artists well. Morton's volume—a descendant of the seventeenth-century *album amicorum,* or book of friends—contained twenty-five drawings of small size (about four by six inches), almost all dating from the years 1827–1830. Unlike the quick Sketch Club drawings, discussed below, these works are painstakingly rendered in pencil and washes; they are fully signed and dated, conceived as complete small-scale works of art which

Fig. 81. THOMAS COLE, *Romantic Landscape: Indian and a Cross*, c. 1845.
Pencil and white wash, 7⅜″ diameter.

functioned as the most elegant kind of artists' "autographs." Morton
presumably was *given* his drawings, while other collectors of such
volumes often paid the artists. Interestingly, landscape did not yet
dominate the New York school; the influence of West and Allston re-
mained strong, and a majority of the drawings are actually figure
pieces. Durand, Edmonds, Sully, Robert Weir, S. F. B. Morse, and
Cole are all represented, along with a number of lesser-known men such
as Charles C. Ingham (1796–1863), George Flagg (1816–1897), and
Frederick S. Agate (1807–1844), whose *Shipwrecked Mother and Child*
(Fig. 82) combines a neoclassic subject with romantic landscape and is
similarly transitional in style.[8]

Nearly all the artists represented in the Morton Sketchbook were
New Yorkers who were associated with one another in both their per-
sonal and professional lives. For example, most important for American
draftsmanship was the founding in 1826 of the National Academy of
Design; significantly, the academy was conceived at a meeting of the

New York Drawing Association (formerly the Society for the Improvement of Drawing), which itself had been begun in order to improve the study and teaching of drawing in New York. Drawing from the antique (casts) and anatomy were taught at the Academy from the beginning, with life drawing instituted in 1830.[9] Though detail and high finish are said to have been emphasized, there are—astonishingly—no drawings known today which were surely done there.

The influence of English romantic artists such as Blake and Fuseli is strongly felt in many of the Morton drawings. English influence, both artistic and poetic, is present too in the drawings of the Sketch Club (a spiritual descendant of the sketching clubs which sprang up in England during the 1790s), predecessor of the Century Association, begun in New York by many of the same men in 1829.[10] A key aim of its founders was "to perfect themselves in the art of drawing," as James Callow points out.[11] The Sketch Club—also known as The Twenty-One—was only one of a number of similar groups formed during the nineteenth century, and it followed the general pattern of Sully's sketch club (see above p. 83). Its heyday occurred in the years just after its founding, when the members took their artistic task most seriously: at their biweekly meeting the host would suggest a topic which would then be drawn by those present. Subjects were taken specifically from Byron, Spenser, Scott, and the like, or could be as vague as "The Emotions."

One group of Sketch Club drawings survives intact (at the Yale

Fig. 82. F. S. Agate, *Shipwrecked Mother and Child*, c. 1830.
Sepia wash, 3⅝ x 5¼".

Fig. 83. SAMUEL F. B. MORSE, *The Elfin Page*, 1829.
Pencil, 7⅞ x 10⅜″.

Fig. 84. ROBERT W. WEIR, *The Elfin Page*, 1829.
Pencil, 7¾ x 10¼″.

University Art Gallery): it consists of nine sketches by Ingham, Morse, Cole, Cummings, Inman, Weir, Dr. John Neilson, Jr. (an amateur who lectured on anatomy at the academy), and William Guy Wall (who made two of the drawings). Asher B. Durand, William Cullen Bryant, Giulian Verplanck, and James Hillhouse, the host, were also present but evidently did not make drawings on that occasion. The subject on this evening, as recorded in the minutes for March 27, 1829, was "The Elfin Page, from Scott's *Lay of the Last Minstrel*." The artists apparently worked independently, yet most represented the moment in the poem (Canto III) when the Elfin Page's spell has been broken and he regains his own evil appearance, frightening the young child he has kidnapped while bounding away over a brook. This was the event depicted both by S. F. B. Morse in his articulate, rather finished drawing (Fig. 83) and by Robert W. Weir in his far looser work (Fig. 84). Cole, interestingly, took a very different tack—and one more prophetic for the future of the school—in sketching a fallen tree and stump in a landscape, showing the two figures only at a great distance.[12]

Despite the strong figural tradition which existed at the beginnings of the school, landscape soon came to dominate our art as more and more artists were drawn to portray America's natural wonders. Thomas Cole was at the center of this development, but there are several other painters with some claim to being co-founders of the Hudson River School, in the sense of being among the first full-time professional landscapists in America. Though there is no one in this early generation whose drawings rivaled Cole's either in number, variety, or impact on his contemporaries, two figures worthy of mention are Alvan Fisher (1792–1863) and Thomas Doughty (1793–1856), both of whom were actively painting and drawing landscapes by 1820. Both normally used drawings as compositional studies for paintings, but their styles are

Fig. 85. THOMAS DOUGHTY, *Mountain Landscape*, c. 1820–1825.
Pencil with oxidized white wash, 11$\frac{1}{16}$ x 8$\frac{3}{8}$".

quite different. Few of Doughty's graphic works survive, yet one can judge that he normally employed either a soft pencil or hard black chalk along with white washes in a manner foreign to Cole's more linear style. *Mountain Landscape* (Fig. 85) is far less conventional than Doughty's usual compositions, but shows his typical use of short, vertical strokes to suggest mass along with a generalized, unspecific treatment of foliage. More of Fisher's drawings survive today, and they demonstrate his use of dark, India-ink washes to create land-

Fig. 86. ALVAN FISHER, *Niagara*, c. 1820–1830.
 Wash, 10½ x 15½″.

scape space (see Fig. 86). Despite the quality that each attained at times, both drawing styles remain generalized, and thus look back to the late eighteenth century rather than ahead to the school at its height.

As the Hudson River School came to maturity during the 1840s and 1850s, its painters increasingly turned to three types of drawings, all of which reflect Cole's practices. These were the panoramic view, the close-up detailed study of a tree or other object, and the quick sketchbook drawing of topography, composition, or lighting effects.

Topographical studies became increasingly detailed by mid-century; drawings of the 1840s are more all-encompassing and more highly realistic than paintings of that period, and thus "work in black and white" once again points toward future developments. Edward Seager (c. 1809–1886) was an unusually able, widely traveled draftsman. As professor of drawing at the Naval Academy, he taught future naval officers the craft of accurately recording in pencil the scenes they saw— a military necessity in the days before photography. In the summers he traversed the eastern states, recording both rural and town views with precision, as in *On the Kenebec River, Holliwell, Me*, c. 1845–50 (Fig.

Fig. 87. EDWARD SEAGER, *On the Kenebec River, Holliwell, Me.*, c. 1845–1850.
Pencil, 9⅞ x 15¹⁄₁₆″.

87). As he had none of the painter's bias against slums and factories, and also no temptation to make his scenes more picturesque than they were, his drawings provide a rare visual record of mid-century America.

Quite different kinds of topographical views were made by two far better known artists of the period, Edwin Whitefield (1816–1892) and Jasper Francis Cropsey (1823–1900). Whitefield's highly detailed drawing *Providence, Rhode Island* (Fig. 88) is finely executed in pencils of varying hardness on a sheet of white "Reynolds's Bristol Board," using a light-blue wash sparingly to indicate the bay and distant hills. The artist pays great attention to the architecture of the city, one of many he drew with an eye toward publishing a series of American views. Whitefield was one of the most prominent botanical and topographical printmakers of mid-century; in addition to his drawings and prints, he prepared several instructional books and lectured widely on such subjects as "Perspective," "Sketching from Nature," and "Shading with Pencil or Brush."[13]

Cropsey was one of the most popular painters of the Hudson River School, and his poetic drawings in charcoal and wash—such as *Chepstow*

Fig. 88. EDWIN WHITEFIELD, *View of Providence, Rhode Island,* c. 1850.
Pencil, 7⅝ x 12½".

Fig. 89. JASPER CROPSEY, *Chepstow Castle on the Wye,* 1849.
Charcoal, gouache and sepia, 9½ x 16⅜".

Castle on the Wye of 1849 (Fig. 89)—stand out from the more literal work of his contemporaries. Though limited and repetitive as a painter, Cropsey deserves recognition as one of the best and most prolific draftsmen of the school. The drawings show an eye not only for detail but also for mass, and for light and shade; moreover, he could draw a whole scene while leading the viewer's eye through foreground and middle ground to the central object. He evidently profited from several years' apprenticeship as an architectural draftsman at the beginning of his career and then from extensive travels, including one seven-year stay in England from 1856 to 1863. Though fine architectural drawings survive (particularly in the Karolik Collection), his sketches of such picturesque scenes as *Chepstow Castle* made as a preparatory study for a painting, remain his outstanding work.

The painters and draftsmen of the landscape school after 1840 were as much influenced by Asher B. Durand (1796–1886) as by Cole, and it was Durand who codified many of their practices. Durand reached artistic maturity around 1850, as did the school itself, and after Cole's death, he was regarded as its senior figure. Particularly significant are his "Letters on Landscape Painting," a guide to the practice of landscape, which were published in 1855–56 in the leading American art magazine of the period, aptly called *The Crayon*.[14] In these articles, Durand preached to the young artist the necessity of going directly to nature, rather than staying in the studio; he glorified the beauty of American scenery, as opposed to foreign travel; and above all he wrote of "the vital importance of drawing." And as a draftsman, he took the tree as his basic subject, admonishing the student:

> Observe particularly wherein it differs from those of other species; in the first place, the termination of its foliage . . .; next mark the character of its trunk and branches. . . . Every kind of tree has its traits of individuality . . . with careful attention, these peculiarities are easily learned, and so, in a greater or less degree, with all other objects.[15]

The tree was nature's basic form: if its form in all its variety and perfection could be mastered, then other forms—mountains, ferns, rocks, and buildings—would follow naturally. Durand urged a selective realism, the artist choosing the "best and most characteristic objects" from nature; his style was tightly realistic and as a printmaker himself he recalled that " a fine engraving gives us all the greatest essentials of a fine picture." Though recognizing other mediums, above all Durand suggested use of the pencil.

Though Durand occasionally worked in washes and in the early years of his career did genre scenes, almost all of the large group of surviving drawings (most of which are at the New-York Historical Society) portray trees, executed in pencil on medium-sized (often toned) sheets of paper. Very often they are inscribed with the locale rather than

Fig. 90. ASHER B. DURAND, *Bolton, Oct. 3, 1863*, 1863.
Pencil, 12¼ x 18½".

the species of the tree as in *Bolton, Oct 3, 1863* (Fig. 90). Here a rather
soft pencil is used boldly yet precisely to suggest the writhing branches
and towering height of fir trees near Lake George, one of Durand's
favorite haunts.

The artists of the Hudson River School drew innumerable trees,
making drawings both for their own enjoyment and for possible later
use in paintings. Their sketches are often similar, yet the work of each
of the major men—such as Durand, Church, Cole, Homer Martin (1836–
1897), David Johnson (1827–1908), and William Trost Richards (1833–
1905)—is consistent in itself, and is thus stylistically distinguishable
from the others. Durand, for example, was close to John F. Kensett
(1816–1872), himself one of the best known of the landscape painters;
the two artists traveled together both in Europe and America, and
Durand's influence is evident in the younger man's work. Yet Kensett's
drawings are highly individualistic: often on light-gray paper, they
incorporate thicker, broader pencil line than Durand's, more generalized
treatment of foliage, and a wider variety of compositions (see Fig. 91).

A superb but little-known draftsman who deserves mention in this
context is Charles Herbert Moore (1840–1930), who in the 1860s was

Fig. 91. JOHN F. KENSETT, *Birch Tree, Niagara, Aug. 26, 1850*, 1850.
Pencil, 17⅛ x 11¼″.

Fig. 92. CHARLES H. MOORE, *Pine Tree*, 1868.
Pencil and ink on cream-colored paper, 25⅛ x 20″.

active in New York at the National Academy, and was based (like so many of the school) at the Tenth Street Studio Building. It was at this time that he made such drawings as *Pine Tree* (Fig. 92), inscribed "Catskill 1868." This drawing is sharply realistic even beyond what Durand could have wished: precise, eerie, technically flawless, it is the work of an American Pre-Raphaelite who came to know Ruskin, and who later went on to a distinguished teaching career at Harvard.

Mid-century painters drew objects other than trees with equal care, generally with the idea in mind of including them in a future painting. Among marine specialists, Fitz Hugh Lane, though a magnificent painter, made rather slight studies of shoreline topography. William

Fig. 93. WILLIAM BRADFORD, *Merchant Ship*, c. 1856.
Pencil, 19⅝ x 14⅛″.

Fig. 94. WORTHINGTON WHITTREDGE, *Bishop Berkeley's House, Newport, Rhode Island*,
1877. Pencil, 15¼ x 22³⁄₁₆″.

Fig. 95. WILLIAM HART, *Shipwreck*, c. 1860–1870.
 Wash, 3⅞ x 6½".

Bradford (1823–1892), on the other hand, was a prolific and able drafts-
man, filling sketchbooks with vigorous, loose sketches as well as highly
detailed studies of sailing ships (see Fig. 93). The landscapists did the
same, drawing figures, farm implements, foliage, and buildings of all
kinds. Of the latter, a notable example is the rare drawing by Worthing-
ton Whittredge (1820–1910), *Bishop Berkeley's House, Newport, Rhode
Island* (Fig. 94); this careful, tonal study of a famous dwelling was
later used in two paintings.

A quite different kind of drawing appears in the small, pocket-sized
sketchbooks which nearly every painter carried on his travels. These
sketches could have a variety of purposes, as seen with Thomas Cole;
in general, however, they show the artist working outdoors, making a
quick, on-the-spot record of topographical outline or atmospheric effect.
Alvan Fisher's sketch books, many of which are owned by the Karolik
Collection, are among the finest of the earlier generation. Among the
"second generation" or mid-century Hudson River School artists, there
were many fine draftsmen, as suggested above, including the brothers
James (1828–1901) and William Hart (1823–1894). Both normally
worked with a medium-soft pencil, using somewhat feathery strokes in a
traditional manner. Yet on occasion William, particularly, produced
rapid impressionistic sketches in dark washes, such as the highly charged
Shipwreck (Fig. 95), the work of minutes on a tiny sketchbook page.

Perhaps the finest hand among the landscape school was that of
Frederic E. Church (1826–1900). As Cole's one-time student, Church

Fig. 96. FREDERIC E. CHURCH, *Sky Aug/67*, 1867.
Pencil on gray paper, 4¾ x 7⅝".

had a wide repertoire; he made thousands of drawings (the largest collection being at the Cooper-Hewitt Museum), using many mediums for a variety of ends. Like so many others, he carried a small sketchbook and would use it to record storms and sunsets nearly as quickly as one could with a camera today. These sketches, such as the one marked "*Aug/67*" (Fig. 96), conceptually capture an instant in time—and of course the dramatic instant bore great importance for Church and his contemporaries. This type of sketch would normally include color notes, with the artist using a numbered shorthand to record the scene. Here, Church concentrates on effects of sky and clouds (as in many of his paintings), with the upper ones marked "5" and "6" ("delicate steel blue" and "exquisite rose blush") and other numbers corresponding to other specific color effects.

Church also produced many detailed pencil studies of foliage, ferns, and other plants; some particularly fine ones date from his trip to Jamaica in 1865. On his travels he drew in quite another way: he would use pencil to make topographical drawings, about fourteen by twenty inches in size, which would later be partially or wholly painted in oil. Particularly on the rapid European travels of 1867 he had a tendency to leave these largely as pencil drawings, filling in perhaps only the sky or mountain peaks with oil; the results were some of the most freshly observed of all landscapes.

Cole had been a highly linear draftsman; Church's line is even sharper and more precise, yet the best of his drawings combine line

Fig. 97. FREDERIC E. CHURCH, *Goat Island August '58*, 1858.
Pencil and white gouache on brown paper, 17⅝ x 12″.

Fig. 98. FREDERIC E. CHURCH, *Chimborazo from the House of Señor Bustamente,*
Riobamba, 1857. Pencil and white gouache on light brown paper, 13⅞ x 21¾″.

with shading and washes which convey a sense of light and of mass.
His transcendentalist feeling for the wonder of light is shown in simple
drawings of trees (see Fig. 97), superficially similar to those of many
of his contemporaries, yet sparkling almost impressionistically.
Church's drawings at their best are both spontaneous and painterly,
and he used pencil and white washes together with unsurpassed skill.
When he found a great subject, such as the magnificent peak of Chim-
borazo in Ecuador, he would sketch it from every angle and distance,
under varying weather, at different times of day—all with the aim of
returning to his studio with a complete visual record which could be used
in making a painting. Thus, his sketch of July 14, 1857 (Fig. 98) uses
pencil and white wash dextrously and economically; unlike his col-
leagues, he focused his drawings, so that the whole mountain becomes an
object at the same time as he studies the drama of light cast on its snowy
peak.

Niagara Falls was the archetypal subject for the Hudson River
School in general, and for Church in particular. His studies leading up
to the painting *Niagara* of 1857 (Corcoran Gallery of Art) are simply
astonishing. One drawing in pencil, with white body color touched with
other hues (Fig. 99), would have pleased Ruskin as much as the finished
painting did: with complete mastery of line and tone, texture and light,
Church sketches a small section of the falls that appears on the left side
of the painting. One feels the speed and certainty of the artist's hand;
his sense of placement on the paper, using both negative and positive

Fig. 99. Frederic E. Church, *Niagara Falls from the Canadian Side*, 1856.
Pencil and colored washes, 10¾ x 12⅜″.

space; and the pure sense of abstraction which leads him to use pinks and ochers in the water; and one is convinced of the thundering reality of the falls themselves.

Some of the major landscapists drew only rarely (like Bierstadt); others, such as Sanford Gifford (1823–1880) drew often but lacked a sure hand. Some of the relatively minor men, on the other hand, including Church's friend Jervis McEntee (1828–1891) and the German-born Johann H. Carmiencke (1810–1867), sometimes approached Church's level in their drawings. For some of the artists, large numbers of drawings have survived—not because they were collected (for they were not, except in the form of gifts or mementos discussed above), but rather owing more to chance: for example, whether the artist's

studio burned or whether his descendants were wise or lucky enough to preserve his unsalable, private studies. Thus one of the great pleasures in American art is to go through one of the huge hoards of a single artist's drawings—the Coles at Detroit, the Churches at the Cooper-Hewitt, the Durands at the New-York Historical Society.

Very few of Homer D. Martin's drawings survive, but those that do suggest that he had learned well from both Durand and Church. In his *Study for "Autumn on the Susquehanna"* of 1868 (Fig. 100), the scribbled, soft-pencil technique recalls Durand's, while the breadth of vision—the feeling that the artist can bring nature under control—is Church's. In its relative looseness and vagueness, Martin's drawing also signals the gradual breakup of the Hudson River School aesthetic: though painters continued to make highly detailed, realistic studies for the rest of the century, the mainstream of the school after 1870 moved in quite a different direction, toward personal, emotional landscapes rather than observed ones. The highly realistic landscape style of mid-century reflected an optimistic, Adamic faith in America and in nature herself; a new landscape style came about as a result of the Civil War and its corruptions of spirit, the realization that the purity of the land had been lost forever, and the increasing influence of foreign style, especially the Barbizon School. With the decline of the Ruskinian mode came a decreasing need for pencil studies of nature's details or for close sketchbook observation. Indeed, the pencil itself—with all its ability to describe the subtlety of form—was displaced by charcoal, bringing its own possibilities of impressionistic speed, emotional impact, and tonal nuance.

Some of the most powerful of American landscape drawings were executed by Martin Johnson Heade (1819–1904), who, though a close associate of Church's, is best known for his highly subjective paintings of thunderstorms, marshes, and tropical orchids. Heade's sketchbooks are typical of the Hudson River School, made up of largely undistinguished linear studies of topography and foliage. Yet he also produced a very different group of about a dozen large landscape drawings, in which he used charcoal with technical facility. *Twilight, Plum Island River* (Fig. 101) represents the culmination of this series of nearly identical works, which vary only in their increasing mastery. Using negative and positive strokes, rubbing the sheet, making a variety of strokes, including some with white and brown chalks, on a warm gray paper, Heade portrays an awesome, magnificent twilight.

Little evidence exists as to where Heade learned the use of charcoal, though one can speculate that his mentor here was William Morris Hunt (1824–1879), whom he could well have known in Newport or Boston. Hunt had returned to America in 1855 after Parisian training with Thomas Couture and J. F. Millet; he brought with him an intense admiration for the Barbizon School, considerable collections of their work

Fig. 100. HOMER D. MARTIN, *Study for "Autumn on the Susquehanna,"* 1868.
Pencil with white wash on brown paper, 12¼ x 20½".

Fig. 101. MARTIN JOHNSON HEADE, *Twilight, Plum Island River,* c. 1865–1870.
Charcoal and colored chalks, 10⅞ x 21⅞".

Fig. 102. WILLIAM MORRIS HUNT, *Niagara Falls*, c. 1878.
Charcoal and pastel, $9^{13}/_{16}$ x $15^1/_4''$.

Fig. 103. WILLIAM MORRIS HUNT, *Landscape by a River with Lights*, c. 1872–1873.
Charcoal, 7 x $10^3/_4''$.

(especially of Millet's drawings), and a belief that charcoal was the only effective drawing material. Hunt became a teacher, with a wide circle of friends (including John La Farge and William and Henry James), and as S. G. W. Benjamin put it, "he became a power."[16] Hunt played a crucial role in introducing the painterly, moody French landscapes to America, and thus in changing American style itself. He became the theorist of the new mode, as Durand had for the previous generation; his widely read *Talks on Art* put down Ruskin, decried the "accumulation of facts," and advised the artist to "do things from memory, because in that way you remember only the *picture*."[17] A great many of Hunt's drawings exist today, despite the burning of his studio and much of his early work in 1872; they vary considerably, from large pastel studies for his murals to finished landscape drawings in colored chalks such as *Niagara Falls* (Fig. 102), to the dashed-off study of evening light on a river in pure charcoal (Fig. 103).

Hunt's contemporary George Inness (1825–1894) was the most widely respected of the late nineteenth-century landscapists. Paint was his natural medium, and he luxuriated in it. Inness made almost no sketches as such, but he did do occasional drawings and watercolors which are finished works of art in themselves (see Fig. 104). Like Hunt, he found in charcoal a means to explore nature's profundity and mystery: each one of his few drawings stands on its own as both experiment and realization, and one regrets that he used the graphic mediums so seldom.

Finally, the highly idiosyncratic drawings of Ralph A. Blakelock (1847–1919) should be mentioned. The large collection at the University of Nebraska Art Galleries suggests his versatility, as on occasion he used watercolor, pastel, pencil, and pen for a variety of subjects, including figures and genre scenes. However, it is the pen-and-ink landscape drawings which are most extraordinary: as in the one simply inscribed *California* (Fig. 105), his line is nervous, slashing, jagged. Such drawings resulted from his trip to the West, to Panama, and elsewhere: they are preparatory studies for possible paintings, but linear sketches further from the Hudson River School mentality can hardly be imagined. In Blakelock, the plight of the late nineteenth-century landscapist is summed up: wanting to convey scenery objectively, his pen seems naturally to lead in an opposite direction—resulting in drawings that record the artist's own tormented psyche rather than the terrain he viewed.

Fig. 104. GEORGE INNESS, *The Fisherman*, 1868.
Charcoal, 10¾ x 15¾″.

Fig. 105. RALPH A. BLAKELOCK, *California*, 1869.
Pen and ink, 6⅜ x 8¹³⁄₁₆″.

7

The Victorian Watercolor,
1820–1880

The developing American watercolor tradition in the nineteenth century often paralleled the growth of the Hudson River School, yet the two modes seldom coincided. The major landscape draftsmen, for example—Cole, Durand, Church, Hunt—almost *never* worked in watercolor, and the watercolorists made relatively few pencil sketches or even oil paintings, preferring to concentrate on the aqueous medium which many of them had learned in England. Yet the two groups overlapped in many ways: both were centered in New York; both painted Hudson River, Catskill, and other approved American scenery; and often they exhibited together, the finished watercolors of William Guy Wall or George Harvey hanging at the National Academy alongside the oils of Cole and Durand. At the beginning at least, watercolorists often pointed the way toward later developments in Hudson River School style; later on, particularly after 1840, watercolor landscapes lagged behind, becoming *retardataire.*

Before considering the academic watercolorists, it may be useful to examine the works of early artist-explorers of the American West, for they offer many clues to the watercolor tradition as a whole. In a sense, these men continued the topographical tradition begun at the turn of the century by Archibald Robertson, Barralet, the Birches, and others. Carrying on a tight, realistic style, using bright, local colors within pen outlines to record Indian life in the West, were such men as Titian Ramsay Peale and Samuel Seymour (act. 1796–1823), who traveled to the Missouri River with Major Stephen Long's expedition in 1819–20. The watercolor sketches of both charm one through their direct observation of the exotic, though they are technically unsophisticated.

During the same period, another figure—of greater talent—was also recording what he saw in the West: this was the Swiss-born Peter Rindisbacher (1806–1834), whose family had settled in western Canada in 1821. Having received rudimentary training in Switzerland, the young artist evidently sketched from the beginning of his travels. His pictures of Indian life are most appealing, and indeed are forerunners of successive treatments of that subject through the nineteenth century. *Indians Inside a Tipi* (Public Archives of Canada) is a highly competent, neoclassic composition, carefully drawn and toned. Somewhat bolder is his *Captain W. Andrew Bulger Saying Farewell, Fort Mackay, Prairie du Chien* (Fig. 106), executed about 1823. This commissioned watercolor commemorates an event of 1815 in the career of Captain Andrew Bulger, who as governor of Red River became a patron of the artist in the years 1821–26 when he was there. It is classically composed, brightly colored, with a two-dimensional design which brings it close to folk watercolors; it gives good evidence for the renown the artist had achieved before his sudden death at twenty-eight.

George Catlin (1796–1872) followed shortly afterward. Catlin traveled to the Missouri and Platte rivers, during the late twenties and thirties, painting and drawing the Pawnee, Sioux, Blackfoot, and Mandan tribes. He particularly admired the latter tribe, and he pictured its strange life and its games and customs with reportorial skill. Never a master watercolorist, Catlin did do quick and able colored sketches of the Mandans (including the well-known *Torture Scene in the Medicine Lodge*) which were published later as a book, O-KEE-PA, *A Religious Ceremony and Other Customs of the Mandans.*[1] Indeed, many of Catlin's drawings and watercolors were made for reproduction, and his own publications and his traveling Indian exhibitions brought him a wide reputation in Europe and America. Though oil portraits are now the best-known of his work, his pencil drawings, such as *Blackfoot Medicine Man Treating His Patient near Fort Union*[2] of 1832 (Fig. 107), later used as an illustration in his book, *North American Indians*, reveal a strong graphic sensibility in the use of a quick, nervous, and varied line.

Far abler as a watercolorist was another Swiss artist, Karl Bodmer (1809–1893), who traveled to the West in 1832–34, and then never again returned to America. Like Catlin's, his drawings of the Indians were designed for publication and wide dispersal, and eighty-two of them were superbly engraved in Prince Maximilian's great book which followed their expedition.[3] Bodmer used the transparent watercolor medium with confidence: his portraits, such as *Makuie-poka* ("Wolf's Son"), (Collection Northern Natural Gas Company, Joslyn Art Museum, Omaha, Neb.) are vigorously executed and brightly colored, and they portray the Indian as a dignified individual (Fig. 108). Bodmer's land-

scape sketches in watercolor are equally appealing; in terms of freshness of execution, they stand up to the best of the academic mainstream.

Finally, mention should be made in this context of Alfred Jacob Miller (1810–1874), a Baltimore painter who had studied at the École des Beaux Arts in Paris and later in Rome. Despite this training, Miller—like most of the western artists—was hardly a major talent; like the others, he depended on the romance of his subjects and his own physical energies to overcome limited pictorial gifts. Nonetheless, Miller brought to his pictures of the West rich colors, rapid execution, and a feeling of excitement often lacking in the work of the earlier men. Picturing thousands of Indians in action in *Trappers' Rendezvous* or suggesting the sensuousness of western life in *The Trapper's Bride* (the white trapper shown marrying an Indian girl he had purchased from her father), Miller succeeded in conveying the spirit of plains life. In 1837 he accompanied a Scottish adventurer, Captain William Drummond Stewart, to the north fork of the Platte River and then to the Rocky Mountains. Miller drew constantly, making several hundred rapid sketches in pencil or pen and sepia washes. On returning east, from these uncolored sketches he made a group of finished oils which caused great excitement when exhibited in New York in 1839.[4] Moreover, Miller made sets of duplicate watercolors for a variety of patrons, including a group of two hundred (at twelve dollars apiece) for the Baltimore collector William T. Walters. *Pierre* (Fig. 109) is one of this set, and demonstrates a reasonably sophisticated use of watercolor; some of the strokes are transparent, most are somewhat opaque, there are thin pen-and-ink outlines beneath, and touches of white gouache add finishing elements for the trapper's costume and in the grasses. This work was based on a small sepia sketch (Gilcrease Institute of American History and Art) done on the spot in 1837, where Miller made a small, rough sketch of Pierre, a Canadian half-breed who appears in many drawings, usually with his mule.

Many other American artists traveled west, most often with military or exploratory expeditions, such as those of the U.S. Corps of Topographical Engineers after its formation in 1838. Most simply recorded what they saw in straightforward fashion, while a few produced drawings and watercolors of real beauty. One of these was Charles Deas (1818–1867), who journeyed to the Platte and beyond during the 1840s, producing on occasion such subtle watercolors as *The Trapper and His Family*, in the Karolik Collection. Seth Eastman (1808–1875) was traveling in the Southwest in the same years, and he too left behind a creditable group of renditions of Indian life and western scenery, loosely executed in transparent watercolors. Eastman was also a fine pencil draftsman; his sketchbook dating from 1850–53, in the Karolik Collection, puts him in the mainstream of the contemporary Hud-

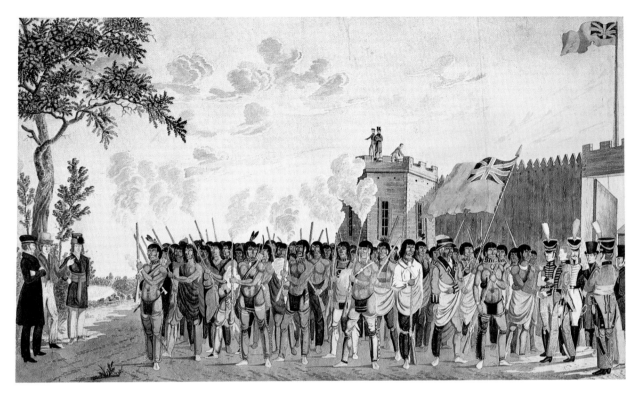

Fig. 106. PETER RINDISBACHER, *Captain W. Andrew Bulger Saying Farewell, Fort Mackay, Prairie du Chien,* c. 1823. Pen and watercolor, 14 x 23⅞″.

Fig. 107. GEORGE CATLIN, *Blackfoot Medicine Man Treating His Patient near Fort Union,* 1832. Pencil, 13⅜ x 19″.

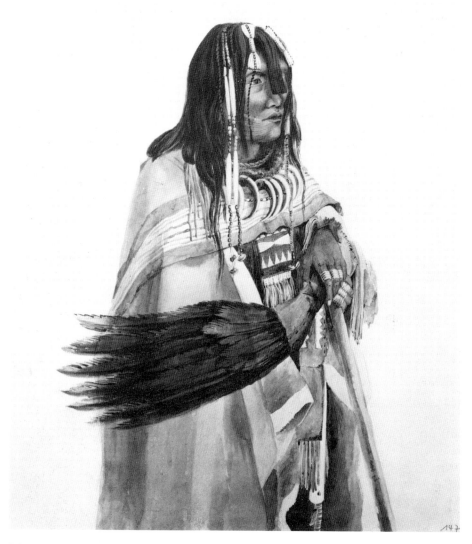

Fig. 108. KARL BODMER, *Makuie-Poka ("Wolf's Son")*, 1833.
 Watercolor, 12¼ x 9⅞".

son River School drawing style. And working in a somewhat similar
style, perhaps less skillfully, were James Madison Alden (1810–1877)
and John Mix Stanley (1814–1872).

The western artists reflected the attitudes of the more sophisticated
eastern school in several ways, notably in the common belief that water-
color meant just that; "painters' colours mixed with water and some
adhesive material, as gum or size instead of oil. Those intended for
drawings on paper are prepared with great care, and are usually formed
into dry cakes with gum."[5] The great distinction between transparent
watercolor and "gouache" or opaque watercolor which became an issue

late in the nineteenth century simply did not exist in the earlier period; transparent and opaque watercolors hung side by side, the difference being one simply of an artist's preference or needs. Thus A. J. Miller, for example, used a purely transparent medium in his traveling, outdoor sketches but resorted to a wider range of technique—including the use of opaque colors and whites—in the finished works being done in his studio. All this is quite consistent with Ruskin's basic statement of 1857, *Elements of Drawing*, which makes it clear that watercolor is in fact the most advanced drawing technique, certainly to be avoided by the dilettante: "You *ought* to love colour," he wrote, "and to think nothing quite beautiful or perfect without it . . . to colour well, requires your life. . . . Every hue . . . is altered by every touch that you add in other places."[6] Moreover, he specifically advises the artist to "use Chinese white, well-ground, to mix with your colours in order to pale them, instead of a quantity of water. . . . This mixing of white with the pigments, so as to render them opaque, constitutes body-colour drawing as opposed to transparent colour drawing."[7]

Similarly, many of the best of the early academic school, including such practitioners as Joshua Shaw (c. 1777–1860) and William Guy Wall (1792–after 1864), arrived from Great Britain as fully trained watercolorists. Shaw had begun exhibiting at the Royal Academy and elsewhere in London as early as 1802. He came to Philadelphia in 1817

Fig. 109. Alfred Jacob Miller, *Pierre*, 1837.
Watercolor, 9⁵⁄₁₆ x 12³⁄₁₆".

Fig. 110. WILLIAM GUY WALL, *View Near Fishkill, (New York)*, c. 1820.
Watercolor, 14 x 21⅛″.

and soon began to travel, making a series of watercolors of American views which were engraved by another London-trained craftsman, John Hill (1770–1850), and were then published as *Picturesque Views of American Scenery* in 1820. Shaw's younger contemporary, Wall, was working on a similar project at the same time: arriving in America in 1818, he had settled in New York before embarking on a series of watercolor views of the Hudson River area. His watercolors, also engraved in aquatint by Hill, appeared as the *Hudson River Portfolio* in the years 1820 to 1825. As with Shaw, his style is generically descended from that of the English master Paul Sandby (1725–1809). Wall's colors—blues, greens, and browns predominating—were rather loosely laid down over light pencil outlines, and only seldom is any body color employed. As one sees in *View near Fishkill* (Fig. 110)—Plate 17 in the *Portfolio*—the artist uses a broad brush for mountains and sky, a smaller one for the conventionalized tree on the left, and much smaller ones for figures and nets in the middle ground.

Wall's *Portfolio* was highly popular: it went through several editions between 1820 and 1828, and its prints were often copied. Moreover, this work gave Wall a respected position at the center of the art world.

His watercolors were exhibited at the American Academy in the year of his arrival, and he went on to become one of the fifteen founding members of the National Academy of Design, a member of the Sketch Club, and a friend of the leading artists of New York. Less is known of him after 1828, when he moved from that city, eventually returning to Dublin; later, in the late 1850s, he was back in the United States, painting in oils in a now old-fashioned manner. Dunlap in 1834 took note of the "great attraction" of Wall's watercolors at the early exhibitions of the National Academy and of the admiration which Thomas Jefferson showed for his work; he also recorded for posterity that this artist's practice "of late" was "to colour all his drawings from nature on the spot."[8] However, the highly finished quality of the known early works suggests that they were at least finished in the studio, even if begun as plein-air sketches.

Watercolors and drawings in small numbers were regularly exhibited in New York, Boston, and Philadelphia. One finds Thomas Doughty showing two landscape watercolors in 1823, John Rubens Smith a series of city views in 1829, along with other artists whose names mean little now. One of the most active watercolorists was William T. Bennett (1787–1844), again someone who was born and trained in England. His sketching trips carried him widely across the United States, and his realistic city views, with emphasis on people and their activities,[9] executed in transparent watercolors over pen outlines, remind one of the work of the Birches and of Krimmel.

A basic shift in American watercolor style occurred between 1830 and 1835; it is seen in the work of Shaw and the others mentioned, and made especially clear in the development of George Harvey (c. 1800–1878), who came to America in 1820. After spending several years "hunting and trapping, scribbling poetry and prose, drawing and sketching," he settled in Brooklyn, having been elected an associate member of the National Academy in 1828.[10] His watercolors of this early period look like Wall's in their loose green and brown washes. However, after practicing as a miniaturist in Boston, he moved back to England, and then about 1833 returned and settled in Hastings-on-Hudson. The watercolor style that he brought back is quite different: *Afternoon—Hastings Landing, Palisade Rocks in Shadow, New York* (Fig. 113), is uniformly stippled with a small brush; different areas vary greatly in density, with the pigments used in much drier form; and there is now an essential interest in atmosphere, light, and color.

Harvey began to make such watercolors about 1835, planning to publish a group of forty of these "Atmospherical Landscapes" (as he called them) in a book to be entitled "Harvey's American Scenery." He explained his new concerns, if not the style itself, by noting that he had purchased land on the Hudson, where he built a cottage and laid out

Fig. 111. WILLIAM HENRY BARTLETT, *Caaterskill Falls from Above the Ravine*, c. 1840.
Watercolor, 4¾ x 7⅞".

the grounds, and commenting: "These exercises in the open air, led me
more and more to notice and study the every-varying atmospheric
effects of this beautiful climate."[11] The watercolors—dating between
1835 and 1840—are remarkable in their freedom from the didactic,
grand manner found in Cole's landscape paintings of the same time.
Indeed, they look ahead to the late 1850s, when tight stippling and an
evocation of light and atmosphere became popular in American art.
The book project was never completed, but all forty watercolors were
exhibited at the Boston Athenaeum in 1844. Many artists responded
enthusiastically, Washington Allston, for example, writing Harvey that
he had been "not only successful in giving the character of our scenery,
but remarkably happy in clothing it with an American atmosphere,
which you have expressed with equal truth and variety."[12]

Perhaps in many ways the most important of all the draftsmen who
recorded American views was William Henry Bartlett (1809–1854),
another London-trained artist, who made four visits to the United
States but never settled here. In 1836 he was commissioned by George
Virtue, the British publisher, to do a series of drawings of the major
sights of the American continent, from Niagara and Lake George to
"Boston and Bunker Hill" and the White House. Over one hundred
were published as steel engravings between 1839 and 1842 in the two-
volume book *American Scenery*, which contained a text by the great
"Knickerbocker" writer Nathaniel Parker Willis (1806–1867). The
book was immensely influential in that it established a basic iconography

Fig. 112. WILLIAM HENRY BARTLETT, *Caaterskill Falls*, engraving from N. P. Willis, *American Scenery*, 1841.

Fig. 113. GEORGE HARVEY, *Afternoon—Hastings Landing, Palisade Rocks in Shadow, New York*, c. 1835–1840. Watercolor, 8⅜ x 13⅝₁₆″.

for the American Grand Tour: Bartlett's views became, almost by definition, *the* picturesque scenes in America, and thus were copied and imitated for years afterward. Moreover, a fruitful comparison may be made between one of his original sepia drawings, *Caaterskill Falls from Above the Ravine*, (Fig. 111) and the resulting print (Fig. 113). The watercolor itself is quickly and loosely drawn; the brush flickers confidently over the small sheet, with more attention given to execution and value than to topographical detail. However, the same scene, translated by the steel engraver for a mass audience, loses the feel of the washes entirely and instead relies upon additive details to suggest the grandeur of the scene.

The *real* effect of Bartlett's up-to-date style was thus never felt here, for there were no watercolor societies and still relatively few watercolorists. Rather, his work was known only through the print, which became accepted as a proper, accurate depiction of American landscape; and not surprisingly, one finds that the landscape drawings and paintings of the next generation are far more highly detailed and topographical than those of the 1830s and 1840s.

A contemporary of Harvey in New York was Nicolino Calyo (1799–1884), a landscape, portrait, and miniature painter, who was born at Malta and trained at the Naples Academy. His very dense, opaque style was established by the time he began a series of views of the great New York fire 1835, which included sketches made "on the spot." Typical is *View of the Great Fire in New York, December 16 and 17, 1835*, c. 1835–1836 (Fig. 114), with its spectacular blaze against the dark sky, or the luminous *View of Hoboken Taken from the Ferry* (Metropolitan Museum). Calyo's consistent, overall use of gouache applied with broad brushes gives his work a very different appearance from Harvey's stippled, transparent watercolors—Harvey's English style points to the future, while Calyo's looks backward. He was an able practitioner, and shared with Harvey and others his period's new interest in dramatic light effects and in the merging of genre scenes with landscape.

Watercolor came into increasing use during this period. Artists must have been encouraged by the reception given to trained watercolorists from abroad, such as Wall and Harvey, as well as by increasing availability of watercolor books and instruction and of the necessary materials themselves. As Albert Ten Eyck Gardner pointed out, commercially prepared pans or cakes of pigment were imported, and therefore expensive, until they began to be manufactured by G. W. Osborne in Philadelphia in the mid-1820s.[13] Of even greater importance for the development of landscape work in this medium was the fact that between 1846 and 1849 the British firm of Winsor & Newton began to produce watercolor paint in tubes (their price list for 1849 includes "moist water colours in patent collapsible tubes"[14]), which were easily transportable and thus eminently suitable for the traveler and for plein-air

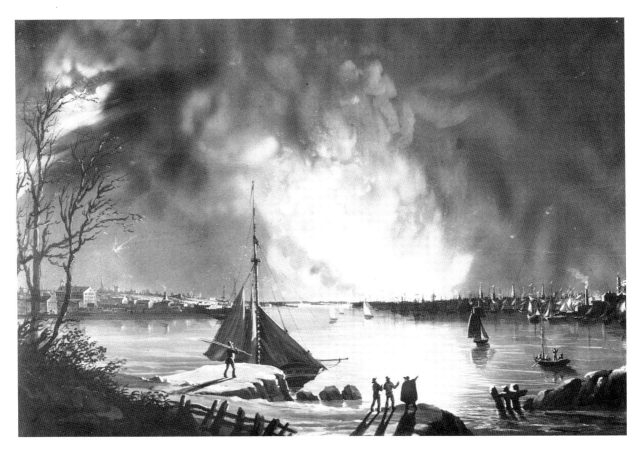

Fig. 114. NICOLINO CALYO, *View of the Great Fire in New York,
December 16 and 17, 1835*, c. 1835–1836. Gouache, 16⅛ x 24⅝".

sketches. Americans now had at their disposal every technical means
for the making of watercolors.

Besides the drawing books already mentioned, there were by this
time a variety of books devoted to watercolor alone, including some
published in this country and a greater number imported from abroad.
The increasing use of the medium is also indicated by the series of
articles (possibly by J. M. Falconer) "The Art of Landscape Painting
in Water Colors," which appeared in the *Bulletin of the American Art-
Union* for November and December 1851. These long pieces outlined both
the materials and techniques of the medium, and "the principles on
which a picture should be constructed, and be treated in its usual
stages." Discussed were sophisticated means of creating lights by
erasing, scraping, or rubbing, and the use of Chinese white in small
amounts; the universal need for an accurate pencil outline drawn first
on the paper; specific suggestions for proper pigments and colors to use
in each part of a landscape, beginning with the sky; and discussion of
treating "particular effects," such as morning haze and sunset. More-
over, Frederick Catherwood (1799–1854), the British painter, explorer
and panoramist, brought a collection of about five hundred English

watercolors to this country, and exhibited them in Boston around 1840, thus introducing American artists to Turner and the other masters.

By mid-century many artists were using watercolor upon occasion, both formally and informally, and at work in New York was a substantial group of watercolor specialists. In 1850 a number of these artists banded together to form the New York Water Color Society, the first such formal organization in America, based on the Society of Painters in Water-Colours which had begun in London in 1804. The fifteen pioneers, nearly all forgotten names by now, included the following: Henry Beckwith (act. 1842–1843), John M. Falconer (1820–1903), John Halpin (act. c. 1845–1870s), John William Hill (1812–1879), Samuel Valentine Hunt (1803–1893), Alfred Jones (1819–1900), Charles Parsons (1821–1910), Juan B. Wandesforde (act. in U.S. c. 1850–69), James Brown (ca. 1820–after 1859), Jasper F. Cropsey (1823–1900), James I. Glasgow (?–?), Owen G. Hanks (c. 1820 – c. 1865), De Witt Clinton Hay (b. c. 1819), Henry B. Gay (?–1862), and Alfred Fredericks (act. 1850–after 1881). These men were oriented toward England in every way: the first nine were born in the British Isles (seven in England), and several were trained there, while only four are known to have been born in the United States. For them as for their predecessors in America, watercolor was closely allied with printmaking: *every* one of the first eight were skilled at either engraving or lithography, several being banknote engravers, and this is also true of Hanks and Hay. Many of these men are known through their later work as illustrators or printmakers, though one (Cropsey) gained a major reputation as a Hudson River School painter, and Falconer, Hill, and Parsons had long and successful careers using the watercolor medium.

The New York Water Color Society organized the first important group show of watercolors in American history: in the New York Exhibitions of the Industry of All Nations ("The Crystal Palace") of 1853 were included thirty-one watercolors by the fifteen members. As before, landscape remained the predominant subject for the watercolorist; sixteen were included in this exhibition (some with titles recalling Harvey's interests, such as Falconer's pair, *Snake Hill, Half Past 7* and *Snake Hill, Half Past 8*), along with eight indoor and outdoor genre scenes, and two still lifes by Beckwith.

Though none of the thirty-one can be identified today, their style is indicated by watercolors such as Falconer's fine *Old Mill, West Milford*, 1851 (Fig. 115), or *Bearded Man in Tall Hat and Long Coat*, 1851 (Karolik Collection). The latter shows a seated figure, with washes of gray and brown over a pencil outline, while the *Old Mill* demonstrates a looser and more sophisticated use of the medium. Moreover, of particular interest is the "Falconer Album" (Karolik Collection), containing sixty mounted drawings and watercolors by his contemporaries

Fig. 115. JOHN M. FALCONER, *Old Mill, West Milford*, 1851.
Watercolor, 9¹⁵⁄₁₆ x 13¹⁵⁄₁₆″.

Fig. 116. CHARLES PARSONS, *Old Macedonian, Wallabout Bay*, 1851.
Watercolor, 10½ x 15¾″.

Fig. 117. Emanuel Leutze, *Cathedral Ruins*, 1841.
 Watercolor, 10½ x 14½".

which the artist collected; included are works by such men as Glasgow and Gay, which are otherwise difficult to find, as well as several by his close friend Jasper Cropsey.

Typical of the style of this period is Charles Parsons' watercolor of 1851, *Old Macedonian, Wallabout Bay* (Fig. 116). Using only transparent washes in a far wider range of hues than the previous generation, Parsons depicts a recognizable (and, in a sense, topographical) scene in New York harbor, while his real interest is in the decaying hulk of the famous old ship which dominates his composition and the Turneresque pink and yellow sky. In contrast to this finished exhibition piece, with its stolid Norwich-school look, one compares the brilliant plein-air sketch in pencil and watercolor (Fig. 117) by Emanuel Leutze (1816–1868). Though Leutze is best known as a figure painter, here he captures a quality of light and mystery, combined with precise detail, in a deliberately unfinished yet elegant sketch that recalls his German training. More typical of American work of the period is that of Jasper Cropsey, a founder of the society and a gifted pencil draftsman, but an uninspired

Fig. 118. George Loring Brown, *Mountain Scene With Crags*, 1849 (?).
Watercolor, 10½ x 8″.

if persistent watercolorist: his *Arched Rock* of 1848 (Karolik Collection)
is little more than a tinted drawing, and one finds virtually the same
style in his work of forty years later. Another popular figure was
George Loring Brown (1814–1889), who produced handsome though
somewhat mechanical watercolors both before and during his long stay
in Europe (about 1839–59), but whose style changed little as the years
went on (Fig. 118).

The exhibition of 1853 was the only one organized by the New York Water Color Society. Despite the fact that a great many artists used watercolor in the following years, the medium did not attract serious public attention in America until the years following the Civil War. The reasons for this are difficult to ascertain, though looking back one does gain a feeling that most watercolors were simply too recognizably English to attract a great following in a country looking for American subjects painted in an American way. To cite one example, neither of the major critics of the period, Henry T. Tuckerman and James Jackson Jarves, gives more than a passing reference to the medium; the former in his eight pages of praise for Cropsey's work, for example, never even mentions his drawings or watercolors.

Despite critical neglect, watercolors and drawings gained increasingly wide public acceptance during the 1850s and 1860s. Exhibitions included them on a par with painting and sculpture with increasing frequency. Moreover, the graphic arts were now seen not only in the formal exhibits of New York and Boston, but also at charitable and industrial fairs and other expositions throughout the country. An example is the *Catalogue of the Works of Art Exhibited at the Fair of the Hartford County Agricultural Society* of 1851, which includes landscape paintings by some of the leading men (F. E. Church, George Durrie, N. A. Moore, and so on); a "watercolor sketch" by Benjamin H. Coe (1799–after 1883); Church's teacher; *Sunset* (in crayons) by Miss Ellen H. Whitman; "A series of four original crayon drawings, called 'The Seasons,'" by Joseph Ropes (1812–1885); *The Lord's Prayer* ("The words of which are arranged in the form of a Goblet") by J. Busch; a pencil drawing by F. O. C. Darley (with the catalogue comment "This drawing exhibits great freedom and skill in the execution"); a "Frame of Pencil Drawings" by George E. Hoadley; and a wide variety of "sepia drawings," "pencil drawings from nature," and "flowers in water colors" by other artists.

Not only was watercolor being more widely practiced by men and women, amateurs and professionals, during the 1850s and 1860s, but there was also an increasing number of important watercolor shows. Particularly significant in bringing advanced English technique to the American audience was the American Exhibition of British Art, held in New York in 1857 and at Philadelphia and Boston the following year. Here were included 188 watercolors (besides a nearly equal number of oils); included were the leading practitioners of the craft of the present and recent past, artists who had been known in America by reputation and through engravings, but seldom by originals of high quality. Interestingly, the extensive selection of "Water Colours" included a wide variety of artists—Ford Madox Brown, of the Pre-Raphaelites; John Ruskin, their champion; John Brett, David Roberts, and other contemporaries; and as well some of the earlier nineteenth-

Fig. 119. WILLIAM RICKARBY MILLER, *New York Bay from Hudson City*, 1858. Watercolor, 11⅞ x 16¼".

century masters, including David Cox and J. M. W. Turner. Some major figures were missing, but nevertheless this exhibition (of which Rossetti was secretary) was of major importance.

Americans of the period were collecting watercolors with increasing taste and eclecticism, with the English school still naturally having most appeal for sophisticated connoisseurs. Numerous collections sold at auction during the 1860s demonstrate that watercolors were now thought worthy of collection and preservation as works of art in themselves. One of the leading sales was that of the collection of John Wolfe of New York at Leeds and Company in December 1863: Wolfe's contemporary taste encompassed oil paintings by English, French, German, Flemish, and American contemporaries as well as a group of twenty-three "Water Color Drawings" by members of the English school, including James D. Harding, Samuel Prout, and Sir John Gilbert, one-time president of London's "Old Watercolour Society."[15]

A particularly able artist of the period was William Rickarby Miller (1818–1893), who arrived in New York during the mid-forties, already a trained and practicing artist. He worked ably both in watercolor and oil, and his style and his subjects brought him close to the Hudson River School. He made sketching trips to the major sights of the East, often exhibited at the National Academy, and made many book and periodical illustrations as well. His watercolor of *Catskill Clove* (Metropolitan Museum of Art) is precise and sunlit, reminiscent of Richards'

Fig. 120. JOHN WILLIAM HILL, *Erie Canal*, 1831.
Watercolor, 9½ x 13½″.

pencil drawings of the same period, while *New York Bay from Hudson City*, 1858 (Fig. 119), shows a topographical view executed with equal control of tone, perspective, and detail.

The rapid influx of up-to-date English watercolors had direct effects both on American style and on patronage of the medium. The stylistic development of the still small American school may, in fact, be demonstrated simply by pointing out the work of the Hill family. John Hill has already been mentioned as an important engraver and aquatintist, whose work in the latter medium particularly helped pave the way for watercolor; his own watercolors were really pen-and-ink drawings with some colored washes, carefully and literally wrought.[16] His son was John William Hill (1812–1879), a founder of the New York Water Color Society and a popular and prolific master, whose early work in the medium resembles not his father's so much as that of William Guy Wall; for example, his *Erie Canal*, 1831 (Fig. 120), shows relatively little use of pen outline, together with a firm handling of detail in a rather loose, tonal manner. His view *New York* of 1852 (New-York Historical

Society) suggests increasing attention to detail, though without significant change of approach, while the watercolors after the mid-1850s show Hill's conversion to the aesthetics of Ruskin and the Pre-Raphaelites. *Apples and Plums* (Fig. 123) is one of many works which combine still life in a properly "natural" setting and which show the heavy white ground and tiny stippled strokes, emphasizing exactness of detail, that typify the style of the Pre-Raphaelite followers in America. It is extraordinarily close, both in subject and technique, to the work of the English watercolorist, William "Bird's Nest" Hunt (1790–1864). J. W. Hill also did pure still-life watercolors, such as *Dead Blue Jay* (Fig. 121), as well as pure landscapes which range from tiny, finished works to larger topographical ones.

J. W. Hill's style was closely followed by *his* son, John Henry Hill (1839–1922), who like his father became friendly with Ruskin and followed his tenets with care. While only nineteen he executed the small round watercolor *Dandelions* (Private Collection), reminiscent of his father's work though less detailed, and by 1860 he had reached full stride with the view of Washington Irving's home, *"Sunnyside," Tarrytown, New York* (Fig. 122). John Henry Hill corresponded with Ruskin over many years (Ruskin once writing him, "You have very great art gifts"), and he also traveled widely in Europe (following an itinerary suggested by Ruskin) and in the western United States. Particularly remarkable are the sketches and the resulting finished watercolor of 1868, *Shoshone Falls* (Washburn Gallery, New York).

John Henry Hill was one of many American artists who went to London at this time; he was, typically, influenced both by the Pre-Raphaelites and by the earlier work of the great watercolor master J. M. W. Turner. Indeed, American watercolor of the 1860s reflects each of these influences, with some artists looking to the Pre-Raphaelites'

Fig. 121. JOHN WILLIAM HILL, *Dead Blue Jay*, c. 1860–1865.
Watercolor, 5¾ x 12".

Fig. 122. JOHN HENRY HILL, *"Sunnyside", Tarrytown, New York,* c. 1860.
Watercolor, 10 x 13⁹/₁₆".

detail, others more to Turner's luminous, quick washes, and still others
(such as Cropsey) trying valiantly to combine the two.

Besides the Hills, the leading American watercolorists working
close to a Pre-Raphaelite manner were Charles Herbert Moore and
William Trost Richards. Moore's pencil drawings, his teaching, and his
friendship with Ruskin have already been noted (see p. 124) and cer-
tainly his miniaturistic *Portrait of Ruskin* (Fogg Art Museum) would
have pleased the master. Even more compelling, however, are his land-
scape watercolors (see Fig. 124), which are as molten, as sharply lit, as
disturbingly precise as anything in our art. Moore goes beyond the Hills
here: his foreground rocks, like those in Heade's painting *Lake
George*, 1863 (Boston) seem the product of quite another world.

Richards was a Philadelphian who had a long and successful career
as a painter, specializing particularly in views of waves at the shore.
As the *Art Journal* reported in 1877, "Richards is one of the first
American painters who adopted the pre-Raphaelite style . . . This was
in 1858, and since that time no artist in this country has achieved
greater success."[17] His highly realistic oils and pencil drawings were

Fig. 123. JOHN WILLIAM HILL, *Apples and Plums*, 1874.
Watercolor, 7⅞ x 11⅜".

done, as one would expect, during the early 1860s, but it appears that he
took longer to master the watercolor medium, for his great work here
comes during the 1870s. Richards' many watercolors never achieve the
hallucinatory quality of Moore's; he concentrates instead on a softer,
more atmospheric, and perhaps "truer" vision of nature. In *Thunder-
heads at Sea: The Pearl* of 1871 (Brooklyn Museum), he studies sea and
sky alone in a purely luminist format. *Moonlight on Mt. Lafayette, New
Hampshire* of 1873 (Fig. 125) is even subtler: examining the effects
of a full moon on the White Mountain landscape, the artist mutes all
of his tones, yet combines high detail with poetic mood.

One of Richards' leading students was Fidelia Bridges (1835–
1923), who by 1861 was capable of producing the very Ruskinian *Milk-
weeds* (Fig. 126), a living still life outlined against the sky very much
in the manner of Richards' own oil paintings of that year. It is
surprising in retrospect that the same mode was possible thirteen years
later, when the elder Hill executed *Apples and Plums* so masterfully.

Thomas (c. 1840–1891) and Henry Farrer (1843–1903), two Eng-
lish-born brothers, were also active in New York among the Pre-

Fig. 124. CHARLES H. MOORE, *Landscape*, c. 1860–1870.
Watercolor, 7½ x 10¾″.

Fig. 125. WILLIAM T. RICHARDS, *Moonlight on Mount Lafayette, New Hampshire*, 1873.
Watercolor, 8⅜ x 14⅛″.

Fig. 126. FIDELIA BRIDGES, *Milkweeds*, 1861.
Watercolor, 16 x 9½".

Raphaelites, working as draftsmen, etchers, and watercolorists. Henry in particular was a master of the watercolor medium, and his work won popularity; yet like so many of his contemporaries, relatively few of his products are known today. *Sunrise, New York Bay* (Fig. 127) dates from 1875, and represents him at his best: it is a finely worked tonal study of a warm summer sunrise. Its limited range of yellow hues and its sky relate it to luminist painting, particularly to the contemporary work of Sanford R. Gifford. And like Moore and Richards, Henry Farrer relied largely on transparent watercolors, although he covered his whole sheet with thin washes and made little use of the white paper for highlights. Moreover, his washes became soft and almost opaque at times, for he brushed one wet tone over another. Interestingly, Martin Johnson Heade uses the same technique in his major watercolor, *Dawn* (Collection of H. John Heinz III). Thomas Farrer worked in a drier, less luminous watercolor style, also making finely detailed period drawings of trees and the like.

During the decades of the 1860s and 1870s watercolor gained increasing respectability and visibility. The Wolfe sale of 1863 has been mentioned; in 1864 there were many French and German watercolors at the New York Metropolitan Fair; two years later a number of them were shown by the French Etching Club; and in the same year the Artists' Fund Society "made a special feature of water-colors" (mainly European)[18] at its exhibition. According to Clement and Hutton, this latter event led to the formation of the American Society of Painters in Water Colors in 1866 (which in 1877 became the American Water Color Society). Its founders were Samuel Colman (1832–1920), a prolific artist and traveler who pictured the West, Venice, and other scenes in a rather tight, opaque style, also Gilbert Burling (1843–1875) secretary, and Albert L. Rawson (1829–1902), treasurer.[19] The society's first show was held during the winter of 1867–68 along with the regular exhibition at the National Academy of Design in New York; it included 278 works by some seventy artists, one-half of whom were members. Almost all the subjects were landscapes, with a smattering of still-life and figure subjects. John Henry Hill had ten entries, and the Farrers were well represented; W. T. Richards and C. H. Moore (both out-of-towners) were not there, but included were a few English and Continental works (a practice carried on in later years) including *Coast Scene* by J. M. W. Turner, lent by John W. Hill, interestingly enough.

Though the society became the center of watercolor activity, perhaps eight thousand works being shown there in the first twenty years of its life, vast numbers of watercolorists were busy elsewhere in the country, and the best of their work was being shown at the Brooklyn Art Association, the Pennsylvania Academy, the Boston Society of Water Color Painters, and elsewhere. Painters of the Hudson River School who were also watercolorists generally worked less inventively

Fig. 127. HENRY FARRER, *Sunrise, New York Bay*, 1875.
Watercolor, 12 x 18½".

in this medium than did the specialists. There is, in fact, a general
"type" of Hudson River watercolor, practiced by George and James
Smillie, the Harts, Albert Fitch Bellows, F. A. Silva, Alexander Wyant,
and others, that is close to their style in oils. Typically they did wood-
land or shore scenes that were highly detailed, but with tiny brush
strokes rather messily handled and with little sense of light or color,
though all were capable of fine work at times. This style (practiced at
its best perhaps by the minor painter William L. Sonntag [1822–1900])[20]
derives from the much-admired English watercolorist Birket Foster
(1825–1899). As early as 1860 *The Crayon* had reported: "The next
great wonder was Birket Foster's drawings . . . they were actually
stippled all over, even the skies, and had the same effect as ivory mini-
atures."[21]

The Americans of this period were quite defensive about water-
color, which they regarded as useful both for sketching and for making
finished pictures; in response to what must have been a fear on the
part of the public and collectors, there were written a number of articles
and books, including A. F. Bellows' *Water Color Painting: Some
Facts and Authorities in Relation to Its Durability*. Bellows here de-
fended the permanence of watercolor with zeal and pointed out its
virtues as well, noting that "for certain luminous qualities, for purity

Fig. 128. Louis C. Tiffany, *Oriental Scene*, c. 1870–1880.
Watercolor and gouache, 24⅝ x 36⅝″.

of tint and tone, for delicate gradations, especially in skies and distances, [watercolor] has decided advantages over oil.''[22]

The success of the annual exhibitions of the Water Color Society demonstrates the rising popularity of the medium: the artists had insisted that they were making finished works of art (often in fact framing them like oils with gold mats and heavy frames), and now the collector was beginning to believe them. Farrer's *Sunrise*, for example, was shown at the 9th Annual Exhibit, in 1876, and brought a price of $125, about average in that exhibition, but comparable only to the amounts being received for small oils by second-level painters. Winslow Homer's prices were the same then as Farrer's; lesser-known artists were charging $30 or $40, while the really major figures of the time, such as Louis Comfort Tiffany or Samuel Colman could ask $1000 or even $1500 for a watercolor (see Fig. 128).

During this period the memory of J. M. W. Turner was everywhere. Nearly every review or article dealing with American watercolor up to 1880 uses the English school, and Turner especially, as a touchstone. J. H. Hill began his career by copying Turner on Ruskin's advice, and an even more important American who acknowledged his debt to Turner

Fig. 129. THOMAS MORAN, *Barnard Castle*, 1862.
Watercolor and gouache, 12⅝ x 18⅝″.

was Thomas Moran (1837–1926). Moran had begun using the medium in the 1850s when working with his brother Edward, and by 1857 he was able to produce an adequate colored drawing, such as *Bridge at Schuylkill Falls* (Karolik Collection). However, his mature style takes shape only in 1861–62, when he went to London specifically to see the great Turners there. Moran did a number of watercolors, such as *Barnard Castle* (Fig. 129), in which he closely follows the general composition of Turner's own watercolor, *Barnard Castle in County Durham* (British Museum), though Moran has made enough significant changes in foreground detail so that his work is not literally a copy of Turner's. Using a wide range of hues and values, Moran employs heavily laid-on transparent colors, one over the other, in the sky and water (in a manner not unlike Farrer's); then in the foreground foliage, the castle, bridge, and highlights on the hill to the right, he mixes his colors with Chinese white, giving his composition a rich and colorful surface. Using this much gouache in what remains essentially a transparent watercolor requires great care and subtlety: Moran's result here is far advanced from the heavy, painting-like gouache used in such earlier works as Calyo's *View of the Great Fire* (Fig. 114).

Fig. 130. Thomas Moran, *Hot Springs of Gardner's River, Yellowstone*, 1872.
Watercolor on tinted tan paper, 20¼ x 28⅝".

From this experience, Moran went on to use watercolor voraciously, and indeed he carried the Victorian landscape watercolor to its highest point. Yet anomalously his reputation in his own time was based as much on the subjects he chose as on his skill: he had either the good or bad fortune to become one of the best-known illustrators of the American West. After a second trip abroad in 1867 he made the first of many western expeditions with F. V. Hayden's government expedition to the Yellowstone, and followed this in the seventies with almost yearly trips to the Colorado River, Yosemite, the Tetons, and the Pacific Coast. Unlike earlier explorer-artists, his imagination was captured by the grandeur of western scenery, not by the picturesque qualities of the Indians; he also differs from his predecessors in bringing a great technique to his art.

Moran did two kinds of watercolor drawing. One was the sketch, compositional or topographical, with colors worked in rapidly over pen or pencil outlines. Like the Hudson River School sketches to which they relate, these would often bear a full date, a description, and perhaps color notes as well.[23] An even quicker sketch, done as an idea for a

Fig. 131. THOMAS MORAN, *Hiawatha Sees Mudjekeewis*
c. 1870–1875. Pen, ink, and washes, 5½ x 4⁵⁄₁₆″.

painting rather than from observation, is his *Hiawatha Sees Mudjekee-wis* (Fig. 131), a small sheet which shows Moran at his most energetic.

Quite different in purpose and execution are the finished water-colors which Moran made; together with his large topographical oils, these won him great popularity in his own day. Some evidently result from an original session outdoors, when the main outlines and perhaps the basic colors would be put in, and then highlights, touches of gouache, and details would be added in the studio. One of the freshest of these is *South Dome, Yosemite* of 1873, (Cooper-Hewitt Museum) in which light and dark washes are boldly applied and much of the pencil work is still visible. Yet going even beyond this, in both technique and vision,

are the Yellowstone watercolors which Moran made during the early 1870s, fifteen of which were reproduced as chromolithographs by Prang and Company in 1876.[24] Most impressive is the large watercolor *Hot Springs of Gardner's River, Yellowstone National Park, Wyoming Territory*, 1872 (Fig. 130); here Moran combines the Turneresque with the Pre-Raphaelite, and adds as well his own originality of technique. The vision is a perfect one: using a rather dry touch and a limited range of hue, concentrating on whites, reds, and blues, Moran creates an otherworldly scene with no sign of the artist's intrusion. Moonlike rocks and hot pools of water are brushed in with infinite care, the tinted tan paper now being used to great advantage, with astonishing, fluid lines of red ink leading one into the composition and off into the distance.

Moran clearly did far more than observe nature: like Church in his South American oils, he re-created it. Moreover, his success in doing so (and the parallel accomplishments of Farrer, Moore, Richards, and others) is hard to explain; it is nonetheless a fact that at a time when American eyes and American taste generally were turning to Paris and Munich with their bravura technique and sentimental subject matter, these American watercolorists carried on Hudson River School realism and the ideals of luminism for perhaps another two decades.[25]

As the Centennial drew near, the human figure began to play an increasing role in American art in general; figure painting was on the rise, in the hands of Duveneck, Chase, and their colleagues in the new Society of American Artists (founded in 1877). Despite the efforts of Moran and others, the celebration of American landscape was felt less and less often in our art, and the introspective period of the "Brown

Fig. 132. ALFRED T. BRICHER, *A Pensive Moment*, c. 1875. Watercolor, 13 x 29".

Fig. 133. Thomas Eakins, *Baseball Players Practicing*, 1875.
Watercolor and pencil, 10¹³⁄₁₆ x 12⅞″.

Decades'' slowly began. The new spirit is well recorded both in the
subject and title of *A Pensive Moment* (Fig. 132) by Alfred T. Bricher
(1837–1908). Bricher was a journeyman landscape and marine painter,
yet also an active member of the Water Color Society who could rise
to real heights in this medium. *A Pensive Moment* is worthy of Winslow
Homer: drawn well, executed largely in wet washes with considerable
use of pink and white body color (or ''gouache'') in the woman's dress,
it echoes the internal loneliness of the era.

By the annual exhibition of 1874–75 the officers of the American
Society of Painters in Water Colors were James D. Smillie, J. C. Nicoll,
and F. Hopkinson Smith, while the ''Board of Control'' included J. G.
Brown, Walter Brown, A. H. Baldwin, and A. T. Bricher. There was still
some foreign representation (Fortuny, Meissonier, Vibert); Winslow
Homer (1836–1910) was now actively exhibiting (though at low prices,

from $30 to $75); Richards, Farrer, Bridges, and Moran were there in force; and there was a large group of works in "black and white," both etchings and drawings, suggesting that pure drawings were also slowly finding collectors and a market. The most highly praised work in this exhibit—at least according to Clarence Cook in his respected column for the *Atlantic Monthly*—was that of Mrs. Maria Spartali Stillman (1844–1927), wife of the late co-editor of *The Crayon* and a great favorite of the English Pre-Raphaelites. Her work was praised for its color, drawing, and expression; it "easily surpassed all else in the exhibition."[26]

This exhibition also marked the second appearance at the Society of Thomas Eakins (1844–1916), whose importance and skill as a pure draftsman are discussed in the following chapter. Taking up watercolor, Eakins probably sought both the challenge of a new medium and the chance for some sales, of which he had had very few in Philadelphia. From the beginning he took the medium seriously, on occasion doing both pencil and oil studies for a planned watercolor, and for this brief period in the seventies—when his great interest was in light and form, rather than expression of human pathos—he became a master of the idiom. On this occasion in New York he exhibited three watercolors, *No Wind—Race Boats Drifting* ($100), *Baseball Players Practicing* (Fig. 133), and *Negroes Whistling Plover*—the last two priced relatively high, at $300. All were praised by the critics of the *Art Journal*, *The New York Times*, and *The Nation*, Eakins' admirer Earl Shinn writing in the latter: "The forms of the youthful ball-players, indeed, exceed most Greek work we know of in their particular aim of expressing alert strength in a moment of tension."[27]

If Eakins' forms are classical at this time—as indeed they are—and his style realistic, then it must be added that the mood of the watercolor is more one of reverie than of exultation. Less obviously but no less effectively than Bricher, he reflects the mood of his time, as the ball-players stand poised in late afternoon sunlight, the artist trying to make sense of an increasingly complex world through the ritual of sport. And his technique, though subtler in tonal variation and more varied in brush stroke, is also perfectly contemporary: he uses the whites of his paper to some extent (on the edges and in the upper right), working transparent washes over it, and uses touches of gouache in the two figures.

Eakins' contemporary Winslow Homer had been a more frequent, though at this time less highly praised, exhibitor at the Society, and if indeed it was Homer who eventually carried the medium to the greatest heights, it must be added that he began slowly. As discussed in Chapter 8, Homer's skill as a pure draftsman had been apparent since his earliest work, for his line was always extremely inventive, and very early he learned to use touches of white wash effectively on tinted paper —perhaps taking something from Church's method. Homer had shown

one work, *The Dinner Horn*, at the society's 5th Annual Exhibit, 1871–1872; and he was among the first watercolorists to concentrate on the figure—which given his training and background as an illustrator was quite natural. More significantly, his style here in the early 1870s, as he began to use the medium seriously, was more transparent, making far less use of gouache or body color than was the norm for figurative watercolorists. Very little gouache is used in the brightly colored *Clambake*, 1873 (Cleveland Museum of Art), and only slightly more in *A Basket of Clams* (Collection of Arthur Altschul) of the same year. In the latter, Homer's interest parallels Eakins' in depicting the figure, outdoors, with light and color playing key roles. Homer's work at this point is less sophisticated than Eakins': his figures are neither so well modeled nor so compelling, his sense of light is more obvious and less thoughtful, his brushwork flatter and less articulated. But Eakins had reached his peak as a watercolorist, and Homer was just beginning.

The first time Homer's watercolors were reviewed occurred in 1874 in *The Nation*, which had been so kind to Eakins, yet Homer's work was found wanting: the critic found it "original," yet also somehow unfinished, commenting that his "study of natural effects and values was always good up to the point at which the work was arrested."[28] The finishing touches (e.g., of gouache) were felt to be lacking—so even at this early point in his career, it is clear that Homer led his contemporaries in his use of purely transparent pigments and the use of the paper itself. Even where he used rather thick body color—in whites and reds of foliage and in the dress of a young girl, in an excellent watercolor of 1874, *In the Garden* (Collection of Arthur Altschul)—a contemporary critic might still have felt the work "arrested" because of its loose handling.

More typical of Homer's style of this time, and more demonstrative of his spare use of body color in the years after 1875, is *The New Novel* of 1877 (Fig. 134). By this time Homer was asking $75 to $100 for his works—the same price as received by a vast number of now-forgotten contemporaries. *The New Novel* represents the archetypal Victorian watercolor: finished, heavily washed in most areas, it depicts a fully dressed young girl reading in a field. Though her pose recalls that often used for nude studies in other times, she remains entirely proper, unaware as it were that her reverie is being observed. Thus the mood is very much that of the period, while Homer's technique is already highly developed: he brushes in a dark-green foliage background with a large brush, overlaying one wash with another; he lays in the dramatic orange dress, with touches of red at either end of the figure; and in the foreground the light-green washes make use of the paper beneath, while the artist—now using a tiny brush—darts about spontaneously in giving the illusion of grass and clover.

The late 1870s was the heyday of the realistic watercolor in

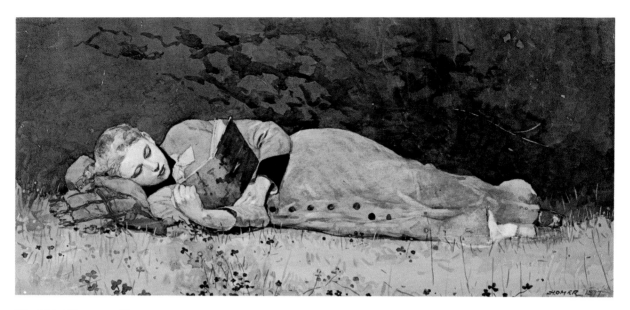

Fig. 134. WINSLOW HOMER, *The New Novel*, 1877.
Watercolor, 9½ x 20½″.

America. The Water Color Society had its own section at the Philadel-
phia Centennial Exhibition in 1876, where 128 watercolors were ex-
hibited. Well represented were the leading men and women, much as in
the annual shows, including Colman, Hart, Tiffany, Bricher, Homer,
Falconer, F. Hopkinson Smith, Richards, J. W. Hill, the Smillies, Henry
Farrer, Moran, and many others (though not Eakins). Watercolors
gained increasing attention in reviews of this time; Clement and Hutton
in their *Artists of the Nineteenth Century and Their Works* of 1879,
for example, give considerable attention specifically to the watercolors
of Homer, Moran, Colman, and Abbey—a drastic change since Tucker-
man's book of 1867, which speaks occasionally of "sketches" or
"studies" but never mentions the *word* watercolor. The society's peak
came in 1880 and 1881, when large catalogues, now lavishly illustrated,
were produced, with about eight hundred works shown each year.

Nearly every practicing artist in this period used watercolor on
some occasion, and the number of once well-known watercolorists whose
work seems simply to have disappeared is astonishing. Among still-life
specialists, the medium was essayed by both Peto and Harnett, and was
frequently used by Harnett's close follower Claude Raguet Hirst (1855–
1942). Another of the trompe l'oeil specialists, John Haberle (1853–
1933) of New Haven, appears to have made just one watercolor (Fig.
135), but it is masterful indeed. Though the transparent medium and
the illusionist, hard-edged aim of this painter would seem unlikely
partners, Haberle succeeds in rendering a life-size dead canary which
hangs on an old cigar-box cover; his handling is minute, essentially

Fig. 135. John Haberle, *Dead Canary*, 1883.
Watercolor and gouache, 8 x 4^{15}/$_{16}$″.

Fig. 136. EDWIN AUSTIN ABBEY, *An Old Song*, 1885.
Watercolor, 27½ x 47½″.

invisible—labels, textures of the wood, even the bird, are convincing—
and he resorts only rarely to body color.

Edwin Austin Abbey (1852–1911) was popular as watercolorist,
illustrator, and muralist on both sides of the Atlantic. Like so many
of his generation, he was American-born and -trained but chose to
spend most of his life abroad. Nonetheless, he remained American in
his own eyes and those of his colleagues; even as an expatriate he con-
tinued to exhibit at the Water Color Society, and his work was in-
fluential here. *An Old Song* (Fig. 136) reminds one of Eakins' late
watercolors, such as *The Pathetic Song* (Private Collection) of about
1881, though Abbey's concern remained more purely illusionistic, with
less interest in surface than Eakins'.

Ruskin's influence did not die out quickly, among either expatriate
or "native" American artists, and perhaps predictably it lasted longest
among those who settled in Italy. One such was Henry R. Newman (1833
or 1843–c. 1917), who lived in Florence for years and was an expert
watercolorist who specialized in still life and architecture. His *Grape
Vines and Roses: An Italian View*, 1883 (Fig. 137) typifies the work
that drew Ruskin's direct praise in a letter to the artist: "I have not for
many and many a day seen the sense of tenderness and depth of color
so united, still less so much fidelity and affection joined with a power
of design."[29]

Fig. 137. HENRY RODERICK NEWMAN, *Grape Vines and Roses: An Italian View*, 1883. Watercolor, 39½ x 26⅜".

8

Figure Drawings of
the Nineteenth Century

American genre painting reached a great peak around 1845 with the highly realistic figure paintings of Mount, Bingham, Woodville, and others. These men, and many of their contemporaries, were prolific draftsmen; pencil sketching came easily to them, and was assumed to be a quick, natural way of recording observed scenes and figures, compositional ideas, and other visual thoughts. However, this generation of painters was largely native-born and -trained, and though many of their paintings are extraordinarily successful, their drawings surprisingly seldom stand up on their own.

William Sidney Mount (1807–1868), for example, drew a great deal, filling many sketchbooks with pencil drawings (most of which are now owned by The Museums at Stony Brook, Long Island). Here one finds pencil sketches from his whole career; they include copies (one sheet of heads is inscribed ''Drawn from Hogarth's works''), groups of figures (some of which later appear in paintings), landscapes, and building interiors and exteriors. Mount was vitally interested in the world around him, and drawings such as *Boy at the Well Sweep* (Fig. 138) were meant as memory aids for the artist's use. The pencil is used as a linear tool, with dark and medium-value hatched areas representing shadows, a few quick strokes suggesting foreground and foliage, while more care is given to details of the figure. Quite different are Mount's more formal portrait drawings in pencil, such as the *Sketch of the Late H. S. Mount* (Private Collection), exhibited at the National Academy in 1841, or his *Portrait of a Lady*, 1842 (Fig. 139). Mount's sketchbook style surpasses the ''Sketch Club'' style of the late 1820s in its natural-

Fig. 138. WILLIAM SIDNEY MOUNT, *Boy at the Well Sweep*, c. 1840–1850. Pencil, 7⅞ x 9¾″.

ness, yet his formal portrait style looks back to the French neoclassic mode practiced at the turn of the century.

Mount's contemporary George Caleb Bingham (1811–1879) of Missouri was the other chief genre painter of the period. He was also a prolific draftsman, but many of his sketches have been lost, and his graphic work exists today primarily in two collections: the dozen or so early drawings (nudes, religious figures, and so on), perhaps made during his year of study at the Pennsylvania Academy in 1838 (at the State Historical Society of Missouri), and the 112 sheets in the "St. Louis Mercantile Library Sketchbook," now owned by the State of Missouri. Bingham is known as a draftsman primarily from the latter, which in fact is not a sketchbook as such, but rather a scrapbook upon whose pages have been mounted a number of his drawings dating from 1845–55. The drawings themselves have a remarkable singularity of purpose and style, consisting almost wholly of studies of single figures, executed lightly in pencil and then given form by the application of gray wash with a small brush. Our view of Bingham as a draftsman is inevitably a narrow one, based as it is essentially on one kind of drawing; it seems likely that other drawings which could flesh out our knowledge of him have been lost.

Bingham's world was a masculine one of shooting, trapping, card-

playing, and living on the river itself. His drawings are of the men he observed in the frontier area of the Missouri River, in their turn standing, sitting, arguing, drunk, humorous, intelligent, half-witted. These drawings are presumably drawn from life, but there appears to be no attempt at individual insight; rather, the artist's interest seems to be in types and poses. These same figures populate Bingham's beautifully painted, complex compositions in oil. Though the drawings were apparently made without specific uses in mind, they provided him with a ready repertoire of characters. Thus one finds here the fiddlers and boatmen, the voters and politicians who appear in the paintings. Typical of the artist's format—and one of his most appealing figures—is the

Fig. 139. WILLIAM SIDNEY MOUNT, *Portrait of a Lady*, 1842.
 Pencil, 9¾ x 7¹¹⁄₁₆″.

Fig. 140. GEORGE C. BINGHAM, *Village Character*, 1847. Wash, 10¼ x 6⅞".

Fig. 141. JAMES G. CLONNEY, *The Fiddler*, c. 1841. Wash, 8½ x 5½".

Village Character (Fig. 140), who appeared in the now-lost painting *The Stump Orator*, 1847, and again in *Stump Speaking, or The County Canvass*, 1853–54 (Boatman's National Bank of St. Louis). In the latter painting he stands below the earnest speaker, in the left-center of the composition, looking quizzical yet unconcerned.

The drawings of Mount and Bingham are almost as remarkable for what they are not as for what they are. Though these are among the ablest and most ambitious painters, in a sense carrying on the history painting tradition of West and Allston albeit in native terms, their drawings show little consciousness of *style* as such. Mount's drawings record scenes and groups, Bingham's single figures; neither artist studies the interrelationship of figures (as Copley did), the details of their forms (hands, feet, bodies, as Allston did), human psychology or individuality.

This was a transitional period for the figure draftsman, and a difficult one. Though significant paintings were being made, one feels that artists were making drawings purely as means to an end, rather than as meaningful objects themselves. Popular mediums were those

of the quick sketch—the pencil, or brush with ink or single-toned wash; the use of heavy, high quality paper declined, as did the use of traditional mediums such as colored chalks, charcoal, whites, and so on. Yet drawing continued to gain popularity, as witnessed by the tremendous expansion of drawing schools and the production of so many books on the subject; what was happening was a slow change from European inspiration to native training. Mount and Bingham had been trained wholly in this country, the latter at the Pennsylvania Academy.

Like others of his time, Bingham took drawing seriously but regarded it as something which could simply be learned from books; his attitude is demonstrated by a letter he wrote home to St. Louis from Philadelphia in 1838, as he was preparing to leave: "I have just been purchasing a lot of drawings and engravings, and also a lot of casts from antique sculpture which will give me nearly the same advantages in my drawing studies at home that are at present to be enjoyed here."[1] Many of the figure painters contemporary with Mount and Bingham drew much as they did. The drawings of James G. Clonney (1812–1867), for example, are similar in spirit to Bingham's, consisting largely of pencil and wash studies of single figures—which are studies for his genre paintings. *The Fiddler* (Fig. 141) is a sketch for the painting of 1841, *Militia Training* (Pennsylvania Academy); it recalls Bingham in pose and attitude, but not in style. Bingham's washes are applied with a fine brush, giving them a linear, hatched effect, while Clonney uses the brush in a more traditional way, more broadly, and with less emphasis on the faces of his subjects.

Quite different was Richard Caton Woodville (1825–1855) of Baltimore, who ranks with the best of the realistic genre painters. With his long stays abroad (Düsseldorf, 1845–51; France and England, 1851–55), one would expect him to draw well. However, this was generally not the case, though his watercolor *The Soldier's Experience*, 1844 (Walters Art Gallery), is a fine genre scene, and his later outline drawings in pencil show a nervous, Germanic line.

Abler as a draftsman was Francis W. Edmonds (1806–1863), a New York genre painter whose paintings relate closely to those of Mount. Edmonds visited Italy in 1840 and 1841, producing fine watercolors; he was also a member of the Sketch Club in New York during the 1840s. On an evening when the artists' subject was *Perseverance*, Edmonds sketched a driver trying to get a balky horse and wagon out of the mud (Fig. 142). Both his choice of subject and his technique (brown washes confidently laid over pencil outlines, with some touching with white) recall George Morland (1763–1804) and the English school of the early nineteenth century. Somewhat similar drawings were made by another Sketch Club member, John Gadsby Chapman, who was fabulously prolific, producing fourteen hundred drawings for Harper's

Bible (1846) and illustrating many other volumes besides. His important *American Drawing Book* of 1847 has been discussed in Chapter 3, above, and it should be noted that his article on etching in that book was the first on the subject by an American.[2]

There is an element of caricature in some of the drawings of Clonney, Bingham, and others at this time, but artists on the whole appear to have drawn a sharp line between "genial" humor (e.g., a black man fiddling), which was acceptable, and anything smacking of social criticism or political satire, which was not. There is a long but thin thread of satire in the American graphic arts which goes back before the Revolution, but until the end of the nineteenth century it never became more than a minor theme in our art. Accordingly, American painters and draftsmen on the whole carefully managed to avoid picturing any of the seamier sides of life, and war, poverty, disease, and prejudice seldom found visual portrayal.

Two exceptions to this rule did exist in the mid-nineteenth century —David Claypoole Johnston (1798–1865) and David G. Blythe (1815–1865). Johnston was trained in Philadelphia as an etcher and lithographer; he was also an actor and a painter, and is best remembered for his satiric drawings and prints in a style influenced by Cruikshank and Rowlandson. As a draftsman, he had the ability to make academic portrait heads in charcoal, such as *David Webster*, 1841 (American Antiquarian Society, Worcester), but he greatly preferred the political

Fig. 142. Francis William Edmonds, *Perserverance*, c. 1845.
Pencil and brown wash, touched with white, 13¾ x 19¾".

Fig. 143. DAVID CLAYPOOLE JOHNSTON,
The Young Artist's First Full Length, c. 1840.
Watercolor, 10½ x 9⅛".

Fig. 144. DAVID GILMORE BLYTHE, *A Free-Trade*
Man (William Blakeley), c. 1854–1858.
Pen and ink, 11½ x 8".

and social commentary featured in *Scraps*, a satiric illustrated journal
he produced in Boston from 1830 to 1849. His work constantly caused
him problems, for his was not a society willing to laugh at itself. As he
wrote to William Dunlap, "the print and booksellers, being threatened
with libel suits on one hand, and extermination on the other, chose
rather to avoid such difficulties, than to continue the sale of my produc-
tions."[3] His use of drawing mediums is never highly sophisticated, but
it is effective nonetheless. Pencil drawings such as *A Type of the Coming
Election* (American Antiquarian Society), with the speakers' remarks
in "balloons," look ahead to later cartoon styles; wash drawings are
equally direct, with strong value contrasts and an emphasis upon the
visual message; and his watercolors, carefully stippled and labored,
reveal the same sense of humor (see, e.g., *The Young Artist's First
Full Length*, Fig. 143).

 An even tougher-minded artist was David G. Blythe of Pittsburgh,
whose paintings often go beyond satire to cry out emotionally about evil
and human degradation. Blythe drew far less often than Johnston, but
no less powerfully: his *A Free-Trade Man* (Fig. 144) is drawn pas-
sionately, the pen defining the figure while slashing and cutting at it.

Line here seems almost uncontrolled, as in de Kooning's work a century later, but the bulbous body and puckered face are modeled successfully, and then are surrounded by a pure black wash which gives the figure the look of a cutout and draws the eye incessantly inward.

A tremendous number of artists were making figure drawings by the middle of the nineteenth century, and it is impossible to mention more than a handful of them. In general, the pre–Civil War manner was essentially a linear one, whether in pencil or wash (as in the various Sketch Club drawings that have been seen), while the years after the war saw increasing sophistication in drawing, particularly as the use of charcoal and then pastel was brought back from France. Typical of the earlier style is the work of Daniel Huntington (1816–1906), one of the leading portrait and religious painters of New York and a student of both Morse and Inman. Huntington drew a great deal—the Cooper-Hewitt Museum alone owns over one thousand of his drawings—in a manner that changed little over his long and much-honored career; his style was a bland one, whether applied to Hudson River landscapes, to portrait studies, or to allegory.

More interesting are the drawings of Huntington's friend Robert W. Weir (1803–1889), the long-time instructor in drawing at the Military Academy, West Point. Weir was highly eclectic, like Huntington, and he never wholly found himself as an artist. His collection of books, drawings, and engravings by European masters was extensive, and in fact he was one of the first important American collectors of drawings. His own work shows the multiplicity of his interests, as he turns to one style, then another. Nevertheless, he worked capably in almost every drawing medium, as seen in the loose pencil, ink, and white wash *Landscape*, 1849 (Yale University Art Gallery), and the very careful watercolor in the Karolik Collection, *Sleeping Lute Player*, c. 1850.

Another artist who, like Weir and Huntington, had much European training, was Emanuel Leutze, the German-born painter of *Washington Crossing the Delaware*, who spent much of his career (1841–59) at Düsseldorf, Germany. Like Weir, his drawings show many influences, and it is only in an occasional landscape sketch (see above Fig. 117) that he seems wholly comfortable. Nevertheless, at times he made varied and highly competent figure drawings, ranging from his linear *Portrait of William Morris Hunt*, done in Rome in 1845 (Museum of Fine Arts, Boston), to the heavily worked engraving-like *David Playing Before Saul*, 1853 (Corcoran Gallery).

The mid-nineteenth-century art world was almost exclusively the province of men. Though women had been studying drawing in large numbers since the beginning of the century, it is clearly true that "artistic endeavors by women of that period were esteemed as genteel accomplishments only; the social conventions forbade women to make serious commitments to any profession, artistic or otherwise, except

under dire necessity.''[4] The career of Lilly Martin Spencer (1822–1902) was thus most exceptional, for in New York she carried on a well-patronized career in portraiture and genre painting, raising a large family and often making use of her husband's help in both household and artistic tasks.

Born in France, she emigrated with her family to America in 1830; her training was begun under several artists in the Cincinnati area, notably the animal and genre painter James Beard (1812–1893). She married in 1844 and four years later moved to New York. Finding that she was "particularly deficiant [sic] in drawing drapery and even coloring," she began to spend her evenings at the drawing classes of the National Academy of Design. Though it is not known what teachers or other models were influential, her drawing style grew far more confident. Her Shakespearean illustration *Alas, Poor Yorick*, 1848, is made in pencil as Huntington and others would have approved, with light hatching to illustrate facial contours, but with a greater interest in the expressive quality of wiry, sharp line. Another drawing from the same sketchbook, probably a year or two later in date, is a portrait of her husband, *Benjamin Rush Spencer* (Fig. 145); the face is in deep shadow, while the shoulders and rest of the body are suggested only by long, nervous strokes. Despite its simplicity, this is a sympathetic and moving drawing, a romantic yet unsentimental vision of a man. Stylistically, it is strongly reminiscent of the work of the German Nazarenes such as Johann Friedrich Overbeck (1789–1869), though there is no evidence that Spencer knew his work.

Eastman Johnson (1824–1906) is best known as a genre and portrait painter who came to maturity just after Mount and Bingham. Despite the recent rediscovery of his major oil, *The Cranberry Harvest* of 1880 (Timken Gallery, San Diego), critics are still not certain that he is a painter of first rank. Be this as it may, there is no doubt that he is one of the most forceful of mid-century draftsmen, clearly surpassing the better-known genre painters in this regard.

Though he is remembered for his training at the Düsseldorf Academy (1849–51), the basic elements of Johnson's graphic style were established before he ever left America. He worked briefly in J. H. Bufford's lithography shop in Boston, and then in 1842 he was back in his home state of Maine, working as a portrait draftsman in Augusta. Even in his earliest known work, *Head of a Man*, dated July 1844 (Brooklyn Museum), his hand is certain, his sense of modeling sound (if still unsophisticated), his interest in texture and the effects of charcoal and chalk on paper already clear.[5] The same qualities, now incorporated in works of larger size, more complex composition, and smoother finish, are apparent in the series of portraits executed in Washington, D.C., in 1845 and 1846: though the artist was only twenty-two, his sitters included John Quincy Adams, Daniel Webster, and Richard

Fig. 145. LILLY MARTIN SPENCER, *Benjamin Rush Spencer*, c. 1848–1852.
Pencil, 19⅜ x 15½".

Peters, Clerk of the Supreme Court. Through these works Johnson's reputation grew, and within the year he had returned to Boston to draw incisive, handsome portraits of Emerson, Hawthorne, and Longfellow. He was a naturally gifted draftsman who (according to his friend the painter George H. Hall) ''worked rapidly and with a sure hand, seldom finding it necessary to make corrections.''[6] Significantly, Johnson's technique of modeling in *charcoal*—rarely using pencil until later in his career—predates by at least a decade the revival of charcoal drawing in America.

While in Boston, Johnson took up oil painting for the first time, though for the rest of his life he seemingly remained more at ease in the less formal drawing mediums. Then in 1849, seeking further training, he went with G. H. Hall to study in Düsseldorf. This German art center with its realistically oriented, rigorous academy by then had supplanted London as the proper place for Americans to study art;

Fig. 146. Eastman Johnson, *Secretary Dobbin*, 1856.
Charcoal with black and white chalk, 29⁷⁄₁₆ x 21⁹⁄₁₆″.

Leutze and Woodville were already there, and other prominent Americans (Bierstadt, Bingham, Whittredge) were soon to follow. Though the majority of Germans were working in more linear styles, Carl Friedrich Lessing (1808–1880) and Eduard J. F. Bendemann (1811–1889) used black chalks and charcoal to make forceful, bust-length portraits—and those of Bendemann particularly may have influenced Johnson, as his work became more controlled in its plasticity and at the same time more bold and varied in use of line. This vigor is apparent in a drawing he made at The Hague in 1852, just after leaving Düsseldorf (*My Jew Boy*, Carnegie Institute, Pittsburgh), and even more so in the great portrait drawing executed after his return to America, *Secretary Dobbin*, 1856 (Fig. 146). This drawing of President Pierce's Secretary of the Navy, James C. Dobbin, has seldom been equaled either in power of characterization or in the vigorous, almost painterly, handling of charcoal and chalks.

Johnson was also occupied with quite different kinds of drawings during the same years. One remarkable work is the highly finished, tonal drawing *Street Vendor* (Fig. 147), recently acquired by the Museum of Fine Arts, Boston. Probably executed during his years at The Hague, this drawing shows the artist dealing with a sentimental subject—common then in both Europe and America—which could easily have become saccharine. Rather, one admires the work both for its story-telling realism and for the extraordinary technical control of the charcoal medium: unlike the portrait sketches, here the artist's hand is invisible as the viewer's eye is drawn to the beggar-boy's stitched trousers, the little boxes in his basket, the handling of light and perspective in the street scene beyond.

Besides these finished drawings, Johnson also made studies in charcoal, pencil, and watercolor for his paintings. For example, his painting of 1868, *Boyhood of Lincoln* (University of Michigan Museum of Art), was preceded by several charcoal studies. One of these is sketched quickly on the reverse of an oil on paperboard, *Head of a Negro Man* (Collection of H. John Heinz III) while a more finished study (Fig. 148) on paper makes use of both charcoal and white chalks. Drawings like this one brought out the best in the artist: while he felt a need in the final oils to achieve an over-all, finished quality, the sketch freed him to focus on essentials, to use a single line or a touch of white to greatest effect, to leave large areas of the sheet either empty or blocked in. In the drawings of Lincoln, one feels the poignancy and wisdom of the boy's expression; in the painting, one admires instead the skill of the artist in re-creating the firelight, the details of tongs, logs, costume, cabin interior, and so on.

For Eastman Johnson as for others, the charcoal portrait was a product of the 1840s and 1850s, after which it was supplanted by the

Fig. 147. EASTMAN JOHNSON, *Street Vendor,* c. 1852–1855. Charcoal, 17¹⁵⁄₁₆ x 15¾″.

Fig. 148. EASTMAN JOHNSON, *Study for "The Boy Lincoln Reading,"* c. 1868. Charcoal, 14⅞ x 12¾″.

daguerrotype and the lithograph. In its heyday, it was practiced widely across the country, with some competent artists such as Johnson's friend Samuel Rowse making it a specialty. After the 1860s Johnson seldom used charcoal in his sketches—and when he did, as in the Indian portraits of 1857 or the much later studies for paintings such as *The Hatch Family,* it was not uniformly successful. He turned increasingly in the seventies to the use of smaller working sketches in pencil and washes, and here again proved a master draftsman. *Study for Corn-husking,* 1876 (Free Library of Philadelphia), is a masterful sheet, twelve sketches of old men with varying expressions and poses. Even more freshly observed is one of the early sketches (Fig. 149) in the long series of works devoted to the cranberry pickers of Nantucket Island: here Johnson has used paper of light brown tone to maximum advantage, sketching the figures with pencil, filling them quickly with low-keyed darker brown and blue washes, touching them with white. On paper, one feels the artist—perhaps for the first time—sensing the pictorial potential of these sun-drenched workers in the fields. He was making visual, shorthand notes, and he also jotted down some observations in the lower left-hand corner ("pails & clothes . . . Bottle in the tree . . ."). The oil sketches of the same scene which follow have the same kind of spontaneity; however, this sketch quality is lost as he comes closer and closer to the large finished paintings.

The greatest pictorial intelligence among all American painters may well have been that of the Philadelphian Thomas Eakins: he brought unique psychological insight to portraiture, and gave unsurpassed dignity to commonplace sporting subjects. That he also drew—masterfully—on occasion is less well known, perhaps because most of his drawings (other than the watercolors) were made purely for his own purposes and were seldom exhibited or published. Eakins was not a prolific draftsman, and in fact his own philosophy as artist and teacher was one which deemphasized drawing. His student Charles Bregler remembers him stating that "there are no lines in nature, there are only form and color," and on other occasions he warned against the harmful effects of students drawing too much, saying, "I prefer the brush."[7] Nevertheless, Eakins drew. Outside of the finished watercolors, considered below, the drawings fall into several categories: his juvenile efforts; the charcoal figure studies; quick, informal pencil sketches for sculpture and paintings; the very carefully planned compositional and perspective studies for rowing scenes and other paintings; and—perhaps most interesting—the finished black-and-white-wash replicas he made of several of his own paintings, for purposes of illustration.

Many of Eakins' future interests are apparent in the *Drawing of a Lathe* (Fig. 150), drawn when he was sixteen, the year before he graduated from Central High School in Philadelphia: a concern for space and depth, mathematically calculated, for the subtleties of value relationships, working in black and white, for the rational world of science and machinery. The drawing is technically remarkable, particularly given its execution by a schoolboy; it is also interesting in looking ahead not only to Eakins' later career, but to the precisionist drawings of Charles Sheeler and others sixty years later.

Fig. 149. EASTMAN JOHNSON, *Berry Picking*, c. 1875.
Watercolor, $7\frac{13}{16}$ x $9\frac{9}{16}$".

Fig. 150. THOMAS EAKINS, *Drawing of a Lathe*, 1860.
Ink and watercolor, 16⅝₁₆ x 22″.

After graduation from school in 1861, Eakins stayed in Philadelphia
(like so many American artists, avoiding the war). Slowly forming the
ambition to be an artist, he studied anatomy, made drawings both from
life and from casts at the Pennsylvania Academy, and worked with his
father, who was a writing master, a teacher of "the copperplate hand of
the old style" who also made documents such as deeds and diplomas.[8]
Realizing that he needed to go abroad for a full, academic training,
he set off for Paris, which was then just replacing Düsseldorf as the
mecca for aspiring artists.

It has usually been assumed that the great series of charcoal figure
drawings including *Nude Woman with a Mask* (Fig. 151) were executed
sometime before Eakins left Philadelphia for Paris late in 1866. It is
possible that some of these drawings—such as the linear, hesitant *Nude
Woman Reclining, Seen from the Front* (Philadelphia Museum)—do
date from the early years; however, the majority of them are confident,
with powerful modeling that relates most closely to Eakin's paintings
of 1874–76—so one must conclude the drawings themselves were made in
these years. Certainly the *Nude Woman with a Mask* is neither a juvenile
effort nor one which could have been made during Eakins' four years
in Europe, for the need for nude models to be masked resulted from
American prudery and was unknown abroad at that time. Eakins'
drawing does bear superficial resemblance to similar drawings by his
French contemporaries such as Courbet and Millet. However, where

Fig. 151. THOMAS EAKINS, *Nude Woman with a Mask, Seated, from the Front*, c. 1873–1875. Charcoal, 24 x 18″.

they worked out from the middle of the drawing, modeling torso and arms first, Eakins seemingly worked in from the edges, using a variety of hatching and sweeping strokes of charcoal to surround and define the tonal, wholly nonlinear figure. The model's heavy, sagging flesh and the shadows cast across it are suggested through a variety of means, the artist handling his medium confidently—stumping, rubbing, using it in an almost painterly fashion. The resulting image is a memorable one,

Fig. 152. Thomas Eakins, *Perspective Study for John Biglin in a Single Scull*,
c. 1873–1874. Pen, pencil and wash on two sheets of buff paper, 27⅜ x 45³⁄₁₆″.

in which technique is subordinated to expression: one feels most of all
Eakins' sensitivity to the plight of the rather grotesque model herself
as he conveys neither an ideal nor a caricature, but the simple truth.
Though his technique is not unlike Trumbull's (Fig. 24), it is hard to
imagine two more different images of the naked female body.[9] Eakins'
work has at times been compared to Rembrandt's, and this very anti-
classical figure particularly recalls Rembrandt's straightforward etch-
ings such as *Nude Woman Seated on a Mound*, 1631.

Also during the 1870s, Eakins made a number of quick pencil
sketches, working studies for both paintings and sculpture. At the same
time, he was making an entirely different kind of drawing, the perspec-
tive studies for various genre pictures: among the most interesting are
the studies for *Chess Players* (Metropolitan Museum of Art), *The
Artist and His Father Hunting Reed Birds* (a fine, complex drawing
now on loan to the Art Institute of Chicago), *Biglin Brothers Turning
the Stake* (Cleveland Museum), and *John Biglin in a Single Scull*
(Museum of Fine Arts, Boston; Fig. 152). Though several of
these drawings deal with complicated three-dimensional problems,
the last nevertheless stands out for the perfect clarity with which it ex-
presses the artist's intentions. Though the drawing was used as the
basis for an oil (at the Yale University Art Gallery) and a finished

watercolor (Metropolitan Museum of Art), it stands perfectly on its own—a study in classic balance, in perspective recession, and in the rower's reflection in the water. As Barbara Novak has observed regarding this work, "The relation of the figure to the calibrated empty space seems profoundly charged."[10]

Finally, Eakins was also an illustrator on occasion, and it is in this field that one finds some of the best of his drawings. Eakins' great, much-studied painting the *Gross Clinic*, 1875, suffered critical abuse before being purchased by the Jefferson Medical College in 1878 for two hundred dollars. Far less well known are the finished India-ink version (Fig. 153) which he made as the model for photogravure reproductions produced by Adolph Braun and Company in 1876, and the ink study of the head of Dr. Gross which belongs to the Philadelphia Museum. Clearly Eakins had unusual concern with tonal value; he realized that a truly accurate reproduction of the painting could be made only if he first translated it into black and white. Thus, using a small brush with intense care, sometimes scraping the surface or adding tiny strokes of white for the lights, he created his own miniature reproduction of his masterpiece.

As a recent study has pointed out,[11] a number of Eakins' works were illustrated in *Harper's, Scribner's*, and elsewhere in the years 1878–81. Outstanding among these is the wash drawing *Rail Shooting from a Punt* (Fig. 154), which again is a monochrome translation by Eakins of his own oil painting of 1876, *Will Schuster and Blackman Going Shooting for Rail* (Yale University Art Gallery). This was one of two drawings commissioned from Eakins for an article, "A Day in the Ma'sh," which appeared in the July 1881 issue of *Scribner's Monthly*; the artist received fifty dollars for the two. *Rail Shooting* was made so that an anonymous craftsman could then copy it as a wood engraving of small size (3½ by 5 inches); thus it required far less detail than the *Gross Clinic* drawing, and allowed the artist to use his brush freely. The original painting is densely and solidly constructed; one recalls the green of the marsh itself, the red shirt of the hunter, the white shirt and black face of the guide. In the drawing, brushwork becomes more important; brushes of at least three sizes were used as Eakins applied the wet, gray washes, working within a very narrow range of values. The whole sheet was first washed with a pale gray, except for Blackman's shirt, which must have been masked out; its intense whiteness in the finished drawing comes not from any use of Chinese white, but results rather from its being the only area where the original paper tone remains. There are in fact only the faintest touches of gouache, restricted to the edge of the boat and the left foot of Blackman; the rest shows a variety of strokes and technical means, including blotting, scraping with a knife or razor, and the use of seemingly accidental splotches of water. The result is a masterwork which differs significantly from

Fig. 153. Thomas Eakins, *Gross Clinic*, c. 1875–1876.
India ink, wash on cardboard, 23⅝ x 19⅛".

Fig. 154. THOMAS EAKINS, *Rail Shooting from a Punt*, c. 1881.
Wash, 8⅞ x 12³⁄₁₆″.

Eakins' usual drawings, from the tight India-ink reproductions, and from the very dry finished watercolors as well.

Thomas Eakins has usually been classified as a great "native realist," though actually he was a highly sophisticated, well-trained artist; his near-contemporary William Rimmer (1816–1879) has been thought a romantic eccentric who worked far out of the mainstream of American art. Yet in fact the similarities between the two may be more important than the distinctions. Both, for example, were powerful sculptors who rejected the long-standing tenets of neoclassicism; both had a strong interest in medicine (Eakins studying it, considering a medical career; Rimmer practicing it and becoming a licensed physician in 1855); they shared a passion for the study of human and animal anatomy; both were well-known teachers of art; and the work of both men was ignored or rejected by their society.

One basic distinction between them can be seen in their drawings, for Eakins drew in order to paint better, while Rimmer drew—often and very ably—more from a love of the craft itself. Of course, Rimmer

did make drawings as studies for paintings—for example, his pencil-and-red-chalk sketch for a painting, *Evening, or The Fall of Day*, c. 1869 (Museum of Fine Arts, Boston) which is essentially a large drawing itself; Rimmer left it untouched after applying the under-painting, much as Allston had done with his *Ship in a Squall*. As Allston had expressed his own vision through history paintings, and Eakins his through portraiture, Rimmer drew a world of myth, populated by fantastic, muscular, superhuman figures. For a country seeking recog-nizable homily in its art, Rimmer idiosyncratically created a world made up half from dreams, half from incredibly close observation of fact.

Though in a sense "self-trained," Rimmer became the most sophis-ticated sculptor and draftsman of his time. As a youth in Boston, he worked as typesetter, sign painter, and lithographer; his lithographic music covers from the late 1830s stand out from the work of his con-temporaries. Over many years he taught himself medicine, often work-ing in the dissecting rooms of the Massachusetts Medical College.[12] In 1860 he carved from granite an extraordinary, agonized head of *Saint Stephen* (Private Collection). The following year saw him begin a long career as a teacher of artistic anatomy, his students later in-cluding John La Farge, William Morris Hunt, and the sculptor Daniel Chester French. After four years (1866–70) as director of the School of Design for Women at the Cooper Union in New York—which ended in failure, much like Eakins' tenure at the Pennsylvania Academy—he returned to Boston, planning to open a drawing school jointly with William Morris Hunt. Nothing came of this—his philosophy and Hunt's being so widely divergent. However, he lectured widely and brilliantly, and about 1876 was asked to publish his lectures on artistic anatomy. For this project he made eighty-one drawings, which were published in 1877 by the heliotype process.

These hard-pencil drawings demonstrate extraordinary subtlety of technique. At his best, as in *The Neck Muscles in Use* (Fig. 155), the artist combines pure outline drawing with fully modeled tonal studies of heads and torsos. His works at times recall Michelangelo or Leonardo, then at others suggest that he was familiar with Mannerist or neo-classic draftsmen. The heads are particularly fascinating, combining (as Lincoln Kirstein has suggested) "anatomy, phrenology, personal observation, and fantasy."[13] He had a fine sense of composition, rhyth-mically varying each drawing on a sheet—but unfortunately the book as published is not faithful to his designs. Most of the anatomy drawings contain groups of individual figures, like this one; a few, however, are finished works of art in which Rimmer demonstrated the various prin-ciples of anatomy and form—such as *The Call to Arms* (Fig. 156). Rimmer thus was both teacher and illustrator, part of a tradition in American art going back to the earliest drawing manuals and to Cop-ley's anatomical drawings; his graphic style looked both back and for-

Fig. 155. WILLIAM RIMMER, *The Neck Muscles in Use*, 1876.
Pencil, 10¾ x 15″.

Fig. 156. WILLIAM RIMMER, *The Call to Arms*, 1876.
Pencil, 10¾ x 15″.

Fig. 157. WILLIAM MORRIS HUNT, *Drummer Boy*, c. 1862–1865.
Charcoal and white chalk on gray-green paper, 40⅛ x 27″.

ward, and his strict sense of craft made him quite out of place in his time. Typical was the opinion of Samuel G. W. Benjamin in his *Art in America* (1880), who acknowledged that Rimmer was "powerful in modelling, a master of art anatomy," but concluded that he was not a major artist, "having little sense of beauty."[14]

Quite different was the reputation of Rimmer's friend William Morris Hunt, upon whom the same Boston art world showered every honor. Hunt's philosophy of drawing and his use of charcoal has already been discussed in its effect upon the landscape draftsmen (see above, p. 131). His charcoal figure drawings range from nudes and ideal heads to sketches for paintings and portraits (the portrait drawings were publicly exhibited at the National Academy and elsewhere). He used the medium inventively, often mixing in watercolor or pastel, at times making a smooth and highly finished surface, at other times creating rough, black images. Typical of his early work abroad is the fine *Faggot Gatherer* (Carnegie Museum, Pittsburgh), while unique in scale and finish among studies for paintings is the *Drummer Boy* (Fig. 157), a full-sized, carefully finished drawing in charcoal with some white chalk. In the latter drawing one can see more clearly than elsewhere Hunt's affinity with Rimmer: what Rimmer accomplished in modeling his faces with thin pencil strokes, Hunt did with similar delicacy in charcoal.

Many other Americans studied in France at mid-century, and some stayed there. One of these was William Babcock (1826–1899), a student of Couture and a friend of Hunt's, and the one who introduced Hunt to Millet. Babcock's drawings generally use charcoal in a rather linear manner to cover the whole sheet, with figures then modeled against landscape backgrounds as in *Feeding the Birds* (Fig. 158). An artist of similar background but perhaps greater talent was Robert Wylie, (1839–1877), whose work was highly regarded in its day both in France and America. Brought to Philadelphia (from the Isle of Man) as a child, he first studied at and then was employed by the Pennsylvania Academy (until about 1863). He then went to France, studying with Barye and Gérôme, and becoming the first of the American colony to discover Brittany, where he remained for the rest of his life. His paintings are well-crafted genre and interior scenes, while, as a contemporary critic noted, "the slightest sketch from his pencil shows a vigorous and intelligent grasp of the subject."[15] His *Three Studies of a Man in Despair* (Fig. 159) is executed in soft pencil on tan-colored "oatmeal" paper; the artist reveals a sure touch as his quick strokes give substance and expression to the figures.

Few artists in this country used charcoal in the painterly way that Babcock or Hunt did upon occasion. More linear control and less "effect" was generally desired, even among artists who had studied in France. Thus typical in their approach to figure drawing were Thomas

Fig. 158. WILLIAM P. BABCOCK, *Feeding the Birds*, c. 1860–1879.
Black and white chalk with charcoal, 9⅝ x 9⅛″.

Fig. 159. ROBERT WYLIE, *Three Studies of a Man in Despair*, c. 1870.
Pencil, 8¾ x 11⅝″.

Hovenden (1840–1895) and Hugh Newell. Coincidentally, both were Irish-born; Hovenden received his training largely in France under Alexandre Cabanel in the years 1874–80, while Newell appears to have been trained in Baltimore, where he settled. A small sketchbook sheet, *Man with a Cane* (Detroit), shows Hovenden's pencil style, while a larger, more finished drawing by Newell, *Cleaning Up*, 1878 (Fig. 160) is a good example of that artist's realistic manner in black and white chalk.

Both Newell and Hovenden as draftsmen can be reminiscent of Winslow Homer during the 1870s, in their techniques and in their subjects (the shepherd girls of Newell, the little boys of Hovenden). Also related to Homer's work in subject and pose is a surprising drawing by William Aiken Walker (c. 1838–1921), a native of Charleston who studied in Düsseldorf during the 1860s. Walker's paintings seem undeservedly popular today, as in his own time, for they are repetitious, uninspired depictions of black life in the old South. However, occasional drawings such as *Seated Woman* (Fig. 161) are fine indeed, in quality surpassing both his own oils and the drawings of better-known con-

Fig. 160. HUGH NEWELL, *Cleaning Up*, 1878.
Charcoal and white chalk, 19¼ x 12⅝".

Fig. 161. WILLIAM AIKEN WALKER, *Seated Woman*, c. 1870–1880.
Pencil, 12¼ x 10¼".

temporaries. *Seated Woman* probably dates from shortly after the artist's return from abroad, given the calligraphic, varied quality of its line; a soft pencil is used to model the voluminous dress of the black woman, while a finer pencil—sometimes used lightly, sometimes pressed hard to create fine darks—outlines her figure.

A preeminent if iconoclastic figure draftsman of this period was Winslow Homer (1836–1910), whose reputation still rests, of course, on the watercolors and oils made in his "maturity" after returning from Tynemouth, England, in 1882. Though most of Homer's works in pencil, chalks, and charcoal predate this late period, they nevertheless demonstrate such sensitivity toward the inherent qualities of drawing that they deserve consideration on their own.

Homer drew from the time he was a young boy; his imaginative pencil sketch *Man on a Rocket*, executed at thirteen, is preserved today at the Museum of Fine Arts, Boston. Like many of his contemporaries, he was trained as a lithographer (at J. H. Bufford's in Boston), and then about 1857 began his career as an illustrator. One of the first illustrations he submitted, to the Boston periodical *Ballou's Pictorial Drawing-Room Companion* in 1857, was a portrait of Rembrandt Peale, which would suggest that he was aware of Peale's own work and of his drawing books as well. As Homer went on, he would normally make drawings that were then wood engraved by a craftsman for mass reproduction in the magazine; at least in the beginning, the drawings were regarded as means to an end rather than as exhibitable or salable themselves. However, the very high quality of Homer's drawings was recognized, for Sheldon in 1879 wrote: "In the spring of 1878 Mr. Winslow Homer exhibited in a Boston auction-room a collection of fifty or more sketches in pencil and in water-colors which possessed unusual interest,"[16] and his drawings had been shown earlier in Brooklyn and New York. Neither artist, magazine, nor collectors paid them much attention, and as a result much of the early work has been lost.

Critics have generally made little of Homer's early drawings, preferring rather to see the importance of his career as an illustrator in what this profession taught him about simplicity of line and silhouette, the need for instant recognizability of subject and "readability" of image, and thus the impact that illustration had upon his later style in watercolor and oil. In fact, the drawings are extraordinary objects in themselves. Though many, many artists of the period were working as illustrators, none developed Homer's sense of drawing with a line that is always quick, probing, and charged with a life of its own.

Homer's first professional accomplishments occurred after he had moved to New York and begun to submit Civil War illustrations to *Harper's* and other magazines. By this time he had received some training as a draftsman, having attended a drawing school in Brooklyn in 1860, as well as the night school of the National Academy of Design,

where he worked under Professor Thomas S. Cummings (1804–1894).[17] The specifics of this training are simply not known, but it is clear that Homer's Civil War drawings are superior to those of the other illustrator-artists in the field. Recording the war and the daily lives of the soldiers were many reasonably competent men, including Conrad Wise Chapman (1842–1910), Alfred R. Waud (1828–1891), Edwin Forbes (1839–1895), Frank Vizetelly (1830–1883), and William Waud (d. 1878), and Homer's very early work—such as the pen-and-wash drawing *From Richmond* of 1862 (Cooper-Hewitt Museum)—is hardly distinguishable from theirs in terms of quality. However, by the end of the war Homer's drawings were far more than reportorial. *Soldier on Horseback* (Fig. 162) of 1863 is executed in broad, sweeping strokes of black and white chalk. The image presses forward toward the viewer, cut at the edges; the drawing is energetically conceived and executed quickly, but with subtle variations in line and value. Moreover, the swirling white sky behind reinforces the thrust of the soldier himself. The drawing foreshadows the artist's lifelong concern with using the blacks and whites of his graphic work for maximum effect.

Soldier on Horseback is reminiscent of French style in both its medium and sweeping line (even though presumably made before his trip to France in 1866); but it was an experiment, and it is not typical of the great number of his drawings of the 1860s and 1870s, which were done in a linear pencil style close to that of his English contemporaries such as Landseer and Millais.

Homer's drawings of the 1870s, whether studies for illustrations or preparatory to his own watercolors or oils, are rather personal experiments—using modest, outdoor subjects—in the expressive possibilities of the pencil. His line is seldom again large or calligraphic; he uses the pencil (often with some white wash) in a great variety of ways, hard and soft, with parallel strokes and hatching, sometimes seeking outline only, at other times conveying the solid forms of his figures. *Girl and Boy Sitting on a Plow*, 1879 (Cooper-Hewitt Museum), appears almost to be made from a single, continuous, nervous line, while *On the Edge of the Farm*, 1875 (Karolik Collection), is a study of tone and texture, made up of varying thin, sharp strokes that suggest marsh grasses.

Interestingly, Homer's line drawings reached their peak during his two-year stay at Tynemouth (1881–82); here he pushed the possibilities of line as far as he was able. In later years he drew relatively little, and went on instead to make the magnificent watercolors discussed in Chapter 7. A drawing of 1882, *Fisher Girls*, (Carnegie Institute, Pittsburgh) represents the pencil style near its peak: line is used the way strokes of watercolor would be later, so that it both describes figures and landscape and is intriguing in its wide range of value, thickness, and energy.

Homer's use of charcoal and white wash also culminates in this

Fig. 162. WINSLOW HOMER, *Soldier on Horseback*, 1863.
Charcoal and white chalk on brown paper, 13⅞ x 8⁷⁄₁₆″.

Fig. 163. Winslow Homer, *Fisher Girl with Net*, c. 1882.
Pencil with gray and white wash on gray paper, 11⅜ x 16⅛".

period, in the years 1880–84. Where a decade before he had made simple, tight pencil and gouache drawings on tan paper of the boys and the boats in Gloucester Harbor, in Tynemouth and then at Prout's Neck, Maine, he produced an epic series of charcoal drawings of figures and the sea. In *Flamboro Head, England*, 1882 (Art Institute of Chicago), a single figure is outlined high above dramatic cliffs, and in the expressive and technical climax of this group, *Fisher Girl with Net* (Fig. 163), pencil, charcoal, and white and gray washes are combined on a textured gray paper. With emphasis now on mass rather than line, one sees a single stalwart woman trudging across the rocks, bearing the heavy fish net, with her face turned down in sadness; with short, thick strokes of white, Homer suggests the pounding sea at her feet, and a larger, swirling brush creates the portentous, windy sky above.

Homer was both a prolific book and magazine illustrator and a master draftsman. But before we reject completely the clichéd notion that illustration and great drawing do not mix, it should be added that Homer's career as an illustrator does come to an end in the late 1870s, just before his pure drawings and watercolors reach full power. Of

course, Homer drew for many reasons: though the drawings just discussed were meant as finished works of art, he also made preliminary, personal sketches for etchings, watercolors, and oil paintings. Particularly illuminating is the series of small pencil sketches he made for the painting *Undertow*, 1886 (Fig. 164); the whole series is at the Clark Art Institute with the painting. Here one sees Homer working on one of his most ambitious compositions, as two nearly-drowned women, clinging to one another, are dragged from the sea by two lifeguards. In one of the early drawings ("Sketch No. 4"), one sees just the two female figures, both clearly conceived as nude, locked in an embrace as if sleeping. In the two sketches which combined come close to the final composition (Fig. 165), the lifeguard on the left has been added, and the right-hand woman's head is now turned; however, Homer's energetic lines now indicate that they are clothed, in keeping with propriety at least as he saw it.

As with Eakins, much has been made of Homer's "native Americanness;" while in fact his linear drawing style owes much to English influence. His image of the strong peasant woman in the landscape also recalls J. F. Millet, and his concern with light, that of French Impressionism. Perhaps it is more accurate to say that Homer represented the eclecticism of his age at its best, the new confidence of the American artist, now able to learn from the academies both of Europe and at home, and a heightened public consciousness which led to a great flowering of all the arts, particularly drawing, after the Civil War.

In the late nineteenth century, for the first time, the artist in America was typically a well-trained draftsman. In 1843 the American painter James DeVeaux wrote from Rome that "drawing the human figure with accuracy is the most important step in our profession."[18] The importance of drawing had gained increasing recognition, beginning with the earliest drawing books and then the efforts of Peale and Chapman. Instruction in drawing was widely available by mid-century, and patronage by then was available to send the more promising talents abroad to London, Düsseldorf, Paris, and other art centers. In his report at the end of the first year of the National Academy, Samuel F. B. Morse noted in 1826 that both classes in the antique and lectures in anatomy had been given, commenting "the students universally have made laudable progress in drawing, the common grammar."[19] Morse was, like his counterparts in other American cities, highly conscious of the need to teach drawing. Before long the Academy maintained both life and antique schools, and in 1845 the life class was opened to women for the first time. The growth of the arts in America, particularly of the patronage that made them possible, is a complex story that has been well analyzed by a number of scholars;[20] of importance here is simply that the American draftsman finally came to maturity during the last third of the nineteenth century.

Fig. 164. WINSLOW HOMER, *Undertow*, 1886.
Oil on canvas, $29\frac{13}{16}$ x $47\frac{5}{8}''$.

Fig. 165. WINSLOW HOMER, *Study for "Undertow" (No. 2)*, c. 1886.
Pencil on greenish-gray paper, 5 x $7\frac{7}{8}''$.

FIGURE DRAWINGS OF THE NINETEENTH CENTURY 205

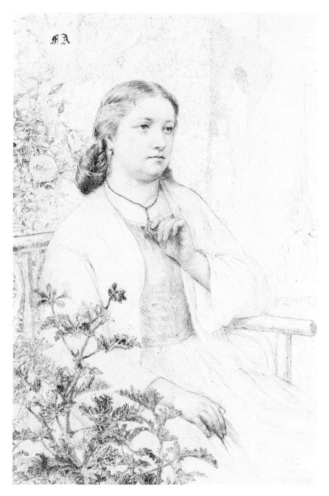

Fig. 166. FRANCESCA ALEXANDER, *Summer*,
c. 1880–1890. Pen and brown ink, 14⅞ x 11".

Fig. 167. WILLIAM M. HARNETT, *Venus de Milo*,
1873. Charcoal, 27⁵⁄₁₆ x 18".

More important than any stylistic unity at this time was the universal seriousness with which artists now took drawing. Homer's approach, as seen, contained elements of British and French style, combined with his own great linear sense. Other artists explored line in their own ways; for example, the drawings of Francesca Alexander (1837–1917), though now forgotten, were extravagantly admired in their time, and indeed are extraordinarily beautiful. This artist was the daughter of Francis Alexander (1800–1880), a successful portrait painter of Boston who had studied drawing with Alexander Robertson in New York. In 1853 he settled in Florence with his wife and daughter, and Francesca remained there all her life, though she always considered herself American and had both friends and patrons in the Boston area. Her great friend, however, was John Ruskin, who found in her drawings everything he had preached in *Elements of Drawing*. Ruskin befriended her, he wrote prefaces to three of her books (including *Roadside Songs*

of *Tuscany*, 1885), and above all he recognized the quality of her art: "No one since Leonardo da Vinci has drawn flowers equal to Francesca's for strength and delicacy, for truth and reverence that comes of truth." Her pen-and-ink drawing *Summer* (Fig. 166) if anything surpasses Ruskin in the probing quality of its line, the taut attention to detail, and the technical control that gives it an etching-like quality.

Artists at this time learned to draw figures whatever their final aim might be. Thus figure drawings were produced not only by portraitists, muralists, and illustrators—as one would expect—but also by the still-life painters, among others. Of these, William Harnett (1848–1892) is much admired as the great master of trompe l'oeil painting, but he

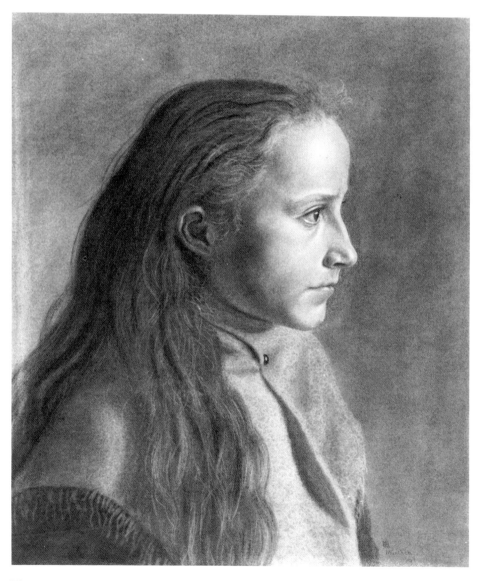

Fig. 168. WILLIAM M. HARNETT, *Head of a German Girl*, 1881. Charcoal, 9½ x 16¼".

was an able traditional draftsman as well. Indeed, in the early 1870s, well before doing any painting at all, Harnett had attended several art schools, including the Cooper Union and the National Academy in New York. It was probably in the antique class at the latter institution that he drew—like so many students before him—a copy of a cast of the *Venus de Milo* (Fig. 167). Even in this work of 1873, Harnett demonstrates a feeling for textures and line and an ability to synthesize and compose that are found in his mature paintings. Interestingly, for the very carefully balanced still-life paintings themselves he apparently made only rough pencil sketches as compositional guides; but in addition, during his mature career he produced several extraordinary finished portrait drawings, of which *Head of a German Girl* (Fig. 168) is outstanding. Working in charcoal with touches of white, in places subtly scratched and rubbed to produce a combination of rich modeling with a strong linear profile and detailed, long hair, Harnett here recalls the technique of the leading Munich masters such as Wilhelm von Kaulbach (1805–1874). The portrait itself is penetrating and intense, the same qualities that the artist brought so remarkably to the inanimate objects of still life.

Most nineteenth-century still-life painters appear to have made drawings; and Harnett is quite typical in that his still-life drawings, as such, are sketchy and unimportant, and his best graphic work dealt with the figure. The same is true of George H. Hall, the mid-century fruit and flower painter whose Düsseldorf training has been noted, and who was a prolific draftsman, and of the other members of Harnett's generation of trompe l'oeil specialists such as John F. Peto, John Haberle, and Jefferson David Chalfant. The last two artists produced some fine drawings, Haberle's including landscape sketches, figures, heads, and, perhaps most appealing, a variety of studies of animals, including mice and lions. Haberle was a still-life specialist who drew for his own amusement, while Chalfant had had two years of training in Paris and was equally at home with small genre paintings as with still life; and his pencil drawings for the former (such as *The Visiting Champion*, at Kennedy Galleries) show a fine linear touch not unlike William Aiken Walker's.

By the 1870s Americans going to study art in Germany were flocking to Munich rather than Düsseldorf. The Munich drawing style is typified not by Harnett, who painted and drew in a tight, old-fashioned way, but by men like Frank Duveneck (1848–1919). Duveneck's paintings are exemplary of the rich, painterly "Munich style"; his drawings are less distinguished, but some, such as the series of nudes lying down or the pastel *Woman in a Black Hat* (Fig. 193), are strong and vigorous. Another Munich-trained Cincinnati artist—of far less reputation than Duveneck but perhaps more gifted as a draftsman—was Louis

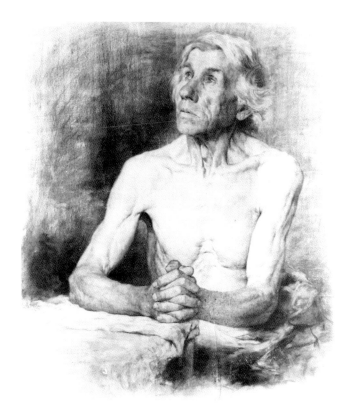

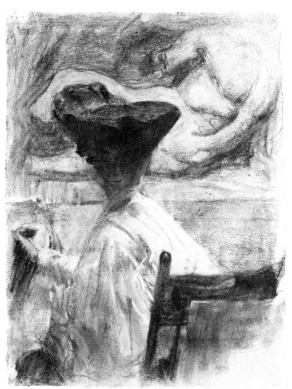

Fig. 169. Louis Ritter, *Half-Length Seated
Nude Man*, c. 1878. Charcoal, 33⅞ x 28½".

Fig. 170. Thomas Anshutz, *Woman Drawing*,
c. 1895. Charcoal, 24½ x 18¾".

Ritter (1854–1892), a landscape and portrait painter who lived in Boston during the last years of his life. His charcoal drawings are virtuoso demonstrations of the medium: in *Half-Length Seated Nude Man* (Fig. 169), face and hands are finely modeled, while the pathos of facial attitude and the emaciated, white body provide a typically German blend of technique and sentiment. Here, one recalls particularly the rich charcoal drawings of the great Munich realist Wilhelm Leibl (1844–1900). And of somewhat similar appearance are the drawings of a later German-trained portraitist, Oscar Fehrer (1872– ?), whose *Music Master*, c. 1895 (Wadsworth Atheneum, Hartford) also shows great skill in the use of charcoal.

Charcoal became nearly universally used, not only in France but in Germany, Italy, England, and America as well. Thus an artist such as Thomas Anshutz (1851–1912), Eakins' pupil and then successor at the Pennsylvania Academy, once a student in Paris, used the medium in a broad, painterly way, showing greater concern for the abstractions of texture and composition than for the specificity of figure and story seen in the work of the Munich men. *Woman Drawing* (Fig. 170) suggests

Fig. 171. JOHN LA FARGE, *Dawn Comes on the Edge of Night*, 1880.
 Charcoal, 13 x 13".

his rich technique, and also has an unusual subject: a woman art student, seen from the back, in the process of making a drawing (probably in charcoal) of a cast of Greek sculpture from the Parthenon.

The flowering of mural painting during the last quarter of the century resulted in many figure drawings and studies of high quality, and again the most common—though not exclusive—medium was charcoal. Its use was established by John La Farge (1835–1910), in his cartoons for the first great decorated interior in America, that of Trinity Church, Boston; and charcoal was also used extensively by William Morris Hunt in his own mural studies. La Farge, of course, was a gifted draftsman who was at home in any medium: his watercolors are out-

standing (see pp. 237–238), as are the nervous, taut pencil studies that he made for stained-glass windows and other projects. *Dawn Comes on the Edge of Night*, 1880 (Fig. 171) is technically excellent and emotionally sensitive. This drawing was made in preparation for murals planned for the Cornelius Vanderbilt house in New York, but in the end was not used there, being adapted instead in 1903 for a stained glass window design. La Farge has been considered "overtrained," too erudite and too educated for real accomplishment as an artist, and there is some truth in this. He was indeed one of the most sophisticated men of his time, a traveler, writer, lecturer, and member of the most cosmopolitan circles in America and abroad—in a sense, a worthy successor to Washington Allston. He was also both a teacher and a theorist: his book, *Considerations on Painting*, well represents the self-conscious, historically oriented aesthetic of the day ("Any work of art which has been deeply felt by its maker is also naturally well-painted").[21]

The most highly regarded muralists of the "American Renaissance" were generally fine draftsmen. Edwin H. Blashfield (1848–1936) was the dean of the profession, and its historian as well.[22] Like Hunt and La Farge, he was French-trained, and was thoroughly educated in the art of the past, at one time editing an edition of Vasari's *Lives of the Artists*. His drawings were typically executed in charcoal or black chalk; as with *Study of Hands* (Fig. 172), they are fine examples of the craft.

Fig. 172. EDWIN HOWLAND BLASHFIELD, *Study of Hands*, c. 1890–1899. Charcoal, 29½ x 21¼".

Edwin Austin Abbey was another leading muralist, who was also an illustrator and watercolorist. Like others of his generation, he felt the lure of the Old World, and in 1878 he settled permanently outside London. *Head of a Celtic Woman* (Fig. 173) is a study in charcoal and white chalk on reddish-brown paper for Abbey's painting of 1897, *The Play Scene in "Hamlet."* As with Blashfield, the final murals and other large-scale paintings were often wooden and overworked, but at the same time there is no doubting the artist's sense of line and form in his drawings.

Drawings increasingly became considered worthy of both exhibition and sale: they were shown at the National Academy, the Pennsylvania Academy, and other major organizations, as well as the Society of American Artists, at watercolor societies in many cities, and at artists' clubs such as The Century and the Salmagundi, both in New York. For the seven years after its founding in 1871, the latter—for example—was called "The Black and White Society"; Abbey and William Merritt Chase (1849–1916) were among its active members. Chase, of course, was one of the most influential painters and teachers of the period, an artist at home in Munich, Paris, and Madrid, who was deservedly one of the most honored painters of the nineteenth century. As a draftsman, his great contribution lies in the area of the pastel, but also worthy of note are his fine pencil sketch sheets, often filled with heads and figure studies, and occasional bravura drawings with brush and ink such as the *Seated Woman* (see Fig. 187).

Among the other able academic draftsmen of this time should be mentioned George De Forest Brush (1855–1941), a vastly talented and still little known "ideal" painter and H. Siddons Mowbray (1858–1928) and Kenyon Cox (1859–1919), muralists whose drawings are primarily in pencil. Finally, Dennis Bunker (1861–1890) was a marvelous draftsman who had studied in the Gérôme atelier in Paris; though he died at twenty-nine, his plein-air landscape paintings and his exciting, nervously linear pencil drawings demonstrate that his was a major talent.

A Munich-trained artist whose pencil drawings are noteworthy was Walter Shirlaw (1838–1909), a muralist and figure painter who (like La Farge and Vedder) had been active in founding the Society of American Artists. His subjects include landscapes, banknote designs, and so on, but the best drawings appear to be the experimental, private sketch sheets he made to study details of a figure or pose, such as the *Studies for "Violin Player"* (Fig. 174).

One of the strongest figure draftsmen in the academic tradition was John Singer Sargent (1856–1925), who was also a preeminent portrait painter and a consummate master of watercolor. Unlike Homer and Eakins, he has never been accused of being a "native American," for as one critic, Samuel Isham, said in 1905: "A more complicated problem of nationality is involved in the case of John S. Sargent. . . . Born in

Fig. 173. EDWIN AUSTIN ABBEY, *Head of a Celtic Woman,* c. 1897.
Charcoal and chalk on red paper, 28¼ x 21½".

Florence of American parents, he received his artistic training in Paris
and has since lived in England, though with much travelling on the
Continent and two or three trips to the land of his allegiance [the
U.S.]."²³

Sargent was a fine draftsman from the beginning. In the early 1870s
he traveled through Europe filling sketchbooks with landscape drawings
in pencil, in a detailed manner related to that of the Hudson River
School. He used such sketchbooks all his life, making figure, animal,
and landscape sketches with increasing strength and control (see the

Fig. 174. WALTER SHIRLAW, *Studies for "Violin Player,"* c. 1880–1890.
Pencil, 19¾ x 14¼".

late *Studies of Turkies* at the Rhode Island School of Design). For a
time influenced by Whistler, and later a friend of the French Impres-
sionists, he also did occasional fine linear portrait studies, such as *Study
for Madame X* (Metropolitan Museum of Art). However, far more fre-
quent are his usually rather heavy-handed, late charcoal portraits,
normally executed not as studies but as finished works, either as com-
missions or gifts; one of the lively drawings of this type is *Lady Ritchie,*
1914 (Collection of Mrs. Edward Norman-Butler, London).

Though Sargent paid his first visit to America only in 1876, he
quickly came into great demand both for oil portraits and for murals in

Fig. 175. JOHN SINGER SARGENT, *Study for "Orestes,"* c. 1910–1915.
Charcoal, 18 x 23¾".

Fig. 176. JOHN SINGER SARGENT, *Study of Horses' Heads for "Apollo in His Chariot
with the Hours,"* c. 1910–1915. Charcoal, 13½ x 9".

this country. His most important commissions in the latter field were American: he worked on the Boston Public Library project (where he came into close contact with E. A. Abbey) from 1890 until 1919; he went on to decorate the new Rotunda at the Museum of Fine Arts, Boston, and then did two large panels for the Widener Library at Harvard. The quality of Sargent's large-scale painting (and indeed the validity of mural painting in any form in the late nineteenth century) has often been attacked, but there is no doubting the studied fluidity and quality of many of Sargent's drawings for these projects. *Study for Orestes* (Fig. 175) and *Study of Horses' Heads* (Fig. 176), both made for the Museum of Fine Arts, Boston, have an energetic, incisive use of charcoal; in a sense both are a high point and an end to the tradition that had begun with Copley's drawings in London over a century earlier.

Sargent is usually classified with Mary Cassatt (1895–1926) and James A. McNeill Whistler (1834–1903) as one of three major American expatriate artists. However, in terms of their drawings, this grouping makes little sense. Cassatt is of interest as a painter and pastelist, and she was an important link between French Impressionism and some important American collectors; perhaps surprisingly, however (particularly in view of her marvelous color prints), her pure drawings are pallid. This is not true of Whistler, one of the great graphic artists of the age, though again his great contribution as a draftsman lies in his pastels, and one finds him favoring this medium and watercolor over the pure drawing. Nevertheless, when Whistler did draw, it was masterfully indeed. His *Study for "Weary"* of 1863 (Fig. 177) is extraordinarily forward-looking both technically and stylistically: it foretells the future popularity of the charcoal medium, while its dense, controlled linearity and its emphasis on the woman's face look forward to the work of the Symbolists. Whistler's subject here is presumably his mistress, "Jo," who also posed for several paintings; the drawing itself (like a companion work at the National Gallery, Washington) is a study for a dry-point print, *Weary*, of 1865.

Related to Whistler's work, in its sensitive linearity and moodiness, are the drawings of two of his contemporaries in America, Abbott H. Thayer (1849–1921) and Thomas W. Dewing (1851–1938), both of whom lived and worked well into the twentieth century. They were friends, and formed a New England circle of late classic painters and sculptors which included also George De Forest Brush and Daniel Chester French. Thayer studied in France, in the Gérôme atelier—one of the last of a number of Americans to do so. Thayer's reputation rightly rests upon his paintings rather than the drawings; however, the latter do occasionally rise to the level of *Portrait Head of a Young Girl*, 1897 (Fig. 178). Here the pencil is used almost like a burin, cutting each line carefully onto the paper, using parallel strokes for her hair and a delicate cross-hatched shadow on one side of her face.

Fig. 177. James Abbott McNeill Whistler, *Study for "Weary,"* 1863.
Black chalk, 9⅝ x 6⅞″.

If such drawings are exceptional for Thayer, they are not for Dewing, who was surely one of the master draftsmen of the period (while being a somewhat uneven, though occasionally brilliant, painter). Dewing was a major pastelist; in addition, his series of silverpoint portraits of women are extraordinary in their use of this difficult and subtle medium (see Fig. 179). Silverpoint first gained popularity during

Fig. 178. Abbott H. Thayer, *Portrait Head of a Young Girl*, 1897. Pencil, 18¾ x 14⅛".

Fig. 179. Thomas W. Dewing, *Head of a Girl*, c. 1890–1895. Silverpoint, 16⅜ x 14".

the fourteenth century in Italy, and has been used on occasion by masters up to the present day. It is a medium that requires great patience and dexterity, that tolerates no hesitation and no mistakes; the artist employs a silver stylus with which he draws upon a prepared paper with a white ground, and the lines—originally hardly visible— over a period of months gain their final light brown or yellowish hue. By the 1890s there was enough of a revival of the medium for Winsor & Newton Ltd. to produce silverpoint kits, though even then it was seldom used. Of all Dewing's work in silverpoint, *Head of a Girl* seems the most perfectly composed and executed: in its subtle modeling and range of tone and shade, it is literally breathtaking.

The academic tradition in America was neither so weak nor so short-lived as modern historians would have us believe. Moreover, the quality of drawings produced by that tradition should be cause to re-evaluate its paintings, though in the light of "modernist" criticism, it seems unlikely that this will occur in the near future. In any case, realistic figure drawings conceived in the manner of an Allston or a Sargent were produced in decreasing numbers as the twentieth century wore on, and though some art students today are still making charcoal drawings from antique casts, they are doing so with less conviction than before.

9

The Impact of Impressionism

Though American artists came to Impressionism late, and most never wholly absorbed it, this French style nonetheless had tremendous impact upon our painting and all aspects of draftsmanship as well. Impressionism was very much on the scene by the 1880s: American critics were using the term frequently, the artists had seen the work of Monet, Pissarro, and the others in Paris, and there had been several New York exhibitions—the most important of which occurred in 1886 when the great French dealer Durand-Ruel brought over three hundred Barbizon and Impressionist pictures.

Each American reacted in his own way to Impressionism. Predictably, the older members of the Hudson River School—Church, Bierstadt, and the other landscape realists—woefully decried "these baleful foreign influences." On the other hand, younger men such as George Inness, Homer Martin, and Alexander Wyant (1836–1892) who had begun in the tightly handled, realistic mode, found their touch becoming more free and their palettes lightening. By the 1880s these three were considered leading American "Impressionists," though the work of each showed at least an equal mixture of Barbizon with Impressionism, and each would have denied that any basic change in his style had occurred. Inness was particularly vociferous: in 1884, the very year in which paintings such as *Niagara* (Tillou Gallery, Litchfield, Conn.) brought him closest to the French avant-garde, he wrote a letter angrily denying that he was in any way "a follower of the new fad 'Impressionism.'" He went on succinctly to classify his own style as distinct from both "the puddling twaddle of Preraphaelism [sic]" on one hand and the "humbug" of Monet on the other![1]

Inness by the late 1860s had rejected the Hudson River School drawing style and had already become a master of the moody, charcoal

Fig. 180. GEORGE INNESS, *The River Bank*, c. 1880–1885.
Watercolor, 14 x 20".

landscape. He went on in the next two decades to produce a group of
drawings and watercolors that is simply extraordinary. Almost un-
known to collectors, they are few in number, extremely varied, and al-
most all very beautiful. Moreover, Inness' graphic work appears to have
had great personal meaning for the artist: almost none of the drawings
were ever exhibited or offered for sale, for he held a group of forty
(almost all that are known) until his death, when he left them to his
daughter, Mrs. Jonathan Scott Hartley.[2] Each one is an experiment in
graphic technique. They include the charcoal drawings of the late
sixties, a large group of quick watercolor sketches done in Italy in the
following decade, and other, even more individualistic works from late
in his life.

Inness' watercolors are brilliantly and quickly executed in wet
washes overlaying one another, often with pencil outlines underneath;
they have a tonal effect—the range of hues being restricted—though
values are likely to vary from very dark greens or blues to touches of
white or pink gouache. The *Dolomites* (Wadsworth Atheneum, Hart-
ford) is an outstanding example of the Italian work, its handling
reminiscent of the later La Farge at his best. Inness apparently felt free
here, working solely for himself, abroad, to essay a technique far looser
than Homer's at the time—and the latter, we recall, was roundly
criticized for its unfinished quality!

In the early 1880s Inness executed several larger drawings which

Fig. 181. J. FRANK CURRIER, *White Beeches*, c. 1875–1880. Watercolor, 11 x 16".

are even bolder, looser, and closer in fact to Impressionism. One of these is *The River Bank* (Fig. 180), accurately described in the Hartley Sale catalogue as "an exquisite composition of pastel foliage colors" with "the intense blue of the morning sky." The colors are indeed those of pastels—and in fact the watercolor and pastel mediums were growing close together at this time. Inness himself combined them in his drawing *Niagara*, c. 1884 (Battell-Stoeckel Trust, Yale University), where ink line, pure wash, body color, chalk and pastel strokes, and rubbing and scratching have all been combined to create yet another of his very painterly drawings.

The critics were puzzled by this radical, anti-Victorian style. The *Art Interchange* called this kind of work "Impression Water Colors," and found an exemplar of the manner in the work of J. Frank Currier (1843–1909). Currier's reputation has now disappeared almost entirely, though sympathetic contemporaries considered him Homer's equal; he was thought to represent the best result of Munich training, and he won a wide reputation as a virtuoso charcoal draftsman, watercolorist, and painter. Ahead of his time, Currier demonstrates in his watercolors (Fig. 181) an astonishing impressionistic freedom of execution, along with succulent surface quality and a complete willingness to let accidents and drips rule. A writer in 1883 found his manner "very eccentric," and noted critically that he used "ordinary water colors very freely washed in, with a view to a very general impression of the subject and no attempt whatever at detail."[3]

Fig. 182. J. Francis Murphy, *The Willow Pond*, 1892.
Watercolor on white paper laid on board, 10¾₁₆ x 14⅞″.

At the same time, other Americans such as J. Francis Murphy (1853–1921) carried on a style of landscape watercolor indebted to Corot, to Inness, and to some extent to Impressionism as well, yet conservative enough to win general acceptance. Murphy could be an elegant watercolorist at times, if at others he accepted a lower level. *The Willow Pond* of 1892 (Fig. 182) stands out in his oeuvre; in comparison to the work of Inness or Currier, it is somewhat old-fashioned, being more tonal, more poetic, more topographical, and ultimately less insistent on the artist's personality as expressed in his brushwork.

James Abbott McNeill Whistler would have disagreed with Inness about many things, but certainly would have concurred in rejecting the Impressionist label on one hand and the Ruskinian on the other. He once wrote that "the imitator is a poor kind of creature. . . . It is for the artist to do something beyond this: . . . in arrangement of colors to treat a flower as his key, not as his model."[4] Where Inness was an American who traveled a great deal, absorbing foreign styles, Whistler—though born and educated here—chose to become an expatriate, and came to play an influential role in avant-garde circles in both France and England.

Whistler's immense graphic talents influenced American style: he led a number of Americans to a new attitude about art, to a new view of etching and lithography, and to a "new" medium, the pastel. If he was not an Impressionist—and in any strict sense he surely was not—he nonetheless led others toward an impressionistic style. Economy of

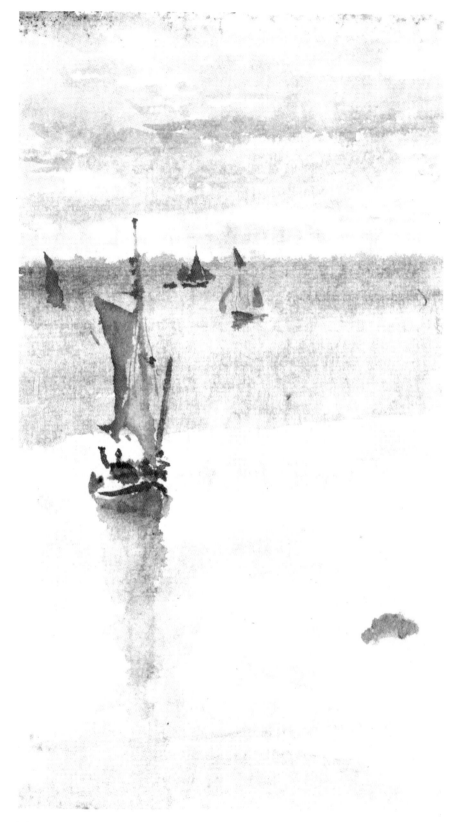

Fig. 183. JAMES ABBOTT MCNEILL WHISTLER, *Sailboats in Blue Water*, 1870–1880. Watercolor, 8¼ x 4⅞″.

means was always important for him, and even his critics recognized that his "audacity is based on directness and simplicity of color."[5] American artists had been moving toward the subjective, the expressive, the moody; Whistler showed them how to reach these ends with quick, incisive strokes. And watercolor for Whistler was the most evanescent of mediums: his small sketches are literally impressions, with a few strokes of a wet brush conveying the most delicate moods of nature (see Fig. 183).

If pastel had played little role in nineteenth-century American art to this date, quite the opposite was true in France, where the medium had captured the imagination of the most advanced artists. Millet had used it often, and William Morris Hunt had brought to Boston a large group of Millet drawings in both charcoal and pastel. Hunt himself practiced pastel on occasion (see Fig. 102). Equally important, pastel was masterfully employed by many of the French Impressionists—Degas, Monet, Morisot, and Renoir all showing pastels during the first Impressionist exhibition in Paris in 1874.[6] Degas took the medium to an ultimate perfection, and his friend and admirer Mary Cassatt became highly competent in it as well. The connection between the pastel and Impressionism on both sides of the Atlantic is a demonstrable yet largely unstudied phenomenon. Apparent reasons for the liaison can be seen—the gentle, soft colors possible with pastel, the opportunity offered literally to sketch in dry colors, the fragility of the medium paralleling the intimacy of Impressionist subjects—but deeper reasons for the rediscovery of the medium at this time also surely exist.

Whistler's influence was crucial for the American revival of pastel. He was working in Venice during 1879–80 and quickly found himself at the center of a group of young American artists known as the "Duveneck boys" (after their teacher, Frank Duveneck, who had traveled to Venice with Chase and Twachtman in 1877). Whistler made hundreds of small pastels at this time; done on lightly textured gray or tan paper, they are linear, rather two-dimensional vignettes of Venice. Their great lucidity was quickly recognized: London critics of 1881 greeted them enthusiastically ("we never feel that the hand has stopped or hesitated for a moment"[7]), and American admirers followed suit.[8] One of the students, Otto Bacher, later wrote a first-hand account entitled *With Whistler in Venice*, which discusses the pastels in detail: "He generally selected bits of strange architecture, windows, piles, balconies, queer water effects, canal views with boats—very rarely figure subjects—always little artistic views that would not be complete in any other medium. . . . He had quantities of vari-colored papers, browns, reds, grays, uniform in size."[9] Bacher reports that Whistler's method was first to outline his subject in black crayon, then filling in with the pastel colors where he thought it necessary. Some were made in one outdoor sitting, while more often only the drawing would be done

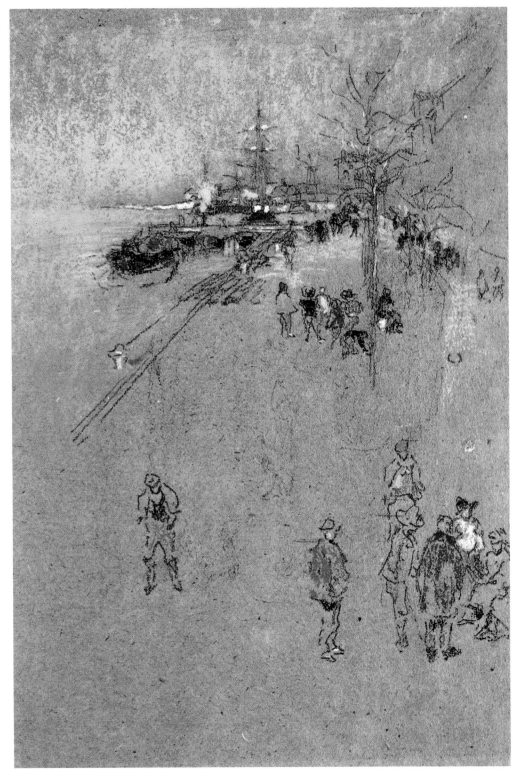

Fig. 184. James Abbott McNeill Whistler, *The Little Riva; in Opal*, c. 1880. Pastel, 11⅜ x 7¾″.

on the scene, and the coloring finished later in the studio. *The Little Riva; in Opal* (Fig. 184) was one of the group shown in 1881 at the Fine Arts Society, London. Still in wonderfully fresh condition, it shows the artist's effortless use of the medium, with his own high angular perspective and occasional quick touches of color unifying the whole.

Dianne Pilgrim has brought to light the important influence upon the Americans of the now-forgotten Italian pastelist Giuseppe De Nittis (1846–1884), a friend of Degas whose work was included in the first Impressionist exhibition. De Nittis had taken up pastel about 1878, and showed the works to Paris' acclaim in 1880. De Nittis' pastel technique was broader and more painterly than Whistler's; his works were notable for "their large size, strong colors and elaborate, ambitious compositions."[10] Thus De Nittis should be considered both for his possible influence on Whistler and, more important, for providing the young Americans an *alternative*, bravura pastel style in contrast to Whistler's modest, linear mode. Mrs. Van Rensselaer noted as early as 1884 that "the pastel painters of today differ widely among themselves, but more, perhaps, are followers of De Nittis than of Whistler."[11]

The pastel movement crystallized in the early 1880s. At this time "a new organization called the Society of American Painters in Pastel, of which Robert Blum was the talented but unpractical president, carried on an interesting if irregular existence."[12] Founded in 1882, the society numbered among its original members Carroll Beckwith, Edwin Blashfield, Robert Blum (1857–1903), William Merritt Chase, H. Bolton Jones (1848–1927), Francis Miller (?–?), and Charles Ulrich (1858–1908), all of whom were also members of the avant-garde Society of American Artists, begun in 1877 by the younger Paris- and Munich-trained figure painters who were reacting to the Hudson River aesthetic. Unlike the Water Color Society, which had a long and regular existence and which played a major role in making watercolor acceptable, the Pastel Society's founding seems more to reflect the interest that had already sprung up. In the year of its founding, for example, the popular American periodical *The Art Amateur* published the first of an informative series of articles entitled "Pastel Painting."[13]

In 1884 the group held its first exhibition (sixty-four works by the members and nine guests) at W. P. Moore's Gallery in New York and it drew considerable attention. *The Art Interchange* commented: "Impressionism is here seen at its sanest and best, and those who are susceptible to the charms of cleverness and dash can find much to delight them in this first effort to acquaint the general public with the possibilities of pastel."[14] The two different approaches to pastel that Mrs. Van Rensselaer had noted were both represented—and she was also correct in finding Whistler's slight, relatively austere method losing ground to the more obvious, bravura technique of men such as Chase and Blum.

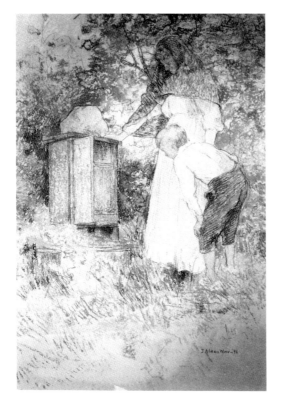

Fig. 185. J. ALDEN WEIR, *Watching the Bees,*
1896. Pastel, 13¼ x 8¾".

Fig. 186. JOHN TWACHTMAN, *Flowering Branch,*
c. 1885–1890. Pencil, 15 x 10¾".

Whistler had his followers, of course, and over the years they included many of the leading American Impressionists, including Twachtman, Childe Hassam, and J. Alden Weir. It should be noted that, with the exception of the great Whistler collection at the Freer Gallery, pastels by these men are scarce and widely dispersed, suggesting that our knowledge of American pastel is still skeletal. Nonetheless, a relatively consistent manner can be seen in the dry, sketchy use of powdered chalks on small pieces of tinted paper which was usually soft in texture (or with considerable "tooth" to hold the flecks of pigment). Typical is Twachtman's *Trees in a Nursery,* Hassam's wonderfully loose and airy *Poppies, Isles of Shoals,* 1890 (both in the Horowitz Collection), and Weir's *Watching the Bees* (Fig. 185), wonderfully linear and at the same time richly colored.

Another pastelist of note—even closer to Whistler spiritually and technically—was Thomas W. Dewing. One senses that in many ways he was the artist La Farge and the others would have liked to be, for Dewing had perhaps the most refined sense of line and texture of his time. Already noted as a draftsman in silverpoint (see page 218), Dewing also made a great many pastels. They are almost always of women, either standing and dressed or lying nude; employing a limited range of hard chalks, all related in color to his small sheets of brown

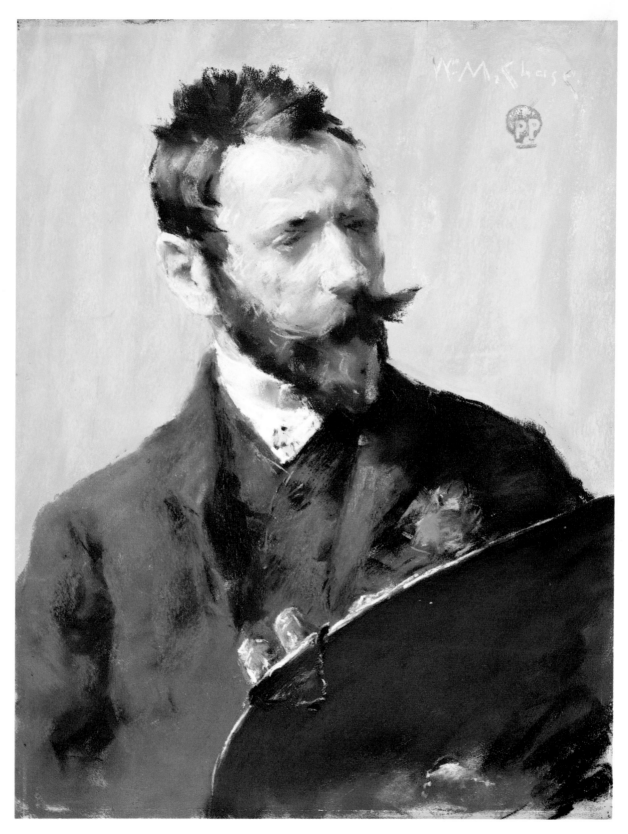

Fig. 187. WILLIAM MERRITT CHASE, *Self-Portrait*, c. 1884.
Pastel, 17¼ x 13½".

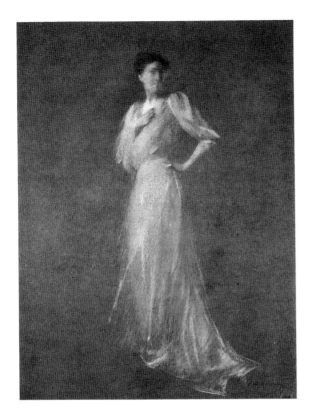

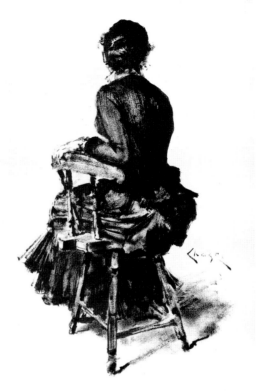

Fig. 188. Thomas W. Dewing, *Woman*, c. 1890–1899. Pastel, 14½ x 11¼".

Fig. 189. William Merritt Chase, *Seated Woman*, c. 1880. Brush and black wash, 16⅞ x 13⅝".

paper, Dewing simply creates coloristic and compositional perfection. His work (see Fig. 188) takes a step further away from reality even than Whistler: using extremely limited means, he created a world so delicate that at times it borders on the ecstatic. He himself had no regard for time or change; his style (judging from the enigmatic numbering system which he used on his drawings) changed not at all between 1890 and 1930.

Reviews of the first exhibition, however, found the glory of pastel not in Whistlerian "notes," but rather in the medium's ability to rival the "finish" and "broad treatment" of oil painting; after all, it was called the Society of *Painters* in Pastel, and many members regarded their work as much painting as drawing.[15] *The Art Amateur* commented that here "one finds all the freedom and nearly all the vigor of oil"; the most highly praised pastelists were the most painterly—Chase and Blum. Chase of course was one of the most influential American artists of the time: a major painter and draftsman, an important teacher, and a leader of the avant-garde. His personality, and his experiences in Munich, Paris, Spain, and Italy, made him a natural leader, and he urged a whole generation of Americans toward bravura brushwork and impressionistic handling. His quickly sketched *Seated Woman* (Fig.

Fig. 190. WILLIAM MERRITT CHASE, *At the Window*, c. 1890.
Pastel, 18½ x 11″.

Fig. 191. WILLIAM MERRITT CHASE, *Luxembourg Gardens*, c. 1880–1890.
Pastel, 9⅝ x 13⅝".

189)—broadly and strongly brushed with ink in a few moments' time—
makes a strong contrast to the extraordinarily delicate pencil drawing
Flowering Branch (Fig. 186) by his friend John Twachtman, and the
same stylistic distinction exists between their pastels.

Chase began to use pastel about 1881 or 1882, and he was repre-
sented in the first exhibition by several works including what one critic
described as "a portrait of the gentleman himself, so clever in pose and
strong in handling as to have satisfied most artists with that one ef-
fort"[16]—presumably the startling, colorful picture now in the Horowitz
Collection (Fig. 187).[17] It is easy to see how Chase's bombastic style
became the rage: this is no sketch, but rather pastel at its richest and
most painterly. Yet in other moods, as he worked further with the
medium, Chase had subtler moments as well—as in the quiet, meditative
At the Window, c. 1890 (Fig. 190), where pastel is used more as a pure
drawing medium, the colors and details softened, and the emphasis
placed—as so often during the Gilded Era—on the loneliness of the
upper-class woman. Particularly closely related is one of E. A. Abbey's
pastels, *Woman in a Garden* (Yale University Art Gallery), of the same
period, where again the facial features seem purposefully blurred. In
these later figurative pastels Chase certainly comes closer to Impres-
sionism than most of his American colleagues, and he does the same in
his landscape oils and pastels of the 1890s. These again (see Fig. 191)
are far more "finished" than those of Whistler and his school: they

make little use of the paper's tone or texture, but they succeed nonetheless in conveying a marvelously colorful light-filled vision—through pastel strokes that are freer and more impressionistic than anything in his oils.

Chase's friend Robert Blum practiced many mediums: he etched, influenced by Whistler; he illustrated a book based on his trip to Japan in 1890; he did murals; and of course he worked in oil and most of the drawing modes as well, including pastel. As president of the Pastel Society, he was an important figure, yet his was never a major talent. Even the best of his pastels. such as *Japanese Girl* at the Clark Art Institute, seem more derivative of Chase than freshly inspired.

A greater talent was that of Mary Cassatt, the only American to exhibit regularly in the Impressionist exhibitions in Paris during the 1870s. Though she spent much of her adult life in France, her influence on American artists and collectors was considerable. Thus, as early as 1873 she persuaded Louisine Waldron Elder (later Mrs. H. O. Havemeyer) to buy a Degas pastel,[18] and she began to use the medium frequently herself in the following years. Her mature style combined qualities of drawing and painting: in *The Black Hat*, c. 1890 (Fig. 192), for example, she uses thin white strokes as highlights and a dark jagged one to describe hat and dress, but then defines the face in a convincing, painterly manner.

Cassatt practiced pastels constantly, the gentle colors and texture of the medium making it a natural one for her sentimental compositions. Quite different is the case of her contemporary Frank Duveneck, who, despite his training in Munich and Venice and his close association with Chase and Twachtman, is known to have made only a few pastels. Yet in one instance of 1890, *Portrait of a Woman with a Black Hat* (Fig. 193), his work is both astonishingly able and remarkably close to Cassatt's in subject and handling. Even here there are distinctions, Duveneck showing more inclination to draw than Cassatt, and making more use of parts of his sheet left empty or only lightly stroked; and the face of his sitter is left imprecise and somewhat blurred, closer to Chase's manner than Cassatt's.

For reasons which remain unclear, the Pastel Society's second exhibition was not held until 1888, despite the favorable reviews that the first show elicited. This second exhibition found Blum still dominant (with thirty-one entries), and saw the addition of such men as Kenyon, Cox, John La Farge, Irving Wiles, Twachtman, and Weir.[19] A third exhibition took place the following year (Birge Harrison and Theodore Robinson now being included, among others), and a fourth and evidently final show occurred in 1890. New members included in this largest of pastel exhibitions were Hassam, Cecilia Beaux, Robert Reid, and Otto Bacher, the work of Hassam being particularly praised.

Critics have speculated as to the demise of the society, which was

Fig. 192. MARY CASSATT, *The Black Hat*, c. 1890. Pastel, 24 x 18″.

Fig. 193. FRANK DUVENECK, *Portrait of a Woman with Black Hat*, 1890. Pastel, 19⅞ x 16½″.

surprising in view of the attention it had received. It may be significant that Hassam and others founded the "New York Watercolor Club" in 1890 and included pastels in their first exhibitions. In addition, a reviewer of the time noted that "some artists show a disposition to blend their techniques, so that it is not always possible to say, at a glance, whether a certain picture is in pastel or in watercolor."[20] This is crucial: the pastel movement did not dissolve, but rather flourished; its result was not only that a great many pastels were produced over several decades but, equally important, that it diverted *watercolor* style significantly. As seen in Chapter 7 the use of gouache had become less and less fashionable toward 1880. The pastel movement reversed this movement, and by the mid-eighties, as a result, there were two quite different methods of watercolor being practiced: one, led by Homer, made maximum use of transparent washes; the other—equally significant at the time—made denser watercolors which imitated many of the effects of pastel.

Thus during the late 1880s and early 1890s one finds a great many pastel-like watercolors, some made with gouache and some with other means. This occurs both in the figurative tradition and in landscape, and among those who have been considered "American Impressionists"

Fig. 194. ARTHUR I. KELLER, *Women at Tea*, c. 1890.
Watercolor, 17½ x 12″.

Fig. 195. William Stanley Haseltine, *Vahrn in Tyrol near Brixen*, c. 1890.
Watercolor and gouache on blue paper, 14⅞ x 22".

and those who have not. Some highly sophisticated watercolors were made, for example, by the New Yorker Arthur I. Keller (1866–1924), who is better known for his ink-and-watercolor illustrations. However, in *Women at Tea* (Fig. 194) he sets up a Chase-like composition executed in transparent watercolor (in the faces, the floor, and elsewhere) together with a flickering overlay of gouache in the whites, reds, blues, and golds. The result has all the apparent fragility and subtlety of pastel without risking that medium's perishability.

The same development occurred among landscapists, as is seen in the work of William Stanley Haseltine (1835–1900). An able member of Church's generation, and in the 1860s a practitioner of a very precise mode of drawing (as in *Indian Rock, Narragansett,* in the Karolik Collection), Haseltine changed with the times. His drawing style of the 1880s is equally "realistic," but his interest lies no longer in the sharp delineation of rocks, but rather in depicting the gentleness of light in nature. Many of the late drawings are pastel-like indeed, making use of washes of low intensity on blue or green tinted paper. Some are sketchy, such as *Bruges* at the Cooper-Hewitt Museum; others fill the sheet com-

Fig. 196. THEODORE ROBINSON, *Decorative Head*, 1889.
Watercolor, 14 x 10″.

pletely, using a range of gentle greens and yellows, along with white
gouache loosely brushed on, as in the exquisite view *Vahrn in Tyrol
near Brixen* (Fig. 195). A variation on this theme occurs when on other
occasions he made densely washed watercolors which in tone and effect
relate to the pastel without resorting to gouache at all.

One of the most sensitive of the American Impressionists was
Theodore Robinson (1852–1896), himself much affected by Monet and
in turn influential on Twachtman, Weir, and others. His watercolors,
such as *Decorative Head* (Fig. 196) and *A Normandy Mill*, 1892
(Horowitz Collection), are pale and sensitive; through rubbing and
washing, working in close detail, then in broader strokes, they also
emulate the look of pastel.

This pastel look was much in vogue during the 1890s, when Thomas
Anshutz did his *Boys Playing with Crabs* (Fig. 197). A sensitive side of
the artist is found in the series of watercolors which resulted from his
visits to the shore (apparently "to the Maurice River, at the mouth of
the Delaware in New Jersey").[21] His teacher Thomas Eakins would have
liked *Boys Playing with Crabs*, depicting in almost Symbolist fashion
three naked boys on a beach, oblivious of themselves and of the intense
sun of a June day. Anshutz's colors here are those of the pastelist—each

Fig. 197. Thomas Anshutz, *Boys Playing with Crabs*, c. 1895.
Watercolor, 14 x 20″.

one seems to have some white mixed with it—but in fact his only medium
is watercolor, and he makes bold use of the paper itself. With no sign of
brush strokes, he employs a narrow range of hues from a pale, acid
green through sandy yellows, pinks, and pale purples; scratching,
erasing, wiping one wash to show another underneath, he creates an
image that is at once believable while being dreamlike.

The watercolors of John La Farge are related to those of Anshutz,
and provide many lessons for the student of American art. La Farge
was, after all, perhaps the most cultivated of all American artists, and
one finds in his sketches a constant struggle between his natural talents
and his even greater intellect. Many of his largest and most carefully
planned watercolors—*Bridle Path, Tahiti* at the Fogg Museum of Art,
Harvard University, for example—are so heavily worked that they
lose a sense of life, while others which he surely meant only as personal
notations are among the most poignant of works of art.

A muralist, a great innovator in stained glass, a writer, theoretician,
and teacher, La Farge seldom found greatness where he sought it. A
great many of his projects, for example, involve figures, yet he almost
never could draw the human form convincingly. Watercolor itself pre-
sented great problems for him, and he tried it for years before finally

mastering it. First exhibiting at the Water Color Society in 1876, he used the medium frequently in the late 1870s, and even more during his journeys in the following decades. Even then, prolific though he was, the chances of failure in an individual work were far greater than of success: though he demonstrates at times a great sensitivity to color values, an understanding of pigments and paper, a willingness to take chances, and a knowledge of composition, these are seldom found together in one work. Perhaps not surprisingly, recalling his wonderful still lifes in oil from the 1860s, a number of small flower watercolors stand out in his oeuvre. One thinks of the *Wild Roses and Water Lily* in the Horowitz Collection, and of the extraordinarily fresh *Bowl of Wild Roses*, 1880, from the large collection of his work at the Museum of Fine Arts, Boston (Fig. 199): here one sees La Farge as he would have liked always to be—an artist capable of finding beauty in the commonplace, and of recording it perfectly and instantly. In *Bowl of Wild Roses* there are no corrections, only the Chinese bowl and blue-gray background contrasting with a medley of white, red, and purple flowers.

La Farge had all the love of color of a Homer or a Sargent, but none of their restraint or their ability to use a single dashing stroke, put down and admired for itself. For La Farge, subject meant everything, and all too often—even in the watercolors from his trips to Japan in 1886 and the South Seas in 1890—the image is reworked and corrected. On occasion, however, he came close to true Impressionism, recording the color and atmosphere and look of a place at a single plein-air sitting: one finds this on a large scale in *Dawn, End of Cook's Bay, Society Island* (New Britain Museum), and on a smaller and more atmospheric sheet, *Sunrise in the Fog over Kyoto*, 1886 (Fig. 198).

La Farge was friendly with Winslow Homer, and it was undoubtedly Homer who led him toward increasing the freshness of his watercolors, as indeed he led many others. Despite the lures of pastel and body color, Homer developed an ever growing instinct for clarity of image and hue; together with his unique understanding of what transparent colored washes could be made to do on white paper, this made him the preeminent watercolorist of the day. During the 1890s his watercolors were widely sought by collectors, and in the years following his death (in 1910), significant groups of them were purchased by the Metropolitan Museum, the Brooklyn Museum, and the Worcester Art Museum among others.

During the 1870s Homer had been one of the better Victorian watercolorists, as we have seen. Like most of his contemporaries, he used washes to fill in colored outlines, covering his whole sheet and using body-color highlights where necessary. However he went abroad to work near the fishing village of Tynemouth on the North Sea during 1881 and 1882, and even the critics of his own time recognized that "the English

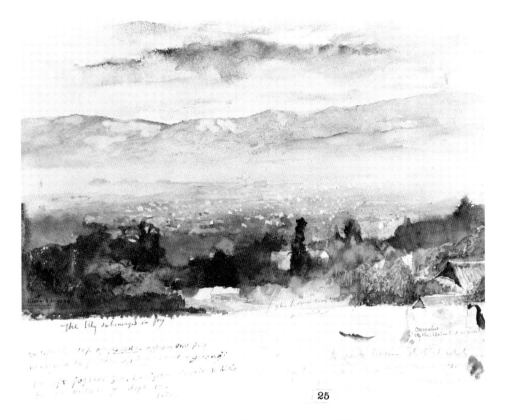

Fig. 198. JOHN LA FARGE, *Sunrise in the Fog Over Kyoto*, 1886.
 Watercolor, 6½ x 11½".

series . . . stand a little apart. They are pictures, not sketches, and are
grayer, subtler, better composed than the others."[22] Subsequent critics
have found in this Tynemouth period dramatic changes in Homer's
attitude—a new seriousness, a new feeling for the strengths of nature—
as well as his concentration now upon watercolor, and the increased
broadness of his style.

Yet despite the fact that more has been written about him than any
other American artist, the reasons for these changes remain elusive.
In England Homer still portrayed young women, as in *Beach Scene,
Tynemouth*, 1881 (Fig. 200), though they are now fisher girls rather
than schoolteachers or resort-goers. There is a new concern for the sea
and for labor, but this evolves slowly. Similarly, Homer's style under-
goes no single dramatic change, but rather seems to mature under a
variety of influences. His graphic sensibility was astonishingly keen,
and he begins to expand the watercolor medium just at the time he had
carried the charcoal-and-wash technique to its limits. In England he
undoubtedly saw the work of Turner and the other great English
masters, though there appears to have been no single figure under whose
spell he fell.[23] Even the most astute of the students of Homer's water-
colors, H. Lester Cooke, could point only to his "mastery of the

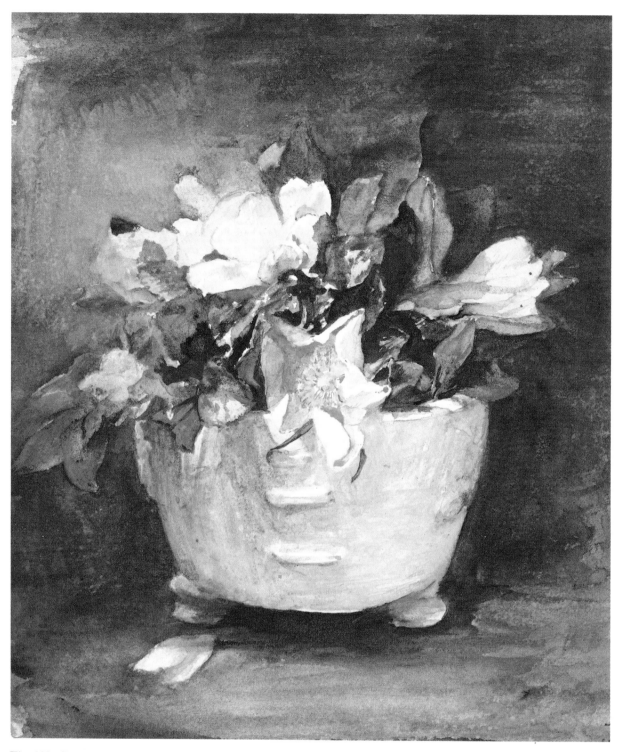

Fig. 199. JOHN LA FARGE, *Bowl of Wild Roses*, 1880.
Watercolor, 10$\frac{15}{16}$ x 9$\frac{1}{16}$".

English academic style," noting major technical advances in his art at this time, including the use of masking agents, scraping and sanding, and the use of a fine knife to draw details.[24] But as Cooke points out, this is still a Victorian watercolor technique; despite his advances, Homer still makes little use of the paper, and fails to focus either composition or tonal arrangement as he would later.

A major break in Homer's approach came during the mid-1880s. Just at the time that American watercolor style in general was tending to become more opaque, and was increasingly concerned with domestic, figurative subjects, Homer began to portray the outdoors with an ever freer and more transparent method. Increasingly he came to use pure colors from the tube, and despite his care and sensitivity, even an admirer such as Mrs. Van Rensselaer found his colors lacking in "suavity," calling them "rude, violent, almost brutal."[25]

Always idiosyncratic, Homer moved to live year-round on the sea at Prout's Neck, Maine, when the other painters were rushing to join the burgeoning clubs and artists' societies. In a period of "feminine" subjects at the end of the nineteenth century, he succeeded in rediscovering the American wilderness through portrayal of the isolated hunter or fisherman. With other artists seeking polish, he took joy in the accidental. And, "the outstanding characteristic of the late work," to quote Cooke again, "and one which ranks in importance with Homer's insistence on transparency, is the calligraphic and expressive strength of his brushwork."[26]

This is not to say that Homer never failed, for his energetic experimentation made this inevitable. But when he succeeded, what success! He was particularly inspired by the Adirondacks, sometimes visiting Keene Valley and more often going to "Baker's," (later the North Woods Club) near Minerva, New York. Here he produced impossible, private visions such as *The Mink Pond*, 1891 (Fig. 203): a dark pool where one squints to make out the muddy greens above and browns below, and is thunderstruck at the drama of the swimming bass, the poised frog and the white water lily—with all attention on two white moths in the center. Concentrating his touches of the primary colors, red, blue, and yellow, in the center, picking up violets and greens farther off, and using the tertiaries—made interesting only by their facile application—in the far reaches, the artist demonstrates his complete control of the medium.

Moreover, it is clear from this work and many others that Homer and La Farge among others of this period were totally cognizant of contemporary color theory. They had certainly read Michel Eugène Chevreul, and quite probably more up-to-date theorists as well. The most advanced American book, published by the V. W. Devoe Company in New York in 1882, was H. W. Herrick's *Water Color Painting: Des-*

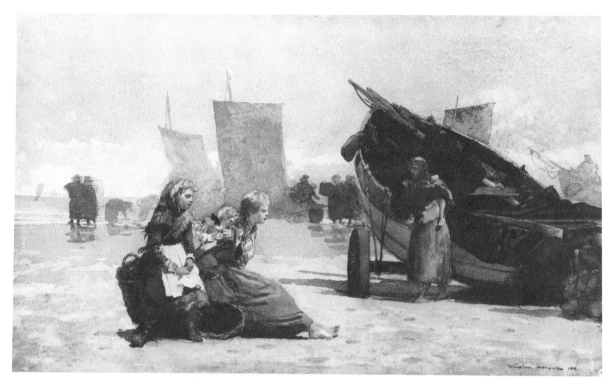

Fig. 200. Winslow Homer, *Beach Scene, Tynemouth*, 1881.
Watercolor and pencil, 11½ x 19½".

*cription of Materials with Directions for Their Use in Elementary
Practice; Sketching from Nature in Watercolor*. Herrick's book is well
informed and makes use, through charts and diagrams, of the earlier
color theories of Herman von Helmholtz, Ogden N. Rood, George Field,
and of course Chevreul.[27] Thus it is clear that the Americans were not
only "instinctively" paralleling the aims of the French Impressionists;
in fact they had the technical and intellectual tools which enabled them
to work with great sophistication.

More loosely treated and even more compelling in some ways is a
watercolor done in the summer of 1892, *Deer Drinking* (Fig. 201). Here
Homer uses a limited range of color, concentrating on the varying grays
of the deer's hide, the log, and the reflections in the water—actually
working within a range of pale violets—and then drawing sunlight into
the picture with dramatic touches of yellow (the complimentary of
violet). Though loosely, calligraphically brushed, the image remains
firm. Unlike the French, Homer uses brushwork to describe and then
echo natural forms, not to abstract them and bring them to the surface.
The control of brush and of tone is extraordinary: there is no visible use
of "technique" at all—no body color, no scraping or masking, almost
no visible pencil outlines—simply the putting down of layers of wash,
once, correctly.

Homer traveled widely, like La Farge, but his watercolors were complete works of art (now usually about fourteen by twenty inches), rather than travel sketches in any sense. Often he went to Canada with his brother Charles; and he journeyed to Florida at least five times between 1886 and 1904 and twice to the Bahamas.[28] The bright sunlight and gay colors of the tropical areas suggested a new palette and new interests, as he now portrayed strong black men fishing or hunting turtles, or dark tropical storms rising. The warmth of southern light tended to simplify his compositions, in a sense to cut down his participation in the scene even further. In *Stowing Sail, Bahamas*, 1903 (Fig. 202), one finds him working in a subtle range of blues and grays, then adding sensuous touches of red at the sloop's waterline and in the pennant at her bow. White paper is now used to maximum effect to suggest the bulk of the boat itself and the gentle motion of the sea. Homer here sketches quickly and directly from nature, for he inscribes his drawing "Sketch from water—Dec. 22, 1903." Again the concept (capturing nature at a specific, never-repeated moment) reminds one of the Hudson River School, however different Homer's method.

Even after his watercolor style had reached full height, Homer returned on occasion to the execution of monochrome drawings. *Two Men in a Canoe* (Fig. 204) was made during the summer of 1895, on a fishing trip with Charles. As his early biographer, William Howe Downes, reports: "On this first jaunt to the wilds of Quebec he made a wonderful series of rapidly wrought drawings . . . [of which] four were in black-and-white wash, slightly warmed with brown tones."[29] Deliberately depriving himself of the colors in which he delighted so much, Homer returned here to the black-and-white world of the illustrator. Whether he did so sentimentally (given his own beginnings), or whether he felt the urge to refresh his eye in pure value studies (like Kline and Pollock later), one simply cannot know. Whatever the reason, these simple wash drawings have about them an ultimate purity of tone and an unmatched ease of handling: Homer here reduces his art to an absolute simplicity and ease.

The late watercolors are the culmination of Homer's work in any medium, for he was essentially a graphic artist, most at home with his colors, a sheet of white paper, and a rounded, wet brush. A painter of light and a naturalist as well, he absorbed a complex of American and foreign influences to produce a highly individualistic art which stands alone. He carried the watercolor medium to its ultimate: as has been written of another of his 1903 watercolors, "The washes are crystalline in their transparency; the drawing is reduced to essentials only, which leave the imagination of the spectator free to supply the details; the brushwork is brilliantly adapted not so much to the form as to the essential nature or movement of the subject."[30]

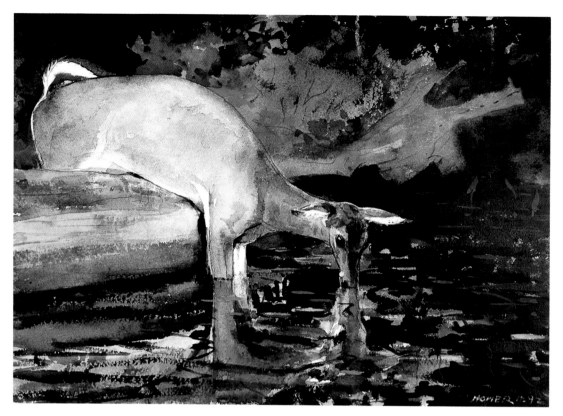

Fig. 201. WINSLOW HOMER, *Deer Drinking*, 1892.
Watercolor, 13½ x 19½".

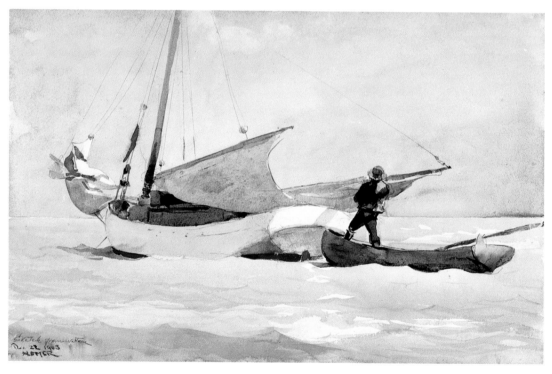

Fig. 202. WINSLOW HOMER, *Stowing Sail, Bahamas*, 1903.
Watercolor, 13¾ x 21¾".

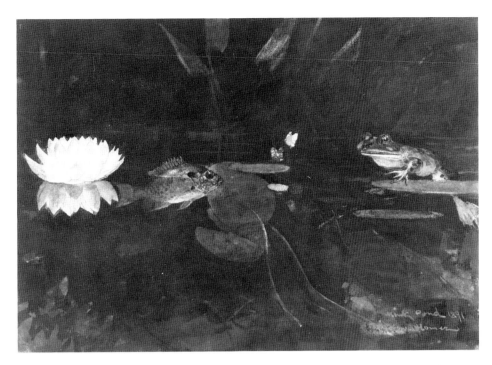

Fig. 203. WINSLOW HOMER, *The Mink Pond*, 1891.
Watercolor, 13⅞ x 20".

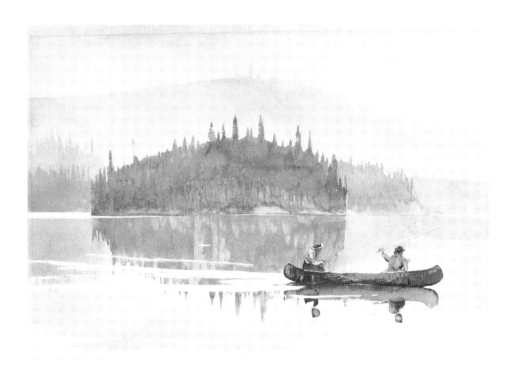

Fig. 204. WINSLOW HOMER, *Two Men in a Canoe*, 1895.
Monochrome watercolor, 13³⁄₁₆ x 19⅜".

Homer had absorbed some of the lessons of French Impressionism and translated them into his own way of seeing. Other, "purer" Impressionists in America attempted to bring the French style home, but they rarely succeeded. One of these—and indeed one of the most highly respected painters of his day—was Childe Hassam (1859–1935), who had had a thorough training in Paris from 1886 to 1889. Like many of the American Impressionists, he was at his best in small works on paper, when he could forget self-conscious emulation of French style. His pastel *Poppies* has already been noted, and closely related to it is a series of watercolors done as illustrations for Celia Thaxter's book of 1894, *The Island Garden*. Perhaps the freshest and most vibrant of these is the watercolor of the same title (Fig. 205), executed in 1892 probably on a visit to Mrs. Thaxter's home on Appledore, one of the Isles of Shoals off the New Hampshire coast. Using primary reds and blues, Hassam here achieves a slashing stroke and a brilliance of color that bring his subject close to the surface while remaining readable.

Hassam's contemporary Maurice Prendergast (1859–1924) was a far more prolific watercolorist, and one whose style is harder to classify. Perhaps the first American who fully absorbed the lessons of French modernism, Prendergast studied in Paris from 1891 to 1894, and returned to Europe for two years beginning in 1898, when Venice particularly attracted him. He was affected by a great many European influences, by the Impressionists, and perhaps more important by the Post-Impressionists, including the Nabis and the Symbolists. In addition, the seriousness with which he approached watercolor and his wet, transparent technique which takes advantage of the paper suggest that he must have been acquainted with the works of Winslow Homer; and this is made even more likely given Homer's popularity in Boston, where Prendergast lived during much of the 1890s.

Prendergast's artistic development remains something of a mystery, for like the other masters of the medium, he has been subjected to more verbiage than clear critical analysis. However, judging from the dated work, his style began to emerge only during his Paris sojourn of the early nineties, when he was recording street scenes, with particular interest in the motion of pedestrians and carriages. Already his compositions were flatter even than Hassam's, and his washes thin and perfectly transparent. He drew both with pencil and with broadly laid-on strokes of wash; uniquely, his pencil lines are not used in the traditional manner (outlining objects which would later be finished by coloring), but rather act as important graphic elements on their own—reinforcing the wash but not subservient to it. This is seen clearly in the marvelous sketchbooks at the Museum of Fine Arts, Boston, and as well in individual drawings such as *Picnic: Boston Garden* (Fig. 206), dating from the mid-1890s. Probably a study for a monotype—a medium in

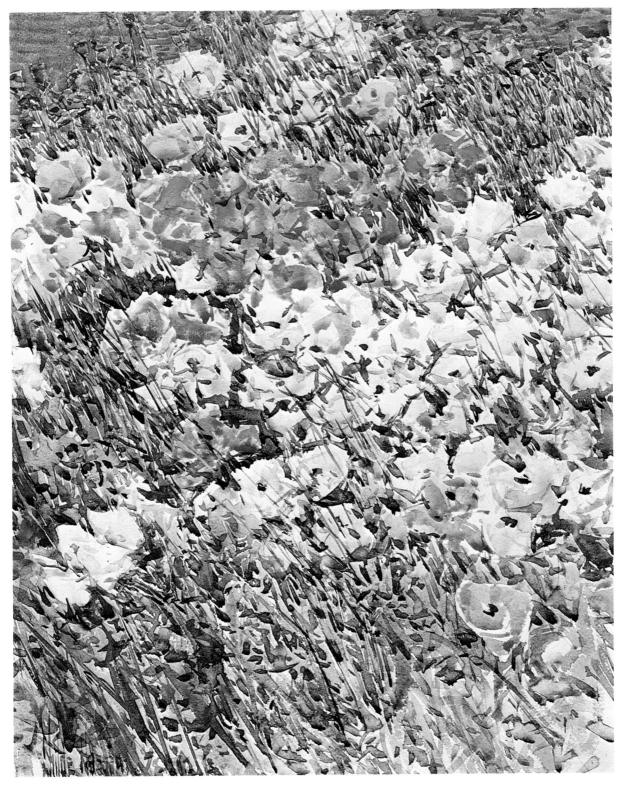

Fig. 205. CHILDE HASSAM, *The Island Garden*, 1892.
Watercolor, 17½ x 14".

Fig. 206. MAURICE PRENDERGAST, *Picnic: Boston Garden*, c. 1895–1897.
Watercolor, 8¾ x 16⅝″.

which he also excelled—this work appears nearly two-dimensional, and thus looks toward the flattening of form which occurs increasingly in his mature work.

A number of Prendergast's masterworks were made in Venice in 1899, notably *Umbrellas in the Rain* (Museum of Fine Arts, Boston) and *Venice* (Fig. 207). In these works the artist appears to have heightened his sense of realism while also increasing his freedom of handling. Compositionally they are among the boldest of his career: *Venice*, for example, is divided horizontally, the lower portion consisting almost totally of reflections from a recent shower, while the figures, flags, blue sky, and the great cathedral of St. Mark's are given just the upper half of the sheet. The white of the paper is used for the women's white dresses and is seen throughout the foreground as well, somehow making believable the substance of the cobblestone plaza. Each color is applied wet, and one runs into another, reinforcing the blurred quality of reflection. Yet accident is always controlled by Prendergast, particularly in this series: each tone retains its own integrity, and each block of color, though quickly applied, was surely and carefully planned. The artist uses brushes of various sizes, and takes great care with detail, particularly in the architecture. The appearance is one of total spontaneity, though in fact it is exactly the precision of line and tone that results in this liveliest of American watercolors.

As he went on, Prendergast sought increasing unity of tone and

brush handling in his work. In *Central Park* of 1901 (Fig. 208), just two years later, one sees significant changes of approach: pencil strokes are barely visible, intensity of hues has been lowered—his favorite bright primaries nearly given up altogether—and one has instead a rich tonal study in blues and greens, with occasional dashes of yellows, browns, and violets. The paper's whiteness is still used effectively, though on a more limited basis; wet, swirling brush strokes are enjoyed for themselves; and the scene becomes ever flatter and more abstract.

Prendergast was taking regular trips to Paris where he was influenced by the French painter Paul Signac, and his watercolors continued to develop. His transparent style became looser and more two-dimensional, with individual strokes growing in importance, as in *Picnic Grove*, c. 1910 (Collection of Arthur Altschul). He continued to experiment in the second decade of the century and there are occasional moments of strength, but now more often ones of frustration. As he painted more in oils, his watercolors began to lose their richness and their transparency; in a late example, *Sunday Promenade*, c. 1915–20 (Yale University Art Gallery), he works and reworks his washes, finally resorting to heavy strokes of white and yellow gouache in order to keep the viewer's eye fixed on the surface of his sheet, as in the French paintings he admired so much.

That Prendergast's contemporary John Singer Sargent was one of the most brilliant watercolorists in history cannot be doubted, but there is some question whether he was an *American* artist. Critics of his own time, such as Sadakichi Hartmann, were inclined to see him as standing "at the head of English portraiture," and even as late as 1923 Royal Cortissoz made no mention of him in his *American Artists*, though devoting a chapter to his friend E. A. Abbey. Yet Sargent always retained his citizenship; he made a number of trips to the U.S. from his home abroad, and in fact many of his portraits and all of his great mural cycles were commissioned here. Moreover, he is rejected (among "Artists from Overseas") by Martin Hardie, the great historian of English watercolor, and in fact most of his work in this medium is now in this country, in the great collections at the Metropolitan Museum, Brooklyn, and Worcester (though little of it was executed here). However, his impact on American watercolor has been extraordinary; even today, artists trying to work in his style abound.

Sargent had two very different careers: one, from the 1870s to about 1900, when he became the most fashionable portrait painter in the world (and also learned about Impressionism directly from Monet); and the second, from the turn of the century to the war, when he traveled widely and created a tremendous number of watercolors. An able draftsman from the beginning, he did occasional watercolor studies early in his career, but they are few indeed.

Fig. 207. MAURICE PRENDERGAST, *Venice*, 1899.
Watercolor, 19⅜ x 14¼″.

Fig. 208. Maurice Prendergast, *Central Park*, 1901.
Watercolor, 14⅛ x 20⅞".

The watercolors dating just after 1900 are loosely handled and use only transparent washes; from these one assumes that Sargent must have known the work of both Whistler and Homer, though again no scholarly study of his style has been published. Certainly he worked so quickly that many—perhaps most—of his works fail. Yet his best ones bear out the words of Albert Gallatin, the first serious critic of American watercolor, when he commented upon "the marvelous dexterity displayed by Sargent . . . and the ease with which he washes in his drawings, as well as their superb breadth of treatment. They are arresting snapshots which dazzle us by their brilliancy, short-hand notes which display the painter's astounding skill."[31] (At the same time, Gallatin noted that "Homer . . . felt much more deeply.") Sargent's virtuoso style is seen in *The Escutcheon of Charles V of Spain*, 1912 (Fig. 209), which Hoopes calls "one of the most brilliant performances of his career."[32] Executed in Granada, depicting a carved coat of arms on a sunny wall, this is a study of tones, the varying tans and yellows interacting with pale-blue and violet complementaries. One feels little sense of brushwork for its own sake, but rather one of wonder at the reality of light and form which appears on the sheet.

Fig. 209. JOHN SINGER SARGENT, *The Escutcheon of Charles V of Spain*, 1912. Watercolor, 11⅞ x 17¾″.

More reminiscent of Homer's work in its cool tones and tropical subject is Sargent's *Muddy Alligators*, 1917 (Fig. 210), one of a series done in Florida in 1917 when he was there to paint a portrait of John D. Rockefeller. Perhaps with Homer in mind, Sargent here uses washes more transparent than usual (normally he seems to have employed *some* body color with almost every tone). Furthermore, he allows the pigments to run and blot, creating an extraordinarily rich composition in blues and greens.

Sargent felt none of Homer's reticence with regard to purity of wash or tone; rather, he used every possible trick to add dash to his watercolors. Gouache was thus perfectly acceptable where necessary; in *Gourds* of about 1908 (Fig. 211), heavy strokes of white and blue body color add to the sunlit effect, where Homer would have used the paper itself. Flattening form in Impressionist fashion, technically Sargent here comes closer to the late Prendergast than to Homer, and his bravura use of light and incredibly varied brushwork clearly demonstrate his affinity with the Impressionists of some thirty years before.

Homer and Sargent between them had carried the realistic watercolor mode to an ultimate point. Even as they were working, the style became "outdated" in terms of modernist discoveries, and with Sargent particularly one feels a conscious disregard for contemporary style. Nonetheless, their followers have probably increased in number regularly up to the present day; Sargent's achievement particularly is found

Fig. 210. JOHN SINGER SARGENT, *Muddy Alligators*, 1917.
Watercolor, 13⅞₁₆ x 20¹⁵⁄₁₆″.

Fig. 211. JOHN SINGER SARGENT, *Gourds*, c. 1905–1908.
Watercolor, 13¹³⁄₁₆ x 19¹¹⁄₁₆″.

echoed and reechoed each year, at hundreds of exhibitions, church fairs, and art colonies around the world.

For Albert Gallatin in 1922 the great American watercolorists were —in the order in which he discussed them—Whistler, Homer, Sargent, Dodge MacKnight, John Marin, and Charles Demuth. One must respect Gallatin's perspicacity, for five of these men retain high rank in our eyes today, while only one—Dodge MacKnight (1860–1950)—has been essentially forgotten. Yet the Museum of Fine Arts, Boston purchased the first of a now extensive collection of his work in 1907, five years before their first Sargent watercolor was acquired, and by 1916 he was the subject of an admiring biography.[33] MacKnight seems to have traveled everywhere: he did views of Morocco and Mexico, of New-foundland and New Hampshire—all in bright sunlight or snow. One of the first of a long line of Sargent's followers, his work shows neither subtle color, elegant handling, nor technical expertise. As Sherman E. Lee wrote, ''Certainly no man produced so much work and gave so little variety to it.''[34]

MacKnight was a Bostonian, and the New England area produced a great many of the better late academic watercolorists, perhaps because of Boston's long-standing admiration for Homer and Sargent. Among the best of their contemporaries was Edward Darley Boit (1840–1916), another well-traveled Bostonian who practiced a direct style, rather more precise than MacKnight's. In the same vein is the work of F. Hopkinson Smith (1838–1915) and Frederick Crowinshield (1845–1918), while later figures worthy of mention would include Robert D. Gareley (1875–1943), Frank W. Benson (1862–1951), best known for his sporting subjects, and Walter Gay (1856–1937), an expatriate who specialized in aristocratic room interiors. In the work of these artists and literally thousands of others less talented, the impact of Impressionism has been reflected down to the present day.

10

Illustration and Fantasy
at the Turn of the Century

Any survey of American drawings will include the work of many artists who were full- or part-time illustrators, and thus to single out a few for an examination of illustration as such is inevitably arbitrary. Our artists have been illustrators from the very beginning; one finds Jacques Le Moyne and John White making watercolors so they could be used in sixteenth-century illustrated books about the New World, while later Catesby and Bartram inaugurated the still-fecund tradition of the naturalist-illustrator. Illustration becomes even more important in the nineteenth century; throughout that period, the artist often thought in terms of book or magazine illustration, as seen with Cole, Homer, Eakins, Rimmer, and La Farge, to mention only a few. In the early part of our own century, the major draftsmen—realists and "modernists" alike—were trained as illustrators; and more recently there has been a renaissance of illustration and the making of fine books by Baskin, Rauschenberg, Motherwell, Dine, and others.

Yet despite all this, historians in the past have made great efforts to separate illustration from art: to be called an "illustrator" rather than an "artist" has been an ultimate mark of derision. It *is* true that the professional illustrator works under special conditions, for he must give prime consideration to whether a work will reproduce well in its final form (woodcut, photogravure, or whatever); he often must work quickly, with emphasis on immediate effect rather than subtleties of line or tone; and the drawings for a given book or article must be stylistically consistent (and thus repetitive). Nonetheless, even working with these restraints, the illustrator has made a major and still little-appreciated contribution to the arts in America.

255

Audubon's magnificent watercolors have already been discussed at length, but in the present context it should not be forgotten that nearly all of them were made as the basis for illustrated books, *The Birds of America* and *The Quadrupeds.* However, Audubon's work represents the culmination of a long tradition, that of the scientist-draftsman, and though this genre was carried on by his sons and by other naturalists and explorers, it never regained great strength or popularity.

Closer to the mainstream was the work of Audubon's contemporary David Claypoole Johnston; the drawings of this "American Cruik-shank" have been mentioned in Chapter 8. With his use of varied graphic mediums, his ability to reproduce his own drawings as prints, and his biting sense of humor, Johnston stands out as a pioneer American illustrator.

However, the most influential of the early illustrators was undoubtedly Felix O. C. Darley (1822–1888). During a long and tremendously prolific career, Darley became by far the most popular of American draftsmen; through the force of his art and the charm of his personality, he brought illustration into the mainstream of our art. Born in Philadelphia, Darley worked largely for the firm of Carey & Hunt during the early 1840s, and became a quick success through his drawings for John Frost's *Pictorial History of the United States.* Moving to New York in 1848, he began to exhibit book illustrations and banknote designs at the National Academy of Design, and became an Academician in 1853. The illustrated editions of Washington Irving's *Sketch Book* (1848) and the *Knickerbocker History of New York* (1850) brought him wide popularity. Working for *Harper's Weekly* and other magazines, illustrating the works of Irving, Cooper, Dickens, Long-fellow, and Harriet Beecher Stowe, he was recognized by contemporary critics as an artist of high merit, Tuckerman commenting that "he holds a master's pencil, and can do justice to the most earnest and pathetic sentiment."[1] His reputation continued undiminished, and in the last decade of his life his illustrations appeared in books beside those of a new generation—including Homer, Pyle, Abbey, and Remington.

Darley worked in various styles and mediums throughout his career, at times making quick pencil sketches, and on other occasions making detailed landscape drawings in the Hudson River manner or pure, finished watercolors of European scenes. However, he normally either brushed on sepia wash with white highlights over light pencil outlines, as in most of the early Irving drawings, or—in a very different manner—made pure outline drawings with a thin pen. These latter, such as the 1856 drawing for Sylvester Judd's novel of 1845, *Margaret* (Fig. 212), are characteristic of his work: his line here is flowing and confident, and derives ultimately from the earlier English draftsman John Flaxman.

Fig. 212. FELIX O. C. DARLEY, *Chilion Played and They Were Silent*, 1856. Pen and ink, 7½ x 9⅛″.

Winslow Homer was one of many artists who began their careers trying to emulate Darley's success, and Homer of course first became known through *Harper's* wood engravings of his Civil War drawings. Hundreds of artists flooded the field at this time, meeting the growing demand for drawings by the burgeoning illustrated book and magazine industry. Homer gave up illustration as soon as he was financially able to do so. ''Purer'' drawings and watercolors gave him more artistic freedom, but his early training always stood him in good stead. Other men, such as Harry Fenn (1845–1911), became popular illustrators, and stayed within the tradition of this painstaking craft.

One of the most admired artists of this period was Charles S. Reinhart (1844–1896), a New Yorker whose friends included Abbey, Stanford White, St. Gaudens, and Henry James. Trained in Munich, he was hired by *Harper's Weekly* in 1870 and did much of his work for that important firm; he also made oil paintings, watercolors, and etchings, and received many honors for them. The illustrations are uniformly made with black ink on white paper, as in *The Street Acrobats* from ''In Cornwall with an Umbrella'' (Fig. 213) published in *Harper's Magazine* in 1881. Reinhart's line is varied and lively, given the use only of line and a single pen. Unlike many of his lesser contemporaries, he

Fig. 213. CHARLES S. REINHART, *Street Acrobats from "In Cornwall with an Umbrella"*, 1881. Pen and ink, 10⅛ x 6⅞″.

Fig. 214. EDWIN AUSTIN ABBEY, *King Lear (Lear, Kent, Fool and Edgar)*, 1902. Pen and ink, 22⅜ x 17½″.

brings to the drawings enough sentimentality to make them readable, but not so much as to cloy.

Reinhart's pen-and-ink style was followed by many other artists, and indeed became the most popular illustrative mode of the late nineteenth century. Stemming from England, it was taken up by leading illustrators at *Harper's, Scribner's,* and the other New York firms, and particularly by Joseph Pennell (1860–1926) and Edwin Austin Abbey. Pennell was another of the extraordinarily prolific, well-known illustrators of the day. Equally facile as draftsman and printmaker, he traveled widely through Europe, producing many books of foreign scenery, as well as several works on illustration itself, including *Pen Drawing and Pen Draughtsmen* of 1889. Yet despite his immense learning, he was never a highly gifted or original draftsman, and the etchings remain outstanding in his oeuvre.

His contemporary E. A. Abbey, on the other hand, mastered the pen-and-ink style, becoming a truly fine practitioner of this medium, and he continued to develop his technique after moving to England in 1878. As an illustrator, Abbey drew for an international audience, and his move abroad caused none of the changes in style or patronage that were sometimes faced by expatriate painters. He was genuinely Anglo-

American, and his major projects in illustration continued to be done for Harper's (including editions of Dickens' *Christmas Stories*, 1875, *Selections from the Poetry of Robert Herrick*, 1882, and *The Comedies of William Shakespeare*, 1899), just as his important paintings were shown in Boston, New York, and Chicago as well as in Paris and London.

Abbey's pen drawings have elegance from the beginning: in the Herrick drawings, then in such works as "Am I in face today?" from Goldsmith's *She Stoops to Conquer* (1884; Yale University Art Gallery), he demonstrates a richer variety of tone and a stronger sense of composition than his contemporaries. By the 1890s Abbey was working even more powerfully in this medium, despite occasional forays into gouache, watercolor, and even oil illustrations, and he reaches his peak in drawings for *The Tragedies and Histories of William Shakespeare,* a book project which was never published. The drawings themselves increase in size, ambition, and power: in "Lear, Kent, The Fool, and Edgar" from *King Lear* (Fig. 214), the artist explores a wide range of textures and of values, from the white of the paper to pure black in the sky. Hatching is strong and never repetitive, and one feels the raging, stormy wind echoing the anguished emotions of the players. Technically unsurpassed, the late work takes Abbey beyond the normal role of the illustrator: these drawings have equal impact as drawings *per se* and as illustrations.

The linear pen-and-ink style gained special popularity during the 1880s, and was practiced for thirty years thereafter by such artists as Thure Thulstrup (1848–1930), William Allen Rogers (1854–1931), William A. Sherwood (1875–1951), Alfred-Laurens Brennan (1855–1921), and Joseph Clement Coll (1881–1921). The style remained essentially static, though Coll on occasion worked in a bravura manner that surpasses even Abbey in immediacy and linear force. Abbey always kept in touch with his subjects, relying on accuracy of setting, costume, and mood; Coll, on the other hand, in his drawings for Talbot Mundy's *King of the Khyber Rifles* (Fig. 215) made for *Everybody's Magazine,* discards the normal restraints of illustration for a demonstration of pen draftsmanship for its own sake.

Elihu Vedder (1836–1923) was as erudite, as ambitious, and as prolific a draftsman as Abbey, and his rambling autobiography, *Digressions of V*, is one of the most charming volumes of the period. Like Abbey a muralist, easel painter, and illustrator, he was also an expatriate, having settled permanently in Rome in 1867. He drew constantly, using paper of widely varying color and texture, and pens, pastels, and chalks of every hue. However, the figure studies are often labored, and it was in illustration that he reached his peak. Indeed, his *Rubáiyát of Omar Khayyám* (1884) was widely regarded as the greatest of all American illustrated books, and Vedder owed much of his reputation to its success. As Royal Cortissoz wrote: "The conclusive triumph

Fig. 215. JOSEPH C. COLL, *King of the Khyber Rifles*,
c. 1905. Pen and ink, 13¼ x 8½″.

Fig. 216. ELIHU VEDDER, *In Memoriam*, from the
Rubáiyát of Omar Khayyám, 1884.

denied him as a painter . . . he won when he made his famous designs
for 'Omar Khayyam,'. . . and the monotone of the reproductions with-
drew attention from everything save his felicities of design and the
graceful eloquence of his line.'[2] Vedder designed the whole book, from
the heavy embossed cover to the text and drawings combined on each
page (see Fig. 216): here he went beyond contemporary practice, for
he brought to the sensual Persian poem his own line and design, thus
giving perfect expression to the *fin de siècle* mood.

Representative of the same languorous moment is the art of Dennis
M. Bunker, a short-lived Bostonian of enormous gifts. Trained first
under Chase and then in Paris at the Académie Julien and with Gérôme,
he was a particular friend and admirer of Sargent and Abbott Thayer.
During a brief career he painted a few nearly-Impressionist landscapes
and a number of accomplished portraits, and developed a highly nerv-
ous, personal style of draftsmanship. Working with a sharp pen,
echoing Art Nouveau as Vedder had, Bunker made drapery and figure
studies, as well as designs for sheet-music covers and other illustrations
(see Fig. 217), all in a taut, controlled, yet sensuous mode.

Fig. 217. Dennis Bunker, *Drawing for Sheet Music Cover*, 1889.
Pen and ink on bristol board, 14½ x 18½″.

A contemporary of Bunker's who was even more highly regarded at the time but is little known today was Robert F. Blum. Trained in lithography, Blum worked as an illustrator for Scribner's in New York beginning in 1879, and practiced this craft even after gaining great reputation as a painter and pastelist. Indeed, he traveled to Japan in 1890 in order to make a set of illustrations for Sir Edwin Arnold's *Japonica*. His drawings in every medium—as in *Joe Jefferson as Bob Acres in "The Rivals,"* c. 1880 (Fig. 218)—combine quick, telling strokes with an inherent sense of volume and light. Blum's work is elegant and economical above all, and he is found at his best in his pure drawings.

Quite different is the work of Arthur Burdett Frost (1851–1928), another of the Harper's illustrators and a friend of Abbey and Reinhart. His specialty was outdoor, sporting scenes that relate to the paintings of Tait and Eakins and were aimed at a broad, popular audience. Another tremendously prolific draftsman (in one year doing over two hundred drawings for publication), he was apparently the first American to draw "comic serials" (see Fig. 219): here he showed both the

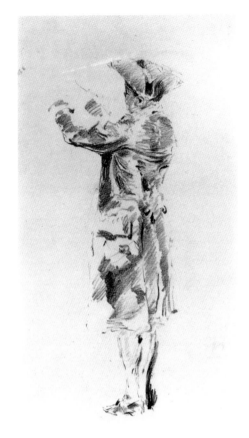

Fig. 218. ROBERT F. BLUM, *Joe Jefferson as Bob Acres in "The Rivals,"* c. 1880. Pencil, 9½ x 3⅝".

Fig. 219. A. B. FROST, *Ouch!*, c. 1890–1899. Pencil, 9¹³⁄₁₆ x 7".

quick graphic touch and the lively sense of humor that typify his work, and that appear in more finished form in the best of his illustrated books, such as *Uncle Remus.*

Less gentle was the humor of Thomas Nast (1840–1902), whom Boss Tweed of New York called "my most powerful enemy." One of the first political caricaturists in America, Nast created images of the Tammany tiger, the Republican elephant, and the Democratic donkey that have become part of America's visual vocabulary. Appearing most often in *Harper's* during the 1860s and 1870s, when his best work was done, Nast's pen-and-ink drawings such as *Let us PREY* from *Harper's Weekly,* September 23, 1871 (Fig. 220), had both political and artistic power; they owe more to the French tradition of Daumier and Gavarni than to the influence of *Punch* and other English magazines.

As the number of illustrated books and periodicals grew, so did the areas in which illustrators could specialize. Literary subjects continued to be popular, and Darley and Abbey were joined in this field by many others. Other draftsmen concentrated on different areas, as Nast with political satire or Frost with the great American outdoors.

One of the "newer" subjects which became popular in the 1890s

Fig. 220. THOMAS NAST, *Let us PREY*, from *Harper's Weekly*, September, 1871.

Fig. 221. FREDERIC REMINGTON, *Commanche Scout*, 1890. Pen and ink, 28½ x 17″.

was the American West. The frontier was dying, and the imagination of eastern readers was piqued by stories and pictures dealing with the great rugged romance of Indian and cowboy life. Two specialists in this genre, Frederic Remington (1861–1909) and Charles Russell (1864–1926), have gained major reputations today, when their subjects have far more appeal than those of Abbey or the others. However, the critic Sadakichi Hartmann summed up "serious" opinion of the period when he linked Remington with Charles Dana Gibson (1867–1944), writing that they "enjoy, of late, an undue share of popularity. They are both close observers of the *immediate*, with great facility of expression, the one for society types, the other for rougher specimens of humanity, like cowboys, soldiers, etc. Remington has a good deal of vigour, Gibson a certain dash, but both only 'represent,' and 'suggest' absolutely nothing."[3] Most art historians still feel this way—that Remington's work is superficial at best—and they resent its wide and genuine popular appeal. Remington's subjects are indeed crucial for his art: his vigor and enthusiasm are easily appreciated, as is his anecdotal, detailed style (which relates to the work of French artists such as Edouard Detaille [1848–1912], whom he admired).

Fig. 222. CHARLES M. RUSSELL, *On the Flathead*, 1904.
Watercolor, 11 x 16".

Remington's first trip West took place in 1880, and his sketches ap-
peared in *Harper's* beginning in 1882. Later he exhibited at the Ameri-
can Water Color Society and at the National Academy, and of course
became as well known for his sculpture and his painting as for his il-
lustrations. As a draftsman he was at his best in the finished ink draw-
ings made with a fine pen. In *Comanche Scout* (Fig. 221), for example,
one sees the artist's skill particularly with the horse, without the loss of
conviction which so often accompanies his quicker brush drawings and
watercolors.

Even more problematic is Charles M. Russell, whose work, despite
its vogue among collectors of western Americana, has gained little
serious critical attention. Though he is often coupled with Remington,
his popular reputation was gained only after Remington's death. The
two men were quite different personally as well, Remington remaining
an Easterner who traveled West occasionally, while Russell lived in
Montana and there took on the role of homespun philosopher and wit.
Pictorially he relied almost wholly on his exotic subjects, which he
portrayed in exaggerated, bright colors; seldom do his pictures demon-
strate the physical structure or level of craft which can be found in
Remington's work. Nonetheless, his watercolors (see Fig. 222) were
reproduced in *Scribner's*, *McClure's*, *Outing*, and *Leslie's* magazines,
among others, and they gained a wide audience.

Henry F. Farny (1847–1916) worked with similar subjects throughout a long career as an illustrator, and in retrospect he may well be the ablest of the late western artists. Certainly he was far better grounded academically than Remington or Russell, having studied in Rome and Düsseldorf in the mid-1860s, then in the early seventies going back to Vienna and Munich, where he worked with Wilhelm von Diez (1839–1907) and with his fellow Cincinnatian, Frank Duveneck. Though he made pen-and-ink illustrations, as well as watercolors and oils, his forte surely was the gouache (see Fig. 223). Often of small size, these works were executed with care for detail, an ability in rendering perspective, and a dramatic but believable sense of color. Where Remington and Russell sought out the action of a massacre or round-up, Farny portrayed the Indian with dignity and a concern for real space and atmosphere. But both his personality and his pictures were quiet, and he never became widely identified with his favorite western subjects.

Somewhat similar is the case of William R. Leigh (1866–1955), another well-trained artist who won several honors in Munich before returning to the United States in 1896. As an illustrator for *Scribner's* and *Collier's*, he worked largely in black and white, preferring charcoal over other mediums. Robert Taft, the historian of the western illustrators, wrote that "of all artists who have entered this field exclusively, Leigh's mastery of draftsmanship is the surest and most skillful,"[4] and this judgment is reinforced by the drawings themselves. Whether working on a large scale, as in *The Buffalo Drive* (Fig. 224), or making elegantly wrought studies of single figures in motion (Fig. 225), Leigh demonstrates a subtlety of touch and a sureness of modeling that eluded his better-known contemporaries.

The illustrators, western and otherwise, were "academic" in the sense that they were well-trained craftsmen who knew European styles and subjects, who normally had to master figure drawing, and who often worked in a wide variety of mediums—and all of this was held against them. To be both academic *and* an illustrator has been nearly a guarantee of critical oblivion in America, and thus there are major talents whose careers are now nearly unknown. One example would be J. Carroll Beckwith, who—again—earned wide respect during his own lifetime. A pioneer in pastel, an experimental etcher and lithographer, a respected painter of portraits as well as genre and historical scenes, Beckwith is now forgotten. Yet he had been a fellow pupil with Sargent of Carolus-Duran in Paris (1873–78), and he later won a number of medals in both France and the United States. Like many of his fellows, he found little distinction between "high" and "popular" art: he was known equally for his portrait of Theodore Roosevelt, his decorations at the Columbian Exposition, and his Christmas card designs for Louis

Fig. 223. HENRY F. FARNY, *In the Enemy's Country*, 1900.
 Gouache, 10½ x 17½″.

Prang, the chromolithographer. Nonetheless, Beckwith's finest work
appears now to be the elegant, small-scale drawings executed in a linear
manner with delicate, colored chalks, as in his *Portrait of a Young
Woman* (Fig. 226).

Beckwith typifies turn-of-the-century illustrators in discarding the
pen-and-ink mode for a gentler harmony of color and line sought through
many mediums. Handsome ink-and-watercolor drawings were made at
this time by J. C. Center (?–?), while a fine though rather faint
calligraphic hand is seen in the travel sketches of Andrew Fisher
Bunner (1841–1897). The same aesthetic appears in the watercolors of
Albert Prentice Button (1872–1934), one of the Boston illustrators who
rejected the bravura style of Sargent and his school for the use of sub-
dued colors in a delicate, detailed manner which looks back to the
Pre-Raphaelites (see Fig. 227).

Walter Appleton Clark (1876–1906) followed a similar route, seek-
ing mood rather than personal expression in his illustrations. A New
Englander who admired Whistler and Puvis de Chavannes, he enjoyed
training in both Paris and New York, as with many of his contem-
poraries. By his early twenties he demonstrated a mature talent. De-
liberately restricting his palette to dark tones, using heavy, muted
washes, "enthralled" by night as one critic wrote,[5] in drawings such

Fig. 224. WILLIAM R. LEIGH, *The Buffalo Drive*, c. 1905–1915.
Charcoal on canvas, 19½ x 30½″.

Fig. 225. WILLIAM R. LEIGH, *Figure Studies*, c. 1905–1915.
Charcoal, 18½ x 24″.

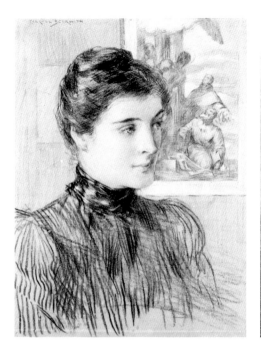

Fig. 226. J. Carroll Beckwith, *Portrait of a Young Woman*, c. 1900. Colored chalks, 10⅞ x 8⅛".

Fig. 227. Albert P. Button, *On the Sands*, c. 1900–1910. Watercolor, 7³⁄₁₆ x 8⅝".

as *Daily Bread* (Fig. 228), which appeared in *Scribner's* in December 1898, he expresses the genteel anguish of the times.

Perhaps the most celebrated of all of the turn-of-the-century men was Howard Pyle (1853–1911). In his career one finds the culmination of many aspects of American illustration, as well as the beginnings of new attitudes toward that art. Pyle was a friend of Abbey, Chase, and Reinhart, all of whom he knew in New York when he studied at the Art Students League in the late 1870s. His work is related to theirs in its consciously archaic style and his medieval and fairy-tale subjects, which included illustrations for *Robin Hood* (1883) and *The Story of King Arthur and His Knights* (1903). But he went beyond the earlier men in many ways: he wrote books as well as illustrating them, he believed in illustrating (along with mural painting) as the highest art, and he grew wealthy doing it. Most important, he rejected the notion of foreign training, and had great impact as head of "the most famous and productive school of illustrators in our history."[6] Teaching first at the Drexel Institute in Philadelphia and then in 1900 opening the Howard Pyle School of Art in Wilmington, Delaware, he numbered among his students N. C. Wyeth (himself a master illustrator who, unfortunately for our purposes, worked usually in oil), Violet Oakley, Frank Schoonover, and Maxfield Parrish.

Though Pyle dealt with a wide range of subjects, becoming particularly adept at colonial and revolutionary subjects, it was his ad-

venturers who best captured public imagination. As Samuel Isham wrote, "Surely never before were pirates so satisfactorily bloody-minded offered for the delectation of youth."[7] Though his methods varied, he often worked in pen and ink, at times emulating Dürer's woodcuts, as in *The Fishing of Thor and Hymir, Study for the North Folk Legends of the Sea* (Fig. 229)—tough, flat, highly effective, with little conscious suavity about it. Certainly the influence of the Arts and Crafts movement may be seen here. Yet as he went on, particularly after 1900, he turned to more "painterly" modes, sometimes using oil paint itself, at other times working in gouache or watercolor. Interestingly, there exists a small, elegant watercolor version of *Thor and Hymir* (Delaware Art Museum) which follows Figure 229 almost exactly.

Maxfield Parrish (1870–1966) was a student of Pyle's who, like N. C. Wyeth, painted his illustrations more often than he drew them. However, his early drawings particularly are astonishing in their

Fig. 228. WALTER APPLETON CLARK, *Daily Bread*, 1898. Washes, 20¼ x 11¹⁵⁄₁₆″.

Fig. 229. HOWARD PYLE, *The Fishing of Thor and Hymir*, 1901. Pen and ink, 8⅛ x 4½″.

Fig. 230. Maxfield Parrish, *Baa Baa Black Sheep*, 1897.
Pen and ink, 12¾ x 10⅜".

Fig. 231. DAVID PELL SECOR, *A Refuge from the Storm, A Shadow from the Heat*, c. 1889. Pen and ink, 14 x 11″.

originality. *Baa, Baa Black Sheep* (Fig. 230), executed for L. Frank Baum's book *Mother Goose in Prose* (1897), is at once stippled and splattered while displaying total control of line and space. Parrish's work has about it an apparent naïveté that charms all ages, and makes it a perfect vehicle for the exotic or imaginary tale. Indeed, by the 1920s he had become one of the most widely reproduced artists in the world.

A possible influence on Parrish was the now-forgotten David Pell Secor (c. 1824–1909), an art critic and collector of plants and Indian relics who spent much of his life in Bridgeport, Connecticut. His drawing, *A Refuge from the Storm, A Shadow from the Heat*, c. 1889 (Fig.

Fig. 232. GEORGE H. HALLOWELL, *The Tree*, c. 1910–1920. Watercolor, 26 x 18¾″.

Fig. 233. WILL BRADLEY, *Pausias and Glycera*, 1895. Pen and ink, 7⅞ x 5⅛″.

Fig. 234. FRANKLIN BOOTH, *Illustrations for Battledore and Shuttlecock* by Amy Lowell, 1916. Pen and black ink, corrections in white gouache, 18⅞ x 14″.

231), is a tour de force in pen-and-ink stippling technique. Its vision, like Parrish's, represents a totally imaginary, airless world which remains as mysterious as its creator.

Related to Parrish also is the work of another Bostonian, George H. Hallowell (1872–1926), a painter, illustrator, and architect. Sargent believed that he had the finest decorative talent in America, and encouraged him by buying several of his works.[8] Yet in both his altar-piece and stained-glass design and in the watercolors from nature, he rejected the bravura technique of Sargent and of his own teacher, Frank W. Benson, and essayed instead a tightly wrought style of exaggerated colors and value contrasts. Among his best subjects were trees in the snow (see Fig. 232), which elicited great admiration from the critics. On one occasion, W. H. Downes wrote of Hallowell: "he feels the dignity and strength of old trees, and . . . lends to inanimate nature a semblance of almost human personality. His trees seem to be telling a wonderful story of struggle, effort, and achievement . . ."[9]

One of the strongest of American illustrators was Will Bradley (1868–1962), a master of line and design. Bradley's work in posters, books, and drawings (see Fig. 233) suggests the influence of Art Nouveau, of Lautrec, of the Arts and Crafts movement, and of Beardsley above all. Unifying typeface with illustration, pushing toward ever more elegant, sensuous productions, he appeared the perfect sophisticate; yet he was largely self-educated, and his style was very much his own. For two years he issued his own magazine (entitled *Bradley: His Book*), "for the exclusive display of his various efforts in decorative art." Like many illustrators, he had no fear of combining the practical with the profitable or the beautiful with the readable, writing on one occasion: "My constant efforts have been to make better and more refined that art which walks hand in hand with business."[10] By 1910 his career as an illustrator was largely over, and he devoted much of his time thereafter to his work as art director of *Collier's Magazine*.

Another highly regarded "decorator" of books and magazines, as well as advertisements, was Franklin Booth (1874–1948). Like Bradley, he taught himself to draw—in his case making painstaking copies of illustrations made from steel and wood engravings; his mature style stands in considerable contrast to Bradley's, retaining as it does an engraving-like appearance, with strong emphasis on black and white contrasts (see Fig. 234). Interestingly, this method may have influenced Rockwell Kent (1882–1971), for the latter's work in pen and ink also refers strongly to the wood engraving.

The animal world became another popular specialty, particularly as interest in the preservation of endangered species grew in the twentieth century. One practitioner was Charles Livingston Bull (1874–

Fig. 235. HARRISON CADY, *Cartoon for the Burgess Series*, 1916.
Ink and washes, 14½ x 18″.

1932), an explorer, taxidermist, and conservationist who was espe-
cially concerned with the plight of the American eagle. Yet of the animal
drawings surely the most remarkable are those of Gerald H. Thayer
(1883–1935), the son of the painter Abbott Thayer. The latter had a
strong interest in ornithology and in animal colors, and had published
Concealing Coloration in the Animal Kingdom in 1909. Gerald made
about two-thirds of the watercolor illustrations for this book, the result
of many years of travel and study for both father and son. Abbott
clearly distinguished this work from his ideal paintings, writing ''I have
to work up through this *science load* that accumulates on my shoulders,
to my art, because on that I must be wholly free.''[11] The point that the
Thayers were making was scientific, but their means—in such works as
Gerald's *Male Ruffed Grouse in the Forest* (Fig. 236)—are astonishing
demonstrations of watercolor technique, perfectly consistent with the
anti-Sargent school which existed at the time.

Less serious in intent but no less appealing are the animal drawings
of Harrison Cady (1877–1970), a popular cartoonist and illustrator
during much of this century. Beginning with odd jobs in 1895, in 1911
he began a long career with *Life* and drew for a great many other
magazines and books as well. Best remembered for his depictions
of Peter Rabbit, Reddy Fox, Jimmy Skunk, and other characters from

Fig. 236. GERALD H. THAYER, *Male Ruffed Grouse in the Forest*, c. 1905–1909.
Watercolor on cardboard, 19¾ x 20″.

Fig. 237. JOHN HELD, JR., *Entertaining Royalty*, c. 1920–1930.
Ink and washes, 10 x 15¾″.

Burgess's *Old Mother West Wind* (see Fig. 235), his work is exuberant and humorous, and it influenced many later draftsmen.

Finally, mention should be made of John Held, Jr. (1889–1958), whose drawings of fifty years ago are still humorous today. Norman Rockwell wrote accurately that "Held, more than anyone else, expressed . . . the brash spirit of the twenties with his famous flappers and collegiate capers, bootleg gin, jazz bands, and necking parties. His drawings, highly stylized, are fragile and delicate, yet entirely appropriate to the artificiality of the era."[12] His incisive, linear drawings parody his time (see Fig. 237), and both his wit and his economy of line became traditions still carried on in the excellent cartoons of *The New Yorker*. His work in a sense thus carries illustration to the modern era: the illustrator's task had run full course, from the satire of Johnston and Darley, to the labored, intellectual drawings of Abbey, then to the incredible fairy world of Parrish and Bradley, and finally again to the single drawing simply as drawing, as a quick and humorous insight into daily life.

11

Twentieth–Century Realism

Though divisions between academic and realist, or abstract and tradi-
tional, artists never became so intense in America as in Europe, none-
theless one can distinguish two major trends in American drawings
before the Second World War. One is that of the realists, led at first by
the former journalistic illustrators of The Eight; the other (to be con-
sidered in the following chapter) is that of the modernists, who had
learned the lessons of Cubism, and who in their early days formed a
cohesive group around Alfred Stieglitz. Still, this division should not
be over-stated, for in fact "realism" in some sense remained basic to all
American artists until the 1940s and Cubism (like Impressionism before
it) was never fully absorbed into American style. Our realists and
modernists never made up two warring camps here, and in fact they
often overlapped, with artists' changing styles. Nonetheless, one can
also discern basic distinctions between them. The realists, for example,
generally worked in black and white, and the heritage of the illustration
remained strong; for them subject and meaning outweighed questions of
style or execution. For the modernists, on the other hand, style was
everything, and their subjects tended far more often to be still lifes
of simple objects; and watercolor was their favored medium.

Crucial for the development of a new, anti-academic realism was the
gathering of several progressive artists in New York just as the
twentieth century began. The leader of the group was Robert Henri
(1865–1929), who, like several of the others, had studied with Thomas
Anshutz at the Pennsylvania Academy in Philadelphia in 1886; had
taken several trips to France; and by 1900 had moved to New York, hav-
ing himself become an influential artist and teacher. Gathered around
Henri in Philadelphia during the 1890s had been several other future
members of The Eight, including Everett Shinn (1876–1953), William

Glackens (1870–1938), John Sloan (1871–1951), and George R. Luks (1867–1933), all one-time students at the Academy who were then working as illustrators for various Philadelphia newspapers. These men had in common their disgust with the academic style and ideal subjects then prevalent at the National Academy; as political liberals and former newspapermen, they believed that paintings and drawings should portray a wide range of subjects, including profane and vulgar events from daily life. "The Eight" were so-called because eight artists grouped together to exhibit independently of the National Academy, and they did so in 1908 at the Macbeth Gallery in New York. Henri, Luks, Glackens, Sloan and Shinn were joined by Arthur B. Davies (also discussed in this chapter), and two quite different artists whose work brought them close to Impressionism, Maurice Prendergast and Ernest Lawson (1873–1939). By the 1930s critics had derisively dubbed them the "Ashcan School," implying that they painted ugliness for its own sake.

These artists had a powerful vision which was often best expressed in their drawings. Particularly memorable graphic images occur in Everett Shinn's work from the first decade of the twentieth century, when he took up pastel and used this previously genteel medium—perhaps ironically—to depict some archetypal Ashcan School subjects. Having studied at the Pennsylvania Academy under Anshutz and Henri while earning a living as an illustrator for the *Philadelphia Press* and other journals, Shinn came to New York in 1897; he had been preceded by Luks and Glackens, and was followed by Henri in 1899 and Sloan in 1904.[1]

Even in the early work, such as *Sixth Avenue Elevated After Midnight* of 1899 (Collection of Arthur Altschul), Shinn's drawing manner is more expressive and less detailed than one would expect of an illustrator. What concerned Shinn was the overall scene and his own reaction to it, and thus his pastels are used quickly and emotionally. One finds little here of the painterly softness of Chase, or the delicate touches of color or line of Whistler or Dewing; rather, the chalks are used quickly, brutally, in short jagged strokes and with an emphasis on black and white with occasional bright colors. The artist reached his full powers with the medium very quickly; *The Docks, New York City*, 1901 (Fig. 238) is typical of his ragged subjects and his ragged technique, the composition flat and crowded, the scene characteristically portraying the quiet desperation of the urban poor. This is a finished, self-contained work, related to illustration but not meant to be reproduced; its style is the same that Shinn practiced—with slowly decreasing abilities—for another four decades.

One of Shinn's colleagues during these years was William Glackens, both having been in the Henri circle in Philadelphia, and both working for *The World* during the late 1890s. (On one occasion about 1903 Glackens made an elegant red-chalk drawing of Shinn, now in the

Fig. 238. EVERETT SHINN, *The Docks, New York City*, 1901.
Pastel, 15½ x 22″.

Horowitz Collection.) Yet despite their personal closeness, Glackens
developed his own drawing style, one that was more varied and more
appealing than Shinn's.

Early in his career Glackens made the drawing called *Seated
Woman* (Fig. 239) in charcoal and washes heightened with pastel (pos-
sibly in tribute to Shinn's use of the medium), and he gave it to his
friend Shinn. The fashionably dressed woman in her hat and veil is
drawn quickly and freely, yet her form rests comfortably in space, and
the artist uses a thick, dark line with total ease; like the other members
of The Eight, Glackens had been to Paris, and this is a drawing of
which Whistler or Sargent would have approved.

Glackens brought an elegant, direct handling to his drawings that
rarely appears in his painted work. Even in the pure illustrations, such
as *The Balcony* (Fig. 240)—a study in washes heightened with white,
which accompanied "The Hermit of Rue Madame" by William Le
Queux in the April 1899 issue of *Ainslee's Magazine*,[2]—one senses a
French touch—a quickness of execution combined with profundity of
observation, while the close-up, angular composition recalls Degas and
Lautrec. Thus the French influence which so mars his paintings anoma-
lously serves to strengthen the drawings. It should be added that, like
Shinn, his most creative work was done before the war. With both men,
the early drawings seem marked by a feeling that things could actually
be changed, that opinions might be swayed by drawings, prints, or il-

Fig. 239. WILLIAM GLACKENS, *Seated Woman*, c. 1902.
Charcoal, 18⅝ x 14¾".

Fig. 240. William Glackens, *The Balcony*, 1899.
Sepia and black ink heightened with white wash, 9½ x 12".

lustrated material; after the war, both turned increasingly to paintings which had little to say, perhaps in response to the new political and economic climate.

In many of their strongest drawings, these socially conscious artists used the most basic of mediums, pencil on white paper. These works have an unstaged quality of observation about them: one feels the artist simply observing, letting his subjects tell their own stories. Glackens had a sophisticated hand and eye but he took care not to show it, particularly in the commonplace subjects, the New York street scenes and the like. Thus in his *Curb Exchange No. 2* (Fig. 241), the pencil is used skillfully to indicate texture, depth, and value, as the "serious" businessmen are contrasted with the apple sellers during the hubbub of a hot day—and Glackens, here the illustrator, never allows his methods to intrude.

The same use of soft pencil is seen in the best of John Sloan's drawings, such as *His Country's Flag*, 1912 (Fig. 242). Like the others, Sloan had been influenced by Anshutz and Henri, and moved to New York in 1904, after which he continued an active career as an illustrator. "The most politically oriented of The Eight and . . . a member of the Socialist Party for four years,"[3] Sloan recorded the urban scene more

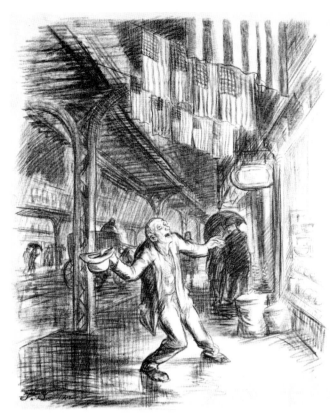

Fig. 241. WILLIAM GLACKENS, *Curb Exchange No. 2,*
c. 1907–1910. Watercolor and black pencil,
24 x 17½".

Fig. 242. JOHN SLOAN, *His Country's Flag,* 1912.
Pencil, 21¾ x 17⅝".

directly and more bitterly than his colleagues: *His Country's Flag*
approaches Daumier in its depiction of an old drunk, staggering in the
rain beneath the Third Avenue "El" and rows and rows of American
flags. And again like the others, Sloan's best work occurs early, when
The Eight were still the avant-garde, when the *New Masses* and other
magazines were using their provocative drawings, before they became
self-conscious teachers and preachers.

Closely associated with Sloan was Jerome Myers (1867–1940), who
spent much of his career recording the New York scene in pastel or
pencil drawings. Allied with The Eight in many ways (Sloan wanted
him to be a member, but Henri blocked it),[4] Myers was involved in both
the Independent Artists exhibition of 1910 and, as an organizer, the
Armory Show of 1913. His urban views often present biting images of
the poor, as in his *Street Scene, New York* of 1906 (Metropolitan
Museum of Art). Perhaps his strongest drawings, however, are the
series of pastel self-portraits executed over the following few years
(see Fig. 243), Myers here created a strong, highly introspective group
of images of himself, one that is nearly unique in American art. The
example in the Altschul Collection stands out: white chalk and charcoal

are used on a deep-red paper to highlight the artist's face and give full expression to the pained expression in his eyes.

Pastel had something of a second revival just before the war, with a new Pastel Society being formed in 1911, and a variety of artists turning to the medium on occasion—perhaps now inspired by Shinn's achievements. However, pastel increasingly became a painterly medium,

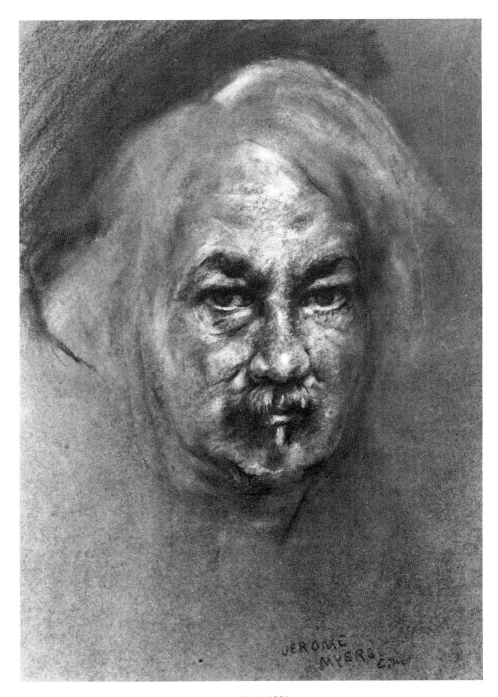

Fig. 243. JEROME MYERS, *Self Portrait*, c. 1915–1920.
Pastel on brown paper, 15⅜ x 12½".

Fig. 244. ARTHUR B. DAVIES, *Study of a Man Standing*, c. 1909.
Black and white chalk on gray paper, 14¼ x 11⅛".

used to give expression to form and light. One artist who employed
it was Arthur B. Davies (1862–1928), who is best known today as a
major force behind the Armory Show and as a painter of exotic ideal
scenes. However, Davies was also an astonishingly prolific draftsman,
who besides pastel used pencil, crayons, watercolors on every possible
kind of paper. At his best, he could be very good. *Purple Landscape*
(Metropolitan) is a loose pastel in greens and blues which approaches
true Impressionism. *Study of a Man Standing*, c. 1909 (Fig. 244), ex-
ecuted in white chalks on a dark paper, has surprising emotional

Fig. 245. ROBERT HENRI, *Painter and His Model*, c. 1918.
Pastel, 12 x 19½".

strength, and speaks again of a nearly forgotten decade of great drafts-
manship in America.

Robert Henri's role in leading American artists toward a new,
tougher realism has already been noted. Like Eakins and Anshutz
before him, he was a teacher of widespread influence, a leader who
helped make possible some of the key exhibitions of his time, and a
major theoretician. He was not generally a gifted draftsman, though
a powerful painter at times, and perhaps not surprisingly, some of his
best drawings are painterly pastels that occur rather late in his career.
Painter and His Model (Fig. 245) was probably done on the third and
last of the artist's trips to Monhegan Island, Maine, in 1918, for in
its very loose execution and varying green tones it is close to dated
works of that year. For a realist leader, it is surprising in many ways,
not least because it represents a last, Sargentesque look at Impression-
ism. Henri of course had been in Brittany in 1889 and had studied with
the Philadelphia Impressionist Robert Vonnoh (1858–1933); a few of
his oils of the early 1890s come as close as any American paintings to
genuine Impressionism. Here one finds the same spirit, the same interest
in light (now seen through darker hues) as before.

Henri once wrote, almost paraphrasing Eakins, "the nude is ex-

Fig. 246. ROBERT HENRI, *Nude Kneeling*, c. 1900. Brown tempera, 19³⁄₁₆ x 12¹⁄₁₆".

Fig. 247. GEORGE LUKS, *Man Asleep on Bench*, c. 1910–1915. Pencil, 7 x 5⅝".

quisite, the most beautiful thing in all the world.''⁵ His generation was the first to paint and draw the nude without self-consciousness; the female particularly became a basic subject in their prints and drawings. Henri did a number of nudes himself, most successfully when done rapidly and naturally: *Nude Kneeling* (Fig. 246), done with a brush and brown ink, must have taken no more than a few minutes, yet it contains a certainty of line and structure that must have pleased the artist.

As former newspapermen, The Eight loved the quick sketch; they valued their ability to capture the essence of a subject quickly, with a few brief lines. This was particularly true of Henri's friend George Luks, who had long experience in Philadelphia and New York as an illustrator and cartoonist. Luks' surly, somewhat brutal character is matched by many of his paintings, which often have strength while lacking technical facility. Yet as with others of his generation, the drawings reveal a different sensibility—and one that may better reflect the real artist.

Luks' sketchbooks were filled, as David Scott put it, with shorthand records ''of colorful characters of every sort—dock workers, slum

Fig. 248. GEORGE LUKS, *Woman and Turkey*, 1924.
Watercolor, 19⅞ x 13¾".

Fig. 249. GEORGE LUKS, *My Garden, Berk Hills*, c. 1931.
Watercolor and tempera, 14 x 20″.

children, and varied social outcasts.'"[6] He often used a black conté
crayon, slightly darker but otherwise very similar in effect to the soft
pencil used by Glackens and the others. In *Man Asleep on a Bench*
(Fig. 247), his strokes are short and certain; one feels in them little con-
scious artistry, but rather the drawing of a man who knew what he
wanted to say. Luks' sketches could express motion and energy as well
as repose, as seen in the vigorous drawing *Wrestlers* (a subject he later
used in a painting) at the Museum of Fine Arts, Boston. As a sketch-
book draftsman, Luks exemplifies the Ashcan School.

More surprising, Luks also used his broad graphic touch to make
figurative watercolors that are powerful yet elegant: in *George Parrish:
Interior of a Tavern* (Metropolitan Museum of Art) and *Woman and
Turkey* (Fig. 248), he uses broad, dark strokes of pure, transparent
watercolor to create energetic, almost frightening pictures of working-
class Americans. This use of watercolor (like Shinn's earlier use of
pastels) was highly innovative in America, and surely owes something
to the European drawings and watercolors Luks had seen at the
Armory Show. Even less expectedly, Luks carried on with experiment-

ing in watercolor, and long after his oil paintings had lost power he made a series of landscape watercolors that make use of vibrating, intense hues that recall the Fauves or Van Gogh. One of these is *My Garden, Berk Hills* (Fig. 249), dating from 1930–31, the culmination of a series begun about five years before: Luks instinctively takes Prendergast one step further toward Expressionism, using short, blocky strokes to dash a variety of intense blues, greens, reds, and oranges onto the white paper, creating a landscape far more emotional than observed.

The realist aspirations of The Eight climaxed in the work of George Bellows (1882–1925), who shared their major aims though he was never formally a member of the group, seldom did illustrations, and had none of the European travel and training that was so important to most of the others. When Bellows arrived in New York from Columbus, Ohio, in 1904, Henri took him on as his student for two years, and the two men became closer and closer friends over the years. Bellows was Henri's natural successor, and he accomplished with apparent ease many of the things Henri had attempted (just as Frederic Church had done in response to his teacher, Thomas Cole). Moreover, Henri thought that Bellows *should* have been in The Eight: "George would naturally have been of the group but it antedated him."[7] (This is puzzling in retrospect, for in the year of the 1908 exhibition Bellows exhibited at the National Academy, winning the second Hallgarten Prize and associate membership in that organization.)

Bellows' early drawings are shorthand notations in the manner of Henri or Luks. By 1913 and his study for *Cliff Dwellers*, (Los Angeles County Museum of Art) he was gaining control of form, handled here rather as Glackens did in *Curb Exchange No. 2*, with the emphasis still on the scene. From here, for the last ten years of his short life, Bellows went on to become one of America's graphic masters: he understood lithography as had no American before him, and his drawings are simply unsurpassed in their time. *Dance in a Madhouse* (Fig. 250), a study to scale for the lithograph of that title of 1917, makes use of black crayon, charcoal, pen-and-ink lines, and touches of red crayon and Chinese white. It is a technical and emotional tour de force. From the time of the early fight scenes, Bellows' crowds had been reminiscent of those of Goya and Gros: here one feels the undulating bodies, the gestures of agony, the loneliness of uncomprehending minds, as the dance goes on.

Another large drawing, almost equally powerful, is the football scene he entitled apocryphally *One Long Arm Spined Animal with Six Legs*, (Metropolitan Museum of Art) which again expresses intense emotion and physical energy through complex use of crayon, charcoal, and gray and black washes. Bellows here controls mass, motion, and value with great skill. Yet he also had a full understanding of pure line, as seen in the careful studies he made for his paintings, such as the

Fig. 250. GEORGE BELLOWS, *Dance in a Madhouse*, 1907.
Black crayon, charcoal, pen and ink, 18⅞ x 24¹⁄₁₆″.

Portrait of Mrs. Tyler (Fogg Art Museum), or—above all—the draw-
ing in lithographic crayon *Lady Jean* (Fig. 251), for the painting of
1924 at Yale. Moving over the paper without missing a stroke, Bellows
uses long firm strokes to delineate the striped dress in which his
younger daughter poses; he lightens pressure on the crayon to suggest
light, then presses harder on the right, creating shadows. Lines around
Jean's face and cuffs, on the other hand, are thin and calligraphic, while
the bodice is shown with tiny dots, each one different. Bellows uses line
here with perfect practicality, recording his daughter's appearance so
that he could paint her without long sittings; he also uses it with great
artistry, for every stroke of his crayon has a life of its own, and each
is a slight variation on the one next to it.

With Bellows' death in 1925, the realistic figurative tradition ap-
pears to have come to a kind of conclusion. Certainly the influence and

Fig. 251. GEORGE BELLOWS, *Lady Jean*, 1924.
Lithographic crayon, 22 x 13½".

Fig. 252. LILIAN WESTCOTT HALE, *Reverie: Portrait of Agnes Ruddy,* c. 1920. Charcoal, 22½ x 20″.

energy of Henri and his followers were waning, and realistic draftsmen went off to pursue several alternate directions. Men like Rockwell Kent (1882–1971) carried on the tradition of the illustrator, at times approaching Bellows' manner, though using a style of greater value contrasts, based perhaps on wood engravings. Glenn O. Coleman (1887–1932) was even closer to The Eight; an illustrator and a Henri student, he had exhibited in the shows of 1910 and 1913, and the best of his drawings, such as *Footlights* (Collection of Rita and Daniel Fraad), remind one technically of a softer version of Bellows.

In retrospect, one can see two basic types of realist drawings emerging from this era: one in which technical and iconographic Expressionism prevailed, such as has been discussed, and another, in which

technique and subject matter are subordinated to "mood." The latter category is one of gentle drawings, often reminiscent of the Edwardian era; they are likely now to be considered "academic." Yet certainly worthy of mention are the figure drawings of such artists as Lilian Westcott Hale (1881–1963), a portraitist who lived much of her life in the Boston area and the wife of another painter, Philip Leslie Hale (1865–1931). A student of Tarbell and Chase, Lilian Hale received many honors for her paintings, including gold medals at the Panama Pacific Exposition, San Francisco, in 1915 and at the Philadelphia Art Club in 1919. Today it is her handling of the charcoal medium that seems most outstanding, particularly in the large, ambitious portrait drawings such as *Drawing from "Blue Taffeta"* (Private Collection) and *Reverie: Portrait of Agnes Ruddy* (Fig. 252). In the latter, the artist makes use of heavy, textured paper which catches bits of the charcoal rubbed lightly across it and creates a vertical, linear effect. Her subject of a solitary, thoughtful woman is typical of the later American Impressionists, but her technical control goes far beyond theirs: the drawing seems simply to flow onto the sheet without conscious planning.

Closely related in mood and style are the drawings of Edwin Dickinson (b. 1891), a distinguished painter and draftsman whose major

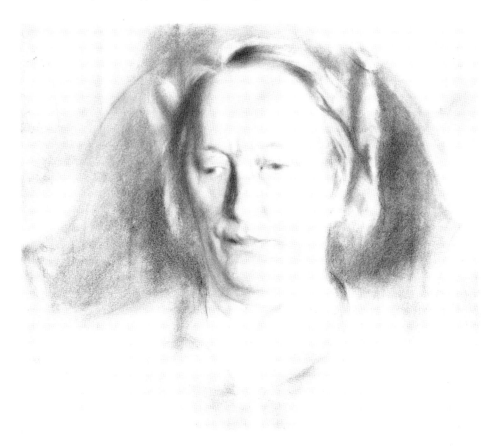

Fig. 253. EDWIN DICKINSON, *Portrait of a Woman*, 1937.
Pencil with extensive stumping and erasure, 10⅝ x 12⅝".

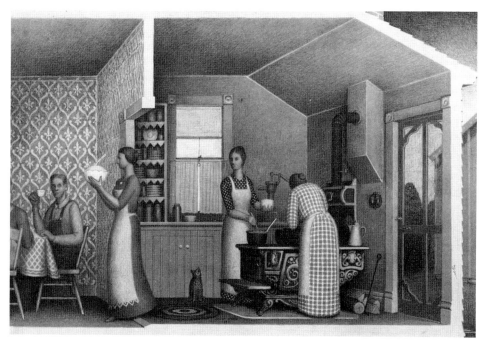

Fig. 254. GRANT WOOD, *Dinner for Threshers (Section No. III)*, 1933.
Pencil on brown paper, 17¾ x 26¾".

oils invoke the imagery of his teacher, Charles W. Hawthorne (1872–1930), while also demonstrating his understanding of Cubism. But his drawings are luminous, tonal, wholly lacking in gimmickry: *Portrait of a Woman*, 1937 (Fig. 253) is at once a portrait, a virtuoso demonstration of what the pencil can do, and a quiet probing of age and life.

Equally sophisticated, surprisingly enough, are the pencil drawings of Grant Wood (1892–1941), who has been unfairly miscast as strictly an "American regionalist" possessing an ingenuous style uninfluenced by European trends. In fact, as Alfred Frankenstein has pointed out, Wood traveled widely abroad and was particularly influenced by the high detail of fifteenth-century Flemish painting.[8] *Dinner for Threshers (Section No. III)* (Fig. 254) is nearly two-dimensional, yet is boldly composed, and is worked with an astonishing variety of strokes of a sharp pencil. Tonal gradations in the figures, walls, and elsewhere are exceedingly fine; the resulting image contains old-fashioned "folk" elements together with a modernist simplicity of form along with great technical skill.

American artists continued to have strong social concerns, particularly during the Depression years. The Russian-born twins Raphael and Moses Soyer (b. 1899) carried on something of the tradition of The Eight after their arrival in New York in 1913, Moses for example having studied with Henri and Bellows; both were serious draftsmen with a strong interest in urban life. And another immigrant whose con-

tribution was important was George Grosz (1893–1959), who came from Germany as a fully developed artist during the 1930s. Like Feininger, Grosz executed his best work before his arrival here, though he did do a series of expressive, coloful landscape watercolors on Cape Cod in 1939.[9]

The interest of The Eight in New York street scenes was carried on into the 1930s and 1940s by Reginald Marsh (1898–1954), a long-time illustrator who had studied with both Sloan and Luks at the Art Students League. Marsh was an incredibly prolific draftsman; he sketched constantly in a loose, caricature-like style. His best paintings— of crowded Coney Island beaches, dance-hall scenes, and the like—remain his most memorable work, for unlike his spiritual predecessors, his drawings seldom have great linear verve or penetrating observation. Among his best finished drawings, however, is *White Tower Hamburger* (Fig. 255), made with pen and ink with quickly applied washes: here dealing with a more ambitious composition than usual, the artist depicts one of his stock of long-legged, slightly ramshackle women striding along toward a group of five deadbeats. In the treatment of space and light, in the individual characterization of the figures, and particularly in suggesting that something interesting may happen here, Marsh rises above his usual graphic style.

Increasing social protest was seen. No longer was it enough simply to portray the slums or the urban poor, as artists from Shinn to

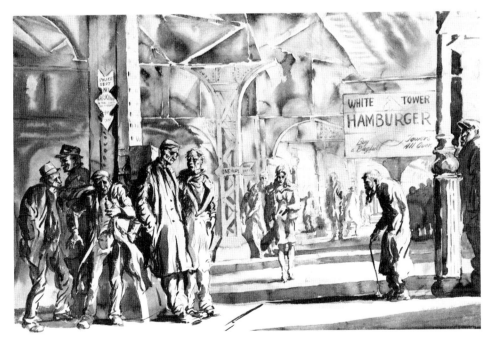

Fig. 255. REGINALD MARSH, *White Tower Hamburger*, 1945. Pen and ink, 26¼ x 39¼".

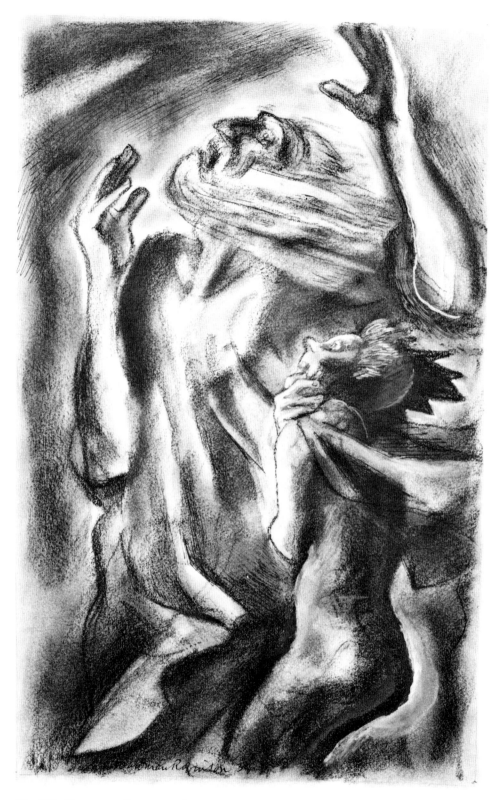

Fig. 256. Boardman Robinson, *Lear and the Fool on the Heath*, 1938.
Charcoal, tempera and touches of pen and ink, 17⅞ x 12″.

Fig. 257. EUGENE HIGGINS, *Adrift*, c. 1940.
Watercolor, 15¼ x 20¾".

Marsh had done, but now artists began to explore a more fundamental, deep-rooted human agony. Watercolor and charcoal were often used to give drawings density and even a sense of brutality perhaps stemming from Luks' earlier example. George O. ("Pop") Hart (1868–1933) did a number of effective works mixing these mediums, including the expressive, biting drawing entitled *The Jury*, 1927 (Museum of Modern Art). John Heliker (b. 1909) used ink and brush in a tough, loosely handled manner in works such as the tormented *Head of a Woman* of 1943 (Los Angeles County Museum of Art).

Closely related stylistically is the work of Boardman Robinson (1876–1952), who was active as a New York newspaper illustrator and satirist before the First World War, and then contributed to *The Masses* during the war along with Bellows and Sloan. Later he turned increasingly to painting, then to murals, and in the 1930s to book illustration. His 1938 series for *King Lear* at the Metropolitan Museum testifies to his crude, strong vision, as seen for example in *Lear and the Fool on the Heath* in charcoal and white washes (Fig. 256). One senses that Robinson in this work, or Eugene Higgins (1874–1958) in his extraordinary dark, morbid watercolor called *Adrift* (Fig. 257), was speaking not only to a particular scene or event but rather to the larger human condition as he saw it.

12

Toward the Modern Era

The movement toward "modernism" was never a steady development in the United States, but rather one marked by fits and starts. Fortunately, a book about drawings need not solve the insoluble questions (Who was the first American to reach pure abstraction? Who influenced whom, and when?); it is enough that early American modernists produced some of the most extraordinary drawings and watercolors in our history.

By 1913 and 1914 Joseph Stella (1877–1946) had fully absorbed the lessons of Italian Futurism, as seen in his great paintings of those years (e.g., *Battle of Light, Coney Island*, Yale University Art Gallery). Yet the Italian-born artist, arriving in New York in 1896, had begun by studying at the Art Students League with William Merritt Chase. By 1900 or so he had become a gifted draftsman, and—perhaps not surprisingly—he began with black-and-white, urban illustrations that are related to the tradition of Henri and Shinn. Stella's drawing called *Miners* (Fig. 258) gives evidence of great dexterity with charcoal; his interest is in value and mass, rather than in line as with The Eight in general. At least in retrospect, one also sees evidence here of a different kind of sensibility: Stella is totally unsentimental, yet passionately concerned with these workers. Moreover, he presents them frontally, directly, with a cropped-photo effect—again quite unlike the more romanticizing views of even Shinn or Luks.

In 1905 Stella had been commissioned by *The Outlook* to do a series of illustrations of Ellis Island immigrants; in 1907 another reform-minded publication, *The Survey*, had sent him to record the mining disaster at Monongah, West Virginia, where half the town's workers had been killed. His own preference, as he put it later, was "to search for tragic scenes." When *The Survey* in 1908 sent him to do a series on

Fig. 258. JOSEPH STELLA, *Miners*, 1908.
Charcoal, $14^{15}/_{16}$ x $19^5/_8''$.

Fig. 259. JOSEPH STELLA, *Pittsburgh in Winter*, 1908.
Charcoal, $17^1/_8$ x $23''$.

Fig. 260. Joseph Stella, *Flowers*, c. 1920–1930.
Colored crayons, 28½ x 22″.

Pittsburgh, he found himself particularly moved: the city was "a real revelation. Often shrouded by fog and smoke, her black mysterious mass . . . was like the stunning realization of some of the most stirring infernal regions sung by Dante."[1] Many powerful figure drawings resulted from this trip, as well as several landscapes, including *Pittsburgh in Winter* (Fig. 259), which gives perfect expression to the artist's combined feelings of wonder and horror at the industrial machine.

Stella drew throughout his career, his images becoming subtler though no less forceful as he went on. Increasingly he turned to line and to delicate colors used very precisely: his portraits in silverpoint (such as *Marcel Duchamp*, Museum of Modern Art) are spare and moving, and the flowers done in pencil and crayon (Fig. 260) contain a sense of ultimate emotional compression, an ability to draw only the necessary. Stella drew in nearly every medium, including pastel used richly and darkly; he made some pencil sketches for his large paintings; and, apparently late in his career, he created some small and very beautiful, purely abstract collages including the "Macchina Naturale" series. Yet despite Stella's relatively wide reputation, only Katherine Dreier and a few others bought his drawings during his lifetime, and most have remained together until recent years.

It might be added that the collecting of American drawings in general is a contemporary phenomenon. As suggested earlier, the first collecting of drawings seems to have been as an advanced form of autograph collecting, during the 1850s. Then watercolors slowly gained acceptance as finished and thereby collectible works of art; this was well established by the 1870s and 1880s. The inclusion of a "black and white" section in the Water Color Society exhibitions very slowly led to a wider acceptance of pure drawings. However, judging from the Armory Show and other exhibitions, as well as from the holdings of Albert Gallatin,[2] Katherine Dreier,[3] Duncan Phillips, Stieglitz, and other pioneers in the twentieth century, there was *still* for them an emphasis on those drawings that could be considered "finished." The very last things to be collected—which is actually just occurring now—are in a sense the "purest" drawings, those unfinished sketches in various mediums which give such unique insight into the artist's working method but which have usually been left behind on his studio floor.

A number of American modernists besides Stella were lured toward increasing abstraction in the years surrounding the Armory Show of 1913, and almost all retreated again to more congenial, realistic subjects during the 1920s. Drawings and watercolors played a crucial role for them from the beginning, and for the first time there came to be artists like John Marin whose best work is almost all in watercolor. For Marin and most of the struggling abstractionists there was a single collector–dealer–patron saint whose influence and support were crucial: this of course was Alfred Stieglitz (1864–1946). Stieglitz ran his New

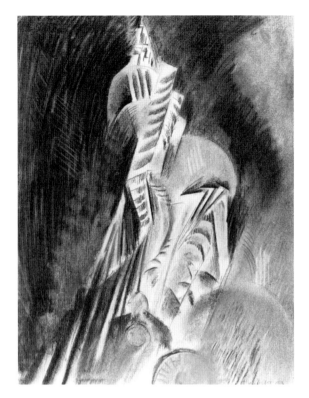

Fig. 261. MAX WEBER, *Abstraction*, 1913.
Pastel, 24 x 18½″.

Fig. 262. ARTHUR DOVE, *Movement No. 1*, 1911.
Pastel, 21⅜ x 18″.

York gallery called "291" from 1905 to 1917; in 1908 he began his inter-
est in modern art with an exhibition of the wash drawings of Rodin, the
great French sculptor, following this with others devoted to Matisse
and then to the Americans John Marin and Alfred Maurer. Within the
next two years he had shown Toulouse-Lautrec, Cézanne, and Picasso,
as well as other Americans, including Arthur Dove and Max Weber.

The latter two very different men were among the founders of
abstraction in America. The Russian-born Weber (1881–1961) grew up
in Brooklyn but had a thoroughly sophisticated Parisian training, first
at the Académie Julien, and then under the successive influences of
Cézanne, Matisse, and Picasso. He exhibited with the avant-garde
French painters in 1906–08, and thus brought back a highly advanced
style when he returned to New York in 1909. By 1913 he was at his peak,
his name well known (and widely derided); a series of pastels of that
year, including *Abstraction* (Fig. 261), show him combining Futurism
and Cubism with considerable understanding. Unfortunately, his crea-
tivity was short-lived. Dropping away from Stieglitz, he took up
"classic" subjects and went on to scenes of Jewish life. Anomalously,
his reputation and patronage grew as his art weakened, and he died
much honored.

A far more single-minded talent was that of Arthur G. Dove (1880–
1946). Like Weber, he was in Paris in 1908, and in 1910 first exhibited

Fig. 263. Arthur Dove, *Tree (41)*, 1935.
Watercolor, 4⅝ x 6⅝".

with Stieglitz, beginning also a lifelong friendship with him. Dove's pastel *Movement No. 1* (Fig. 262), c. 1911–12, executed in light and dark blues, is almost purely abstract: in it one senses only something of natural form, gathered together by a strong hand. Always highly idiosyncratic, Dove's art was understood by very few, and he was patronized by Duncan Phillips almost alone. Phillips wrote of him: "He had found a new direction. In the history of our period in painting he will be remembered as one of the few great individualists."[4] It is still unclear whether this is true or not: watercolor specialists today are likely to include him as a major figure ("one of the most revolutionary artists of his generation"[5]), while others pay him less heed. Certainly his work is as difficult to grasp as any American's: the vast majority of his watercolors are late (dating from the 1930s, after he spent years working with oils and collages), very small (five by seven inches on the average), and intellectual rather than beautiful.

Dove was no technical virtuoso with watercolor: he used one pigment at a time, washed it onto the paper, and then went on with the others. His is a poetic style which changed little. His watercolors express "his deep feeling for nature and a desire to translate . . . its mood and impact . . . through abstract shapes,"[6] as in *Tree* (Fig. 263). This work includes a landscape element with low horizon, a limited range of hues (some washed very wet on the paper), and a central, abstract form

Fig. 264. JOHN MARIN, *Clouds and Mountains at Kufstein*, 1910.
Watercolor, 15 x 18⅛″.

—which here is formed with a typically wavering line in black ink. Like
most of Stieglitz's artists, Dove was deeply and honestly concerned with
finding a way to express in his work the most vital of nature's forms.
In particular, he thought of the watercolor as analogous to music, noting
that his aim was "to weave the whole into a sequence of formations,
rather than to form an arrangement of facts."[7]

John Marin (1870–1953) viewed nature much as Dove did, but un-
like him, Marin had both tremendous personal energy and artistic
courage. He seemed to view the basic irreconcilability of art and life as
a personal affront, and he spent his life trying to break it down. He
did not possess a unique sense of color or tonal harmony, and seldom
employed the sophisticated technique of the watercolorist, preferring to
reject the solutions of Homer and Sargent as he went his own way. He
literally *drew* with basic water-soluble pigments on paper; he thought
of his watercolors as "drawings," and often said that line (whether
made by brush, pen, or pencil) was crucial.[8] Marin's watercolors tell
more about himself than about the worlds of urban New York and
coastal Maine that he depicted so frequently (he reportedly produced
over a hundred watercolors during one summer). As a recent critic has
written, "The Futurist exaltation of energy, courage, and virility and

Fig. 265. JOHN MARIN, *Breakers, Maine Coast*, 1917.
Watercolor, 15⅞ x 29¾".

its scorn of intellectualism are echoed in Marin's writings and objectified in his work."[9] Though Marin's critical reputation appears to have suffered recently, perhaps because he is so much the Expressionist, many would still agree with Sherman E. Lee's assessment: "I consider him one of our most important and profound artists."[10]

Spending the years 1905–10 in Europe, and becoming particularly cognizant of current French art, Marin returned not an eclectic (like Weber, ready to try anything) but prepared instead to begin his own search. Even in the watercolors done just as he was leaving Europe, such as *Clouds and Mountains at Kufstein*, 1910 (Fig. 264)—one of the Tyrol series exhibited at "291" the following year—there is a sense of his identity. Critics of the day praised him, finding in him not feared abstraction but rather a continuation of Whistler's gentleness; and in fact these early works are wetter, more tonal, and more realistic than the later ones. But they also go far beyond Whistler or Prendergast in remaking nature, in seeing the world as made up of flat line and shape that the artist arbitrates.

By 1912–13, a period which threw so many artists off their stride, Marin was just hitting his. In watercolors like *The Brooklyn Bridge* (Metropolitan Museum) or pure pencil drawings like *Downtown, New*

Fig. 266. JOHN MARIN, *The Red Sun—Brooklyn Bridge*, 1922.
Watercolor, 21½ x 26¼″.

York (Wadsworth Atheneum), he showed that he had already absorbed
the lessons of Futurism; the "new art" at the Armory Show confirmed
his breaking-up of nature and his increasing disregard for the pretty.
In *Breakers, Maine Coast*, 1917 (Fig. 265), one of the excellent group
of modernist works in the Ferdinand Howald Collection (Gallery of
Fine Arts, Columbus, Ohio), there is both an objective view of the
crashing sea and the artist's subjective excitement at being *in* nature.
Colors here are muted to blues and greens of low intensity, the com-
position has an Oriental flatness, and line increases in importance—
both the pencil drawing underneath the washes and the dark, jagged
lines brushed onto the surface.

Anyone with Marin's immense productivity risks failure, but even
his failures were energetic ones; he does not seem to have had un-
productive periods, but instead there were simply times when the picture
did not work out. Marin seemed to be always involved with his art:
though he often said that he only worked directly from nature, at other

Fig. 267. OSCAR BLUEMNER, *Bright Red Houses*, c. 1926.
Watercolor, 9¼ x 12⅜".

times, during a winter for example, he would report being busy on the watercolors of the previous summer.[11]

By the 1920s Marin had reached a complete style: as his biographer Sheldon Reich writes, "His visual imagery has become richer than before, and paintings such as *The Red Sun—Brooklyn Bridge* have a sense of fulfillment."[12] One of a series of New York views done late in 1922, this watercolor (Fig. 266) makes use of his now-basic palette, intense reds and violets, light and dark blues and yellows. Typically, color is drawn onto the heavy, dry watercolor paper directly from the tube with a thick, square-ended brush. Here, the view from the bridge is blocked out by Marin's own border—reaffirming the artist's control of what is seen—and by the diagonal grids of steel cables. Seldom is one wash laid over another, and the only white is that of the paper itself. The result is pure Marin: a crude, personal vision that expresses the power of the artist and of the city itself.

Marin went on and on, at times becoming even more abstract, and

another height was reached in the 1930 series done near Taos, New Mexico. Increasingly the Maine subjects seemed to bring out more than the ones of New York, though other subjects (occasionally now the human figure) were explored as well. Predictably, as he came nearer in time to the Abstract Expressionism that his work foretells, his own hand became less certain. For almost all his life, Marin's work was admired and collected; as early as 1922, Gallatin declared him the supreme American watercolorist. Yet his manner appears to have had relatively little influence, and unlike Sargent, he has had few imitators —perhaps the greatest compliment of all.

Other artists were working in related, abstracting styles. Oscar Bluemner (1867–1938) is one who has received surprisingly little attention, conceivably because he came to this country from Germany when he was twenty-five and in a sense already trained. Yet Stieglitz took him up and gave him several exhibitions, and he was included in exhibitions of American artists beginning with one at the Anderson Galleries in 1916. Like his contemporaries, he used only transparent colors, but he washed one over another in order to produce a dense, emotional effect. In *Bright Red Houses* (Fig. 267), reds and oranges of high intensity are juxtaposed with complementary greens and blues; as with Marin (and also reminiscent of the German Emil Nolde), the result is a deeply personal, somewhat fearful vision of nature.

In the decade following the Armory Show, a number of American artists outside the Stieglitz group sought pure abstraction in their work. One was Stanton Macdonald-Wright (1890–1973), who with Morgan Russell had developed "Synchromism" by 1913, and first showed this abstract coloristic style in the United States in 1914 with such watercolors as *Study for Conception Synchromy*, 1914 (Collection of Mr. and Mrs. Henry M. Reed). Others were influenced by Cubism, Futurism, and Dada, affected in many cases by Marcel Duchamp's arrival in New York in 1915; seeking to eliminate all reference to nature, these men concentrated largely on paintings or constructions and paid relatively little attention to drawing as such. At the same time, there are notable exceptions, such as Man Ray (b. 1890)—an unusual figure in many ways, not least that he was American-born and -trained, yet gained his major reputation only after his 1921 move to Paris, where he still lives. In New York in 1917 he founded a Dada group with Duchamp and Francis Picabia. About the same time he did his first "rayographs" (photographic prints directly exposed to light and objects, without use of a lens), and he went on to become a major photographer and filmmaker.

Man Ray's drawing *Jazz*, 1919 (Fig. 268), made with an air brush with thin pen lines, emulates a machinelike perfection in which the hand of the artist is not apparent. As Duchamp said approvingly, Man Ray "treated the paint brush [as] a mere instrument at the service of the mind."[13] Drawings of similar intent (but greater linearity) were

Fig. 268. MAN RAY, *Jazz*, 1919.
Airbrush, 27¼ x 21¼".

made by the widely traveled abstract sculptor John Storrs (1887–1956),
as seen in the series of silverpoint drawings exhibited at Knoedler in
1928 and in earlier pen and ink works such as *Machine Form* (Yale
University Art Gallery). Mention should finally be made of a third
draftsman—more eclectic than the others—whose debt also is to Cubism
and to the machine. This is Paul Gaulois (1901–1943), a brilliant, tragic
figure much admired by Katherine Dreier. His *Seated Nude*, c. 1922

Fig. 269. PAUL GAULOIS, *Seated Nude*, c. 1922.
Colored crayons on tan paper, 15¼ x 9¾".

Fig. 270. MARSDEN HARTLEY, *Self Portrait*, c. 1910.
Pencil, 11¹⁵⁄₁₆ x 9".

(Fig. 269), brings the human form back into a Cubist grid made up of in-
dustrial shapes.

Equally abstract, though less dependent on machine imagery, are
the drawings of Jan Matulka (1890–1972), a Czechoslovak-born artist
who came to New York in 1907 and was studying at the National
Academy of Design in 1911–16, the great years of artistic ferment. His
dark crayon drawing *Abstraction* of 1923 (Yale University Art Gallery)
looks back to analytic Cubism for its inspiration, yet is a powerful,
explosive work on its own. And at least superficially similar are the
equally abstract watercolors of Jay van Everen (1875–1947), an Ameri-
can artist who never went abroad, yet who by 1920 was exhibiting with
the Société Anonyme; James Daugherty wrote that his work was
"romantic, lyric, and precise," all qualities visible in the small water-
colors executed about 1920 as tile designs for the New York subway
(Fig. 271).

Daugherty (1889–1974) himself drew with pastels in a manner that
recalls Stella's Futurist paintings. His *Moses*, c. 1919 (Fig. 272), recalls
the energy of the Italian style with its colorful, broken surface planes.

After 1920 Daugherty was increasingly active as a muralist, and later became yet another of the American illustrators (reversing the usual trend of beginning one's career with illustration); he was noted particularly for his work with children's books, including *Daniel Boone* (1939) and *Abraham Lincoln* (1943).

As has been repeated often, the burden of the early modern artists in America was tremendous, and often became unbearable. The long battle for the acceptance of art in America had finally been won, but the painters and sculptors of the early twentieth century were forced by the nature of their efforts to turn the clock back, and to draw upon themselves widespread anger and rejection. That they survived at all is due to their personal courage, to the steadfast backing of their few powerful friends, and perhaps to an extent to their own re-absorption into the realist mainstream of our art. It was simply impossible to remain an abstract painter for long: gradually the lure of the land and of objects reasserted itself, and an American compromise was reached— led by the Stieglitz artists—between Cubism and realism.

Marsden Hartley (1877–1943) was an early member of the Stieglitz group, and had his first one-man show at "291" in 1909. Originally a student of Chase, later influenced by Prendergast, Hartley went abroad at the time of the Armory Show and absorbed most of the avant-garde styles. From the beginning he was a gifted and varied draftsman: even before going to Europe he worked with a compulsive, nervous line that records his own emotions rather than the objective world. His *Self Portrait*, c. 1910 (Fig 270), is typical of his soft-pencil technique, and tells much about his own introspective personality.

Influenced by Cézanne, Hartley went on to do many still-life and

Fig. 271. JAY VAN EVEREN, *Untitled, No. 3*, c. 1920. Watercolor, 7⅞ x 7⅞".

Fig. 272. JAMES DAUGHTERY, *Moses*, c. 1919. Pastel, 18 x 18".

Fig. 273. MARSDEN HARTLEY, *Peaches and Lemons*, c. 1927–1928.
Watercolor, 6¾ x 9⅝".

Fig. 274. JEROME BLUM, *Fruit*, 1924.
Charcoal and pastel on Japanese rice paper, 12½ x 16½".

Fig. 275. ALFRED H. MAURER, *Apples and Nuts*, c. 1927–1928.
Pastel, 18½ x 22″.

landscape drawings that emulate first one aspect of Cubism, then an-
other. His series of *Military Symbols* (Metropolitan Museum of Art)
dating from 1913–14 are rough, angular studies in charcoal for the well-
known paintings relating to German militarism. Hartley was par-
ticularly taken by Maine, and did powerful crayon and charcoal studies
of the woods and mountains there. Even more expressionistic are his
pastels of still-life subjects and landscapes—particularly the "Dog-
town" series from the early 1930s. He used watercolor more rarely, but
his *Peaches and Lemons* (Fig. 273), probably dating from his long
French visit during the 1920s, finds him using the medium with a
simplicity and mastery reminiscent of Dove.

The Americans had learned from Cézanne and the Cubists that
still life enabled them to retain a link with the observed world while
experimenting radically with the very nature of art; thus still life—the
middle-class subject of nineteenth-century painting—became a major
vehicle for our avant-garde during the 1920s. The drawing *Fruit*
(Fig. 274) by Jerome Blum (1884–1956) is powerful, linear, certainly
Cézannesque: space seems deliberately unclear, so that one looks to the
strength of varying shape, texture, and line. Even more ambiguous is
the pastel *Apples and Nuts* (Fig. 275) by Alfred H. Maurer (1868–
1932), also one of Stieglitz's early artists, and another of the tormented

pioneers of the modern movement in America. In this work of about 1927–28, Maurer has taken a full step beyond Blum: the object has been replaced by the work of art itself, and references to fruit and paper (perhaps blackboards?) on a tabletop are unimportant relative to the artist's strong handling and color. The grid created by four dark verticals is totally arbitrary, as are the flickering light sources above and below. We see here a construction of the artist's imagination stopping just short of total abstraction.

It is surely not coincidental that Stieglitz himself was a great photographer and that the artists to whom he remained closest over the years—Dove, Marin, Demuth, and O'Keeffe—all expressed themselves enormously well in works on paper, in various modes of drawing, and moreover that each of them remained close to nature as a source and inspiration. Stieglitz was particularly sympathetic to the work of Charles Demuth (1883–1935), for Demuth above all was a master watercolorist for whom line, edge, and the nuance of tone meant most. Demuth studied with Anshutz in Philadelphia, then with Chase, and was in Paris twice before the Armory Show. Pennsylvania Academy watercolor annuals in 1908 and 1912 included his work, and in 1914 the Daniel Gallery gave him a one-man show of his watercolors. The influence of Rodin is clear in the scribbled line and loose washes of this early work (as in *Strolling*, 1912, at the Museum of Modern Art). Like his close friend Marin, Demuth instinctively felt at home with watercolor and could absorb a wide variety of influences (including Marin's) while finding his own way.

Demuth became an illustrator—but of a very different kind than the members of The Eight, for he chose his own subjects, and the results were meant not to be reproduced but rather to stand on their own. His first series was done in 1915–16 for Zola's *Nana*, and the twelve drawings, located in various collections, make vigorous, animated use of pencil line and watercolor. Then in 1917–18 he set to doing Henry James's *The Turn of the Screw*, a series of fine works on smooth, inexpensive paper. Here in drawings such as *Flora and the Governess* (Fig. 276), Demuth achieves a new kind of drawing: color and wash are used descriptively, giving form to the large foreground figures, *and* emotionally, while the pencil line plays, Matisse-like, around the composition, now describing contour, now running into a distant yet flattened space, now simply expressing the artist's energy. During this same period Demuth did watercolors of nightclub scenes, the circus, and vaudeville, each filled with pale, evocative washes, strange elongated figures, and playful line.

On the verge of his mature style, Demuth in 1917 traveled to Bermuda with Hartley and did a series of architectural watercolors there, including *Old Houses* (Fig. 277). The witty, irrational line of the illustrations is replaced here by a disciplined Cubist image of

Fig. 276. CHARLES DEMUTH, *Flora and the Governess*, from *The Turn of the Screw*, 1918.
Watercolor, 8⅛ x 10¼″.

Fig. 277. CHARLES DEMUTH, *Old Houses*, 1917.
Watercolor, 9½ x 13½″.

Fig. 278. CHARLES DEMUTH, *Iris*, c. 1920–1925.
Watercolor, $13^{15}\!/_{16}$ x $9^{15}\!/_{16}$".

straight lines and subtle washes, each blotted or stained to vary from the next. Geometry dominates, and the effect is quite different from the slashing expressiveness of Marin: Demuth's watercolors are elegant, soothing, and totally controlled. One feels the artist ridding himself of earlier freedom, seeking in these faceted forms a way to balance spontaneity with conception.

Demuth achieves this aim with startling success, beginning about 1919 with the flower and fruit watercolors. By the early 1920s he had found a style as original and compelling as Marin's, though one very

Fig. 279. CHARLES DEMUTH, *Still Life: Apples and Bananas*, 1925.
Watercolor over pencil, 11⅞ x 18″.

different. Demuth was personally aristocratic, somewhat weak in health,
and withdrawn, and his watercolors are similarly restrained: value
relationships are considered carefully, only fortuitous accidents are
allowed as the medium is always under control, and the white paper
and pure pencil line are used to maximum effect. In *Iris* (Fig. 278),
which Stieglitz left to the Metropolitan Museum, there is a gentle sense
of spatial and coloristic perfection. Many of the fruit subjects are
bolder now, as with *Still Life: Apples and Bananas*, 1925 (Fig. 279):
here the faceted, brilliant red apples lie against ripe yellow bananas,
with the artist heightening compositional focus by means of a calli-
graphic red strip on either side—a technical device rather like Marin's;
then space is controlled and flattened by ambiguous, interlocking gray
and tan washes with flowing penciled borders.[14]

Demuth knew just how far to take modernism. Though his pure,
transparent tones look easy, he was a technical master—yet managed
to be one of the great watercolor poets as well. Albert Gallatin was
his first biographer, and a great enthusiast for his work, but even he
noted the coolness of Demuth's fruit, finding in it "none of the juiciness
or passion of Renoir or Cézanne. This fruit [is] from a country whose
vin du pays is iced water."[15]

Fig. 280. GEORGIA O'KEEFFE, *New York Rooftops*, c. 1925–1930.
Charcoal, 24½ x 18¾".

Of all his artists, Stieglitz was personally closest to Georgia
O'Keeffe (b. 1887), whose work he first showed at "291" in 1916. She
moved to New York in 1918 after having taught in Texas, Virginia, and
South Carolina; Stieglitz arranged an exhibition of her work at the
Anderson Galleries in New York, then showed it at his own Intimate
Gallery (1926–29), and later at An American Place. They were married
in 1924, and his own great work is the series of perhaps five hundred
photographs which he took of O'Keeffe before his death in 1946.

Fig. 281. GEORGIA O'KEEFFE, *An Orchid*, 1941.
Pastel, 27 x 21½".

Like many of the artists who came to New York, O'Keeffe reacted
visually and made a series of large sketchbook drawings from her studio
window. If *New York Rooftops* (Fig. 280) is any indication, she felt
none of the almost fearful emotionalism of a Marin at seeing the city,
nor did she celebrate it as Stella had: it was simply another place she
could accept for a time, and she found interesting forms there for her
work in charcoal. Even in this relatively early drawing, O'Keeffe seems
able to achieve what the others had sought all along: the stern, flat focus

Fig. 282. Georgia O'Keeffe, *Red Cannas*, c. 1920.
Watercolor, 19⅜ x 13″.

of modernism drawn with exquisite human feeling. Marin had all the emotion, but the formal problems often escaped him; Demuth was the technician who had difficulty in reaching his soul. O'Keeffe is the rare artist in history, for she is complete.

In 1916 and 1917 she was doing totally abstract watercolors, such as *Blue No. II* (Brooklyn Museum), that are successful, and quite her own. She developed toward realism during the next decade, and gave up nothing. *Red Cannas* (Fig. 282) is watercolor at its purest: green, gray, red, and violet, put on wet with a rather large, rounded brush, it is the work of a moment, and of a lifetime. Without pencil line, background, or reference to planning or to real space, the artist quickly, unbelievably deftly, allows perfection to occur.

When O'Keeffe took up pastels and used them with flower subjects, she disproved once and for all time the clichéd notions about women artists, pastel as an "easy" medium, and the flower as a sentimental subject. Her pastel of 1941, *An Orchid* (Fig. 281), takes the viewer into a real flower which functions also as abstraction and symbol. The artist's use of the medium, as with the other graphic tools, is unsurpassed in terms of both vision and technique. She stands as the last and perhaps the greatest of the modernists from "291."

Rather near in some ways to O'Keeffe's vision was that of Charles Sheeler (1883–1965): both have been called "precisionists" for their hard edges and their purity, though they were never closely associated. O'Keeffe worked in New York, with Stieglitz; Sheeler, a professional photographer as well as a painter and draftsman, lived in Bucks County, Pennsylvania, but exhibited at the Armory Show, later at Anderson and then Daniel Gallery in New York. Sheeler's *Bucks County Barn*, 1923 (Fig. 283), drawn with tempera and crayon on paper, is pure precisionism (a term his careful work warrants far more than O'Keeffe's): linear, bare, sunlit, and textured, it shows the well-trained American artist making comfortable use of Cubism—a far step from the agonies of Maurer or Weber.

Sheeler went on to make some of the ablest drawings of the period. In his so-called *Self Portrait* (Fig. 284) he employs a black conté crayon, pencil, and touches of watercolor; it is a wry, evocative image, and one which gives evidence of Sheeler's complimentary career as a photographer. In the faceted, glinting telephone, one is reminded of Demuth's control; in the clear gradation of value, with no sign of the artist's "touch," one recalls O'Keeffe. And the banal subject itself, having been chosen by the artist and thereby given dignity, of course appeals to us as a predecessor of the Pop aesthetic.

Even more tonally sophisticated is the great drawing of 1934, *Feline Felicity* (Fig. 285), a portrait of a cat curled up in a favorite Shaker chair. With intense mastery of his medium, Sheeler presents a cropped,

Fig. 283. Charles Sheeler, *Bucks County Barn*, 1923.
Tempera and crayon, 19¼ x 25½".

Fig. 284. Charles Sheeler. *Self Portrait*, 1923.
Watercolor, conté crayon and pencil, 19¾ x 25¾".

322 TOWARD THE MODERN ERA

Fig. 285. CHARLES SHEELER, *Feline Felicity*, 1934.
Black conté crayon on white paper, 14⅛ x 13¼″.

photographic image, while working out perspective, light, and tonal variations with complete believability. As accomplished as his paintings, these drawings were tremendously time-consuming, and only a handful of them were made.

Quite different draftsmen, equally part of their period, relied on pure line rather than on mass and value. Gaston Lachaise (1882–1935) was a French-born sculptor who emigrated to Boston in 1906, and finally moved to New York in 1912. He exhibited at the Armory Show and many times subsequently, including a one-man show at Stieglitz's Intimate Gallery in 1927. A master not only of sculptural mass and curve, Lachaise was also a prolific draftsman whose work of the 1930s recalls Rodin and Matisse, with an added Art Deco flavor: the curves of his penciled nudes (see Fig. 286) flow smoothly and calligraphically in these dream-like versions of his sculpture.

Fig. 286. GASTON LACHAISE, *Nude*, c. 1930.
Pencil, 19 x 12".

324 TOWARD THE MODERN ERA

Fig. 287. STUART DAVIS, *Davits*, 1932.
Ink, 28¼ x 20¼".

Drawings which rely instead on straight lines were made by Stuart Davis (1894–1964), who in 1909 had left school to study with Robert Henri. Beginning as a realist and illustrator who contributed to *Harper's Weekly* and *The Masses*, by the early 1920s Davis was beginning to combine synthetic Cubism with the color and energy of urban life to form his own abstract, "proto-Pop" style. *Davits* of 1932 (Fig. 287) is constructed with typically consistent, thick line, laid down with care as the artist observes the real world, then records it as flat image with multiple perspectives. Davis also used watercolor and gouache successfully, often in order to explore ideas for later paintings.

Far less self-consciously concerned with modern aesthetics was Edward Hopper (1882–1967), one of the most prolific draftsmen and watercolorists of his time (the great body of his oeuvre is at the Whitney Museum). In the early years of the century Hopper, like so many others, had studied with Henri, as well as with Luks and Kenneth Hayes Miller, and he was active for many years as a commercial illustrator and an etcher. At his best Hopper ranks among the major watercolorists, yet his natural "touch" was practically nonexistent. Among his best pencil drawings are the very earliest, such as *Man with a Stick* of 1901, in the Fraad Collection. After that he occasionally did passable work in conté crayon, studies of his wife, Jo, or occasional architectural studies for paintings, but they are few. Even watercolor, paradoxically, meant little to him in technical terms: it was simply the right medium to use out of

Fig. 288. EDWARD HOPPER, *Yawl Riding a Swell*, 1935.
Watercolor, 20 1/16 x 28 1/4″.

doors during the summer, and he had little interest in brushwork, texture, or tonal variation.

In his study Sherman Lee found Hopper's watercolors simply cold and sterile, but there is more to them than this—for the best are powerful, evocative visions of the American scene. Hopper succeeded either despite or because of his lack of concern for technique: what counted for him was image, and his images can be strong indeed. Critics have struggled with the anomaly of this artist, and have described him as a "poet of the inanimate."[16] His watercolors have "a steadiness and conviction that look like something from another world."[17]

House of the Fog Horn No. 3, 1929 (Fig. 289), is a typical geometric composition, divided into three horizontal forms with only the chimney strangely reaching to the very top of the sheet. This building at Two Lights, Maine was a favorite subject, and Hopper did it until he got it right. He cares little about the foreground, made up of brown and yellow washes, rather drily applied, that make no attempt to lure the viewer's eye either through realism of terrain or elegance of brushwork. Of greater interest is the house, brightly though coldly lit on one side,

Fig. 289. EDWARD HOPPER, *House of the Fog Horn, No. 3*, 1929.
 Watercolor, 13^{15}/$_{16}$ x 19^{15}/$_{16}$".

in deep afternoon shadow on the other. The building is central and real;
and the rich dark blue of the sea to the right becomes compelling in this
barren scene. As in his oil paintings, which are equally strong and
equally difficult, Hopper finds strength and geometry in nature, and puts
it down in such a way that one feels for the loneliness of man.

Hopper was a long time in reaching success; his first retrospective
was at the Museum of Modern Art in 1933. In early days he exhibited
frequently at the Whitney Studio Club and at the Frank Rehn Gallery. In
1935 the Worcester Art Museum—with its long history of perspicacity
in the acquisition of American watercolors—purchased Hopper's water-
color of that year, *Yawl Riding a Swell* (Fig. 288). Unusually large for
his watercolors, rare also in its limited hues and its inclusion of human
figures, this shows the artist at his technical and expressive height. He
makes some concessions here to the watercolor medium, wiping washes
over each other more gently than usual, allowing the texture and
whiteness of the paper to show, and then clotting the strange blue sea
with tiny dark strokes. But as usual, his power is in the image—here
a tiny yawl which despite the relatively flat sea is pitched high out of

Fig. 290. CHARLES BURCHFIELD, *Dandelions Seed Balls and Trees*, 1917.
Watercolor, 22¼ x 18¼″.

Fig. 291. CHARLES BURCHFIELD, *Lavender and Old Lace*, 1939–1947.
Watercolor, 37 x 50″.

the water. As in some of Homer's seascapes, the boat is fully rigged and
one makes out no sense of concern on the part of the crew, yet there is
an enigmatic air of unease, of imbalance, in the scene.

Hopper is often yet inaccurately compared to Charles Burchfield
(1893–1967), his contemporary whose work was also shown at the Mu-
seum of Modern Art (1930) and at the Rehn Gallery. Burchfield, how-
ever, was as energetic and experimental in his watercolors as Hopper
was cold and precise in his; moreover, Burchfield was a natural, gifted
draftsman whose pure pencil drawings are inventive and lively. A long-
time resident of Buffalo, New York, Burchfield was at his best not when
portraying the urban scene in a Hopperesque mode—which he did oc-
casionally—but rather when confronted directly by nature. One of the
most calligraphic of watercolorists, in works like *Dandelions Seed Balls
and Trees,* 1917 (Fig. 290), Burchfield seeks to express in his brushwork
nature's own pulsating vitality. Creating not symbol but a personal
expressionism, his slashing strokes of green and black watercolor (some-

times transparent, sometimes opaque) seem to reinforce nature's patterns of growth and decay, of sunlight and shadow. Burchfield may be considered an Expressionist, like Marin; both were drawn continually to nature for their inspiration, and both expressed tremendous energy on paper. But Marin readjusts nature's forms through Cubist eyes, seeing only what he selects; Burchfield tries instead to mirror nature, to show her truths to the unseeing.

As he went on, Burchfield found himself making larger and larger watercolors, often having to piece several sheets of paper together, as in *Lavender and Old Lace* (Fig. 291). He worked surprisingly slowly, often going back to improve old compositions, and his style merely mellowed over a long career. *Lavender and Old Lace* was made over an eight-year period, from 1939 to 1947; whatever he had lost in terms of the astonishing freshness of brushstroke of thirty years before has been compensated for in an increased subtlety of vision, in ever more haunting compositions.

Like the best of the modernists, Burchfield ended almost where he had begun—close to nature. As with Marin, O'Keeffe, Sheeler, and others, he had seen the modern movements from abroad, and had absorbed them into a style he could live with. Without pretension, in a sense without fully knowing it, he was a member of perhaps the greatest generation of American watercolorists.

13

Drawings of the War Years:
Linear Emotion

American art during the war years and the following decade was domi-
nated by two major movements, Surrealism and Abstract Expression-
ism, and drawing played a crucial role in both. Economic and political
unrest in Europe during the 1930s caused a number of leading artists to
emigrate to the United States, and as a result of their influence many
native American artists whose previous training drew upon Regionalism
and American Cubism began to incorporate Surrealist techniques and
images in their art.[1] At the same time, a more traditional figurative
draftsmanship continued to develop, stemming from both European
Expressionism (many of its practitioners were, in fact, foreign-born)
and American social realism; the drawings are characterized by an
animated line and expressive, distorted forms. Their subject matter is
strongly emotional, ranging from the violent to the poignant, and often
has compelling psychological content or moralistic implications.

American drawings of this period, whether realistic or tending to-
ward abstraction, whether European-influenced or more "native,"
tended to rely more than ever before on the character of line. Pure line
came almost to have a life of its own—it was a fine, thin line that flowed
in sweeps and curves. Though it resulted often in dreamlike images,
line for its own sake took on a unique importance in American art.

Drawings of the time are often difficult to classify in an easy way
with regard to their style, their influence, or even the nationality of the
artist. Thus Lyonel Feininger (1871–1956), for example, though born in
New York, went to Germany in 1887 and became an important figure in
the formation of German Expressionism. Later a member of the faculty
at the Bauhaus, he returned to America only during the mid-1930s,

Fig. 292. LYONEL FEININGER, *The River*, 1940.
 Watercolor, 13 x 20".

when he settled in New York. However, his American oeuvre is a large
one; less impassioned and less cynical than his earlier work, drawings
such as *The River* (Fig. 292) of 1940 show the artist being transformed
by the calmer American environment, though still retaining great inter-
est in line for its own sake and in the delicacy of colored washes.
Feininger also made line-and-color views of the buildings of mid-
Manhattan, somewhat reminiscent of those of Stella and O'Keeffe in
earlier decades. As he went on, his style became increasingly simplified
as the influence of Cubism dropped away and lyrical washes rather than
line came to dominate the drawings.

Surrealism arrived in the United States in the late 1930s with the
emigration of many European artists fleeing repressive political cli-
mates and impending war. Their art was made known to the American
public through exhibitions in a number of avant-garde New York
galleries, and especially through the landmark exhibition "Fantastic
Art, Dada and Surrealism" held at the Museum of Modern Art during
the winter of 1936–37. As a result, young American artists quickly took
up Surrealist imagery and technique, though they never subscribed to
Surrealist aesthetic programs or political manifestos. Automatic writing
—or the direct translation of psychic images onto the picture surface
through use of calligraphic gesture—became the most widely employed
Surrealistic practice; indeed, the development of American Surrealism
created a primacy of drawing, since the imagery of that style is largely

Fig. 293. SALVADOR DALI, *Rhinoceros*, 1951.
Pen and ink, 33¾ x 23⅜″ (sight).

pictographic. Compositional structure came to be based on line, with drawn forms creating a pattern independent of color areas.

The Spanish artist Salvador Dali (b. 1904) played a major role in Surrealism as it was being developed in Paris. Dali was less a believer in "automatic writing" than in what has been called "the use of a

Fig. 294. PETER BLUME, *Rock and Stump*, 1943.
Pencil, 18½ x 22½".

fastidious illusionism to render his hallucinatory visions convincing.'"[2]
Dali moved to New York during the 1930s and has lived there off and on
ever since. His work was given a retrospective exhibition at the Museum
of Modern Art in 1941, and his vision was an influential one for Ameri-
can artists. Dali was always a prolific draftsman; his *Rhinoceros* of
1951 (Fig. 293) occurs well after his most creative period as a painter,
yet it is a wonderfully controlled, powerful work whose direct realism
somehow retains the hallucinating vision so important to this artist.

Peter Blume (b. 1906) is a more "native" artist than Dali, having
been brought to the United States at the age of five and having trained
here. Considered one of the earliest American Surrealists, Blume's
frightening vision is political and social in nature; he paints not dream
but nightmare in *The Eternal City* (1934–37, Museum of Modern Art).
A painstaking, careful craftsman, he labors over his compositions for
many years, often using drawings in a traditional manner. Thus, the
fine pencil drawing *Rock and Stump* (Fig. 294) is a preparatory sketch
from 1943 for a painting, *The Rock* (Art Institute of Chicago), not com-
pleted until five years later. Moreover, the artist's vision changed over
this period; the rock in the final painting is far flintier, and less organic,
than in the drawing.

Fig. 295. PAVEL TCHELITCHEW, *Portrait of Frederick Ashton*, 1938.
Silverpoint on white prepared paper, 20 x 12½".

Fig. 296. JOHN WILDE, *Wedding Portrait (Male)*, 1943. Pencil, 27¾ x 17¼″.

Fig. 297. JOHN WILDE, *Wedding Portrait (Female)*, 1943. Pencil, 27¾ x 17¼″.

The drawings of Pavel Tchelitchew (1898–1957) do not fall easily into a school or movement, though their eerie imagery does relate them in a way to Surrealism. A Russian-born artist with long experience in Paris—and a familiarity with the work of Dali and Tanguy[3]—Tchelitchew came to this country only in 1934. He was a ceaseless experimenter, and made many types of drawings—studies for paintings, illustrations for books and magazines, and stage designs for theater and ballet. He also made drawings which can stand wholly alone, and here his portraits are most compelling. His *Self-Portrait* of 1934 (Metropolitan Museum of Art), for example, is a spontaneous yet highly controlled work in ink and wash, in which the head looms up menacingly on the paper and the eyes engage the viewer's. A similar strange quality characterizes the *Portrait of Frederick Ashton* of 1938 (Fig. 295), done in the delicate and exacting silverpoint medium which the artist often employed. Though there is no automatism or accident in either of these images—in fact, the opposite, for every line is perfectly controlled—

Fig. 298. MORRIS GRAVES, *Bird in Spirit*, 1943.
Gouache, 24 x 30".

their mysterious, otherworldly mood relates to Tanguy's work. The connection with Surrealism becomes even closer in considering Tchelitchew's own description of his process:

> Line, flowing in a stream of consecutive points from the nerves of an artist's finger-tips, conducts its own almost somnambulistic energy, dreamlike in its undeterred automatism, but by no means hypnotized. Just as every dream is relevant if rightly read, since its loose fragments refer to some waking experience, so the spontaneous draughtsman's rapid line is supported by intuition based on past observation.[4]

Similar in its precise delineation and psychological penetration to Tchelitchew's portrait is the diptych by a little-known American draftsman, the Midwesterner John Wilde (b. 1912). Wilde's double *Wedding Portrait* of 1943 (Figs. 296 and 297) is highly detailed in the facial areas while being barely outlined elsewhere. The viewer is engaged by the intensity of the sitters' gazes, by the solidity of their faces and the

realism of their wounds and flaws, while being intrigued by the cryptic inscriptions, references, and diagrams surrounding them. Certainly the influence of Surrealism is manifest here.

Astonishingly similar in its spirituality is the work of Morris Graves (b. 1910), an artist who has done his best to stay away from the "mainstream" of fashionable style, and who has been drawn to the Orient rather than to Europe. Graves' marvelously linear drawings are technically comparable to those of his New York contemporaries, though his fragile, dreamlike images are very much his own. One of his largest and most haunting drawings is *Bird in the Spirit*, 1943 (Fig. 298), about which the artist commented, "My feeling is delight that the hand has moved so well. It doesn't hesitate."[5] Here one feels something of Mark Tobey's influence (Graves' former teacher) and even more of his lifelong study of the Orient and its philosophies. The bird depicted in this drawing is a recurrent theme and an important personal symbol for Graves; it is here both camouflaged and imprisoned by a network of weblike white strokes that define an unknowable space.

A related, linear style which became widely practiced during the 1940s was developed by a group of artists whose main concern was social and political commentary. Like the Abstract Expressionists, their exact contemporaries, these artists derived an aesthetic from transplanted European traditions, but their heritage was Expressionism rather than Surrealism. Furthermore, they share with Gorky, de Kooning, and others an emphasis on energetic, forceful line, strength of composition, and a sense of movement; however, these elements are used in a figurative style to express public concerns rather than a more private content.

One such artist is Hyman Bloom (b. 1913), who in 1920 came from Lithuania to Boston, and was trained in art schools in that city. He claims his early influences to have been Michelangelo and Blake, the monumentality and expressionism of whose images he emulates. Although his first exhibitions were of paintings, Bloom has been increasingly active as a draftsman since World War II. His subjects derive from the social-realist tradition, but are executed in linear, expressionistic style. The images in his cadaver series, for example *Autopsy*, 1953 (Whitney Museum of American Art), represent Bloom's reaction to the Nazi atrocities of the war. In these works, line is used to fragment a gruesome subject, while tonal contrasts describe an eerie, flickering light. The lack of clarity and definition of the image also adds to the timeless sense of fear and violence. Similarly, Bloom's drawings of the aged, such as *Nude Old Woman* (Fig. 299), make use of the calligraphic possibilities of the brown crayon while creating a horrifying, grotesque image of an enfeebled woman. Bloom is both realist and Symbolist: he draws a single human being, yet comments at the same time on the inevitability of old age and death.[6]

Fig. 299. HYMAN BLOOM, *Nude Old Woman*, c. 1945.
Brown crayon, 9½ x 7⅞″.

Bloom's later graphic images include landscapes and fish skeletons
filled with overlapping, entwined forms which crowd the picture surface.
Lacking a ground plane or unified perspective, forms swim around the
page with the same absence of solidity and focus that marked the
cadaver images. This uncertainty and fragmentation of forms typify
Bloom's approach. The mystical, linear qualities of his images link him
with the early, Surrealist efforts of the Abstract Expressionists.

Rico Lebrun (1900–1964) came to the United States from Italy in
1924, and shortly thereafter began to work as an illustrator for *Vogue*
and *The New Yorker*. He would return to illustration later in his career

Fig. 300. RICO LEBRUN, *Running Woman with Child*, 1948.
Ink on gray paper, 18¾ x 25¾″.

with his Dante's *Inferno* as well as works by Brecht and Melville; indeed, some credit must be given his years as a commercial artist for the economical, descriptive line and the forceful sense of design which appear so strongly in his later drawings. Like Bloom, Lebrun was active in WPA projects during the 1930s; and, as with Bloom, the experience of the Depression and the war developed in Lebrun a penchant for dramatic subject matter which allowed him to comment upon social injustice.

Lebrun's best-known work is his painting *The Crucifixion* (Syracuse University), a huge polyptych completed in 1950, whose theme of man's inhumanity to man relates to Picasso's *Guernica* and Goya's *Disasters of War* series, both of which Lebrun knew well. Over two hundred drawings, including compositional sketches, details, and figure studies— in ink wash, chalk, and other mediums—contributed to the final painting; this group includes many of his most powerful drawings, such as *Woman of the Crucifixion*, 1950 (Collection of Channing Peake), in which geometric areas of tone are laid over a complex linear structure, resulting in a dark, monumental image.

An expressionistic, almost Baroque, ink line is the basic element of Lebrun's drawings. They are spontaneously and rapidly executed, the result being an image full of motion which fills the page, as is seen in his poignant *Running Woman with Child*, 1948 (Fig. 300). Presum-

"If it had not been for these thing, I might have live out my life talking at street corners to scorning men. I might have die, unmarked, unknown, a failure. Now we are not a failure. This is our career and our triumph. Never in our full life could we hope to do such work for tolerance, for justice, for man's understanding of man as now we do by accident. Our words— our lives—our pains nothing! The taking of our lives—lives of a good shoemaker and a poor fish peddler—all! That last moment belongs to us—that agony is our triumph." — Bartolomeo Vanzetti

Fig. 301. BEN SHAHN, "*Sacco and Vanzetti,*" 1952.
 Ink, 5¾ x 8⅝".

ably a mother trying to escape war, the drawing expresses pure anguish: one feels fear itself, one senses the artist rushing to finish the drawing before the holocaust. Lebrun's jagged lines of pen and brush whipped across the paper are sometimes heavy with ink, at others nearly dry: the result approaches abstraction while it gives expression to human torment.

An even more direct social comment is to be found in Ben Shahn's (1898–1969) drawing *Sacco and Vanzetti* (Fig. 301). Later issued as a poster, this image recalls the gouache series exhibited by Shahn in 1931–32 on the theme of the Sacco-Vanzetti case. In this drawing, with its angry ragged line, more controlled than Lebrun's but no less ex-

pressive, and direct, frontal presentation of the figures, Shahn intentionally returns to his style of the 1930s, with its primitivism, bluntness, and deep sense of caring. The massive, looming heads with empty eyes, the scratched angular line, the abbreviated, empty figures create an anger and pathos that are a key theme in Shahn's many images of protest.

Shahn in fact was one of the ablest graphic realists of his time. His *Portrait of Dr. J. Robert Oppenheimer*, 1954 (Museum of Modern Art), for example, also uses simple, direct means to convey a complexity of emotions. Here the artist employs his nervous line to describe a minimum of detail; attention is focused on the hands and especially on the monumental head with its intense, deep-set eyes. Through a dense concentration of line, produced by the rapid movement of a dry brush on the forehead, and broad wet strokes for the eyes and brows, Shahn is able to suggest both the sitter's intelligence and the agony of his political ordeal. Not all of his drawings are so intensely critical as *Oppenheimer*; many drawings of sports figures, musicians, and animals, for example, use the same jagged silhouette toward a whimsical or pathetic end.

Drawings play a lesser role in the work of Jack Levine (b. 1915), though he is nonetheless a fine draftsman. Primarily made as preparatory figure or compositional studies for oil paintings (for which he also makes finished oil studies), Levine's drawings are made with a variety of mediums, including pencil, charcoal, oil wash, and pen and ink, often on colored paper. *The Mourner*, 1952 (Fig. 302), is characteristic: the lumpy figure of the ward boss is created with light, sweeping strokes of charcoal; the pastel highlights and pink paper anticipate the florid color and mood of the painting *Gangster Funeral*, 1953 (Whitney Museum of American Art), for which this is an early study. Though Levine's grotesque, neckless gangster, hypocritically solemn, is close to caricature, his forceful, rapid execution draws more of our attention even than his subject—thus suggesting one dividing line between illustration and art.

Levine's art expresses a satiric view of certain aspects of American society; his style looks back at least in part to Soutine and the European Expressionists, and is characterized by brilliant, shimmering colors, chaotic perspective, and distorted form. However, he was equally able as a "pure" draftsman, as in his portrait drawings—for example, the one in pencil of *Ruth Gikow*, 1948—or in scenes from contemporary Jewish life, such as *Jewish Cantors in a Synagogue*, 1930 (both at the Fogg Art Museum). Levine's delicate line relates him closely to his time, while his political and ethnic subjects inevitably separate him from the avant-garde members of his generation.

Equally serious and even more eclectic are the graphic works of Philip Evergood (1901–1973), who was a prolific draftsman and print-

Fig. 302. JACK LEVINE, *The Mourner*, 1952.
Pastel on pink paper, 23 x 18″.

maker. The drawings generally relate to Shahn and Levine in their
social realism, though the style varies widely from a brushy, expres-
sionistic mode with brush and ink, to pen drawings reminiscent of
Marsh particularly, to fine pencil drawings executed in a wavering yet
certain manner that suggest the influence of German Expressionism.
An especially effective example is the pencil drawing of 1944, *Removing
a Diseased Gall Bladder* (Collection of Frank and Lidia Kleinholz, Port
Washington, N.Y.).

An emphasis on drawing was continued during the 1940s by the
Abstract Expressionists, many of whose early works were in the

Fig. 303. ARSHILE GORKY, *Abstract Forms*, c. 1931–1932.
Pen and India ink, 22½ x 29″.

biomorphic, Surrealist tradition. For these artists, drawing came to
mean gesture rather than description of form, and thus they abandoned
the traditional realist function of draftsmanship. Further, though these
artists cared deeply about drawing, they were in a sense indiscriminate
with regard to its usual materials and scale. They often drew not on
paper but on large canvases, and used various kinds of paint and
collage in doing so. Although relatively few traditional drawings were
made during the early 1940s, drawing actually *absorbed* painting:
paintings by artists such as Pollock and Kline are essentially linear,
gestural, and depend on drawn elements for their structure. They were
quite properly considered drawings by their creators.[7]

A major figure in this development was Arshile Gorky (1904–1948),
who emigrated to the United States in 1920 from Turkish Armenia.
Gorky was primarily a draftsman, and it is in drawing that the develop-
ment of his style is most visible; it is also through drawings that he was
most influential. Moreover, Gorky's oil paintings themselves are actually

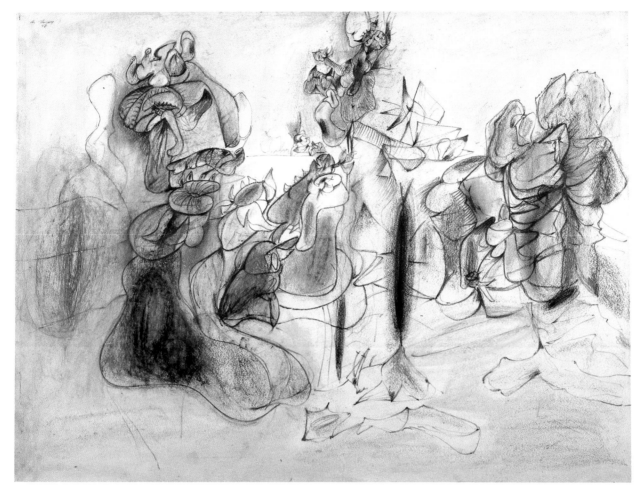

Fig. 304. ARSHILE GORKY, *Anatomical Blackboard*, 1943.
Ink and crayon, 20 x 27¼″.

large drawings, for they are thinly painted and line moves free of color accents. In both the "pure" drawings and in paintings, Gorky's phenomenal feeling for line is always apparent. Throughout his career, his drawings make use of conventional mediums: pencil, ink (generally black, with occasional additions of brown), and wax crayon. All of them, whether the Cubistic images of the 1930s, done primarily in ink, or the great drawings of the 1940s, characterized by a wavering pencil line with colored crayon accents, emphasize linearity: shading, modeling, or creating a sense of volume is simply not his concern.

Gorky's drawings of the 1930s depend stylistically on other masters, particularly the contemporary Cubist-Surrealist modes of Miró and Picasso.[8] As can be seen in *Abstract Forms*, 1931–32 (Fig. 303),[9] Gorky's menacing biomorphic shapes lie parallel to the picture plane against a dense, or sometimes totally blank ground which frames them. Though the forms are closed, they are connected and overlapped by a single, sweeping contour. Spaces created by the intersection of line are filled

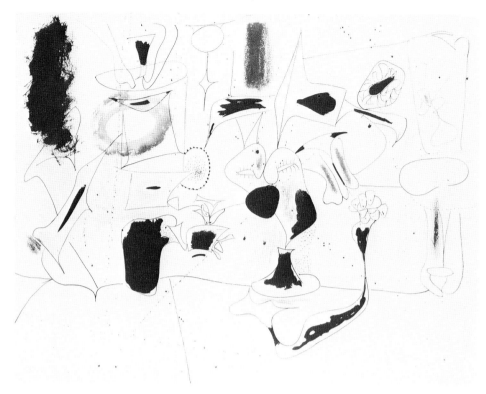

Fig. 305. ARSHILE GORKY, *Composition*, c. 1945–1946.
Pen and ink, 20 x 26¼".

either with opaque ink or a hatching pattern which creates an inter-
mediate tone, or are left empty. This causes the forms simultaneously
to appear to be on the picture plane and to advance and recede parallel
to it. The technique employed is reminiscent of one which delights
children in grade-school classes—covering a sheet with a single, curv-
ing, self-crossing line, and coloring in the figure-creating units which
result—an analogy which suggests Gorky's relation to the subconscious,
automatic-writing techniques of the Surrealists.

Gorky's career reveals the direction of the American vanguard
from the 1930s to the 1940s, the shift from abstract Cubism to abstract
Surrealism, and then to a new, freer abstraction.[10] His drawings of
the 1940s expand the dream-imagery concept initiated in the earlier
compositions; the forms in pencil, ink, or crayon increasingly resemble
strange mutant plants, animals, and human figures, as in *Anatomical
Blackboard*, 1943 (Fig. 304). They are connected more by contiguity
than by the tight formal unity and geometric structure of the earlier
drawings. Some of the drawings of this period, such as *The Plough and
the Song*, 1944 (Oberlin College, Allen Memorial Art Museum), or *Com-
position* (Fig. 305), were used to develop ideas later appearing in
Gorky's paintings (which, like the drawings, express autobiographical
themes revolving around a fantasized natural imagery).

Like Gorky, Mark Tobey emphasized line in his oil paintings as well as in his works in tempera on paper, and his work also merges traditional characteristics of painting and drawing. Tobey's oeuvre suggests an accumulation of influences—both exotic and native—which separate him from the mainstream developments of the 1940s and 1950s, yet on several occasions he exhibited with artists such as Motherwell, Pollock, and Hofmann. Moreover, his characteristic manner—a skein of "white writing" hovering over a dark, ghostly background—is close to the mystical automatic-writing techniques of his contemporaries, and is considered by some critics to be the earliest example of "all-over" painting.

Born in Wisconsin in 1890, Tobey first studied at the Art Institute of Chicago and then briefly with Kenneth Hayes Miller in New York. In the early 1920s he was converted to the Bahai faith and introduced to Chinese calligraphy, thus beginning a lifelong involvement with Oriental philosophy and art. However, his linear style is as closely linked to Klee and Kandinsky as it is to Chinese brushwork; his "white writing," seemingly dependent in its form and mystical content on Oriental influences, was actually first inspired by the flashing lights on Broadway, as made explicit in titles of drawings and paintings of the late 1930s and early 1940s: *Broadway* (c. 1935, tempera, Metropolitan Museum of Art) or *Broadway Boogie* (1942, tempera, Collection of Mr. and Mrs. Max Weinstein, Seattle).

Universal Field, 1949 (Fig. 306), demonstrates the interaction of

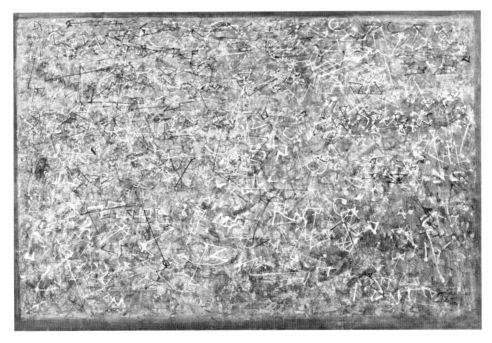

Fig. 306. MARK TOBEY, *Universal Field,* 1949.
Tempera and pastel on cardboard, 28 x 24".

drawing and painting elements in Tobey's work. The tiny, nervous, darting forms resemble hieroglyphics, and are as elusive in their meaning. They lead the eye back and forth over layers of subdued, delicate color which evoke an indefinite, soft atmosphere not unlike that of Mark Rothko's more monumental paintings of the 1960s. Tobey's drawings, however, retain a small scale, proportioned to the calligraphic elements which comprise the primary meaning of his work: "He has made line the symbol of spiritual illumination, human communication and migration, natural form and process, and movement between levels of consciousness."[11]

The emphasis on calligraphic technique and personal expression which Tobey shared with Gorky was also to be found in the drawings of artists for whom Gorky was a major influence. Beginning in the early 1940s, a number of New York artists—including Baziotes, Rothko, Pollock, and Newman—began experimenting with automatism, which they employed in order to bring forth universal symbols. These men were drawn to primitive art and exotic myth, which as romantics they believed to possess spiritual truths akin to those of the subconscious mind.[12] Gorky had significant influence on them, as did the linear style and biomorphic fantasies of the Spanish Surrealist Joan Miró.

The early work of William Baziotes (1912–1963) reflects an interest in fantastic subject matter. By 1941 this work was characterized by doodle-like forms floating over phosphorescent, nocturnal colors, reflecting an interest in underwater life that at the same time mirrored the artist's imagination. The separation of drawn forms, which define the structure of the images, from the colored areas, which create a sense of atmosphere and an indefinite space, is to be found in both his paintings and his drawings. Works such as the pastel drawing *Sea Forms* (Fig. 307) typify a later, more polished style that nonetheless always retains a free linear play over the surface.

The early drawings of Robert Motherwell (b. 1915), like Gorky's, reflect the influence of Picasso in their grotesque biomorphic forms placed against a solid abstract ground. Equally important for Motherwell is the French literary tradition from the Romantics through the Surrealists, which he studied during the 1930s; and he pays homage to both these interests in his great collage of 1944, *Mallarmé's Swan* (Fig. 309). Here, drawn line and applied form create a lively tension between surface and depth. The subtle color juxtapositions and linear gesture characterize all of Motherwell's work in collage, a medium which he has developed with special understanding. In the early 1940s, after meeting several of the Surrealist émigrés, he began to experiment with various automatist techniques, and line became more important in his work. As would be the case with many artists whose early works incorporated various Surrealist properties, line and linear imagery would evolve into

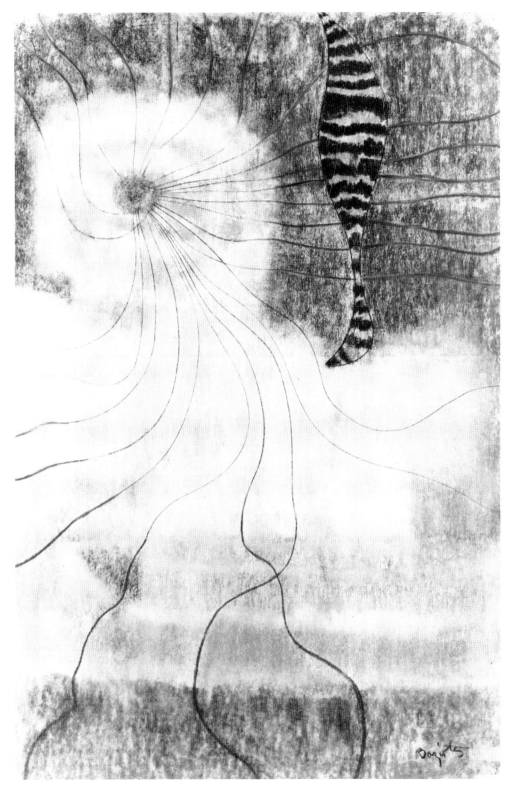

Fig. 307. WILLIAM BAZIOTES, *Sea Forms*, 1951.
Pastel on paper on masonite, 38⅛ x 25⅛".

gesture and shape; in Motherwell's more recent collages, such as *Sky and Pelikan* (Fig. 310), the motion creating the form on paper is its primary linear component.

Barnett Newman (1905–1970) began making Surrealist drawings in the mid-1940s. At this time he experimented with automatic writing, which allowed him to make public the most informal kind of drawing with its spontaneous daydreaming aspect. His drawings contain fantastic forms suggesting fertility and growth, and as such are similar to Gorky's vegetal–sexual themes. Their titles often refer to exotic mythologies and religions, such as *Song of Osiris* (1945, Estate of the Artist), and are executed in dense scribblings in oil, oil crayon, and wax crayon on paper. A few years later Newman's biomorphic forms evolved into geometric ones with mythic meanings. These shapes, most frequently circles or shafts dividing the canvas, appeared simultaneously in drawing and painting, and were the initial forum for Newman's development of vertical stripes in his painting.

Newman largely abandoned drawing during the 1950s, working exclusively in oils.[13] However, in 1960 he made a series of twenty-two drawings in ink on paper in which he experimented with black as a color and with the differing densities of line produced by ink as it drags over the paper. These drawings, though thematically and structurally related to his painted "Stations of the Cross" series, are not studies for those paintings, or exercises, but finished, highly controlled images, like his monumental paintings but for a more intimate scale.

What appears to be underwater biomorphic imagery is found in the early works of Mark Rothko (1903–1970); they exhibit the same interdependence of linearity and color that is found with Baziotes and Gorky, as well in the work of Miró. During the early 1940s, when Rothko began to experiment with automatism, he seldom worked in oil, preferring watercolor and gouache because of the ability of those mediums to produce luminous, transparent effects and a sense of atmosphere. He combines this coloristic delicacy with an awkward, primitive linearism in such works as *Baptismal Scene* (Fig. 308).

Rothko's major interest in drawing, like Newman's, occurs in the early work; by 1950 he had eliminated figurative images and automatic calligraphy from his style, returned to working with oils, and began to paint the washes of color floating across the canvas which constitute his mature style. Indeed, suppression of the descriptive, of the linear and representational aspect of Surrealism, is typical of the stylistic changes apparent in works of artists such as Newman and Motherwell during this period. For them, the search for the universal and the sublime caused the drawn aspect of their work, which referred to finite and specific elements in nature and myth, to disappear. However, for other artists, such as Pollock and de Kooning, line and gesture came to assume an even more central role.

Fig. 308. MARK ROTHKO, *Baptismal Scene*, 1945.
Watercolor, 19⅞ x 14″.

The drawings of Jackson Pollock (1912–1956) were made at ir-
regular periods throughout his career, were seldom exhibited, and show
an uneven quality. Pollock's mature painting style is essentially
gestural; it is structured through line, and characterized by spontaneous
execution that reveals the artist's process—both qualities adapted from
traditional draftsmanship.

Pollock was born in Cody, Wyoming, and studied art in high school,

Fig. 309. ROBERT MOTHERWELL, *Mallarmé's Swan*, 1944.
Collage using gouache, crayon and paper on cardboard, 43½ x 35½".

Fig. 310. ROBERT MOTHERWELL, *Sky and Pelikan*, 1961.
Collage with brush and ink, 29 x 23".

then with Thomas Hart Benton at the Art Students League in New York. The few surviving drawings from this period are copies of old masters, or reflect the realist, regionalist style of his teacher. Another, more lasting influence for him was Surrealism, to which Pollock was first exposed at the 1936–37 Museum of Modern Art exhibition. At this time he was approaching a mental breakdown and began psychiatric therapy in which he was urged to make drawings in order to bring to the surface the images of his unconscious. His drawings from this period, such as *Untitled*, 1944 (Fig. 311), are brutal, tense, and violent, and

Fig. 311. JACKSON POLLOCK, *Untitled*, 1944.
Brush, spatter, pen and black and colored inks, 18⅞ x 24⅞″.

are characterized by jagged, frenzied line and deep, opaque color. The
images rise from automatic-writing techniques, and like those of many
of his contemporaries, appear as personal dreams and universal symbols
at the same time. The pictographic content of these drawings persisted
in the images made during the 1940s and ultimately generated Pollock's
mature painting style.

In the winter of 1946–47, Pollock made a radical break with tradi-
tional painting as he began to drip and pour enamel over canvas. This
innovation was accompanied by an abandonment of traditional graphic
means. By 1948 he had adapted the drip technique to paper, which, like
canvas, was used horizontally. The same mediums—enamel and alumi-
num paint—which Pollock used on canvas were also used on paper. Both
paintings and drawings depend structurally on the graphic quality of
the drips, however painterly the surface. Pollock himself used the term

Fig. 312. JACKSON POLLOCK, *Number 12*, 1949.
Oil on paper mounted on composition board, 31 x 22½″.

Fig. 313. HANS HOFMANN, *Reclining Nude*, c. 1950.
Match and ink, 8½ x 11¹⁄₁₆″.

"drawing" to refer to the figurative delineations in his paintings, suggesting that for him drawing had little to do with medium but was defined by gesture.[14]

Like the works on canvas, Pollock's all-over drip drawings on paper are an overlapping skein of lines for which color serves as accent, as is the case with *Number 12*, 1949 (Fig. 312). The technique of pouring paint, like that of automatic writing, was used to produce a less controlled drawing, a more rapid, flowing line, than a brush or pencil would allow.[15] In Pollock's work, more than that of any other artist of his generation, drawing virtually disappears as a separate medium with its own materials and characteristics, but assumes paramount importance as technique in his whole oeuvre.

As is the case with Pollock's work, the drawing element in the works of Hans Hofmann (1880–1966) is as significant in his paintings as in the works of art on paper. Hofmann was primarily concerned with the problems of drawing as they related to painterly surface. His early

drawings, like his paintings, are of figurative subjects; their patterning and crude line reflect the influence of both Matisse and the German Expressionists on this German-born artist. Such works as *Reclining Nude* (Fig. 313) combine thick, slashing ink lines with heavily brushed and rubbed areas. Hofmann's work from this point becomes increasingly abstract; his images after the 1940s explore in coloristic terms the conjunction of shapes of different densities that are anticipated here in variously shaded, hatched, and scumbled areas. Hofmann also uses "drawn" gestured line as accent, demonstrative of expressive energy, on the surface of many of his paintings, as in *The Pond*, 1958 (Richard Brown Baker Collection).

Franz Kline (1910–1962) also regarded drawing as a gestural technique rather than a medium, although he is more concerned than Pollock with the textural properties of his materials. His early drawings, of about 1940, are in the social-realist tradition, depicting New York, especially Brooklyn and the Greenwich Village area, and remind one of the drawings of Robert Henri or John Sloan.[16] By 1949–50 his paintings and drawings were evolving toward the dark, massive, slashing forms that would characterize his final style, though still retaining a hint of Miróesque Surrealism, as can be seen in his *Rice Paper Abstract* of 1949 (Collection of Dr. and Mrs. Theodore J. Edlich, Jr.).

Fig. 314. FRANZ KLINE, *Untitled*, 1952.
Brush and ink, 8½ x 10⅞".

Fig. 315. SAM FRANCIS, *Middle Blue, No. 5*, 1960.
Watercolor, 26¾ x 40¼″.

His ink drawings of the 1950s, like his paintings, contain clear, calligraphic forms which appear to be spontaneously and rapidly executed, but are actually carefully controlled. Some are studies for larger-scale paintings; in fact, it was Kline's drawings with a three-inch housepainter's brush on newspaper that led him to the expanded scale of his black-and-white paintings of the late 1950s.[17] Like the drawings of his friend de Kooning, to whom he gives major credit as an influence, Kline's works on paper often use nonlinear means to create shape and edge, as in his *Folded Drawing* of 1959 (Marlborough Gallery). Kline also experimented with textures and the variegated surface produced by a combination of materials and techniques, as is apparent in his ink drawing *Untitled* of 1952 (Fig. 314).

Like Kline's, some of the later gestural painters' works are characterized by an easy confluence of the drawing and painting mediums. The evolution of a linear, draftsmanlike painting technique, with which Pollock and others struggled and which exists in their work as a tense, energetic surface, is more established and comfortable in the work of artists such as Sam Francis (b. 1923) and Philip Guston (b. 1913). Francis' imagery is particularly elegant. He makes use of bars or blots

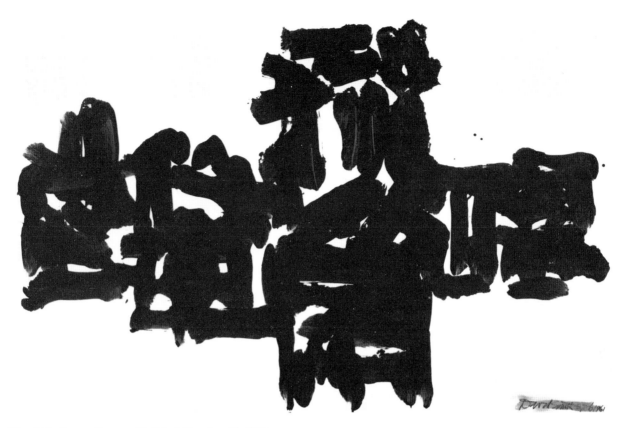

Fig. 316. DAVID SMITH, *Untitled Number II*, 1961.
India ink, egg yolk, and watercolor, 25½ x 39¾″.

of color which divide his picture surface at uneven angles and are combined with spheres, calligraphic scribbles, and drops produced by flicking a loaded brush onto the surface. His watercolors, such as *Middle Blue, No. 5*, 1960 (Fig. 315), are often more successful than his paintings, though they relate closely; here his characteristic shapes are rendered in bright colors which pool and bleed into one another.

The ink drawings of Philip Guston—most of which were made between 1949 and 1954—are, like his paintings of that period, concerned with the definition of shape and ground. They either circumscribe a floating form or, by means of grouping vertical strokes, define the mass and surface texture of such a form. The fact that Guston's drawings, such as the untitled ink drawing of 1953 (Fig. 317), so closely resemble his paintings links him with the earlier Abstract Expressionists. Yet his imagery is dominated more by painterly concerns than by linear gestures; his drawings represent the explorations of his interest in mass and space in a different, noncoloristic medium.

The work of many sculptors of this era is based on the same linear structure that characterizes much Abstract Expressionist painting. Their images evoke the grotesque, primitivistic forms that typify the

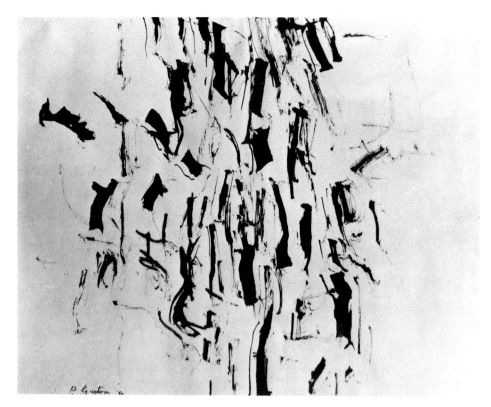

Fig. 317. PHILIP GUSTON, *Untitled*, 1953.
Ink, 16¾ x 22″.

Surrealist phase of their contemporaries; the drawings of such sculptors
as Herbert Ferber, Seymour Lipton, David Hare, and David Smith are
characterized by attenuated forms and open spaces that are analogous
to the linear skeins of paint in Pollock's work. Their constructions,
often in nontraditional materials, are rhythmic, gestural, and self-
expressive. A similar gestural quality—an interplay between line, open
space, and movement—is found in the drawings of these sculptors, such
as *Untitled Number II* by David Smith (Fig. 316). This drawing, in
India ink, egg yolk, and watercolor, is marked by calligraphic movement
that softens the geometric structure of the design.

 Willem de Kooning (b. 1904) is one of the few major artists of this
era for whom drawing remains a separate yet essential medium: seldom
does he confuse drawing with painting. His drawings are extraor-
dinarily innovative, yet he retains much of the traditional character of
the drawing medium in terms of scale, medium, and function. He is
perhaps the most prolific draftsman of his generation, and certainly the
most influential.

 De Kooning received his initial artistic training in Rotterdam,
Holland, his birthplace. After emigrating to New York City in 1926, he
worked first as a sign painter and later became involved with the WPA
Federal Art Project. During the 1930s he was exposed to the varied

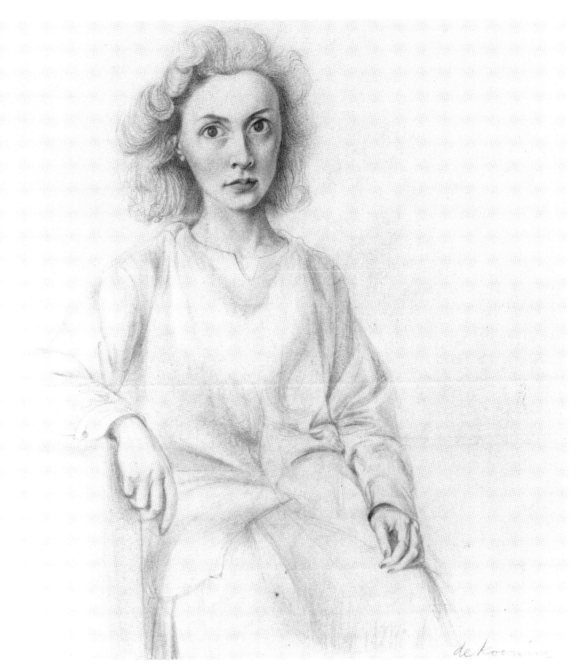

Fig. 318. WILLEM DE KOONING, *Elaine de Kooning*, 1940–1941.
Pencil, 12¼ x 11⅞".

styles—from School of Paris to social realism—then current in New York; these influences are all apparent at times in his work. An early realistic drawing, *Elaine de Kooning* of about 1941 (Fig. 318), reflects the linear refinement of Picasso's works during his classical period in the 1920s as well as foreshadowing the personal expressive attitude that would later characterize de Kooning's more gestural drawings. In the drawing of *Elaine,* one's attention is drawn immediately to the sitter's powerful, oversized head, especially to her penetrating eyes;

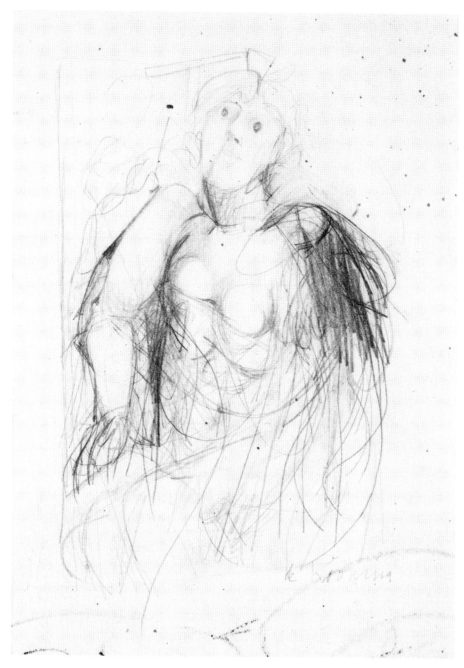

Fig. 319. WILLEM DE KOONING, *Woman*, 1942.
Pencil, 7½ x 5".

line is used masterfully yet so gently as to be understated. In a drawing
(Fig. 319) which followed shortly after, the eyes of a woman are still
intense (as in all de Kooning's women), but now sweeping pencil lines
dominate and the figure appears to struggle to free herself from them.
The artist's characteristic line, free, sweeping, yet always intelligible,
is already fully developed here.

Most significant for de Kooning was the influence of Arshile Gorky,

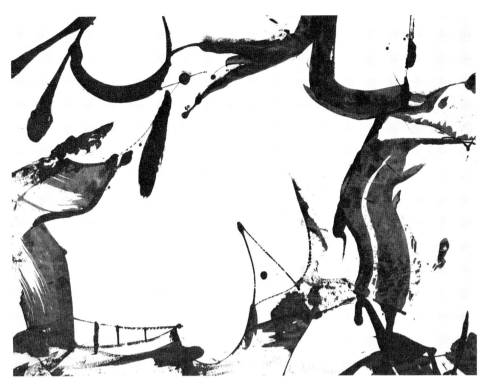

Fig. 320. Willem de Kooning, *Untitled*, 1949.
Black enamel, 27⅞ x 29⅞".

whom he met in the mid-1930s and who became his lifelong friend. Gorky's interpretation of Surrealism inspired de Kooning to make nearly abstract drawings. Thus his work of the mid-1940s, such as *Abstraction* (1945, pastel and pencil, Collection of Allan Stone), and *Untitled*, 1949 (Fig. 320) evokes the grotesque, biomorphic forms of Picasso and Gorky; it also establishes de Kooning's own, personal imagery: the human, particularly the female form, abstracted, dissected, rearranged, here nearly becomes landscape.

The same configurations, translated into a calligraphic ink drawing, appear in an untitled work of 1950 (Collection of Thomas B. Hess). In this drawing the components of his fragmented figure imagery, which would soon culminate in the "Woman" series, are readily apparent: the breast-belly shape, the leering eyes, the automobile-like shapes. This drawing was constructed through a process invented by de Kooning: drawings made on tracing paper are piled on top of one another, shuffled, amended; the images resulting from this combination give birth to another drawing. The process of accumulating his familiar shapes into unfamiliar configurations would be repeated several times; this particular drawing probably evolved after many such changes.

This innovative technique was developed in the many drawings and paintings produced after 1950 belonging to the "Woman" series, for which the artist is best known. Images such as *Woman* of 1952 (Fig.

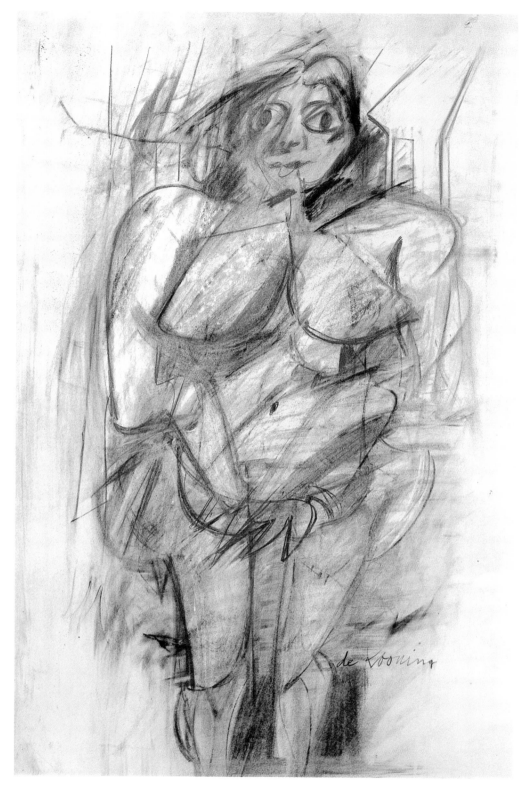

Fig. 321. WILLEM DE KOONING, *Woman*, 1952.
 Pencil and pastel, 21⅜ x 16″.

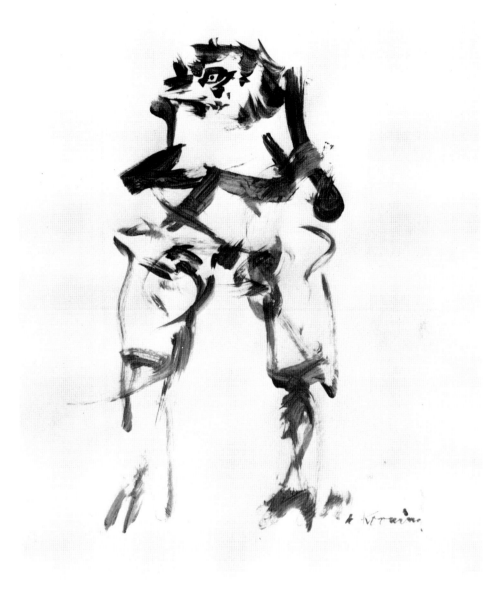

Fig. 322. WILLEM DE KOONING, *Woman*, 1961.
Brush and ink on paper, 23¹¹⁄₁₆ x 18¹¹⁄₁₆″.

321) are characterized by a vigorous, sometimes violent gesture, a monumental certainty and sense of presence; at the same time there is in these works an unfinished, exploratory, almost tentative handling of line. De Kooning could be simultaneously brutal and gentle, cruel and loving. The drawings reveal a constant exploration of medium and support, as can be seen in the torn and pasted works, such as *Study for Woman*, 1951 (Collection of Kimiko and John Powers), in

which the support of three assembled drawings becomes the image. In drawings such as *Blue and White (San Francisco)*, 1960 (Collection of the Artist), the torn edge of the paper creates line without being line. Parallel to the paradoxical juxtaposition of vigor and hesitation is the combination of creative and destructive gestures by which de Kooning builds his drawings: he tears and defaces compositions to create new ones, as in *Study for Woman*; he fragments and dislocates shapes and forms to construct a figure, as in *Monumental Woman*, 1953 (Collection of Mr. and Mrs. Harold Rosenberg).[19]

As is the case for other Abstract Expressionist artists, the gesture —line propelled by emotion and physical energy—is a major aspect of de Kooning's style, and one which dominates all his works, both on canvas and on paper. De Kooning intentionally blurs the distinction between painting and drawing, using graphic means and materials on canvas, and oil, enamel, and house paint on paper. His oeuvre typifies the merger of drawing and painting in Abstract Expressionism. During the 1950s the two mediums developed simultaneously, exploring the same kinds of problems. And yet his drawings remain distinct: they are not preparatory sketches in the conventional sense, but rather are "working drawings," made before, during, and after a painting project, or at times without relation to one. Drawings for de Kooning are a reservoir of visual ideas that contribute to but do not predict his paintings.

The paradoxical quality of de Kooning's style is less apparent in his brush-and-ink drawings of the 1960s, such as *Woman* of 1961 (Fig. 322), which are created with a few broad strokes. These drawings are totally gestural while being still recognizable; the style evokes Zen brush drawing, but the theme of woman as a coy, menacing, and erotic being is one that de Kooning introduced in the 1950s. In these drawings, as in the somewhat more radical works of the 1950s, the gesture—the self-proclaiming element of de Kooning's drawings—and experiment— the aspect of construction through destruction which is in effect self-effacing—remain paramount.

Except in the works of de Kooning, drawing as it is traditionally conceived and used had almost disappeared by the mid-1950s in the avant-garde (though it was alive and well elsewhere), despite the importance of linear, gestural techniques in the paintings of the Abstract Expressionists. Pollock, in a 1950 interview, explained how drawing is absorbed by painting in his work: "Yes, I approach painting in the same sense one approaches drawing; that is, it's direct. I don't work from drawings, I don't make sketches and drawings and color sketches into a final painting."[20] For modernist artists of Pollock's generation, drawing had by and large ceased to be an independent, experimental medium. It remained to the next generation of artists to revive drawing as such as a vital, expressive medium.

14

Drawing Today: Many Directions

Painting and drawing nearly merged during the Abstract Expressionist era, and there were many pessimistic prognostications for the future of draftsmanship as such. Yet quite the opposite has occurred: though American artists have been working in ever more varied styles and mediums during the past two decades, the craft of drawing has at the same time enjoyed a great and unexpected renaissance. Indeed, an interest in drawing appears to be one of the few constants in the art of the present day, which otherwise presents the critic with a bewildering multiplicity of images. Of course, one legacy of the 1940s remains, for the boundaries of what must be considered "drawing" have certainly expanded; our definition would now include not only representational and nonobjective, intimate sketches and monumental finished objects—as before—but also conceptual work where gesture is informational rather than graphic, as well as realist drawings where evidence of the artist's involvement has been suppressed. Yet even given this expansion of drawing modes, the fact remains that recent American drawings are as sensuous, as direct, and as beautiful as at any time in our history.

The most influential contemporary draftsmen have been Jasper Johns (b. 1930) and Robert Rauschenberg (b. 1925)—and perhaps one should add the related work of Larry Rivers (b. 1923). The paintings of these men are generally and properly discussed as transitional between the moribund gestural tradition of Abstract Expressionism and the dispassionate figuration of Pop; their drawings give special insight into these developments.

The drawings of Jasper Johns, for example, relate closely to his paintings in imagery and their concern for sensuous surface, yet their relationship to the paintings is complex. Occasionally he uses drawings

367

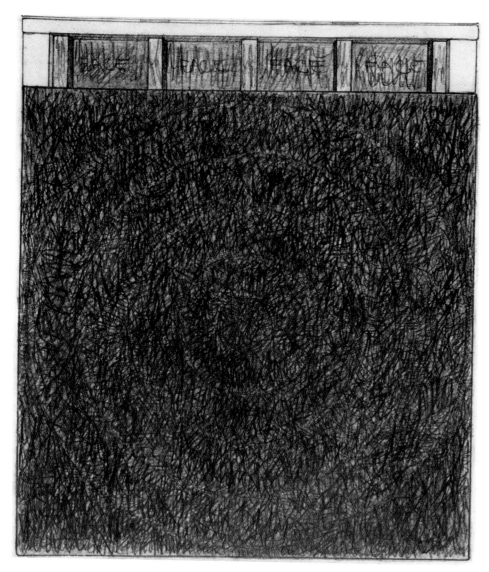

Fig. 323. JASPER JOHNS, *Target with Faces*, 1958.
Pencil and wash, 16¼ x 12½".

as studies for paintings in a traditional way, as is the case with the 1955 pencil drawing *Target with Four Faces*, which anticipates the painting of the same title (Museum of Modern Art). More frequently, however, drawings of the same subject will appear *after* the painting, with the image not so much corrected or adjusted as rendered alternatively. Thus the same image, *Target with Faces*, appears in a pencil-and-wash drawing (Fig. 323) dating three years later: now the fluidity of the ground-covering hatching minimizes the iconic function of the target, so important in the original work. The tension between surface and ground, between actual and apparent three-dimensionality, becomes more subtle as collage elements are eliminated and close tonalities in the target and face areas flatten the image while conventional shading on the partitions insists on the illusion of volume. A similar transformation

occurs in the pencil drawing *Device Circle* (Collection of Mr. and Mrs. Ben Heller), which converts the original multilayered, roughly textured, and collaged surface into a flat image in which surface activity and material presence are replaced by graphic description.

Johns' drawings are tonal, usually without color, and he uses conventional mediums—pencil, ink, conté crayon, and graphite wash; his innovations appear in his subjects and the way he draws them. A great deal of the appeal of these drawings lies simply in the extraordinary touch of the artist, perhaps equaled in American art only by Winslow Homer nearly a century before. The gestural presence of Johns' hand has many expressions—an almost lazy, wet, calligraphic stroke; a more energetic, irregularly rhythmic, dense hatching; a sharp, precise line. *Flag* of 1958 (Fig. 324), a key work from one of Johns' most important series, uses the familiar grid of the American flag as the structure for a particularly rich network of line and texture in pencil and graphite wash. Quite different is the monumental drawing *0 through 9*, 1961 (Fig. 325), in which the artist has rubbed and blurred heavily colored surfaces, then used white (negative) lines in defining the contours of his superimposed numbers, and finally rubbed most of the right-hand area over a roughly textured surface. The surface alternates gradually from transparency to heavy density, causing the numbers to advance and recede while their shared contours root them to a single plane.

Fig. 324. JASPER JOHNS, *Flag*, 1958.
Pencil and graphite wash, 7½ x 10⅜″.

Fig. 325. JASPER JOHNS, *O Through 9*, 1961.
Charcoal and pastel, 54 x 45".

Johns' drawings occasionally incorporate chance gestures, as occur in such ink-on-paper or ink-on-film drawings as *Tennyson*, 1958, or *Device*, 1962, in which the ink, applied very wet, is allowed to blot, run, and pool with little apparent guidance from the artist's hand. Conventional shading, such as models the bulb in the pencil-and-graphite wash drawing *Light Bulb*, 1958, or separates the rectangles in *Three Flags*, 1959, counterbalances the random gestures. Traditional draftsmanship and realistic imagery are the norms against which Johns conducts his experiments with mediums and technique.

Though Robert Rauschenberg has been closely associated with Johns as a founder or precursor of Pop art, his drawings are quite different, depending less on gesture or hand and even more on technical innovation and image. Moreover, the drawings are generally larger than Johns', and do not have the direct relationship to paintings that often occurs in his work. Rauschenberg's medium in the drawings around 1960 demonstrates his general impulse to marry painterly gesture to direct realistic images: he uses a variety of conventional graphic mediums—pencil, gouache, wash, colored pencil—but adds techniques such as collage and photo-transfer, the latter particularly being new to drawings.

The transfer technique (which would later play a major role in his paintings) was first developed by Rauschenberg in the late 1950s; it is seen in the reversed numbers and letters and the seven images of *The Mona Lisa* in the drawing of that title (Fig. 326). In this process, the artist takes a rubbing on paper from a newspaper or other printed matter that has been wetted with lighter fluid. The grainy impression that results works well with the other graphic mediums Rauschenberg employs, while the mechanical properties of the transferred photograph contrast with the softness of tone and texture characteristic of pencil. This harmonious disjunction has a disorienting effect on the viewer, and

Fig. 326. ROBERT RAUSCHENBERG, *The Mona Lisa*, 1960.
Mixed media and rubbing, 22¾ x 28¾".

is analogous to the tension produced in Rauschenberg's paintings by the uneasy combination of action-painting technique with incongruously grouped objects which invade the viewer's space. Unlike Johns, who experiments within the permutations of traditional draftsmanship, Rauschenberg constantly imports devices and techniques from outside conventional boundaries in creating his drawings.

Though drawings often relate to his paintings, Rauschenberg does not use them as preliminary sketches, nor does he (like Johns) make drawings after painted images to explore the changes which can result from the use of a new medium. Rauschenberg instead uses drawings simply to make meaningful objects, and to explore imagery. Illustrating Dante's *Inferno* with thirty-four drawings suggests something of the artist's intellectuality and his courage, for in this classic series he brings all his powers to this classic of literature. Images from contemporary American life, particularly those circulated by news media, become episodic of the thirteenth-century text. In the illustration for *Canto XXXI* (Fig. 327) for example, the monumental Olympic weight-lifters serve as the guardians of the final gate to Hell, their power symbolized by Rauschenberg in the image of a great chain. The tiny figures at the bottom of the picture and the anonymous Everyman in boxer shorts (upper left) emphasize by contrast the mammoth proportions of the athletes. Rauschenberg's forms are personal in meaning while being completely familiar; they are juxtaposed with animated colored, scribbled, hatched, and blotted areas, which are simultaneously personal (related to the self-expressive gestures of action painting) and non-associative, or purely formal.

The same kind of struggle between image and technique, between art and meaning perhaps, is seen in the drawings of Larry Rivers. He has a clear debt to de Kooning: where Rauschenberg symbolically erased a de Kooning drawing in order to declare his independence of the old aesthetic (in the very act acknowledging his debt to the older artist), Rivers has simply taken up and developed de Kooning's line. This is apparent in the broadly drawn, nearly abstract series of pencil drawings leading to the painted *Portrait of Birdie*, (Museum of Art, Rhode Island School of Design) 1954, and is further acknowledged in the 1963 pencil portrait *De Kooning with My Texas Hat* (Collection of the Artist). Rivers, perhaps even more than Johns and Rauschenberg, serves as a pivotal figure between action painting and Pop; from de Kooning, he has extracted not only the tenuous, pure line and the peculiar pastel hues, but also the proto-Pop imagery. Rivers blends these familiar forms with portraits and personal allusions to his family and friends, as in *Frank's French Money*, 1962 (Fig. 328); his drawings characteristically combine the energetic linearity and complex figuration seen here. They often incorporate a variety of graphic media as well as

Fig. 327. ROBERT RAUSCHENBERG, *Canto XXXI*, from *Dante's Inferno*, 1959–1960. Red and graphite pencil and gouache, 14½ x 11½″.

Fig. 328. Larry Rivers, *Frank's French Money*, 1962.
Crayon and pencil, 12¾ x 14¼".

hand written and stencil-like lettering, collage elements, and erasures, to create the effect of multilayered surfaces with displaced, floating imagery. Yet some of Rivers' best drawings are the simplest, such as the sketchbook portrait of de Kooning or the haunting *Self Portrait* of 1953 in pastel and pencil (Fig. 330).

While Rauschenberg's drawings are complete and somehow final, those of Rivers and especially Johns have been open-ended in their strong effect on some of the artists associated with the Pop movement. The vocabulary of familiar, banal subject matter introduced by Johns has been expanded, and his varied gestural technique has had equal impact. Thus Roy Lichtenstein (b. 1923) and James Rosenquist (b. 1933) both make strong, blunt, linear images whose execution repeats the commercial techniques that are used in their paintings. Such works as Lichtenstein's *Jet Pilot,* 1962 (Collection of Richard Brown Baker), are direct and two-dimensional, using ready-made imagery—in this case, a comic strip—and techniques such as the Ben Day dots or its forerunner, frottage, to standardize and depersonalize the image. Occasionally

Fig. 329. Roy Lichtenstein, *Drawing for Cathedral Series*, 1969. Ink wash, 28 x 42″.

Fig. 330. LARRY RIVERS, *Self Portrait*, 1953.
Pencil and colored chalk, 28½ x 21″.

Fig. 331. ANDY WARHOL, *Mao*, 1973.
Pencil, 81¼ x 42¼″.

Lichtenstein's drawings show great individual strength, as in his *Drawing for Cathedral Series*, 1969 (Fig. 329), a fluid, vibrating ink drawing reminiscent of German Expressionist prints, that served as the basis for a series of lithographs. However, drawings by Lichtenstein and Rosenquist in general show few traces of the artist's hand; their drawings relate more to ideas than to handling of graphic mediums.

Another surprising exception to the depersonalized, nongestural approach of Pop drawings is Andy Warhol's *Mao* (Fig. 331). Warhol pioneered the replication of commercial logos and packages as "high art" subject matter; for many of his projects, Warhol has neither created the image nor participated directly in the execution.[1] However, despite a posterlike simplicity and very large scale (81 by 42 inches), the drawing of *Mao*—perhaps meant as a drawing-like pastiche—ironically shows the very real graphic talent of its creator.

The paintings of Robert Indiana (b. 1928) relate to those of Warhol and the "cooler" of the Pop artists in their banal subjects, their ironic comments on American civilization, and their totally anonymous execution. Though they are colorful and effective, it is hard to imagine objects that could be less "gestural"—and yet Indiana from the beginning has also been a most able, personal draftsman. Dating from the early 1960s is a series of drawings including *The American Eat* (Fig. 332), in which a stenciled, lettered circle is superimposed with dense, rapid hatching

Fig. 332. ROBERT INDIANA, *The American Eat*, 1962.
Frottage in conté crayon, 25 x 19″.

which is similar to Johns' technique. The image is actually a rubbing taken from a nineteenth-century brass stencil for the American Hay Company, which Indiana found in his studio, in lower Manhattan.[2] In some of the drawings, the letters on the outer ring are altered, for example, from HAY to WAY or HAM, and the EAT in the center, which evokes a diner's flashing neon sign, is replaced with elements of other commercial logos either found or invented by the artist. The frottage technique used in this drawing, which depends on an intermediate object to create the design, indicates an intentional detachment from the image; however, its sensuous surface and the experimentation with technique and linear pattern links Indiana to a more expressionistic tradition of draftsmanship.

The case of Jim Dine (b. 1935) is quite different: though nominally associated with "Pop," he is a romantic realist who possesses great graphic sensibility. The figurative watercolors he was making during the late 1950s have passionate images presented with a personal involvement like de Kooning's. In the years since then, Dine has become Johns' equal as one of the most inventive printmakers of our time, equally at home in lithography and etching. Dine's drawings stand by themselves; they are not preliminary to work in other mediums, though they are likely to deal with the same favorite subjects—shoes, neckties, bathroom supplies, paintbrushes, saws and other tools. Drawings from the early 1960s reflect the mood of that time, and are likely to contain concept and graphic ease in equal amounts, as in *Toothbrush and Tumbler Holder* of 1962 (Fig. 333): here the artist combines calligraphic pen strokes and quickly laid-on wash with the most banal of subjects, then adds a real screw—a Duchampian element which makes clear both his serious intent and his sense of humor, and totally removes him as well from the earlier aesthetic.

The theme of hearts has involved Dine since the mid-1960s; they have appeared in his paintings, prints, and a large straw sculpture, though never more beautifully than in the series of watercolors of 1968–1971. One of the largest and most complex of these is *Twenty Hearts* (Fig. 334), where the artist creates an even grid of floating hearts; in each image he varies form and color, seemingly involved in an endless quest for perfection. Using softer colors than usual—pale blues, pinks, yellows, a dark gray, a touch of green—then splattering the surface with a typical red of high intensity, Dine creates a drawing so beautiful that critics worry increasingly about his modern "relevance."

In his more recent drawings Dine has lessened his use of watercolor, returning to more purely linear images while adding occasional collage elements, and dropping the guise that they are studies. In the extraordinarily sensuous yet restrained series of drawings of paintbrushes of 1974, or the rich, tonal charcoal images of saws and other tools from

Fig. 333. JIM DINE, *Toothbrush and Tumbler Holder*, 1962.
India ink, wash and aluminum screw, 29 x 23".

the same year, Dine gives further evidence of being one of the finest draftsmen now on the American scene.

Claes Oldenburg (b. 1929) is as serious a draftsman as Dine; he is also a romantic realist and a humorist, but his drawings have quite different purposes from Dine's. Oldenburg is primarily a sculptor, and one who would remake the world if he could; thus drawing for him is an essential working tool. Dine admits that he rates drawing highly ("I always treated my drawing with equal importance as painting"[3]), while Oldenburg tends to deny the seductiveness of drawing for its

Fig. 334. Jim Dine, *Twenty Hearts*, 1970.
 Watercolor, 44 x 34″.

own sake, insisting that his work is concerned with reportage, with his reaction to the urban environment ("Style in drawing is re-creation"[4]).

But drawing comes easily to Oldenburg: he has a quick and easy touch with pencil or brush and paper, and as a product of the early 1960s this worries him. The facility and frequency with which he makes drawings causes him to discount their importance; yet they are a forum for development of his ideas, often the initial record of a subject which will be realized in another medium (such as soft sculpture). Oldenburg's early drawings are naïve, spontaneous, linear; many are intimate figure studies. About 1960 he applied his scribbly style to street imagery; by this time he had given up painting and was working exclusively with sculpture and drawing. A notebook sketch, *Gym Shoes* of 1961, showing sneakers elevated on a pedestal, indicates that many of Oldenburg's incongruous juxtapositions are based on observed reality. Early in the sixties Oldenburg made a series of imaginative drawings of a group of his favorite home and office objects. These drawings, in crayon and watercolor, became the basis for his soft-sculpture projects, evolving from a realistic, "hard" representation of the object to one that anticipates or imagines the soft effect, e.g., *Study for a Soft Type-writer*, 1963 (Collection of Mr. and Mrs. Peter J. Solomon).

Oldenburg's sketchbook style is the basis for his major drawings of the 1960s. His sometimes liquid, sometimes jagged and irregular line creates evocative objects whose identity and meaning are uncertain. In *Study for the Image of the Buddha Preaching* (Fig. 335), the image —an elephant embracing a nude woman with a Kewpie-doll face—appears in its most distinct form in the finely shaded and firmly outlined sketch in the upper right corner of the sheet. However, the dreamlike quality of the half-erotic, half-ridiculous subject is best realized in the loosely sketched figure at the left which floats upward from an ambiguous base to loom out at the viewer.[5]

Oldenburg is best known for the drawings in charcoal or pencil with watercolor in which he gives sumptuous, calligraphic expression to ideas about reforming our environment—as in his *Proposed Colossal Monument for the Battery, New York: Vacuum Cleaner (View from the Upper Bay)* 1965 (Fig. 336). Typically he distorts scale and anthropomorphizes the appearance of familiar objects; the clothespin drawing of 1967 (*Late Submission to the Chicago Tribune Architectural Competition of 1922*) (Collection of Philip Johnson) resembles both an architectural monument and a self-righteous orator. Thus the close connection between the absurd and the ordinary, key to Oldenburg's imagery, is worked out in his drawings: "Drawing is my basic method. I think of drawing as a form of writing. My concrete images are drawings realized—'monumentalizations.' "[6]

Aspects of Oldenburg's subject matter, especially the erotic sub-

Fig. 335. Claes Oldenburg, *Study for the Image of the Buddha Preaching*, 1967.
Pencil, 30⅛ x 22⅛".

jects and those satirizing American junk foods, are the point of departure for similar themes rendered in oils, prints, and drawings by the California artist Wayne Thiebaud (b. 1920). Most of Thiebaud's drawings are in the same mode as his paintings, in which simple, banal objects are isolated on a sheet or repeated in a pattern suggesting a stamped design. Yet unlike many contemporary painters, Thiebaud's style is not flat or mechanistic, but extremely painterly, using thick impasto and rich coloration. He has the ability to take any object—a

Fig. 336. CLAES OLDENBURG, *Proposed Colossal Monument for the Battery, New York: Vacuum Cleaner (View from The Upper Bay)*, 1965. Charcoal and wash, 23 x 29″.

candied apple, a piece of cake—totally out of context, to make us look at it through *his* eyes. Like the best of his contemporaries, he fears nothing—not even the impossible task of using pastels to draw a white rabbit on white paper. His *Rabbit* (Fig. 337) is a sensuous, memorable creation—at once a highly detailed study of a family pet, a tour de force in pastel technique, and coloristically a subtle exploration of white tonal variations. Somehow, as in his other work, it succeeds as a believable object: the rabbit is not only given full body and texture, but seems quite naturally to cast a strong blue shadow.

Saul Steinberg (b. 1914) is as whimsical as Thiebaud, and like him has earned the admiration of avant-garde collectors during the past decade. Yet Steinberg came to this country from Roumania in 1942, and was first exhibited at the Museum of Modern Art in 1946—so his is clearly a talent of long standing. However, perhaps only now can we see how relevant and how humorous Steinberg really is: his world is made

Fig. 337. Wayne Thiebaud, *Rabbit*, 1966.
Pastel, 15 x 20".

up of fantasy, of fairytale dreams and confrontations, of objects that
become words, and turn into other objects. His medium is a clear,
probing line that does fantastic things, and occasionally he adds color
washes; his vehicle is the *New Yorker* magazine, for which he does
covers and many cartoons as well (see Fig. 338).

These drawings emphasize craft and technique; they take the real
world and rework it, giving it both personal and universal meaning;
they are used both in traditional ways and in new ones. These are
the artists of the avant-garde, and it has been presumed that their way
of seeing was totally different from that of men like Leonard Baskin
(b. 1922) and Andrew Wyeth (b. 1917) who have been thought to be
traditional realists. Yet history may judge that the gap between them
was not so great after all: for Baskin and Wyeth, among others, were
interested in the craft and elegance of drawing long before Johns and
Dine, and their work is not unrelated to that of the more "advanced"
artists.

Fig. 338. SAUL STEINBERG, *Hero and Monster,* 1966.
Pen and ink, 19 x 25″.

Leonard Baskin sees Shahn and Lebrun as his forerunners, and his drawings, like theirs, are well-wrought cries of anguish in an unfeeling world. Baskin has so many talents that he is undisciplined at times: a powerful sculptor and medalist, an extraordinary connoisseur, a print-maker who excels in the woodcut, a bookmaker, designer, and perhaps above all an illustrator. Baskin is sensitive about his eclecticism, perhaps not realizing how many others share it ("I have not barricaded myself against my time, quite the contrary, but perhaps more than most I have plumbed older art and artists"[7]). Having particular interest in strange beasts and flowers, he has illustrated a number of original books (e.g., *The Poppy and Other Deadly Plants,* 1967), and has taken on as well the *Old Testament,* Homer, Swift, Dante, and a wide variety of other known and unknown figures including General Custer and his Indian opponents. He has usually made his drawings by dragging a pen or brush loaded with black ink across white paper, occasionally adding black or gray washes (as in *Ugolino and Anselmo, Canto XXXIII* of the Inferno, Fig.

Fig. 339. Leonard Baskin, *Ugolino and Anselmo, Canto XXXIII*, 1968.
Ink, 26 x 20".

Fig. 340. A<small>NDREW</small> W<small>YETH</small>, *The Apron*, 1967.
Pencil and watercolor, 22 x 28″.

339), and more recently has successfully begun to explore watercolor in a dense, vibrant manner.

Even more revered by his friends, even more castigated by modernist critics, has been Andrew Wyeth. He is perhaps the most popular of living American artists, and his art (like Audubon's) has been so widely and so badly reproduced that it is often unfairly judged. Wyeth is without doubt one of the ablest of draftsmen, and like Baskin's, his art is not out of another century but in fact shares a great deal in both style and attitude with the work of the avant-garde.

Wyeth's subjects come from the world around him, but unlike the Pop artists, r like even Baskin, he brings little bitterness or irony to these subjects. Modern artists are urban, almost by definition, while Wyeth is rural in his habits and his outlook. Other artists group together, painting and drawing more in reaction to other art than to the observed world, while Wyeth remains very much alone. Yet his drawings show him to be not as far from the mainstream as one might expect. The early watercolors, around 1940, are loose and brushy, carrying on the late Sargent manner like many others of that time. Drawings of the mid-forties, such as *Beckie King* (Dallas Museum), are tight and

Fig. 341. ANDREW WYETH, *Garret Room*, 1962.
 Watercolor and dry brush, 17½ x 22½".

linear with more than a little of a Surrealist spirit. By the 1950s the
mature style is established, and from this period come some of Wyeth's
most beautifully wrought pencil drawings, such as *Rope and Chains*,
1956 (Private Collection), or, slightly later, *Farm Wagons* (Fig. 342),
a study for the painting *Marsh Hawk* of 1964. For pure dexterity with
a pencil combined with a curiosity which seeks out every nuance of form
and light, these drawings are unequaled in their time; they recall the
work of Rimmer and Church, the latter also serving as a model for
Wyeth's habit of making very extensive studies of all types for each
major painting.

Other Wyeth studies make use of several mediums, such as the large
drawing of Christina Olsen called *The Apron*, 1967 (Fig. 340): here
pencil is used quickly to give general form to the composition, a wide
brush fills in a watercolor background in various ochres and browns

Fig. 342. ANDREW WYETH, *Farm Wagons*, 1964.
Pencil, 19½ x 39⅜".

Fig. 343. ANDREW WYETH, *The Mill*, 1958.
Watercolor and dry brush, 12 x 22¼".

(as Eakins had done), then the face is worked with small brushes, using the pigments dryly and with infinite care. The result is a study—and at the same time an emotional, singular work of art.

Wyeth's style has become clichéd, as happens with all widely admired artists. Yet even in his best-known images, such as *The Mill*, 1958 (Fig. 343), one senses a strength of vision, an ability to simplify and abstract nature: like Oldenburg, he remakes what he sees into what he wants to see. Color is restrained here, tans and browns predominating; "gesture"—as in more recent realism—is hardly visible; the composition is strong, dominated by three basic horizontals broken by regular, dark verticals. Using a fine dry brush, putting the watercolor sometimes thickly, sometimes thinly, onto white paper, Wyeth takes the medium to a high technical level. The artist also has a natural sense of surface—not for texture that reproduces reality, but for texture that becomes a new reality. He is naturally restrained in terms of color, so that a watercolor of 1962, *Garret Room* (Fig. 341), appears unusually rich: here in the silk patchwork quilt run together a riot of reds, blues, yellows, and browns which recall Dine's palette.

The drawings of Wyeth and Baskin represent a major aspect of contemporary American draftsmanship; their immediate predecessors appear to be earlier realists such as Hopper and Shahn. In addition, there is a lesser-known group of artists working today in a realist manner similar to Wyeth's, who are producing drawings with surreal, mysterious overtones; their ancestry is to be found in the romantic Surrealism of the preceding generation—in the works of artists such as Graves and Tchelitchew, whose work is similarly evocative and similarly stands apart from the mainstream.

The impact of the banal subject matter of Pop art has not gone unnoticed by these rather isolated draftsmen; however, the manila envelope of Leo Dee's *Paper Landscape* (Fig. 344) and the household objects in Walter Murch's *Study for "The Birthday"* (Fig. 345) are nonetheless closer to traditional academic drapery studies or still-life drawings than to Oldenburg's hamburgers. Leo Dee (b. 1931) draws in silverpoint, an archaic medium requiring great control. The image is highly detailed, yet the delicate medium and the deliberately incomplete form give it a dramatic, almost surreal fragility. Equally ethereal, though more obvious, are the pencil, crayon, and wash drawings of Canadian-born artist Walter Murch (1907–1967), composed of realistically described objects in a dense atmosphere of soft light and mellow tonalities. Both artists are much concerned with drawing as craft, and as well with composition—Murch placing his objects with great care, Dee making intriguing use of the large sheet of white paper of which he uses only a portion. A third artist whose work is equally traditional in

Fig. 344. LEO DEE, *Paper Landscape*, 1972.
Silverpoint, 35⅛ x 26″.

Fig. 345. WALTER MURCH, *Study for "The Birthday,"* 1963.
Pencil, wash and crayon, 23 x 17½".

subject matter and technique is Theo Wujcik (b. 1946), a young Californian. Wujcik is both a lithographer and a draftsman, and his silverpoint portraits, such as *Ed Moses*, 1973 (Fig. 346) present images at once delicate and soft while they are tough and probing.

Realism has had many faces during the last decade. Thus Abstract Expressionism and Pop art were the generating forces for two further modes of realist drawing which became current toward the end of the 1960s. One trend can be found in the personal images of Al Leslie and

Fig. 346. THEO WUJCIK, *Portrait of Ed Moses*, 1973.
Silverpoint, 21 x 26″.

Philip Pearlstein, which depart from traditional assumptions about the intimacy of drawings (yet are lyrical and even romantic compared to these artists' more severe painted images). Other artists, such as Close, Estes, Haas, and Celmins, pursue the realistic tradition as a means of achieving objectivity; especially in the work of Close and Estes, the aim is to explore technical issues introduced to drawing by other art forms such as photography. In their use of an intermediate object (such as the photograph) to create their images, and in their disinterested scrutiny of the urban environment, Close and Estes are the natural heirs of Pop art.

Abstract Expressionist art is fundamentally concerned with gesture and with the active involvement of the ground in the all-over linear design. These qualities are found in the drawings of Philip Pearlstein (b. 1924), who began his career as an action painter and has over the last ten years become a leading representative of a new realist mode. His drawings, like his paintings, record awkward, "unposed" conjunctions of figures. They are drawn with severe contour lines that tend to stretch in irregular patterns beyond the borders of his sheet, and the quality of linear abstraction is intensified by Pearlstein's reduction of color to near-monochrome. The space created by the blank paper is often used as an active design element, creating a two-

Fig. 347. AL LESLIE, *Constance Pregnant Almost 4 Months*, 1970.
Charcoal and pencil, 30 x 40″.

dimensional effect. Pearlstein himself describes this process: ''I con-
centrate on drawing the contours of shapes, seeing them for the moment
as flat areas. If I get the contours of all the shapes, including the shapes
of empty spaces, correctly measured against one another, the drawing
works itself out.''[8]

A similar linear emphasis and concern for design is found in the
drawings of Al Leslie (b. 1927), which are, like Pearlstein's, intimate by
virtue of their close scrutiny of the subject. Leslie's early participation
with the Abstract Expressionist movement is apparent in his broad
drawing style and his interest in materials. In *Constance Pregnant
Almost 4 Months* (Fig. 347), the documentary intention of the drawing,
one of a series called ''Coming to Term,'' is coupled with an intimate
subject and a sensuous graphic technique. Various thicknesses of char-
coal line are used to define the figure and the bed on which she reclines.
The juxtaposition of the area of charcoal rubbed over the figure with
the lighter area above, from which most of the charcoal shading has
been rubbed away, creates a strong positive–negative design silhouetting
the figure. At the same time, the cool light over the body reveals the
figure as fully three-dimensional, and also suggests a nocturnal atmos-
here, affording the viewer a very private vision. The image is at once
romantic and abstract.

Fig. 348. RICHARD ESTES, *Woolworth's America*, 1974.
Gouache on board, 16 x 20".

An even more romantic approach is found in the figure studies of
William Bailey (b. 1930), in which suggestive contour lines and soft
modeling, rather than precise delineation, evoke the form and character
of his subject. In such drawings as *Study of a Nude Girl*, 1973 (Yale
University Art Gallery), greatest attention is paid to the sitter's face,
while the rest of the form is left incomplete. Like Bailey, Alex Katz
(b. 1927) makes figure drawings in an academic yet personal manner.
Many of them are preparatory studies for paintings and are in general
flat and crudely modeled, with a narrow tonal range; occasionally, how-
ever, Katz's even hatching technique produces evocative portraits, such
as *2:30, I* (Collection of Marlborough Gallery).

Contrasting with the subjective and relatively gestural approach of
realist draftsmen such as Leslie and Pearlstein is a more objective
mode, sometimes called "photo-realism," in which evidence of the
artist's hand and imagination is suppressed in favor of close fidelity to
reality. These artists tend to limit their subject in an effort to focus
on formal and technical problems; their subjects are isolated, frontal,
and, above all, depersonalized—qualities they share with their Pop art
predecessors.

For many "new realist" artists, the traditional role of the prepara-
tory drawing has been supplanted by the photograph. As the nineteenth-

century landscape painter recorded interesting views in his sketchbook, so some contemporary realist artists gather ideas for paintings with snapshots. Richard Estes manipulates his camera's lens as if it were a pencil arranging a composition: he selects subjects (generally New York building façades) that are flat and symmetrical, and photographs them in ways that maximize the appearance of regularity and the reflection of light from shiny glass and steel surfaces. He frequently combines several photographs to create his composition, though always emulating the precision and clarity of the photograph. His watercolors and gouaches are also highly finished transcriptions of scenes recorded by his camera. *Woolworth's America*, 1974 (Fig. 348), exploits the translucency of watercolor in the multiplication of reflections on dime-store counters. As is typical of Estes, the extremely detailed vision is strictly regularized and ordered; no figure, no misplaced item or piece of litter is depicted to give evidence of human presence. However, the watercolors are less austere than Estes' oil paintings of similar subjects: his technique is looser, and in this drawing, the view down Woolworth's aisles presents the observer with an open space, rather than his usual closed façades which parallel the picture plane.

Watercolor is generally a popular medium for photo-realist artists. John Salt (b. 1937), in his images of wrecked cars, uses the softness of the medium to temper the demanding precision and sharp focus of his photographic model, and like Estes, Ralph Goings emphasizes reflecting surfaces through fine watercolors.

Chuck Close (b. 1940), on the other hand, is concerned with precisely those flaws omitted by Goings and Estes. The human face, with all its marks and idiosyncracies, is the subject of Close's drawings, paintings, and prints, and the photograph is used to provide him with a maximum of information about the topography of the face. His drawings deal with the process of making drawings, and though they are frequently followed by paintings, they are not compositional or color studies in any conventional sense. Rather, drawings such as the 1973 *Bob* series serve as both a tool and a record of Close's process of making gradual pencil enlargements of a photographed subject. The image begins in tiny scale and without focus, registering only the major shapes and areas of dark and light, then the face becomes larger and more in focus in subsequent drawings and the tonal gradations become more subtle, but the image never fully resolves (this occurs only in the paintings).

The problem of focus is also Close's chief concern in his 1968 *Self Portrait* (Fig. 349). The detachment from the subject effected through use of a photograph is furthered by the graphic technique: stumping and erasure are used extensively in this graphite drawing to minimize the presence of the artist's hand. The photograph, unlike the human eye, makes no hierarchical decisions about good and bad features when recording a portrait, and does not adjust focus to compensate for nearer

Fig. 349. CHUCK CLOSE, *Self Portrait*, 1968.
Pencil, 29⅛ x 23″.

or more distant features. Thus in the *Self Portrait* physical imperfections are not shunned, and details are recorded in varying degrees of focus (the carefully detailed mustache better focused than the tip of the cigarette).

The buildings drawn by Richard Haas (b. 1936), such as *487 Broome Street* (Collection Mr. and Mrs. Arie Kopelman), are not as relentlessly realistic as Close's, although precisely drawn. The linear emphasis and detailing of each rectangular surface unit are suggestive of an architect's drawing; indications of atmosphere and shadow produced by thin pencil strokes and by rubbing with the side of the pencil

Fig. 350. Vija Celmins, *Ocean Image*, 1970 .
Graphite and acrylic spray, 14¼ x 18⅞″.

soften the sharp angularity of the form. Like Estes or Wyeth, Haas
idealizes his subject: lower Manhattan here appears without pedestri-
ans, traffic, litter, or graffiti. By depicting buildings of past eras, he also
adds an aspect of romanticism: again, even in the purest realism the
role of the artist is a major one.

Although like other photo-realists Vija Celmins (b. 1938) depicts
a familiar and impersonal subject matter, her graphite drawings of
oceans or desert floors become mysterious and strange. The tactile
realism of her meticulously rendered subjects, such as *Ocean Image*
(Fig. 350), is undercut by an evenness of tonal modulation, a monotony
of pattern, and by the excision of a fragment of her subject from its
knowable context. Despite the detailed rendering of form and light in
her drawings, they are in some ways closer both to surreal and abstract
art than to photo-realism. The uniformity of drawing from one margin
to the other, and the similarity of one drawing to the next, indicates the
intentional suppression of the artist's hand in favor of objectivity. One
critic, calling Celmins a "Photovisionary," sees in her imagery and

style an attempt to evoke the infinite and universal—a contemplative, spiritual orientation rather different from the formal and sociological concerns of other photo-realists.[9]

The development of various modes of more or less objective realism during the 1960s was paralleled by the growth of several individualistic modes of figurative art in which subject matter stems not from the world of observed reality but rather from the artist's fantasy. The drawings of Lee Bontecou (b. 1931) depict bizarre, organic, and mechanical forms of her own invention, in unorthodox materials such as soot on muslin. During the sixties she worked primarily in sculpture, as did Celmins, and was exhibited by Leo Castelli with artists who are now regarded as the leaders of the major movements of the decade: Johns, Lichtenstein, Stella, Warhol. Yet Bontecou's works—now mainly

Fig. 351. LEE BONTECOU, *Untitled*, 1963.
Pencil, soot and muslin, 24 x 18".

drawings and prints—have never been considered mainstream; rather they represent an undercurrent of imaginative departure from reality that descends somehow from the creations of Duchamp.[10] Bontecou's eerie creatures sometimes border on the gimmicky, but her better drawings, such as *Untitled*, 1963 (Fig. 351), have a sense of movement and depth, of forms silently gliding and hovering over undulating surfaces, that creates an ominous effect.

The California artist Edward Ruscha (b. 1937) is a self-proclaimed Surrealist; his images are as absurd and amusing as Bontecou's are absurd and threatening. In his drawings such as *Wax* (Fig. 352), ribbon-like words hover over carefully graduated backgrounds made of gunpowder, which is applied by hand. Sometimes he stains his floating objects with non-drawing materials such as blood, vegetable juices, or Pepto-Bismol.

California is the center for a group of artists whose fantasy creations contain both humorous and surreal aspects. A romantic, spiritual quality is to be found in the drawings of artists working in Northern California, such as William T. Wiley and William Allen, and Robert Camblin, a Texas artist, works in a similar style. Their drawings are primarily in watercolor, characterized by fine delineation and translucent, though frequently bright, color washes. Their subjects are always derived from nature, rather than urban culture. Wiley's *Victory Guardians* (Fig. 353) is a typical fantasy construction whose subject is the coming of spring; the forms in the drawing are based on a personal iconography not altogether explained by its caption.

Fig. 352. EDWARD RUSCHA, *Wax*, 1967.
Gunpowder, 14½ x 23″.

Fig. 353. WILLIAM T. WILEY, *Victory Guardians*, 1973.
Watercolor, brush, felt-tipped pen, indelible pencil, pen and ink, 22⅜ x 30″.

In contrast, another group of drawings made by artists in California and elsewhere is about contemporary culture, boldly drawn in an outline style with dense internal hatching. Their humor is crude and satiric, not wry and punning; their figures are generally caricatures with gross anatomical exaggerations which emphasize the sexual themes of the drawings. Jim Nutt (b. 1938) first evolved this style in Chicago, where a number of artists developed an absurdist drawing style. Nutt's drawings, generally in colored pencil, indicate inspiration from a disparate group of sources: kitsch, art of the insane, folk, popular and primitive art, fantastic art and Surrealism. He suspends all rules of illusionistic space, realistic figure drawing, and compositional balance in his theatrical, bizarre drawings of human confrontation. The drawings of Roy de Forest (b. 1930) more often depict animals than people; his outlined forms are ornamented with irregular colored scribbles and abstract patterns such as stripes or grids. Nonsense inscriptions are sometimes included in the drawings. More autobiographical is the work of the Connecticut draftsman, John Fawcett (b. 1939); combining drawing, collage, and text, each work records several days of the artist's life in humorous yet moving fashion. Like de Forest and the others, Fawcett looks into himself (and thus into American society); he finds mostly nonsense—television shows, cartoon characters, the Super Bowl. Technically these drawings contrast with Pop art, for they are involved and

Fig. 354. JOHN FAWCETT, *Felix and the Cats*, 1972.
Pen and ink and collage on board, 30 x 22".

personal where Pop is cool; yet the message they convey about our time is much the same (see Fig. 354).

Nonobjective art continued to be important during the 1960s, yet for "color field" and "hard edge" painters, drawing in the conventional sense is seldom an integral part of their art. These painters are almost exclusively concerned with formal problems, rather than with image, and with the relationship of shape and particularly of color, so that linear and gestural elements play almost no role in their art. Painters such as Kenneth Noland, Jules Olitski, and Morris Louis seldom make drawings, and avoid reference to the hand of the painter in their works, revealing him rather as a mind and an eye.

Despite their lack of involvement with drawing as an art form, some aspects of their work do refer to drawing. In particular, the staining technique, invented by Helen Frankenthaler (b. 1928) in 1952 and used subsequently by Louis and others, bypasses the preliminaries of priming the canvas and planning the design, and so allows for intimacy and especially directness, two traditional attributes of drawing, while achieving a monumental scale uncharacteristic of drawing. Frankenthaler occasionally makes drawings, which are generally oil on paper, with configurations similar to those found in her paintings. Both her paintings and drawings, unlike those of her contemporaries, can be called gestural; that is, her stained forms are directional and speak of the force and guidance of the hand, rather than, as with Louis' forms, appearing to follow the force of gravity. Further, her works include linear elements, which function expressively and compositionally, and which maintain a connection with drawing that reopens the issue of the convergence of drawing and painting.

Frank Stella's (b. 1936) early black paintings reverse the expected color relationships of drawing by using a white line on a black ground. Line is used to reflect the main structuring element of the image, the canvas edge, a function even more significant in the shaped canvases of the early 1960s. These lines take their meaning from the shape of the support; they neither describe an imaginary setting nor are metaphors for a real object. Illusionistic space is eliminated, and in his assertion of flatness and his use of line as objective presence rather than as allusion, Stella proposes a new interpretation of drawing which is further developed by minimalists such as Sol Lewitt and Dorothea Rockburne.

Ellsworth Kelly (b. 1923) is one of the few hard-edge painters who is also a prolific draftsman. His drawings and collages (which employ torn and pasted elements reflecting the influence of the assembled drawings of de Kooning) are used in preparation for his painting, as testing ground for his ideas, and occasionally as finished works. Kelly's mature drawing style, evolved during the 1950s through a period of experimentation with such various techniques as automatic writing and col-

Fig. 355. ELLSWORTH KELLY, *Avocado*, 1967.
Pencil, 29 x 23″.

lage, includes two major types of work. The collages, such as *White on Green*, explore form/ground relationships in which edge stands for line. The plant drawings, on the other hand, are composed of uninflected, highly controlled pen or pencil lines. Here, as in *Avocado* (Fig. 355), natural forms are simplified and abstracted so that only silhouette remains. The austere outline form acquires an almost totemic presence on the blank page, and gives evidence of great linear control.[11]

Minimalist and conceptualist art grew out of the hard-edge movement, stressing the importance of the art object as presence rather than metaphor. Drawings are likely to stress extension, demarcation, and

Fig. 356. RICHARD SERRA, *Untitled*, 1972.
 Lithographic crayon, 37¾ x 49¾".

movement, rather than description, as properties of line. For the most part, drawings become a means to another end: either as a sketch or diagram for a sculpture or earthwork, or as a visual memorandum of an intellectual construct. Despite this subordination of interest in technique to that of documentation, they sometimes achieve animated, sensuous surfaces. Richard Serra's (b. 1939) 1972 drawing (Fig. 356) in lithographic crayon, for example, creates a dense, forceful image as visually heavy as the metal plates he frequently uses in his sculpture. In drawing as in sculpture, Serra's line acts as a vector, as a current running through physical space, reaffirming its boundaries.

Interest in the potential of mediums is also characteristic of these artists. Eva Hesse's (1936–1970) *Repetition Nineteen I* (Museum of Modern Art, New York), though a working drawing for a sculptural project, is rendered with painterly concern for light and volume, in a sensuous and carefully crafted combination of gouache, watercolor, and pencil. A similar richness is apparent in Bruce Nauman's (b. 1941) 1973 untitled drawing which combines pencil, pastel, and watercolor in smooth washes, dry-brushed areas, animated scribbles, cool, measured lines, and handwritten notations concerning the scale and position of the earthwork for which this drawing is a diagram.

Cy Twombly's drawings show a far more idiosyncratic style. Twombly (b. 1929), whose education at Black Mountain College in

Fig. 357. Cy Twombly, *Before the Battle*, 1963.
Mixed media, 19¾ x 27½".

1951 exposed him to the ideas of Rauschenberg and composer John
Cage, has worked in Rome since 1957. His art demonstrates connections
with the gestural style of Rauschenberg, as well as with the intellectual
notation systems of the conceptualists. Twombly's drawings seem almost
juvenile in their random scribbles and graffiti-like writings. *Before the
Battle*, 1963 (Fig. 357), depicts a landscape, directly transcribed from
the artist's vision, celebrating, rather than suppressing, the spontaneous
gesture. Other drawings, such as the blackboard-like drawings of the
late 1960s, with more apparent discipline and structure, also deal with
the energy of the artistic gesture. The active surface texture of these
drawings results from the tendency of the oil and crayon strokes to
skip and glide over the prepared ground. Twombly uses the same
frenzied line in his paintings, which appear very much like drawings
on canvas, and which intentionally subordinate the distinctions between
art forms to the preeminence of the calligraphic gesture.

 The term "romantic minimalist" has been employed to describe
certain contemporary artists whose drawings are soft, luminous, and
generally neutral in tonality.[12] Foremost among these artists is Agnes

Fig. 358. DOROTHEA ROCKBURNE, *Neighborhood*, 1973.
 Vellum, colored and graphite pencil on white wall, 16′ long.

Martin, whose lightly penciled grids on both paper and canvas describe with subtle understatement the tension between the superimposed structure of the linear pattern and the primacy of the canvas as object. Dorothea Rockburne's elegant, ethereal drawings use nongraphic elements such as folds, tears, and markings made with carbon to stand for line. These drawings (see Fig. 358) challenge two basic premises of draftsmanship: the assumption that drawing is the contact of a graphic instrument on paper, and that the paper or ground defines the boundaries of drawing. Rockburne uses whole walls, often employing pencil and colored lines as well as collage elements: thus her drawings become environments also. Her work and that of Sol Lewitt (b. 1928) raise a number of crucial issues. Their drawings are strictly linear, and are truly two-dimensional, made directly on the wall, eliminating paper, frame, and thus illusionism. Their value is insisted upon as a function of their permanence: they are either perpetuated in place or destroyed, painted over.[13] Finally, some of these drawings pose the ultimate challenge to the concept of draftsmanship, an issue raised by Warhol, Celmins, Rockburne, and others who attempt to suppress all traces of

Fig. 359. CHRISTO, *Valley Curtain (Project for Rifle, Colorado)*, 1971.
Mixed media, 28 x 22″.

the artist's hand, for many of Lewitt's drawings are not actually drawn by him, but are executed by others according to his direction.

More artists are making more different kinds of drawings today than ever before in America; at the same time, they are consciously challenging many traditional artistic concepts. Thus the assumption that drawings are the most intimate and personal expressions of an artist's creativity because of their small size and spontaneity has been deliberately overturned by the predilection for large-scale, finished drawings such as Warhol's *Chairman Mao* or Johns's *0 through 9*. Similarly, the self-revealing gesture, the presence of the hand, which became synonymous with drawing in the 1940s and 1950s, is often intentionally depersonalized by neutral imagery, as can be seen in the desert or ocean drawings of Vija Celmins, or suppressed altogether, as in the drawings of Dorothea Rockburne or Sol Lewitt.

The limits of what is considered a drawing have been greatly expanded since the 1950s. Drawings are made on cloth and walls in addition to paper; they are made with gunpowder, torn edges, soot, colored paper, Mylar, airbrush and printing transfer techniques in addition to pencil, ink, charcoal, and watercolor. The interaction of various art forms, the result of combinations of techniques and materials in all mediums and the ability of many artists—Johns, Rauschenberg, Oldenburg, Serra, Close—to work with equal facility in a variety of art forms, tends to minimize the significance of medium.

Perhaps even more revolutionary is the expansion of those gestures and techniques which can be considered to function as drawings. This development is due in part to the advent of photo-realist art, which has substituted the photograph for the preliminary study, and so makes the viewer as aware of the process of creation as of the finished product. The function of drawing has been expanded even further by nonfigurative artists, the conceptualists, minimalists, and creators of earthworks. The works of these artists imply a "new definition" for drawing that is independent of consideration of materials used. In some cases, such as Christo's *Valley Curtain*, 1971 (Fig. 359), the drawing (which includes a photograph and architect's plan) is intended as the only surviving document of the project it describes. For other artists, drawing does not signify a work of art on paper but rather has become a work of art marked by the direct presence of the artist by means of manual or intellectual gesture. Walter de Maria's *Mile Long Drawing* of 1968, consisting of mile-long parallel chalk lines twelve feet apart on the Mojave Desert, deliberately asserts a departure from the conventional assumptions about drawing. This leads to the speculation that related works, such as Dennis Oppenheim's *Cancelled Crops*, 1969, or Robert Smithson's *Spiral Jetty* (Fig. 360), which are monumental linear

Fig. 360. ROBERT SMITHSON, *Spiral Jetty*, 1970.
Earthwork, Great Salt Lake, Utah.

gestures made by manipulating natural elements, may also be concerned
with the nature and process of drawing.

This development, from the concept of a drawing as an intimate
work on paper to that of drawing as gesture in nature, is not a final
one, nor can the results of new attitudes toward the medium be predicted.
The viewpoint which interprets an earthwork or a photograph as func-
tioning as drawing is consistent with techniques and directions sug-
gested by Johns and Rauschenberg. Nonetheless, drawing appears so far
to have had more effect on artists than new points of view have had on
drawing. Artists will continue to experiment, as they should, but there
are as yet no signs that the pencil or the brush and paper has lost its
basic, inexplicable seductiveness. Ingres said that "drawing is the
probity of art"; my guess is that artists will continue to seek truth
in works of art on paper for many years to come.

Notes

CHAPTER 1: THE BEGINNINGS: EARLY COLONIAL DRAFTSMEN

1. Edgar P. Richardson, *Painting in America* (New York, 1965), p. 16.
2. Jacques Le Moyne de Morgues, *Brevis narratio . . .* (Frankfurt, 1591).
3. Stefan Lorant, *The New World: The First Pictures of America, Made by John White and Jacques Le Moyne and Engraved by Theodore de Bry* (New York, 1946), p. 31.
4. In the collections of the British Museum and the Victoria and Albert Museum, London.
5. See *English Drawings and Watercolors, 1550–1850, in the Collection of Mr. and Mrs. Paul Mellon* (exhibition catalogue, Pierpont Morgan Library, New York, 1972), p. 1.
6. Paul Hulton and David Beers Quinn, *The American Drawings of John White, 1577–1590, with Drawings of European and Oriental Subjects* (Chapel Hill, N.C., 1964), p. 8.
7. Graham Reynolds, *A Concise History of Watercolors* (New York, 1971), p. 47.
8. It is possible that he is the Michel Le Bouteux who was a French architect and engineer, active from 1730 to 1760, and who executed several views of French castles and towns and served as personal architect to the King of Portugal.
9. John A. Kouwenhoven, *The Columbia Historical Portrait of New York* (New York, 1953), p. 48.
10. Anna Wells Rutledge, "Who Was Henrietta Johnston?," *Antiques* 51, no. 3 (March 1947), p. 185.
11. As quoted in John Hill Morgan, *John Watson, Painter, Merchant, and Capitalist of New Jersey, 1685–1768* (Worcester, Mass., 1941), p. 90.
12. Mark Catesby, *The Natural History of Carolina, Florida, and the Bahama Islands . . .* (London, 1731–1743), p. xi.
13. John Smibert, *The Notebook of John Smibert*, essays by Sir David Evans, John Kerslake, and Andrew Oliver (Boston, 1969), pp. 90, 102.
14. George Francis Dow, *The Arts and Crafts in New England, 1704–1775* (Topsfield, Mass., 1927; reprint ed., New York, 1967), pp. 277, 284.
15. Alfred Coxe Prime, *The Arts and Crafts in Philadelphia, Maryland, and South Carolina, 1721–1785* (Topsfield, Mass., 1929; reprint ed., New York, 1969), pp. 11, 293.
16. Rita Suswein Gottesman, *The Arts and Crafts of New York, 1726–1776* (New York, 1937), pp. 130, 351.
17. Quoted in Charles Coleman Sellers, *Benjamin Franklin in Portraiture* (New Haven, 1962), p. 16.
18. Ibid., p. 17.
19. Prime, *Arts and Crafts, 1721–1785,* p. 8.

CHAPTER 2: THE REVOLUTIONARY PERIOD, 1755–1780: DRAWING FLOURISHES

1. Quoted in Gordon S. Wood, *The Creation of the American Republic, 1776–1787* (Chapel Hill, N.C., 1969), p. 114.
2. Quoted in William Dunlap, *A History of the Rise and Progress of the Arts of Design in the United States* (New York, 1834; reprint ed., New York, 1969), vol. 1, p. 38.
3. Quoted in Dennis Mahon, *I Disegni del Guercino*

(Bologna, 1967), p. 3. It should also be noted that the relationship of West's drawing style to that of John Hamilton Mortimer (1740–1779) has been discussed by Allen Staley and Frederick Cummings in their *Romantic Art in Britain: Paintings and Drawings, 1760–1860* (exhibition catalogue, Philadelphia Museum of Art, 1968), p. 100. I am grateful to John Caldwell for his help in bringing these references to my attention.

4. Kilburn's advertisement is quoted on p. 4 and Dwight's on p. 127 in Rita Suswein Gottesman, *The Arts and Crafts of New York, 1726–1776* (New York, 1937).

5. Joseph Ewan, ed., *William Bartram: Botanical and Zoological Drawings, 1756–1788* (Philadelphia, Pa., 1968), p. 6.

6. Jules David Prown, *John Singleton Copley* (Cambridge, Mass., 1966), vol. 1, p. 1.

7. Jules David Prown, "An 'Anatomy Book' by John Singleton Copley," *Art Quarterly* 26, no. 1 (Spring, 1963), pp. 31–46, reproduces the entire book.

8. Theodore Bolton, *Early American Portrait Draughtsmen in Crayons* (New York, 1923; reprint ed., New York, 1970), p. ix.

9. James Watrous, *The Craft of Old-Master Drawings* (Madison, Wisc., 1957), p. 112.

10. Ibid.

11. Guernsey Jones, ed., *Letters and Papers of John Singleton Copley and Henry Pelham, 1739–1776 (Collections of the Massachusetts Historical Society, vol. 71, Boston, 1914)*, p. 26.

12. Prown, *John Singleton Copley*, vol. 1, p. 58.

13. To complicate this question further, it should be noted that Bolton (*Portrait Draughtsmen*, p. 36) lists a Copley pastel portrait *of* Liotard as being owned in 1915 by "A. Jarvis, Toronto." However, Jules Prown has studied a photograph of this pastel, and he is convinced that it is neither by Copley nor of Liotard; there is no evidence that the two artists ever met. For Liotard's work, see François Fosca, *La Vie, les Voyages, et les Oeuvres du Jean-Etienne Liotard* (Paris, 1956).

14. Quoted in Prown, *John Singleton Copley*, vol. 1, p. 17.

15. Prown, *John Singleton Copley*, vol. 2, p. 304.

16. *The Salem Gazette*, May 10–17, 1769, n.p.

17. See William Lamson Warren, "Connecticut Pastels, 1775–1820," *Bulletin of the Connecticut Historical Society*, vol. 24, no. 4 (October 1959), pp. 97–128.

18. George Francis Dow, *The Arts and Crafts in New England, 1704–1775* (Topsfield, Mass., 1927; reprint ed., New York, 1967), p. 2.

19. Alfred Coxe Prime, *The Arts and Crafts in Philadelphia, Maryland, and South Carolina, 1721–1785* (Topsfield, Mass., 1929; reprint ed., New York, 1969), p. 28.

CHAPTER 3: NEOCLASSIC DRAWINGS: THE FIGURE AND THE LAND

1. Theodore Sizer, *The Works of Colonel John Trumbull, Artist of the American Revolution* (rev. ed., New Haven and London, 1967), p. 110.

2. I am indebted to William Howze for pointing out this connection.

3. Theodore Sizer, ed., *The Autobiography of Colonel John Trumbull, Patriot Artist, 1756–1843* (New Haven, 1963; reprint ed., New York, 1970), p. 167.

4. John Davis Hatch, "The Question of American Draughtsmanship," *American Collector* 11, no. 1 (February 1942), p. 7. It should be noted also that these drawings were owned by the artist all of his life, apparently never being exhibited; they were bequeathed to his nephew-in-law Professor Benjamin Silliman, and they came down in the Silliman family until sold at auction in 1896. The drawings remained together, in various hands, until purchased by Yale in 1938.

5. John Hill Morgan, *Gilbert Stuart and His Pupils* (New York, 1939), p. 85.

6. William Dunlap, *A History of the Rise and Progress of the Arts of Design in the United States* (New York, 1834; reprint ed., New York, 1969), vol. 1, p. 176.

7. Harold E. Dickson, *John Wesley Jarvis* (New York, 1949), p. 31, note 28.

8. Theodore Bolton, *Early American Portrait Draughtsmen in Crayons* (New York, 1923; reprint ed., New York, 1970), p. 63.

9. Rita Suswein Gottesman, *The Arts and Crafts of New York, 1777–1799* (New York, 1954), p. 32.

10. Ibid., p. 182.

11. Ibid., p. 17.

12. This was published as *Elements of the Graphic Arts* (New York, 1802).

13. Fifty-three of these watercolors were sold at auction in 1905, and they have now spread out into many collections; a fine group is in the Addison Gallery, Andover, including the relatively boldly-handed *View of Canadian Falls from the Back of Table Rock.*

14. Dunlap, *Rise and Progress*, vol. 1, p. 275.

CHAPTER 4: ROMANTICISM AND THE EARLY NINETEENTH CENTURY

1. As quoted in the standard biography, Edgar P. Richardson, *Washington Allston, A Study of the Romantic Artist in America* (Chicago, 1948), p. 49.
2. Ibid., p. 29.
3. Jared B. Flagg, *The Life and Letters of Washington Allston* (New York, 1892; reprint ed., New York, 1968), p. 49.
4. Quoted by Mary Alice Hinson in "A Study of Washington Allston" (unpublished paper, Yale University), p. 4. See also Washington Allston, *Lectures on Art, and Poems* (New York, 1850; reprint ed., New York, 1967) for his theories and opinions.
5. See Murray's London edition of 1817, vol. II; the location of the originals is not known.
6. Rembrandt Peale, autobiographical letter, quoted in C. Lester Edwards, *The Artists of America* (New York, 1846; reprint ed., New York, 1970), p. 201.
7. Ibid., p. 205.
8. John A. Mahey, "The Studio of Rembrandt Peale," *American Art Journal* 1, no. 2 (Fall, 1969), pp. 20–40.
9. See Rembrandt Peale, "Philadelphia Musem," MS dated January 5, 1835 (Coll. American Philosophical Society, Philadelphia).
10. For this and much other information about American drawing books and manuals, I am indebted to Peter Cort Marzio, "The Art Crusade: A Study of American Drawing Books and Lithographs, 1830–1860" (Ph.D. dissertation, University of Chicago, 1969), p. 42 ff.
11. Rembrandt Peale, "Reminiscences," *The Crayon* 1, no. 24 (June 13, 1855), p. 370, as quoted in Marzio, "The Art Crusade," p. 47.
12. Rembrandt Peale, *Graphics: The Art of Accurate Delineation* (Philadelphia, 1854), p. 3.
13. Jules David Prown, *John Singleton Copley* (Cambridge, Mass., 1966), vol. 1, p. 16.
14. Carl W. Drepperd, *American Drawing Books* (New York, 1946), p. 4.
15. John Gadsby Chapman, *The American Drawing Book: A Manual for the Amateur and Basis of Study for the Professional Artist, Especially Adapted to the Use of Public and Private Schools, as well as Home Instruction* (New York, 1847), p. 6.
16. This theme is well expounded in Marzio, "The Art Crusade," which also includes an expanded bibliography of American drawing books published in the years 1822–1860.
17. See John C. Ewers, *Artists of the Old West* (New York, 1965), p. 27.
18. Robert Cantwell, *Alexander Wilson, Naturalist and Pioneer* (Philadelphia, 1961), p. 125.
19. Letter to the author from Edward H. Dwight, January 30, 1975.
20. Quoted in *The Original Water-Color Paintings by John James Audubon for "The Birds of America"*, intro. by Marshall B. Davidson (New York, 1966), vol. 1, facing pl. 70.
21. For this and other information about Audubon's work, I am indebted to Edward H. Dwight's excellent exhibition catalogue, *Audubon: Watercolors and Drawings* (Munson-Williams-Proctor Institute, Utica, N.Y., and Morgan Library, New York, 1965).
22. Ibid., p. 44.
23. Thomas Sully, *Hints to Young Painters* (Philadelphia, 1873), p. 15.
24. *Fifty Sketches and Studies for Portraits by Thomas Sully, 1783–1872, From an Old Sketchbook . . .* (exhibition catalogue, Ehrich Galleries, New York, 1924), see no. 39.
25. William Dunlap, *A History of the Rise and Progress of the Arts of Design in the United States* (New York, 1834; reprint ed., New York, 1969), vol. 2, pp. 234–5.
26. Ibid., p. 237.

CHAPTER 5: FOLK AND COUNTRY DRAWINGS

1. Donald A. Shelley, *The Fraktur-Writings or Illuminated Manuscripts of the Pennsylvania Germans* (Pennsylvania German Folklore Society Publications, vol. 23, Allentown, Pa., 1961), pp. 101–7.
2. John Joseph Stoudt, *Pennsylvania Folk-Art: An Interpretation* (Allentown, Pa., 1948) is an example of such iconographic interpretations; for a critique, see Shelley, *Fraktur-Writings*, pp. 82–3.
3. Frances Lichten, *Folk Art of Rural Pennsylvania* (New York, 1946), p. 93.
4. Shelley, *Fraktur-Writings*, pp. 124–5, and 180.
5. Edward Deming Andrews and Faith Andrews, *Visions of the Heavenly Sphere: A Study of Shaker Religious Art* (Charlottesville, Va., 1969), p. 91.
6. *Ibid.*, p. 86.
7. Mary Lyn Ray, "A Reappraisal of Shaker Furniture and Society," in Ian M.G. Quimby, ed., *Winterthur Portfolio 8* (Charlottesville, Va., 1973), pp. 107–32.
8. The visual resemblances, however, are suggestive. Compare, for example, the fraktur drawing *Sunflower and Two Birds* in the Museum of Fine Arts, Boston (*M. & M. Karolik Collection of American Water Colors and Drawings, 1800–1875*, Boston, 1962, vol. 2, no. 1328, fig. 350) with *A Present from*

Mother Ann to Mary H. in the Abby Aldrich Rockefeller Folk Art Collection, Williamsburg, Va. (Andrews and Andrews, *Visions of the Heavenly Sphere*, fig. 7).

9. A very similar work, conceivably by the same artist, was found in Lebanon County, Pennsylvania. See Jean Lipman and Alice Winchester, *The Flowering of American Folk Art* (exhibition catalogue, Whitney Museum of American Art, New York, 1974), no. 127.

10. A remarkably similar drawing with an inscription describing Aurora, the goddess of Dawn, is mentioned in *Selection 1: American Watercolors and Drawings (Bulletin of the Rhode Island School of Design 58, no. 4, January, 1972)*, p. 13.

11. A similar, unsigned still life, found in New Haven,

was exhibited at the Museum of Modern Art in 1932; see Holger Cahill, *American Folk Art: The Art of the Common Man in America, 1750–1900* (exhibition catalogue, Museum of Modern Art, New York, 1932), no. 62. This watercolor is now at Williamsburg and is believed to be by another artist; see Nina Fletcher Little *The Abby Aldrich Rockefeller Folk Art Collection* (Boston, 1957), no. 30.

12. Jean Lipman, "Deborah Goldsmith," in Lipman and Alice Winchester, eds., *Primitive Painters in America, 1750–1950* (New York, 1950), pp. 90–1.

13. Leigh Rehner, *Henry Walton, 19th Century American Artist* (exhibition catalogue, Ithaca College Art Museum, Ithaca, N.Y., 1968), pp. 9–13.

14. Jean Lipman, *Rediscovery: Jurgan Frederick Huge (1809–1878)* (New York, 1973), p. 9.

CHAPTER 6: DRAWINGS OF THE HUDSON RIVER SCHOOL

1. John W. McCoubrey, *American Tradition in Painting* (New York, 1963), p. 23.

2. Wolfgang Stechow, *Dutch Landscape Painting of the Seventeenth Century* (London, 1966), p. 15.

3. William Dunlap, *A History of the Rise and Progress of the Arts of Design in the United States* (New York, 1834; reprint ed., New York, 1969), vol. 2, p. 357.

4. For these ideas, I am indebted to Oswaldo Rodriguez.

5. *The Landscape Magazine: Containing Preceptive Principles of Landscape* (London, 1793), p. 55.

6. The Detroit Institute also owns a second, almost identical drawing (acc. no. 39.161); this suggests both Cole's serious attitude toward drawing and the difficulty of telling whether any single drawing was made from nature, or in the studio.

7. Letter to the author from Professor Howard Merritt, University of Rochester, July 7, 1975.

8. I am grateful to John Caldwell for bringing this scrapbook to my attention.

9. Thomas S. Cummings, *The Historic Annals of the National Academy of Design* (New York, 1865; reprint ed., New York, 1971), p. 117.

10. James T. Callow, *Kindred Spirits: Knickerbocker Writers and American Artists, 1807–1855* (Chapel Hill, N.C., 1967), p. 13.

11. Ibid.

12. I am grateful to Michael Quick for his identification of these drawings.

13. *M. & M. Karolik Collection of American Water Colors and Drawings, 1800–1875* (Boston, 1962), vol. 1, p. 305.

14. Note that *The Crayon* has been republished in a facsimile edition by AMS Press, New York, 1970.

15. Asher B. Durand, "Letters on Landscape Painting," *The Crayon* 1, no. 3 (January 17, 1855), p. 34.

16. Samuel Benjamin, *Art in America: A Critical and Historical Sketch* (New York, 1880), p. 194.

17. Helen M. Knowlton, ed., *W.M. Hunt's Talks on Art* (Cambridge, Mass., 1875 and 1887), pp. 61, 73.

CHAPTER 7: THE VICTORIAN WATERCOLOR, 1820–1880

1. Original manuscript in the Beinecke Rare Book and Manuscript Library, Yale University; also see the Centennial Edition, Yale University Press, 1967.

2. This drawing was reproduced in George Catlin, *Souvenir of the North American Indians* (London, 1850), vol. 2 facing pl. 80.

3. Alexander Philip Maximilian, Prinz von Wied-Neuwied, *Travels in the Interior of North America* (1 volume and atlas; London, 1843); first published in Coblenz in 1839–41, according to Ewers.

4. See John C. Ewers, *Artists of the Old West* (New York, 1965), p. 134.

5. *Chamber's Encyclopedia of Universal Knowledge for*

the People (10 vols.; Philadelphia, 1873), vol. 10, p. 89.

6. John Ruskin, *Elements of Drawing* (London, 1857; reprint ed., New York, 1971), p. 133.

7. Ibid., p. 137.

8. William Dunlap, *A History of the Rise and Progress of the Arts of Design in the United States* (New York, 1834; reprint ed., New York, 1969), vol. 2, p. 322.

9. See particularly *Bennett's View of South Street from Maiden Lane, New York*, 1828 (Metropolitan Museum of Art, New York).

10. Quoted in Donald A. Shelley, "George Harvey and

his Atmospheric Landscapes of North America," *New-York Historical Society Quarterly* 32, no. 2 (April 1948), p. 107.

11. George Harvey, Preface to the *Four Seasons*, reprinted in *The Magazine of History*, extra number 107, vol. 27, no. 3 (Tarrytown, N.Y., 1925), p. 133.

12. Ibid., p. 134.

13. Albert Ten Eyck Gardner, *A History of Water Color Painting in America* (New York, 1966), p. 8.

14. Martin Hardie, *Water-colour Painting in Britain* (London, 1966), vol. 1, p. 22.

15. See also *Catalogue of a Choice Collection of Original Water Color Sketches by Members of the Celebrated London "Sketching Society"* (auction catalogue, H.H. Leeds and Miner, New York, March 26, 1864).

16. See his *View from My Work Room Window in Hammond Street, New York City* (Metropolitan Museum of Art).

17. Quoted in Clara Erskine Clement and Laurence Hutton, *Artists of the Nineteenth Century and Their Works* (Boston and New York, 1884; reprint ed., St. Louis, 1969), vol. 2, p. 210.

18. Ibid., p. xxxi.

19. The founding members were William Craig, John Falconer, Alfred Fredericks, Frederick Durand, Edward Hooper. Constant Mayer, William Thwaites, and William Hart. Only the watercolors of Falconer and Hart are known today in any number.

20. See especially his *Landscape* at the Cooper-Hewitt Museum (acc. no. 1956.183.1).

21. *The Crayon* 7, no. 11 (November, 1860), p. 321.

22. Albert Fitch Bellows, *Water Color Painting: Some Facts and Authorities in Relation to Its Durability* (1868), n.p.

23. See, for example, *The Mountain Range of the West Side of the San Louis Valley, March 1, 1883* (Addison Gallery of American Art, Phillips Academy, Andover, Mass.).

24. Ferdinand V. Hayden, *The Yellowstone National Park and the Mountain Regions of Idaho, Nevada, Colorado, and Utah* (L. Prang & Co., Boston, 1876).

25. Worthy of mention, a watercolorist in this tradition and a friend of Moran, is the Philadelphian James Hamilton (1819–1878); see particularly his *Beach Scene* (Metropolitan Museum of Art, acc. no. 66.-142).

26. *Atlantic Monthly* 35, no. 210 (April 1875), p. 509.

27. *Nation* 20 (February 18, 1875), p. 120. I am grateful to Maygene Frost Daniels for calling this review to my attention.

28. *Nation* 18 (March 12, 1874), p. 172.

29. Clement and Hutton, *Artists of the Nineteenth Century*, vol. 2, p. 148.

CHAPTER 8: FIGURE DRAWINGS OF THE NINETEENTH CENTURY

1. E. Maurice Bloch, *George Caleb Bingham: The Evolution of an Artist* (Berkeley, 1967), pp. 37–8.

2. *M. & M. Karolik Collection of American Water Colors and Drawings, 1800–1875* (Boston, 1962), vol. 1, p. 102.

3. Quoted in William Dunlap, *A History of the Rise and Progress of the Arts of Design in the United States* (New York, 1834; reprint ed., New York, 1969), vol. 2, p. 330.

4. *Lilly Martin Spencer, 1822–1902: The Joys of Sentiment* (exhibition catalogue, National Collection of Fine Arts, Smithsonian Institution, Washington, D.C., 1973, essay by Robin Bolton-Smith and William H. Truettner), p. 19.

5. For this and much of the following, I am indebted to Patricia Hills' exhibition catalogue, *Eastman Johnson* (Whitney Museum of American Art, New York, 1972).

6. Ibid., p. 8.

7. Lloyd Goodrich, *Thomas Eakins: His Life and Work* (New York, 1933), p. 76.

8. Ibid., p. 3.

9. Also outstanding in the same series at the Philadelphia Museum are *Nude Woman Reclining, Back Turned* (acc. no. 29.184.42), which in pose is close to Trumbull's, and *Nude Man Seated, Hands Clasped* (acc. no. 29.184.44).

10. Barbara Novak, *American Painting of the Nineteenth Century* (New York, 1969), p. 195.

11. Ellwood C. Parry, III, and Maria Chamberlain-Hellman, "Thomas Eakins as an Illustrator, 1878–1881," *American Art Journal* 5, no. 1 (May 1973), pp. 20–45.

12. Truman H. Bartlett, *The Art Life of William Rimmer, Sculptor, Painter and Physician* (Boston, 1882; reprint ed., 1970), pp. 8–18.

13. *William Rimmer, 1816–1879* (exhibition catalogue, Whitney Museum of American Art, New York, and Museum of Fine Arts, Boston, 1946–47, essay by Lincoln Kirstein), n.p.

14. Samuel G.W. Benjamin, *Art in America: A Critical and Historical Sketch* (New York, 1880), p. 163.

15. Lucy H. Hooper, "American Art in Paris" *Art Journal* 4 (New York, 1878), p. 91, quoted in *M. & M. Karolik Collection of American Water Colors and Drawings, 1800–1875* (Boston, 1962), vol. 1, p. 312.

16. G. W. Sheldon, *American Painters* (New York, 1879), p. 25.

17. Lloyd Goodrich, *Winslow Homer* (New York, 1944), p. 12.

18. Robert W. Gibbes, *A Memoir of James De Veaux* (Columbia, S.C., 1846), p. 135.
19. Thomas S. Cummings, *Historic Annals of the National Academy of Design* (Philadelphia, 1865; reprinted, New York, 1971), p. 41.
20. See particularly, Neil Harris, *The Artist in American Society: The Formative Years* (New York, 1966).

21. Fromentin, quoted by John La Farge in *Considerations on Painting* (New York and London, 1895), p. 22.
22. Edwin H. Blashfield, *Mural Painting in America* (New York, 1913).
23. Samuel Isham and Royal Cortissoz, *The History of American Painting* (New York, 1943), p. 428.

CHAPTER 9: THE IMPACT OF IMPRESSIONISM

1. George Inness, Jr., *The Life, Art and Letters of George Inness* (New York, 1917; reprint ed., New York, 1969), pp. 168–74.
2. They were finally sold at the auction of her estate in 1927; see *Works by George Inness: The Collection of Mrs. Jonathan Scott Hartley Including . . . His Entire Collection of Water-Colors* (auction catalogue, American Art Association, March 24, 1927).
3. *The Art Interchange,* January–July, 1883, quoted in Hereward Lester Cooke, "The Development of Winslow Homer's Water-Color Technique," *Art Quarterly* 24, no. 2 (Summer, 1961), p. 183.
4. Quoted in John McCoubrey, *American Art, 1700–1960: Sources and Documents* (Englewood, N.J., 1965), p. 186.
5. Quoted in Clara Erskine Clement and Laurence Hutton, *Artists of the Nineteenth Century and Their Works . . .* (Boston, 1874; reprint ed., St. Louis, 1969), vol. 2, p. 347.
6. Dianne H. Pilgrim, "The Revival of Pastels in Nineteenth-Century America," (unpublished article), p. 8.
7. "Art Notes and Reviews," *The Art Journal* 43 (London, March, 1881), p. 93.
8. "Whistler's Water Colors and Prints," *Art Age* 9, no. 68 (March 1889), p. 60.
9. Otto H. Bacher, *With Whistler in Venice* (New York, 1908), pp. 74-5.
10. Pilgrim, "Revival of Pastels," p. 12.
11. M.G. Van Rensselaer, "American Painters in Pastel," *Century* 29 (December 1884), p. 207.
12. Katherine M. Roof, *The Life and Art of William Merritt Chase* (New York, 1917), Roof says little about the Society's shows, noting only that "it had at least three exhibitions . . . the last one . . . in 1889" (p. 108).
13. "Pastel Painting, Part I and Part II," *Art Amateur* 7, nos. 2 and 3 (July and August 1882), pp. 28–30, 49, 52. I am grateful to Mary Alice Hinson, who pointed this out to me.
14. *The Art Interchange* 12, no. 7 (March 27, 1884), n. p.
15. Mary Alice Hinson, "The American Pastel Revival: Fashion and Style" (unpublished paper, Yale University), passim.

16. *The Art Journal* 10 (New York, 1884), p. 189.
17. Chase here signed his pastel with "PP" on a red disk; this was the emblem of the Pastel Society, used on catalogues and mats by the others, but apparently only by Chase as a signature.
18. Moussa M. Domit, *American Impressionist Painting* (exhibition catalogue, National Gallery of Art, Washington, D.C., 1973), p. 67.
19. Pilgrim, "Revival of Pastels," p. 18.
20. *Ibid.*, p. 22, quoting from a review in *Art Amateur* 24, no. 1 (December 1890), p. 3.
21. Dianne H. Pilgrim, *American Impressionist and Realist Paintings and Drawings from the Collection of Mr. and Mrs. Raymond J. Horowitz* (exhibition catalogue, Metropolitan Museum of Art, New York, 1973), p. 120.
22. Samuel Isham and Royal Cortissoz, *The History of American Painting* (New York, 1943), p. 356.
23. Homer's work is closest perhaps to that of his English contemporary Charles Edward Holloway (1838–97), who also worked on England's East Coast.
24. Cooke, "Development," p. 169.
25. M.G. Van Rensselaer, *Six Portraits: Della Robbia, Correggio, Blake, Corot, George Fuller, Winslow Homer* (Boston and New York, 1889), p. 247.
26. Cooke, "Development," p. 184.
27. Marylyn Brown, "The Late-Nineteenth-Century American Watercolor Manual and Color Theory" (unpublished paper, Yale University, 1974).
28. Lloyd Goodrich, *Winslow Homer* (New York, 1944), pp. 228–229.
29. William Howe Downes, *The Life and Works of Winslow Homer* (Boston and New York, 1911), p. 180.
30. Cooke, "Development," p. 190.
31. A.E. Gallatin, *American Water-Colourists* (New York, 1922), p. 6.
32. Donelson F. Hoopes, *Sargent Watercolors* (New York, 1970), p. 74.
33. Desmond Fitzgerald, *Dodge MacKnight, Water Color Painter* (Brookline, Mass., 1918).
34. Sherman E. Lee, "A Critical Survey of American Watercolor Painting" (Ph.D. dissertation, Western Reserve University, 1941), p. 225.

Chapter 10: Illustration and Fantasy at the Turn of the Century

1. Henry T. Tuckerman, *Book of the Artists: American Artist Life* (New York, 1867; reprint ed., New York, 1966), p. 476.
2. Royal Cortissoz, *American Artists* (New York, 1923; reprint ed., New York, 1970), pp. 95–6.
3. Sadakichi Hartmann, *A History of American Art* (Boston, 1901), vol. 2, pp. 113–4.
4. Robert Taft, *Artists and Illustrators of the Old West, 1850–1900* (New York, 1953), p. 242.
5. Richard Butler Glaenzer, "Walter Appleton Clark: An Appreciation," *International Studio* 31, no. 122 (April 1907), p. xl.
6. Henry C. Pitz, "Pyle, the Teacher," in *Howard Pyle: Diversity in Depth* (exhibition catalogue, Delaware Art Museum, Wilmington, Del., 1973), p. 14.
7. Samuel Isham and Royal Cortissoz, *The History of American Painting* (New York, 1943), p. 504.
8. William Howe Downes, "George H. Hallowell's Pictures," *The American Magazine of Art* 15, no. 9 (September 1924), p. 455.
9. Ibid.
10. "Will H. Bradley and His Work," *The Book Buyer* 13, no. 4 (May 1896), p. 233.
11. Nelson C. White, *Abbott H. Thayer, Painter and Naturalist* (Hartford, Conn., 1951; revised ed., 1967), p. 117.
12. Walt Reed, ed., *The Illustrator in America, 1900–1960s* (New York, 1966), p. 92.

Chapter 11: Twentieth-Century Realism

1. See John Caldwell, "The Drawings of Everett Shinn" (unpublished paper, Yale University, 1973).
2. William LeQueux, "The Hermit of Rue Madame," *Ainslee's Magazine* 3, no. 3 (April 1899), p. 268.
3. Dianne H. Pilgrim, *American Impressionist and Realist Paintings and Drawings from the Collection of Mr. and Mrs. Raymond J. Horowitz* (exhibition catalogue, Metropolitan Museum of Art, New York, 1973), p. 149.
4. William I. Homer, *Robert Henri and His Circle* (Ithaca and New York, 1969), p. 129.
5. Robert Henri, *The Art Spirit* (Philadelphia, 1930 and 1951), p. 208.
6. David W. Scott, "George Luks," entry in the *Brittanica Encyclopedia of American Art* (New York, 1973), p. 352.
7. Homer, *Circle*, p. 130.
8. Alfred Frankenstein, "Grant Wood," entry in the *Brittanica Encyclopedia of American Art* (New York, 1973), p. 603.
9. See, for example, *Trees and Underbrush, Cape Cod* (Metropolitan Museum of Art, acc. no. 39.166.1).

Chapter 12: Toward the Modern Era

1. Joseph Stella, "Discovery of America: Autobiographical Notes," *Art News* 59, no. 7 (November 1960), pp. 41–2, 62–7 (original notes written in 1947).
2. Much of Gallatin's wide-ranging collection of drawings and watercolors is at the Metropolitan Museum of Art.
3. Most of the collection formed by Miss Dreier, with Marcel Duchamp (who made up the "Société Anonyme"), is at the Yale University Art Gallery.
4. Duncan Phillips, "Arthur Dove," *Magazine of Art* 40, no. 5 (March 1947), p. 193.
5. *Ten Americans: Masters of Watercolor* (exhibition catalogue, Andrew Crispo Gallery, New York, 1974), n.p.
6. Robert Goldwater, "Arthur Dove, A Pioneer of Abstract Expressionism in American Art," *Perspectives USA* 2 (Winter, 1953), p. 78.
7. *New Oils and Watercolors by Arthur G. Dove* (exhibition catalogue, An American Place, New York, 1940), n.p.
8. Phoebe K. Scholl, "A Study of the Styles and Techniques of Some Outstanding Recent American Watercolor Painters" (Ph.D. dissertation, Columbia University, 1970), p. 50.
9. Ibid., p. 72.
10. Sherman E. Lee, "A Critical Survey of American Watercolor Painting" (Ph.D. dissertation, Western Reserve University, 1941), p. 277.
11. Ibid., p. 248.
12. Sheldon Reich, *John Marin: A Stylistic Analysis and Catalogue Raisonné* (Tucson, 1970), vol. 1, p. 148.
13. *Collection of the Société Anonyme: Museum of Modern Art 1920* (New Haven, 1950), p. 174.
14. Interestingly, Stanton MacDonald-Wright did several rather similar watercolor still lifes in 1917, perhaps a source of inspiration for Demuth. See Wright's *Still Life No. 2.* (Columbus Gallery of Fine Arts, acc. no. 31.277).
15. Albert Gallatin, *Charles Demuth* (New York, 1927), p. 9.
16. James Thrall Soby and Dorothy C. Miller, *Romantic Painting in America* (New York, 1943), p. 39.
17. Hilton Kramer, "Realists and Others," *Arts* 38, no. 1 (January 1964), p. 22.

1. The major impact of European surrealism on American art was not its theoretical aspect (the manifestos, the cultist life style). Rather, artists such as Newman, Rothko, and Gottlieb called their early works "surrealist" because they employed automatic gestures, and because they sought to express through their imagery deep psychological and philosophical meaning. Thomas B. Hess, *Barnett Newman* (exhibition catalogue. Museum of Modern Art, New York, 1971), p. 51.

2. William S. Rubin, *Dada, Surrealism, and Their Heritage* (exhibition catalogue, Museum of Modern Art, New York, 1968), p. 111.

3. The Julian Levy Galleries, with whom Tchelitchew first showed in 1934, had previously exhibited Dali and Tanguy. Lincoln Kirstein, *Pavel Tchelitchew* (New York, 1964), p. 30.

4. Tchelitchew, as quoted in *Pavel Tchelitchew: Drawings,* ed. by Lincoln Kirstein (New York, 1947), p. 9.

5. Ida Rubin, ed., *The Drawings of Morris Graves* (New York, 1974), p. 70.

6. Marvin S. Sadik, *The Drawings of Hyman Bloom* (exhibition catalogue, University of Connecticut Museum of Art, Storrs, Conn., 1968), introduction, n. p.

7. Barnett Newman defines drawing as playing the essential role in his monumental paintings: "Drawing is central to my whole concept. I don't mean making *drawings*, although I have always done a lot of them. I mean the drawing that exists in my paintings." Barnett Newman, as quoted in Dorothy Gees Seckler, "Frontiers of Space," *Art in America* 50, no. 2 (1962), p. 86.

8. Even Gorky's early realist drawings and paintings, such as *Study for the Artist and His Mother*, pencil, or *Portrait of Vartoosh*, oil on canvas, reflect the influence of Picasso on Gorky. In this case, the influence is from the master's "Classic" imagery. Gorky's admiration and imitation of Picasso is a dominant theme throughout his career, and a dependence he celebrated.

9. This work is probably one of a series of studies for the painting, *Nighttime, Enigma, and Nostalgia*, completed in 1934.

10. Irving Sandler, *The Triumph of American Painting* (New York, 1970), p. 44.

11. William C. Seitz, *Mark Tobey* (exhibition catalogue, Museum of Modern Art, New York, 1962), p. 20.

12. Sandler, *Triumph*, p. 62.

13. However, he consistently emphasized the role drawing plays in his paintings, even though the primary element in Newman's abstractions is color. He purged the figurative, linear aspect from his work, as did Rothko, in a search for art which expresses the sublime.

14. Bernice Rose, *Jackson Pollock: Works on Paper* (New York, 1969), pp. 9–10.

15. Sandler, *Triumph*, p. 113.

16. His exuberant reaction to New York is said to be the theme of his abstract black and white works as well, which are compared to "steel girders silhouetted against the New York sky." John Gordon, *Franz Kline, 1901–1962* (exhibition catalogue, Whitney Museum of American Art, New York, 1968), p. 9.

17. Ibid., p. 11.

18. Thomas B. Hess, *Willem de Kooning Drawings* (Greenwich, Conn., 1972), p. 38.

19. Hess explains the imagery of this drawing as the result of a drive de Kooning made around Washington, D.C., when he had a retrospective there in 1953. He was particularly impressed by the Federalist architecture he saw, and in making this drawing, combined the monuments of the city with his figure of Woman. Her nose is the Washington Monument, her left breast, the Jefferson Memorial. Hess further suggests, "De Kooning has always insisted that Woman was not only a figure but also a structure for any kind of painting with any content he chose. The basic layout of Woman was his donnée; with it he was free to paint as he wanted," even, "to give his impressions of a drive through Washington, D.C." Ibid., pp. 45–46.

20. Jackson Pollock, from a taped interview made by William Wright, Summer, 1950. Reprinted in Francis V. O'Connor, *Jackson Pollock* (exhibition catalogue, Museum of Modern Art, New York, 1967), p. 81.

Chapter 14: Drawing Today: Many Directions

1. This is true, for example, of the paintings of the sixties, in which a photograph was often the source of the image, and assistants were responsible for its transfer to silk-screen and then its inking onto a canvas.

2. Indiana himself has identified his sources: "The commercial brass stencils found in deserted lofts—of numbers, of sail names, of the names of nineteenth-century companies (THE AMERICAN GAS WORKS)—became the matrix and substance of my painting and drawing. So then did all things weave together." Indiana, as quoted in *Stankiewicz and Indiana* (exhibition catalogue, Walker Art Center, Minneapolis, 1963), n.p.

3. Jim Dine, personal letter, as quoted in *Catalogue of American Drawings* (Solomon R. Guggenheim Museum, New York, 1964), n.p.

4. Claes Oldenburg, 1968, as quoted in *Claes Oldenburg* (exhibition catalogue, Stedelijk Museum, Amsterdam, 1970), p. 34.

5. The title of the drawing refers to the poem it was to accompany, both intended for a commemorative volume of art works and poetry for Frank O'Hara.

6. Claes Oldenburg, as quoted in *Claes Oldenburg* (exhibition catalogue, Arts Council of Great Britain, Tate Gallery, London, 1970), p. 7.

7. Leonard Baskin, *Baskin: Sculpture, Drawings and Prints* (New York, 1970), p. 17.

8. Philip Pearlstein, as quoted in *Philip Pearlstein: Zeichnungen und Aquarelle, die Druckgraphik* (exhibition catalogue, Städliche Museen, Berlin, 1972), p. 14.

9. Elke Solomon, *Recent Drawings* (exhibition catalogue, American Federation of Arts, 1975), n.p.

10. Richard Field, *Prints and Drawings by Lee Bontecou* (exhibition catalogue, Davison Art Center, Wesleyan University, Middletown, Conn., 1975), pp. 3–4.

11. E. C. Goossen, who calls Kelly's plant drawings "perfectly organic in rhythm, but as austere as if . . . shaped in piano wire," suggests that these simple line drawings, too, lead to paintings. The contours of the drawings create shapes in the areas between the forms. Translated to canvas, this "negative silhouette, a symbol of space," becomes an active, independent shape. E.C. Goossen, "Ellsworth Kelly," *Derrière le Miroir*, no. 110 (Paris, 1958), pp. 8–9.

12. Solomon, *Recent Drawings*, n.p.

13. Peter Plagens, "The Possibilities of Drawing," *Artforum* 8, no. 2 (October 1969), p. 55.

List of Illustrations

421

1769, pastel, 23⅛ x 17½″ (58.7 x 44.5 cm.), The Henry Francis du Pont Winterthur Museum, Winterthur, Delaware.

Fig. 17. JOHN SINGLETON COPLEY, *Fleeing Woman and Child, and Boy in a Hat,* Study for *The Death of Major Peirson,* 1783, black and white chalk on gray-blue paper, 13⅞ x 22¼″ (35.2 x 56.5 cm.), Museum of Fine Arts, Boston, M. & M. Karolik Collection.

Fig. 18. JOHN SINGLETON COPLEY, *Study of a Horse, For Saul Reproved by Samuel For Not Obeying the*

Commandments of the Lord, 1797–1798, black and white chalk on gray-blue paper, 13⅜ x 11¼″ (34.0 x 28.6 cm.), Addison Gallery of American Art, Phillips Academy, Andover, Massachusetts.

Fig. 19. UNKNOWN ARTIST, *Portrait of a Lady,* 1790, pastel, 21 x 15½″ (53.3 x 39.4 cm.), New York State Historical Association, Cooperstown, New York.

Fig. 20. CHRISTIAN REMICK, *Perspective View of the Blockade of Boston,* 1768, watercolor, 13 x 61″ (33.0 x 154.9 cm.), Essex Institute, Salem, Massachusetts.

CHAPTER 3: NEO-CLASSIC DRAWINGS: THE FIGURE AND THE LAND

Fig. 21. JOHN TRUMBULL, *Attention,* after Charles Le Brun, c. 1778, pencil, 7¾ x 6¼″ (19.7 x 15.9 cm.), Beinecke Rare Book and Manuscript Library, Yale University.

Fig. 22. JOHN TRUMBULL, *Reverend Enos Hitchcock,* 1791, pencil, 2¹⁵⁄₁₆ x 4⅝″ (7.5 x 11.7 cm.), Yale University Art Gallery, New Haven, Connecticut, Gift of Mrs. Winchester Bennett.

Fig. 23. JOHN TRUMBULL, *Reclining Female Nude,* c. 1795–1796, chalks on blue paper, 14 x 22½″ (35.6 x 57.2 cm.), Yale University Art Gallery, New Haven, Connecticut, Gift of the Associates in Fine Arts.

Fig. 24. JOHN TRUMBULL, *The Indian Chief Hopothle Mico,* 1790, pencil, 4⅞ x 4″ (12.4 x 10.2 cm.), Fordham University Library, Bronx, New York.

Fig. 25. ST. JOHN HONEYWOOD, *Ezra Stiles,* 1786, pen and brush with wash, 5¾ x 4⅜″ (14.6 x 11.1 cm.), Beinecke Rare Book and Manuscript Library, Yale University, New Haven, Connecticut.

Fig. 26. GILBERT STUART, *Seated Baby,* c. 1785, pencil, 7 x 4½″ (17.8 x 11.4 cm.) (sight), Museum of Fine Arts, Boston, Gift of Marian W. Balch and Theodore E. Stebbins, Jr.

Fig. 27. JAMES SHARPLES, *George Washington,* c. 1795, pastel, 9½ x 7½″ (24.1 x 19.1 cm.), Private Collection.

Fig. 28. CHARLES BALTHAZAR JULIEN FEVRET DE SAINT-MÉMIN, *An Osage Warrior,* c. 1804, watercolor, 7½ x 6¾″ (19.1 x 17.1 cm.), The Henry Francis du Pont Winterthur Museum, Winterthur, Delaware.

Fig. 29. CHARLES BALTHAZAR JULIEN FEVRET DE SAINT-MÉMIN, *Paul Revere,* 1800, black and white chalk on pink prepared paper, 20¼ x 14¼″ (51.4 x 36.2 cm.),

Museum of Fine Arts, Boston, Gift of Mrs. Walter Knight.

Fig. 30. JOHN VANDERLYN, *Sarah Russell Church,* 1799, crayon, 8⁷⁄₁₆ x 6⅜″ (21.4 x 16.2 cm.), The Metropolitan Museum of Art, New York, Bequest of Ella Church Strobell, 1917.

Fig. 31. JOHN VANDERLYN, *Costume of Columbus,* c. 1840–1842, pencil and chalks, 18½ x 13″ (47.0 x 33.0 cm.), Senate House State Historic Site, Palisades Interstate Park, and Recreation Commission, New York State Office of Parks and Recreation.

Fig. 32. ARCHIBALD ROBERTSON, *West Point and the Narrows of the Hudson River,* c. 1799, pen and ink, 9 x 11⅜″ (22.9 x 28.9 cm.), Collection of Mr. and Mrs. Paul Mellon, Washington, D.C.

Fig. 33. ARCHIBALD ROBERTSON, *The Highlands of the Hudson River,* c. 1805–1810, watercolor, 14½ x 19¼″ (36.8 x 48.9 cm.), Kennedy Galleries, New York.

Fig. 34. MICHEL FELICE CORNÉ, *Sailing Ship "Charles" of Boston,* 1802, gouache, 13½ x 19¾″ (34.3 x 50.2 cm.), Museum of Fine Arts, Boston, Bequest of Clarice O. Davis.

Fig. 35. WILLIAM STRICKLAND, *Waterworks, Fairmount Park, Philadelphia,* c. 1815–1820, gouache, 14¹⁄₁₆ x 19¹³⁄₁₆″ (35.7 x 50.3 cm.), Museum of Fine Arts, Boston, M. & M. Karolik Collection.

Fig. 36. JOHN RUBENS SMITH, *St. George's Church, after the Fire of January 5, 1814,* 1814, watercolor, 20½ x 25″ (52.1 x 63.5 cm.), Museum of the City of New York, Bequest of Mrs. J. Insley Blair.

Fig. 37. CHARLES WILLSON PEALE, *View of West Point from the Side of the Mountain,* 1801, watercolor, 6¼ x 7¹⁵⁄₁₆″ (15.9 x 20.2 cm.), American Philosophical Society, Philadelphia.

CHAPTER 4: ROMANTICISM AND THE EARLY NINETEENTH CENTURY

Fig. 38. WASHINGTON ALLSTON, *Belshazzar's Left Hand,* c. 1820–1830, charcoal heightened with white chalk on gray-green paper, 9⅛ x 12⅜″ (23.2 x 31.4

cm.), Fogg Art Museum, Cambridge, Massachusetts, Loan: The Washington Allston Trust.

Fig. 39. WASHINGTON ALLSTON, *Ship in a Squall,* c.

CHAPTER 5: FOLK AND COUNTRY DRAWINGS

Aldrich Rockefeller Folk Art Collection, Williamsburg, Virginia.

Fig. 67. DEBORAH GOLDSMITH, *The Talcott Family*, 1832, watercolor, 14¼ x 17¾″ (36.2 x 45.1 cm.), Abby Aldrich Rockefeller Folk Art Collection, Williamsburg, Virginia.

Fig. 68. HENRY WALTON, *Francis and Charles Cowdrey*, c. 1839, pen and watercolor, 11½ x 12⅝″ (29.2 x 32.1 cm.), The Metropolitan Museum of Art, New York, Gift of Edgar William and Bernice Chrysler Garbisch, 1966.

Fig. 69. THEODORE BARRELL, attr. to, *Deed and Architectural Plans: The Barrell House*, c. 1833, watercolor, 31 x 41″ (78.7 x 104.1 cm.), Abby Aldrich Rockefeller Folk Art Collection, Williamsburg, Virginia.

Fig. 70. FITZ HUGH LANE, *Burning of the Packet Ship Boston*, 1830, watercolor, 19¼ x 27″ (48.9 x 68.6 cm.), Cape Ann Historical Association, Gloucester, Massachusetts.

Fig. 71. JURGAN FREDERICK HUGE, *Bunkerhill*, 1838, watercolor, 19 x 32″ (48.3 x 81.3 cm.), The Mariners Museum, Newport News, Virginia.

Fig. 72. THOMAS A. AYERS, *The Devil's Pulpit*, 1857, pencil, charcoal and wash, 17 x 11⅜″ (43.2 x 28.9 cm.), The New York Historical Society, New York, Gift of James Gore King, 1925.

Fig. 73. C. C. HOFMANN, *Berks County Almshouse, Hospital and Lunatic Asylum*, 1865, ink and watercolor, 23⅝ x 40⅝″ (60.0 x 103.2 cm.), Whitney Museum of American Art, New York, Gift of Edgar William and Bernice Chrysler Garbisch.

Fig. 74. DAVID JOHNSTON KENNEDY, *Entrance to Harbor —Moonlight*, 1881, gouache, Chinese white and pencil, 9¼ x 14¹⁵⁄₁₆″ (23.5 x 37.9 cm.), The Metropolitan Museum of Art, New York, Rogers Fund, 1968.

Fig. 75. WILLIAM BROOKS, *Hardware*, (Drawing for an 1840 Hardware Trade Card), 1840, pencil, 9⁹⁄₁₆ x 11⅞″ (24.3 x 30.2 cm.), Addison Gallery of American Art, Phillips Academy, Andover, Massachusetts.

Fig. 76. CYRUS W. KING, *12943 Objects*, c. 1874, pencil and black ink, 11¾ x 14¾″ (29.9 x 37.5 cm.), Private Collection.

CHAPTER 6: DRAWINGS OF THE HUDSON RIVER SCHOOL

Fig. 77. THOMAS COLE, *White Cedars Near Niagara*, 1829, pencil, 9¾ x 7¹⁵⁄₁₆″ (24.8 x 20.2 cm.), The Detroit Institute of Arts, William H. Murphy Fund.

Fig. 78. THOMAS COLE, *Gnarled Tree Trunk*, c. 1825–1829, pen and ink, 14¹³⁄₁₆ x 10¹¹⁄₁₆″ (37.6 x 27.2 cm.), The Detroit Institute of Arts, William H. Murphy Fund.

Fig. 79. THOMAS COLE, *Tranquillity*, c. 1835–1840, pen and ink over pencil, 2⅝ x 3¼″ (6.7 x 8.3 cm.), The Detroit Institute of Arts, William H. Murphy Fund.

Fig. 80. THOMAS COLE, *Albany*, c. 1840, pen and ink, 10⅛ x 15⁵⁄₁₆″ (25.7 x 38.9 cm.), Albany Institute of History and Art, Albany, New York.

Fig. 81. THOMAS COLE, *Romantic Landscape: Indian and a Cross*, c. 1845, pencil and white wash, 7⅜″ (18.7 cm.), diameter, Collection of John Davis Hatch, Lenox, Massachusetts.

Fig. 82. F. S. AGATE, *Shipwrecked Mother and Child*, c. 1830, sepia wash 3⅝ x 5¼″ (9.2 x 13.3 cm.), The New York Historical Society, New York, Bequest of Emily Elleson Post, 1944.

Fig. 83. SAMUEL F. B. MORSE, *The Elfin Page*, from Scott's *Lay of the Last Minstrel*, 1829, pencil, 7⅞ x 10⅜″ (20.0 x 26.4 cm.), Yale University Art Gallery, New Haven, Connecticut.

Fig. 84. ROBERT W. WEIR, *The Elfin Page*, from Scott's *Lay of the Last Minstrel*, 1829, pencil, 7¾ x 10¼″ (19.7 x 26.0 cm.), Yale University Art Gallery, New Haven, Connecticut.

Fig. 85. THOMAS DOUGHTY, *Mountain Landscape*, c. 1820–1825, pencil with oxidized white wash, 11¹⁄₁₆ x 8⅜″ (28.1 x 21.3 cm.), Yale University Art Gallery, New Haven Connecticut, Gift of Mrs. John Hill Morgan.

Fig. 86. ALVAN FISHER, *Niagara*, c. 1820–1830, wash, 10½ x 15½″ (26.7 x 39.4 cm.), Private Collection.

Fig. 87. EDWARD SEAGER, *On the Kenebec River, Holliwell, Me.*, c. 1845–1850, pencil, 9⅞ x 15¹⁄₁₆″ (25.1 x 38.3 cm.), Yale University Art Gallery, New Haven, Connecticut. The John Hill Morgan Fund.

Fig. 88. EDWIN WHITEFIELD, *View of Providence, Rhode Island*, c. 1850, pencil, 7⅝ x 12½″ (19.4 x 31.8 cm.), Private Collection.

Fig. 89. JASPER CROPSEY, *Chepstow Castle on the Wye*, 1849, charcoal, gouache and sepia, 9½ x 16⅜″ (24.1 x 41.6 cm.), Collection of Robert C. Graham, Stamford, Connecticut.

Fig. 90. ASHER B. DURAND, *Bolton, Oct. 3, 1863*, 1863, pencil, 12¼ x 18½″ (31.1 x 47.0 cm.), The New-York Historical Society, New York, Gift of Miss Nora Durand Woodman, 1932.

Fig. 91. JOHN F. KENSETT, *Birch Tree, Niagara, Aug. 26, 1850*, 1850, pencil, 17⅛ x 11¼″ (43.5 x 28.6 cm.), The Metropolitan Museum of Art, New York, Purchase, Morris K. Jesup Fund, 1976.

Fig. 92. CHARLES H. MOORE, *Pine Tree*, 1868, pencil and ink on cream-colored paper, 25⅛ x 20″ (63.8 x 50.8 cm.), The Art Museum, Princeton University, Princeton, New Jersey.

Fig. 93. WILLIAM BRADFORD, *Merchant Ship*, c. 1856, pencil, 19⅝ x 14⅛″ (49.9 x 35.9 cm.), Old Dartmouth Historical Society and Whaling Museum, New Bedford, Massachusetts.

Fig. 94. WORTHINGTON WHITTREDGE, *Bishop Berkeley's*

House, Newport, Rhode Island, 1877, pencil, 15¼ x 22⅜" (38.7 x 56.4 cm.), Museum of Fine Arts, Boston, M. & M. Karolik Collection.

Fig. 95. WILLIAM HART, *Shipwreck,* c. 1860–1870, wash, 3⅞ x 6½" (9.8 x 16.5 cm.), Collection of John Davis Hatch, Lenox, Massachusetts.

Fig. 96. FREDERIC E. CHURCH, *Sky Aug/67,* 1867, pencil on gray paper, 4¾ x 7⅝" (12.1 x 19.4 cm.), Cooper-Hewitt Museum of Decorative Arts and Design, Smithsonian Institution, New York.

Fig. 97. FREDERIC E. CHURCH, *Goat Island August '58,* 1858, pencil and white gouache on brown paper, 17⅝ x 12" (44.8 x 30.5 cm.), Cooper-Hewitt Museum of Decorative Arts and Design, Smithsonian Institution, New York.

Fig. 98. FREDERIC E. CHURCH, *Chimborazo from the House of Señor Bustamente, Riobamba,* 1857, pencil and white gouache on light brown paper, 13⅞ x 21¾" (35.2 x 55.2 cm.), Cooper-Hewitt Museum of Decorative Arts and Design, Smithsonian Institution, New York.

Fig. 99. FREDERIC E. CHURCH, *Niagara Falls from the Canadian Side,* 1856, pencil and colored washes, 10¾ x 12⅜" (27.3 x 31.4 cm.), Cooper-Hewitt Museum of

Decorative Arts and Design, Smithsonian Institution, New York.

Fig. 100. HOMER D. MARTIN, *Study for "Autumn on the Susquehanna,"* 1868, pencil with white wash on brown paper, 12¼ x 20½" (31.6 x 52.4 cm.), The St. Louis Art Museum, Gift of William MacBeth.

Fig. 101. MARTIN JOHNSON HEADE, *Twilight, Plum Island River,* c. 1865–1870, charcoal and colored chalks, 10⅞ x 21⅞" (27.6 x 55.6 cm.), Private Collection.

Fig. 102. WILLIAM MORRIS HUNT, *Niagara Falls,* c. 1878, charcoal and pastel, 9¹³⁄₁₆ x 15¼" (24.9 x 38.7 cm.), Fogg Art Museum, Harvard University, Cambridge, Massachusetts, Gift of Trustees of the Naûshon Trust.

Fig. 103. WILLIAM MORRIS HUNT, *Landscape by a River with Lights,* c. 1872–1873, charcoal, 7 x 10¾" (17.8 x 27.3 cm.), Fogg Art Museum, Harvard University, Cambridge, Massachusetts, Purchase: Gifts for Special Uses Fund.

Fig. 104. GEORGE INNESS, *The Fisherman,* 1868, charcoal, 10¾ x 15¾" (27.3 x 40.0 cm.), Collection of Mr. and Mrs. S. Morton Vose II, Brookline, Massachusetts.

Fig. 105. RALPH A. BLAKELOCK, *California,* 1869, pen and ink, 6⅜ x 8¹³⁄₁₆" (16.2 x 22.4 cm.), Addison Gallery of American Art, Phillips Academy, Andover, Massachusetts.

CHAPTER 7: THE VICTORIAN WATERCOLOR, 1820–1880

Fig. 106. PETER RINDISBACHER, *Captain W. Andrew Bulger Saying Farewell, Fort Mackay, Prairie du Chien,* c. 1823, pen and watercolor, 14 x 23⅞" (35.6 x 60.6 cm.), Amon Carter Museum of Western Art, Fort Worth, Texas.

Fig. 107. GEORGE CATLIN, *Blackfoot Medicine Man Treating His Patient near Fort Union,* 1832, pencil, 13⅜ x 19" (34.0 x 48.3 cm.), The New York Public Library, Astor, Lenox and Tilden Foundations, Rare Book Division, New York.

Fig. 108. KARL BODMER, *Makuie-Poka ("Wolf's Son"),* 1833, watercolor, 12¼ x 9⅞" (31.1 x 25.1 cm.), Northern Natural Gas Company Collection, Joslyn Art Museum, Omaha, Nebraska.

Fig. 109. ALFRED JACOB MILLER, *Pierre,* 1837, watercolor, 9⁵⁄₁₆ x 12³⁄₁₆" (23.7 x 31.0 cm.), Walters Art Gallery, Baltimore.

Fig. 110. WILLIAM GUY WALL, *View Near Fishkill (New York),* c. 1820, watercolor, 14 x 21⅛" (35.6 x 53.7 cm.), The New-York Historical Society, New York.

Fig. 111. WILLIAM HENRY BARTLETT, *Caaterskill Falls from Above the Ravine,* c. 1840, watercolor, 4¾ x 7⅞" (12.1 x 20.0 cm.), The New-York Historical Society, New York, Gift of Daniel Parish, Jr., 1900.

Fig. 112. WILLIAM HENRY BARTLETT, *Caaterskill Falls,* engraving from N. P. Willis, *American Scenery,* 1841.

Fig. 113. GEORGE HARVEY, *Afternoon—Hastings Landing, Palisade Rocks in Shadow, New York,* c. 1835–1840, watercolor, 8⅜ x 13⁵⁄₁₆" (21.3 x 33.8 cm.), The New-York Historical Society, New York.

Fig. 114. NICOLINO CALYO, *View of the Great Fire in New York, December 16 and 17, 1835,* c. 1835–1836, gouache; 16⅛ x 24⅝" (41.0 x 62.5 cm.), The New-York Historical Society, New York.

Fig. 115. JOHN M. FALCONER, *Old Mill, West Milford,* 1851, watercolor, 9¹⁵⁄₁₆ x 13¹⁵⁄₁₆" (25.2 x 35.4 cm.), Museum of Fine Arts, Boston, M. & M. Karolik Collection.

Fig. 116. CHARLES PARSONS, *Old Macedonian, Wallabout Bay,* 1851, watercolor, 10½ x 15¾" (26.7 x 40.0 cm.), Private Collection.

Fig. 117. EMANUEL LEUTZE, *Cathedral Ruins,* 1841, watercolor, 10½ x 14½" (26.7 x 36.8 cm.), Corcoran Gallery of Art, Washington, D.C., Gift of Rear Admiral E. H. C. Leutze.

Fig. 118. GEORGE LORING BROWN, *Mountain Scene With Crags,* 1849(?), watercolor, 10½ x 8" (26.7 x 20.3 cm.), The Detroit Institute of Arts, Merrill Fund.

Fig. 119. WILLIAM RICKARBY MILLER, *New York Bay from Hudson City,* 1858, watercolor, 11⅞ x 16¼" (30.2 x 41.3 cm.), The New-York Historical Society, New York.

Fig. 120. JOHN WILLIAM HILL, *Erie Canal,* 1831, watercolor, 9½ x 13½" (24.1 x 24.3 cm.), The New-York Historical Society, New York, Purchase, 1967.

Fig. 121. JOHN WILLIAM HILL, *Dead Blue Jay*, c. 1860–1865, watercolor, 5¾ x 12″ (14.6 x 30.5 cm.), The New-York Historical Society, New York, Gift of Mrs. C. W. P. Gellatly, 1957.

Fig. 122. JOHN HENRY HILL, *"Sunnyside," Tarrytown, New York*, c. 1860, watercolor, 10 x 13⁹⁄₁₆″ (25.4 x 34.5 cm.), Museum of Fine Arts, Boston, M. & M. Karolik Collection.

Fig. 123. JOHN WILLIAM HILL, *Apples and Plums*, 1874, watercolor, 7⅞ x 11⅜″ (20.0 x 28.9 cm.), Private Collection.

Fig. 124. CHARLES H. MOORE, *Landscape*, c. 1860–1870, watercolor, 7½ x 10¾″ (19.1 x 27.3 cm.), Fogg Art Museum, Harvard University, Cambridge, Massachusetts, Transferred from Fine Arts Department.

Fig. 125. WILLIAM T. RICHARDS, *Moonlight on Mount Lafayette, New Hampshire*, 1873, watercolor, 8⅜ x 14⅛″ (21.3 x 35.9 cm.), The Metropolitan Museum of Art, New York, Gift of Rev. E. L. Magoon, 1880.

Fig. 126. FIDELIA BRIDGES, *Milkweeds*, 1861, watercolor, 16 x 9½″ (40.6 x 24.1 cm.), Munson-Williams-Proctor Institute, Utica, New York.

Fig. 127. HENRY FARRER, *Sunrise, New York Bay*, 1875, watercolor, 12 x 18½″ (30.5 x 47.0 cm.), Collection of Mr. and Mrs. Thomas L. Colville, New Haven, Connecticut.

Fig. 128. LOUIS C. TIFFANY, *Oriental Scene*, c. 1870–1880, watercolor and gouache, 24⅝ x 36⅝″ (62.5 x 93.0 cm.), The Detroit Institute of Arts, Gift of Archives of American Art.

Fig. 129. THOMAS MORAN, *Barnard Castle*, 1862, watercolor and gouache, 12⅝ x 18⅝″ (32.1 x 47.3 cm.), Private Collection.

Fig. 130. THOMAS MORAN, *Hot Springs of Gardner's River, Yellowstone*, 1872, watercolor on tinted tan paper, 20¼ x 28⅝″ (51.4 x 72.7 cm.), Reynolda House, Inc., Museum of American Art, Winston-Salem, North Carolina.

Fig. 131. THOMAS MORAN, *Hiawatha Sees Mudjekeewis (Sketch for "Hiawatha")*, c. 1870–1875, pen and brown ink, gray and brown washes, pencil, 5½ x 4⁵⁄₁₆″ (14.0 x 11.0 cm.), Cooper-Hewitt Museum of Decorative Arts and Design, Smithsonian Institution, New York.

Fig. 132. ALFRED T. BRICHER, *A Pensive Moment*, c. 1875, watercolor, 13 x 29″ (33.0 x 73.7 cm.), courtesy of Vose Galleries, Boston.

Fig. 133. THOMAS EAKINS, *Baseball Players Practicing*, 1875, watercolor and pencil, 10¹³⁄₁₆ x 12⅞″ (27.5 x 32.7 cm.), Museum of Art, Rhode Island School of Design, Providence, Jesse Metcalf and Walter H. Kimball Funds.

Fig. 134. WINSLOW HOMER, *The New Novel*, 1877, watercolor, 9½ x 20½″ (24.1 x 52.1 cm.), Museum of Fine Arts, Springfield, Massachusetts, The Horace P. Wright Collection.

Fig. 135. JOHN HABERLE, *Dead Canary*, 1883, watercolor and gouache, 8 x 4¹⁵⁄₁₆″ (20.3 x 12.5 cm.), Yale University Art Gallery, New Haven, Connecticut, Gherardi Davis Fund.

Fig. 136. EDWIN AUSTIN ABBEY, *An Old Song*, 1885, watercolor, 27½ x 47½″ (69.9 x 120.7 cm.), Yale University Art Gallery, New Haven, Connecticut, Edwin Austin Abbey Memorial Collection.

Fig. 137. HENRY RODERICK NEWMAN, *Grape Vines and Roses: An Italian View*, 1883, watercolor, 39½ x 26⅜″ (100.3 x 67.0 cm.), Collection of Jo Ann and Julian Ganz, Jr., Los Angeles.

CHAPTER 8: FIGURE DRAWINGS OF THE NINETEENTH CENTURY

Fig. 138. WILLIAM SIDNEY MOUNT, *Boy at the Well Sweep*, c. 1840–1850, pencil, 7⅞ x 9¾″ (20.0 x 24.8 cm.), The Museums at Stony Brook, New York.

Fig. 139. WILLIAM SIDNEY MOUNT, *Portrait of a Lady*, 1842, pencil, 9¾ x 7¹¹⁄₁₆″ (24.8 x 19.5 cm.), Fogg Art Museum, Harvard University, Cambridge, Massachusetts, Louise E. Bettens Fund.

Fig. 140. GEORGE CALEB BINGHAM, *Village Character*, 1847, wash, 10¼ x 6⅞″ (26.0 x 17.5 cm.), Mercantile Library Collection, St. Louis.

Fig. 141. JAMES G. CLONNEY, *The Fiddler*, Study for *Militia Training*, c. 1841, wash, 8½ x 5½″ (21.6 x 14.0 cm.), Museum of Fine Arts, Boston, M. & M. Karolik Collection.

Fig. 142. FRANCIS WILLIAM EDMONDS, *Perseverance*, (Drawing for The Artist's Sketching Club), c. 1845, pencil and brown wash, touched with white, 13¾ x 19¾″ (34.9 x 50.2 cm.), Museum of Fine Arts, Boston, M. & M. Karolik Collection.

Fig. 143. DAVID CLAYPOOLE JOHNSTON, *The Young Artist's First Full Length*, c. 1840, watercolor, 10½ x 9⅛″ (26.7 x 23.2 cm.), Private Collection.

Fig. 144. DAVID GILMORE BLYTHE, *A Free-Trade Man (William Blakeley)*, c. 1854–1858, pen and ink, 11½ x 8″ (29.2 x 20.3 cm.), Museum of Art, Carnegie Institute, Pittsburgh.

Fig. 145. LILLY MARTIN SPENCER, *Benjamin Rush Spencer*, c. 1848–1852, pencil, 19⅜ x 15½″ (49.1 x 39.3 cm.), National Collection of Fine Arts, Smithsonian Institution, Washington, D.C.

Fig. 146. EASTMAN JOHNSON, *Secretary Dobbin*, 1856, charcoal with black and white chalk, 29⁷⁄₁₆ x 21⁹⁄₁₆″ (74.8 x 54.8 cm.) Addison Gallery of American Art, Phillips Academy, Andover, Massachusetts.

Fig. 147. EASTMAN JOHNSON, *Street Vendor*, 1852–1855, charcoal, 17¹⁵⁄₁₆ x 15¾″ (45.6 x 40.0 cm.), Museum of Fine Arts, Boston, Lucy Dalbiac Luard Fund.

Fig. 148. EASTMAN JOHNSON, *Study for "The Boy*

Lincoln Reading," c. 1868, charcoal on buff paper heightened with Chinese white, 14⅞ x 12¾" (37.8 x 32.4 cm.), The Detroit Institute of Arts, Gift of John S. Newberry.

Fig. 149. EASTMAN JOHNSON, *Berry Picking,* c. 1875, watercolor, 7¹³⁄₁₆ x 9⁹⁄₁₆" (19.8 x 24.3 cm.), Addison Gallery of American Art, Phillips Academy, Andover, Massachusetts.

Fig. 150. THOMAS EAKINS, *Drawing of a Lathe,* 1860, ink and watercolor, 16¹⁵⁄₁₆ x 22" (41.4 x 55.9 cm.), The Hirshhorn Museum and Sculpture Garden, Smithsonian Institution, Washington, D.C.

Fig. 151. THOMAS EAKINS, *Nude Woman with a Mask, Seated, from the Front,* c. 1873–1875, charcoal, 24 x 18" (61.0 x 45.7 cm.), Philadelphia Museum of Art.

Fig. 152. THOMAS EAKINS, *Perspective Study for John Biglin in a Single Scull,* 1873–1874, pen, pencil and wash on two sheets of buff paper, 27⅜ x 45³⁄₁₆" (69.5 x 114.8 cm.), Museum of Fine Arts, Boston, Gift of Cornelius V. Whitney.

Fig. 153. THOMAS EAKINS, *Gross Clinic,* c. 1875–1876, India ink, wash on cardboard, 23⅝ x 19⅛" (60.0 x 48.6 cm.), The Metropolitan Museum of Art, New York, Rogers Fund, 1923.

Fig. 154. THOMAS EAKINS, *Rail Shooting from a Punt,* c. 1881, wash, 8⅞ x 12³⁄₁₆" (22.5 x 31.0 cm.) Yale University Art Gallery, New Haven, Connecticut, Mabel Brady Garvan Collection.

Fig. 155. WILLIAM RIMMER, *The Neck Muscles in Use,* p. 13 of *The Body,* 1876, pencil, 10¾ x 15" (27.3 x 38.1 cm.), Museum of Fine Arts, Boston, Bequest of Caroline Hunt Rimmer.

Fig. 156. WILLIAM RIMMER, *The Call to Arms,* p. 26 of *The Body,* 1876, pencil, 10¾ x 15" (27.3 x 38.1 cm.), Museum of Fine Arts, Boston, Bequest of Caroline Hunt Rimmer.

Fig. 157. WILLIAM MORRIS HUNT, *Drummer Boy,* c. 1862–1865, charcoal and white chalk on gray-green paper, 40⅛ x 27" (101.9 x 68.6 cm.), Museum of Fine Arts, Boston, Ellen Kelleran Gardner Fund.

Fig. 158. WILLIAM P. BABCOCK, *Feeding the Birds,* c. 1860–1879, black and white chalk with charcoal, 9⅝ x 9⅛ (24.4 x 23.2 cm.), Addison Gallery of American Art, Phillips Academy, Andover, Massachusetts.

Fig. 159. ROBERT WYLIE, *Three Studies of a Man in Despair,* c. 1870, pencil, 8¾ x 11⅝" (22.2 x 29.5 cm.), Museum of Fine Arts, Boston, M. & M. Karolik Collection.

Fig. 160. HUGH NEWELL, *Cleaning Up,* 1878, charcoal and white chalk, 19¼ x 12⅝" (48.8 x 32.1 cm.), Addison Gallery of American Art, Phillips Academy, Andover, Massachusetts.

Fig. 161. WILLIAM AIKEN WALKER, *Seated Woman,* c. 1870–1880, pencil, 12¼ x 10¼" (31.1 x 26.0 cm.), Collection of Jo Ann and Julian Ganz, Jr., Los Angeles.

Fig. 162. WINSLOW HOMER, *Soldier on Horseback,* 1863, charcoal and white chalk on brown paper, 13⅞ x 8⁷⁄₁₆" (35.2 x 21.4 cm.), Museum of Fine Arts, Boston, Anonymous Gift.

Fig. 163. WINSLOW HOMER, *Fisher Girl with Net,* c. 1882, pencil, with gray and white wash on gray paper, 11⅜ x 16⅛" (28.9 x 41.0 cm.), Sterling and Francine Clark Art Institute, Williamstown, Massachusetts.

Fig. 164. WINSLOW HOMER, *Undertow,* 1886, oil on canvas, 29¹³⁄₁₆ x 47⅝" (75.7 x 121.0 cm.), Sterling and Francine Clark Art Institute, Williamstown, Massachusetts.

Fig. 165. WINSLOW HOMER, *Study for "Undertow" (No. 2),* c. 1886, pencil on greenish-gray paper, 5 x 7⅞" (12.7 x 20.0 cm.), Sterling and Francine Clark Art Institute, Williamstown, Massachusetts.

Fig. 166. FRANCESCA ALEXANDER, *Summer,* c. 1880–1890, pen and brown ink, 14⅞ x 11" (37.8 x 27.9 cm.), Museum of Fine Arts, Boston, Bequest of Mrs. Arthur Croft.

Fig. 167. WILLIAM M. HARNETT, *Venus de Milo,* 1873, charcoal, 27⁵⁄₁₆ x 18" (69.4 x 45.7 cm.), Yale University Art Gallery, New Haven, Connecticut, John Hill Morgan Fund.

Fig. 168. WILLIAM M. HARNETT, *Head of a German Girl,* 1881, charcoal, 9½ x 16¼" (24.1 x 41.3 cm.), Fogg Art Museum, Harvard University, Cambridge, Massachusetts, Bequest of Meta and Paul J. Sachs.

Fig. 169. LOUIS RITTER, *Half-Length Seated Nude Man,* c. 1878, charcoal, 33⅞ x 28½" (86.0 x 72.4 cm.), Cincinnati Art Museum, Gift of Charles E. Mills.

Fig. 170. THOMAS ANSHUTZ, *Woman Drawing,* c. 1895, charcoal, 24½ x 18¾" (62.2 x 47.6 cm.), Collection of Mr. and Mrs. Raymond J. Horowitz, New York.

Fig. 171. JOHN LA FARGE, *Dawn Comes on the Edge of Night,* 1880, charcoal, 13 x 13" (33.0 x 33.0 cm.), Fogg Art Museum, Harvard University, Cambridge, Massachusetts, Gift of Family of the late Frederick A. Dwight of Rumsen, New Jersey.

Fig. 172. EDWIN HOWLAND BLASHFIELD, *Study of Hands,* c. 1890–1899, charcoal, 29½ x 21¼" (74.9 x 54.0 cm.), Private Collection.

Fig. 173. EDWIN AUSTIN ABBEY, *Head of a Celtic Woman,* c., 1897, charcoal and chalk on red paper, 28¼ x 21½" (71.8 x 54.6 cm.), Yale University Art Gallery, New Haven, Connecticut, The Edwin Austin Abbey Collection.

Fig. 174. WALTER SHIRLAW, *Studies for "Violin Player,"* c. 1880–1890, pencil, 19¾ x 14¼" (50.2 x 36.2 cm.), Cooper-Hewitt Museum of Decorative Arts and Design, Smithsonian Institution, New York.

Fig. 175. JOHN SINGER SARGENT, *Study for "Orestes,"* c. 1910–1915, charcoal, 18 x 23¾" (45.7 x 60.3 cm.), Corcoran Gallery of Art, Washington, D.C.

Fig. 176. JOHN SINGER SARGENT, *Study of Horses' Heads for "Apollo in His Chariot with the Hours,"* c. 1910–

1915, charcoal, 13½ x 9" (34.3 x 22.9 cm.), Corcoran Gallery of Art, Washington, D.C.

Fig. 177. JAMES ABBOTT MCNEILL WHISTLER, *Study for "Weary"*, 1863, black chalk, 9⅝ x 6⅞ (24.4 x 17.5 cm.), Sterling and Francine Clark Art Institute, Williamstown, Massachusetts.

Fig. 178. ABBOTT H. THAYER, *Portrait Head of a Young Girl*, 1897, pencil, 18¾ x 14⅛" (47.6 x 35.9 cm.), Museum of Art, Rhode Island School of Design, Providence, Gift of Mrs. Gustav Radeke.

Fig. 179. THOMAS W. DEWING, *Head of a Girl*, c. 1890–1895, silverpoint, 16⅜ x 14" (41.6 x 35.5 cm.), National Collection of Fine Arts, Smithsonian Institution, Gift of John Gellatly.

CHAPTER 9. THE IMPACT OF AMERICAN IMPRESSIONISM

Fig. 180. GEORGE INNESS, *The River Bank*, c. 1880–1885, watercolor, 14 x 20" (35.6 x 50.8 cm.), Canajoharie Library and Art Gallery, Arkell Hall Foundation, Canajoharie, New York.

Fig. 181. J. FRANK CURRIER, *White Beeches*, c. 1875–1880, watercolor, 11 x 16" (27.9 x 40.6 cm.), Collection of Nelson C. White, Waterford, Connecticut.

Fig. 182. J. FRANCIS MURPHY, *The Willow Pond*, 1892, watercolor on white paper laid on board, 10³⁄₁₆ x 14⅞" (25.9 x 37.8 cm.), The University of Michigan Museum of Art, Ann Arbor, Bequest of Margaret Watson Parker.

Fig. 183. JAMES ABBOTT MCNEILL WHISTLER, *Sailboats in Blue Water*, c. 1870–1880, watercolor, 8¼ x 4⅞" (21.0 x 12.4 cm.), Fogg Art Museum, Harvard University, Cambridge, Massachusetts, Grenville L. Winthrop Bequest.

Fig. 184. JAMES ABBOTT MCNEILL WHISTLER, *The Little Riva; in Opal*, c. 1880, pastel, 11⅜ x 7¾" (28.9 x 19.7 cm.), Private Collection.

Fig. 185. J. ALDEN WEIR, *Watching the Bees*, 1896, pastel, 13¼ x 8¾" (33.7 x 22.2 cm.), Corcoran Gallery of Art, Washington, D.C., Bequest of James Parmelee.

Fig. 186. JOHN TWACHTMAN, *Flowering Branch*, c. 1885–1890, pencil, 15 x 10¾" (38.1 x 27.3 cm.), Yale University Art Gallery, New Haven, Connecticut, Anonymous Gift.

Fig. 187. WILLIAM MERRITT CHASE, *Self-Portrait*, c. 1884, pastel, 17¼ x 13½" (43.8 x 34.3 cm.), Collection of Mr. and Mrs. Raymond J. Horowitz, New York.

Fig. 188. THOMAS W. DEWING, *Woman*, c. 1890–1899, pastel, 14½ x 11¼" (36.8 x 28.6 cm.), Collection of Mr. and Mrs. Raymond J. Horowitz, New York.

Fig. 189. WILLIAM MERRITT CHASE, *Seated Woman*, c. 1880, brush and black wash, 16⅞ x 13⅝" (42.9 x 34.6 cm.), Cooper-Hewitt Museum of Decorative Arts and Design, Smithsonian Institution, New York.

Fig. 190. WILLIAM MERRITT CHASE, *At the Window*, c. 1890, pastel, 18½ x 11" (47.0 x 27.9 cm.), The Brooklyn Museum, Gift of Mrs. Henry Wolf Austin M. and Hamilton A. Wolf.

Fig. 191. WILLIAM MERRITT CHASE, *Luxembourg Gardens*, c. 1880–1890, pastel, 9⅝ x 13⅝" (24.4 x 34.6 cm.), National Collection of Fine Arts, Smithsonian Institution, Washington, D.C.,

Fig. 192. MARY CASSATT, *The Black Hat*, c. 1890, pastel, 24 x 18" (61.0 x 45.7 cm.), Collection of Mr. and Mrs. Paul Mellon, Washington, D.C. .

Fig. 193. FRANK DUVENECK, *Portrait of a Woman with Black Hat*, 1890, pastel, 19⅞ x 16½" (50.5 x 41.9 cm.), Cincinnati Art Museum, Gift of the Artist.

Fig. 194. ARTHUR I. KELLER, *Women at Tea*, c. 1890, watercolor, 17 ½ x 12" (44.5 x 30.5 cm.), Private Collection.

Fig. 195. WILLIAM STANLEY HASELTINE, *Vahrn in Tyrol near Brixen*, c. 1890, watercolor and gouache on blue paper, 14⅞ x 22" (37.8 x 55.9 cm.), The Metropolitan Museum of Art, New York, Gift of Mrs. Roger Plowden, 1967.

Fig. 196. THEODORE ROBINSON, *Decorative Head*, 1889, watercolor, 14 x 10" (35.6 x 25.4 cm.), The Brooklyn Museum, Dick S. Ramsay Fund.

Fig. 197. THOMAS ANSHUTZ, *Boys Playing with Crabs*, c. 1895, watercolor, 14 x 20" (35.6 x 50.8 cm.), Private Collection.

Fig. 198. JOHN LA FARGE, *Sunrise in the Fog Over Kyoto*, 1886, watercolor, 6½ x 11½" (16.5 x 29.2 cm.), The Currier Gallery of Art, Manchester, New Hampshire, Gift of Mr. Clement S. Houghton.

Fig. 199. JOHN LA FARGE, *Bowl of Wild Roses*, 1880, watercolor, 10¹⁵⁄₁₆ x 9¹⁄₁₆" (27.8 x 23.0 cm.), Museum of Fine Arts, Boston, Bequest of Elizabeth Howard Bartol.

Fig. 200. WINSLOW HOMER, *Beach Scene, Tynemouth*, 1881, watercolor and pencil, 11½ x 19½" (29.2 x 49.5 cm.), Sterling and Francine Clark Art Institute, Williamstown, Massachusetts.

Fig. 201. WINSLOW HOMER, *Deer Drinking*, 1892, watercolor, 13½ x 19½" (34.3 x 49.5 cm.), Private Collection.

Fig. 202. WINSLOW HOMER, *Stowing Sail, Bahamas*, 1903, watercolor, 13¾ x 21¾" (34.9 x 55.2 cm.), The Art Institute of Chicago, Mr. and Mrs. Martin A. Ryerson Collection.

Fig. 203. WINSLOW HOMER, *The Mink Pond*, 1891, watercolor, 13⅞ x 20" (35.2 x 50.8 cm.), Fogg Art Museum, Harvard University, Cambridge, Massachusetts, Grenville L. Winthrop Bequest.

Fig. 204. WINSLOW HOMER, *Two Men in a Canoe*, 1895, monochrome watercolor, 13³⁄₁₆ x 19⅜" (33.5 x 49.2 cm.), Private Collection.

Fig. 205. Childe Hassam, *The Island Garden*, 1892, watercolor, 17½ x 14″ (44.5 x 35.6 cm.), National Collection of Fine Arts, Smithsonian Institution, Washington, D.C. .

Fig. 206. Maurice Prendergast, *Picnic: Boston Garden*, c. 1895–1897, watercolor, 8¾ x 16⅝″ (22.2 x 42.2 cm.), Jointly owned by Margaret and Raymond Horowitz and Rita and Daniel Fraad, New York.

Fig. 207. Maurice Prendergast, *Venice*, 1899, watercolor, 19⅜ x 14¼″ (49.2 x 36.2 cm.), Collection of Mr. and Mrs. Jacob M. Kaplan, New York.

Fig. 208. Maurice Prendergast, *Central Park*, 1901, watercolor, 14⅛ x 20⅞″ (35.9 x 53.0 cm.), Collection of Mr. and Mrs. Jacob M. Kaplan, New York.

Fig. 209. John Singer Sargent, *The Escutcheon of Charles V of Spain*, 1912, watercolor, 11⅞ x 17¾″ (30.2 x 45.1 cm.), The Metropolitan Museum of Art, New York, Joseph Pulitzer Fund, 1915.

Fig. 210. John Singer Sargent, *Muddy Alligators*, 1917, watercolor, 13⅜ x 20¹⁵⁄₁₆″ (34.5 x 53.2 cm.), Worcester Art Museum, Worcester, Massachusetts.

Fig. 211. John Singer Sargent, *Gourds*, c. 1905–1908, watercolor, 13¹³⁄₁₆ x 19¹¹⁄₁₆″ (35.1 x 50.0 cm.), The Brooklyn Museum, Museum Purchase by Special Subscription.

Chapter 10: Illustration and Fantasy at the Turn of the Century

Fig. 212. Felix O. C. Darley, *Chilion Played and They Were Silent*, from *Margaret*, 1856, pen and ink, 7½ x 9⅛″ (19.1 x 23.2 cm.), Delaware Art Museum, Wilmington.

Fig. 213. Charles S. Reinhart, *Street Acrobats from "In Cornwall with an Umbrella"*, *Harper's Weekly*, Nov. 1881, pen and ink, 10⅛ x 6⅞″ (25.7 x 17.5 cm.), Library of Congress, Washington, D.C. .

Fig. 214. Edwin Austin Abbey, *King Lear (Lear, Kent, Fool, and Edgar)*, 1902, pen and ink, 22⅜ x 17½″ (56.8 x 44.5 cm.), Yale University Art Gallery, New Haven, Connecticut, Edwin Austin Abbey Memorial Collection.

Fig. 215. Joseph C. Coll, *King of the Khyber Rifles*, c. 1905, pen and ink, 13¼ x 8½″ (33.7 x 21.6 cm.), New Britain Museum of American Art, New Britain, Connecticut, Joseph Clement Collection.

Fig. 216. Elihu Vedder, *"In Memoriam,"* illustration to verse 100–101 in *Rubáiyát of Omar Khayyám, The Astronomer-Poet of Persia*, trans. by Edward Fitzgerald, Boston, 1884.

Fig. 217. Dennis Bunker, *Drawing for Sheet Music Cover*, 1889, pen and ink on bristol board, 14½ x 18½″ (36.8 x 47.0 cm.), University of Kansas Museum of Art, Lawrence, The Letha Churchill Walker Fund.

Fig. 218. Robert F. Blum, *Joe Jefferson as Bob Acres in "The Rivals,"* c. 1880, pencil, 9½ x 3⅝″ (24.1 x 9.2 cm.), Cincinnati Art Museum, Gift of Mrs. Henrietta Haller.

Fig. 219. A. B. Frost, *Ouch!*, c. 1890–1899, pencil, 9¹³⁄₁₆ x 7″ (24.9 x 17.8 cm.), Library of Congress, Washington, D.C.

Fig. 220. Thomas Nast, *Let Us PREY*, from *Harper's Weekly*, September 1871.

Fig. 221. Frederic Remington, *Comanche Scout*, 1890, pen and ink, 28½ x 17″ (72.4 x 43.2 cm.), The Thomas Gilcrease Institute of American History and Art, Tulsa, Oklahoma.

Fig. 222. Charles M. Russell, *On the Flathead*, 1904, watercolor, 11 x 16″ (29.9 x 40.6 cm.), The Thomas Gilcrease Institute of American History and Art, Tulsa, Oklahoma.

Fig. 223. Henry F. Farny, *In the Enemy's Country*, 1900, gouache, 10½ x 17½″ (26.7 x 44.5 cm.), Kennedy Galleries, New York.

Fig. 224. William R. Leigh, *The Buffalo Drive*, c. 1905–1915, charcoal on canvas, 19½ x 30½″ (49.5 x 77.5 cm.), Collection of Mr. and Mrs. Bernard Lederman, Brooklyn, N.Y.

Fig. 225. William R. Leigh, *Figure Studies*, c. 1905–1915, charcoal, 18½ x 24″ (47.0 x 61.0 cm.), The Thomas Gilcrease Institute of American History and Art, Tulsa, Oklahoma.

Fig. 226. J. Carroll Beckwith, *Portrait of a Young Woman*, c. 1900, colored chalks and pencil on gray paper, 10⅞ x 8⅛″ (27.6 x 21.6 cm.), The Metropolitan Museum of Art, New York, Gift of Janos Scholz, 1949.

Fig. 227. Albert P. Button, *On the Sands*, c. 1900–1910, watercolor, 7³⁄₁₆ x 8⅝″ (18.3 x 21.9 cm.), Museum of Fine Arts, Boston, Gift of Mrs. John G. Pierce, Sr. in memory of John G. Pierce.

Fig. 228. Walter Appleton Clark, *Daily Bread*, from *Scribner's Magazine*, 1898, washes, 20¼ x 11¹⁵⁄₁₆″ (51.4 x 30.3 cm.), Library of Congress, Washington, D.C.

Fig. 229. Howard Pyle, *The Fishing of Thor and Hymir*, 1901, pen and ink, 8⅛ x 4½″ (20.6 x 11.4 cm.), Delaware Art Museum, Wilmington.

Fig. 230 Maxfield Parrish, *Baa Baa Black Sheep*, 1897, pen and ink, 12¾ x 10⅜″ (32.4 x 26.4 cm.), Fogg Art Museum, Harvard University, Cambridge, Massachusetts, Gift of Charles Bain Hoyt.

Fig. 231. David Pell Secor, *A Refuge from the Storm, A Shadow from the Heat*, c. 1889, pen and ink, 14 x 11″ (35.6 x 27.9 cm.), The Metropolitan Museum of Art, New York, Gift of the Artist through A. R. Conkling, 1889.

Fig. 232. GEORGE H. HALLOWELL, *The Tree*, c. 1910–1920, watercolor, 26 x 18¾″ (63.0 x 47.6 cm.), Museum of Fine Arts, Boston, Bequest of Dudley Leavitt Pickman.

Fig. 233. WILL BRADLEY, *Pausias and Glycera*, 1895, pen and ink, 7⅞ x 5⅛″ (20.0 x 13.0 cm.), The Metropolitan Museum of Art, New York, Gift of Fern Bradley Dufner, The Will Bradley Collection, 1952.

Fig. 234. FRANKLIN BOOTH, Illustrations for *Battledore and Shuttlecock* by Amy Lowell, in *Scribner's Magazine*, August, 1916, pen and black ink, corrections in white gouache, 18⅞ x 14″ (47.9 x 35.6 cm.), Cooper-Hewitt Museum of Decorative Arts and Design, Smithsonian Institution, New York.

Fig. 235. HARRISON CADY, *Cartoon for the Burgess Series*, 1916, ink and washes, 14½ x 18″ (36.8 x 45.7 cm.), New Britain Museum of American Art, New Britain, Connecticut.

Fig. 236. GERALD H. THAYER, *Male Ruffed Grouse in the Forest*, c. 1905–1909, watercolor on cardboard, 19¾ x 20″ (50.2 x 50.8 cm.), The Metropolitan Museum of Art, New York, Purchase, Rogers Fund, 1916.

Fig. 237. JOHN HELD, JR., *Entertaining Royalty*, 1920–1930, ink and washes, 10 x 15¾″ (25.4 x 40.0 cm.), Library of Congress, Washington, D.C.

CHAPTER 11: TWENTIETH-CENTURY REALISM

Fig. 238. EVERETT SHINN, *The Docks, New York City*, 1901, pastel, 15½ x 22″ (39.4 x 55.9 cm.), Munson-Williams-Proctor Institute, Utica, New York.

Fig. 239. WILLIAM GLACKENS, *Seated Woman*, c. 1902, charcoal, 18⅝ x 14¾″ (47.3 x 37.5 cm.), Collection of Mr. and Mrs. Raymond J. Horowitz, New York.

Fig. 240. WILLIAM GLACKENS, *The Balcony*, 1899, sepia and black ink heightened with white wash, 9½ x 12″ (24.1 x 30.5 cm.), Collection of Arthur G. Altschul, New York.

Fig. 241. WILLIAM GLACKENS, *Curb Exchange No. 2*, c. 1907–1910, watercolor and black pencil, 24 x 17½″ (61.0 x 44.5 cm.), Collection of Arthur G. Altschul, New York.

Fig. 242. JOHN SLOAN, *His Country's Flag*, 1912, pencil, 21¾ x 17⅝″ (55.2 x 44.8 cm.), Yale University Art Gallery, New Haven, Connecticut, Gift of Dr. Charles E. Farr.

Fig. 243. JEROME MYERS, *Self Portrait*, c. 1915–1920, pastel on brown paper, 15⅜ x 12½″ (39.0 x 31.8 cm.), Collection of Arthur G. Altschul, New York.

Fig. 244. ARTHUR B. DAVIES, *Study of a Man Standing*, c. 1909, black and white chalk on gray paper, 14¼ x 11⅛″ (36.2 x 28.3 cm.), The Metropolitan Museum of Art, New York, Anonymous Gift, 1909.

Fig. 245. ROBERT HENRI, *Painter and His Model*, c. 1918, pastel, 12 x 19½″ (30.5 x 49.5 cm.), Collection of Rita and Daniel Fraad, New York.

Fig. 246. ROBERT HENRI, *Nude Kneeling*, c. 1900, brown tempera, 19³⁄₁₆ x 12¹⁄₁₆″ (48.7 x 30.6 cm.), The Metropolitan Museum of Art, New York, Gift of Walter C. Baker, 1967.

Fig. 247. GEORGE LUKS, *Man Asleep on Bench*, c. 1910–1915, pencil 7 x 5⅝″ (17.8 x 14.3 cm.), Munson-Williams-Proctor Institute, Utica, New York.

Fig. 248. GEORGE LUKS, *Woman and Turkey*, 1924, watercolor, 19⅞ x 13¾″ (50.5 x 34.9 cm.), Whitney Museum of American Art, New York.

Fig. 249. GEORGE LUKS, *My Garden, Berk Hills*, c. 1931, watercolor and tempera, 14 x 20″ (35.6 x 50.8 cm.), Childs Gallery, Boston.

Fig. 250. GEORGE BELLOWS, *Dance in a Madhouse*, 1907, black crayon, charcoal, pen and ink with touches of red crayon and Chinese white, 18⅞ x 24¹⁄₁₆″ (47.9 x 61.1 cm.), The Art Institute of Chicago, Charles H. and Mary F. S. Worcester Collection.

Fig. 251. GEORGE BELLOWS, *Lady Jean*, 1924, lithographic crayon, 22 x 13½″ (55.9 x 34.3 cm.), Fogg Art Museum, Harvard University, Cambridge, Massachusetts, Bequest of Meta and Paul J. Sachs.

Fig. 252. LILIAN WESTCOTT HALE, *Reverie: Portrait of Agnes Ruddy*, c. 1920, charcoal, 22½ x 20″ (57.2 x 50.8 cm.), Collection of Mr. and Mrs. Stuart P. Feld, New York.

Fig. 253. EDWIN DICKINSON, *Portrait of a Woman*, 1937, pencil with extensive stumping and erasure, 10⅝ x 12⅝″ (27.0 x 32.1 cm.), The Baltimore Museum of Art, Thomas E. Benesch Memorial Collection Fund.

Fig. 254. GRANT WOOD, *Dinner for Threshers (Section No. III)*, 1933, pencil on brown paper, 17¾ x 26¾″ (45.1 x 67.9 cm.), Whitney Museum of American Art, New York.

Fig. 255. REGINALD MARSH, *White Tower Hamburger*, 1945, pen and ink, 26¼ x 39¼″ (66.7 x 99.7 cm.), Whitney Museum of American Art, New York, Anonymous Gift.

Fig. 256. BOARDMAN ROBINSON, *Lear and the Fool on the Heath*, 1938, charcoal, tempera and touches of pen and ink, 17⅞ x 12″ (45.4 x 30.5 cm.), The Metropolitan Museum of Art, New York, Gift of 134 Artists, 1950.

Fig. 257. EUGENE HIGGINS, *Adrift*, c. 1940, watercolor, 15¼ x 20¾″ (38.7 x 52.7 cm.), The Metropolitan Museum of Art, New York, Gift of the New York Water Color Club, 1937.

Fig. 288. Edward Hopper, *Yawl Riding a Swell*, 1935, watercolor, 20¹⁄₁₆ x 28¼″ (51.0 x 71.8 cm.), Worcester Art Museum, Worcester, Massachusetts.

Fig. 289. EDWARD HOPPER, *House of the Fog Horn, No. 3*, 1929, watercolor 13¹⁵⁄₁₆ x 19¹⁵⁄₁₆″ (35.4 x 50.6 cm.), Yale University Art Gallery, New Haven, Connecticut, Gift of George Hopper Fitch.

Fig. 290. CHARLES BURCHFIELD, *Dandelions Seed Balls and Trees*, 1917, watercolor, 22¼ x 18¼″ (56.5 x 46.4 cm.), The Metropolitan Museum of Art, New York, A. H. Hearn Fund, 1940.

Fig. 291. CHARLES BURCHFIELD, *Lavender and Old Lace*, 1939–1947, watercolor, 37 x 50″ (94.0 x 127.0 cm.), New Britain Museum of Art, New Britain, Connecticut.

CHAPTER 13: DRAWINGS OF THE WAR YEARS: LINEAR EMOTION

Fig. 292. LYONEL FEININGER, *The River*, 1940, watercolor, 13 x 20″ (33.0 x 50.8 cm.), Worcester Art Museum, Worcester, Massachusetts.

Fig. 293. SALVADOR DALI, *Rhinoceros*, 1951, pen and ink, 33¾ x 23⅜″ (85.7 x 59.4 cm.) (sight), Private Collection.

Fig. 294. PETER BLUME, *Rock and Stump*, 1943, pencil, 18½ x 22½″ (47.0 x 57.2 cm.), Private Collection, Princeton, New Jersey.

Fig. 295. PAVEL TCHELITCHEW, *Portrait of Frederick Ashton*, 1938, silverpoint on white prepared paper, 20 x 12½″ (50.8 x 31.8 cm.), Fogg Art Museum, Harvard University, Cambridge, Massachusetts, Meta and Paul J. Sachs Collection.

Fig. 296. JOHN WILDE, *Wedding Portrait* (Male), 1943, pencil, 27¾ x 17¼″ (70.5 x 43.9 cm.), Whitney Museum of American Art, New York, Gift of the Artist in Memory of Helen Wilde.

Fig. 297. JOHN WILDE, *Wedding Portrait* (Female), 1943, pencil, 27¾ x 17¼″ (70.5 x 43.9 cm.), Whitney Museum of American Art, New York, Gift of the Artist in Memory of Helen Wilde.

Fig. 298. MORRIS GRAVES, *Bird in Spirit*, 1943, gouache, 24 x 30″ (61.0 x 76.2 cm.), The Metropolitan Museum of Art, New York, A. H. Hearn Fund, 1950.

Fig. 299. HYMAN BLOOM, *Nude Old Woman*, c. 1945, brown crayon, 9½ x 7⅞″ (24.1 x 20.0 cm.), Grunwald Center for the Graphic Arts, University of California, Los Angeles.

Fig. 300. RICO LEBRUN, *Running Woman with Child*, 1948, ink on gray paper, 18¾ x 25¾″ (47.6 x 65.4 cm.), University of Nebraska, Sheldon Memorial Art Gallery, Lincoln.

Fig. 301. BEN SHAHN, *"Sacco and Vanzetti,"* 1952, ink, 5¾ x 8⅝″ (14.6 x 21.9 cm.), Fogg Art Musuem Harvard University, Cambridge, Massachusetts.

Fig. 302. JACK LEVINE, *The Mourner*, 1952, pastel on pink paper, 23 x 18″ (58.4 x 45.7 cm.), Private Collection.

Fig. 303. ARSHILE GORKY, *Abstract Forms*, c. 1931–1932, pen and India ink, 22½ x 29″ (55.9 x 73.7 cm.), The Art Institute of Chicago, The Grant J. Pick Memorial Fund.

Fig. 304. ARSHILE GORKY, *Anatomical Blackboard*, 1943, ink and crayon, 20 x 27¼″ (50.8 x 69.2 cm.), Collection of Walter Bareiss, New York.

Fig. 305. ARSHILE GORKY, *Composition*, c. 1945–1946, pen and ink, 20 x 26¼″ (50.8 x 66.7 cm.), Collection of Mr. and Mrs. Stephen D. Paine, Boston.

Fig. 306. MARK TOBEY, *Universal Field*, 1949, tempera and pastel on cardboard, 28 x 44″ (71.1 x 111.80 cm.), Whitney Museum of American Art, New York.

Fig. 307. WILLIAM BAZIOTES, *Sea Forms*, 1951, pastel on paper on masonite, 38⅛ x 25⅛″ (96.8 x 63.8 cm.), Whitney Museum of American Art, New York.

Fig. 308. MARK ROTHKO, *Baptismal Scene*, 1945, watercolor, 19⅞ x 14″ (50.5 x 35.6 cm.), Whitney Museum of American Art, New York.

Fig. 309. ROBERT MOTHERWELL, *Mallarmé's Swan*, 1944, collage using gouache, crayon and paper on cardboard, 43½ x 35½″ (110.5 x 90.2 cm.), Contemporary Collection of The Cleveland Museum of Art.

Fig. 310. ROBERT MOTHERWELL, *Sky and Pelikan*, 1961, collage with brush and ink, 29 x 23″ (73.7 x 58.4 cm.), Yale University Art Gallery, New Haven, Connecticut, Gift of the Artist.

Fig. 311. JACKSON POLLOCK, *Untitled*, 1944, brush, spatter, pen and black and colored inks, 18⅞ x 24⅞″ (47.9 x 63.2 cm.), The Art Institute of Chicago, Ada Turnbull Hertle Fund.

Fig. 312. JACKSON POLLOCK, *Number 12*, 1949, oil on paper mounted on composition board, 31 x 22½″ (78.7 x 57.2 cm.), The Museum of Modern Art, New York, Gift of Edgar Kaufmann, Jr., .

Fig. 313. HANS HOFMANN, *Reclining Nude*, c. 1950, match and ink, 8½ x 11¹⁄₁₆″ (21.6 x 28.1 cm.), Addison Gallery of American Art, Phillips Academy, Andover, Massachusetts.

Fig. 314. FRANZ KLINE, *Untitled*, 1952, brush and ink, 8½ x 10⅞″ (21.6 x 27.6 cm.), Bowdoin College Museum of Art, Brunswick, Maine, Gift of Walter Gutman, 1964.

Fig. 315. SAM FRANCIS, *Middle Blue, No. 5*, 1960, watercolor. 26¾ x 40¼″ (67.9 x 102.2 cm.), University Art Museum, University of California, Berkeley, Gift of Julian J. and Joachim Jean Aberbach, New York.

Fig. 316. David Smith, *Untitled Number II*, 1961, India ink, egg yolk, and watercolor, 25½ x 39¾″ (64.8 x

101.0 cm.), Whitney Museum of American Art, New York, Gift of Candida Smith.

Fig. 317. PHILIP GUSTON, *Untitled*, 1953, ink, 16¾ x 22″ (42.5 x 55.9 cm.) (sight), Collection of Dore Ashton, New York.

Fig. 318. WILLEM DE KOONING, *Elaine de Kooning*, 1940–41, pencil, 12¼ x 11⅞″ (31.1 x 30.2 cm.), Allan Stone Gallery, New York.

Fig. 319. WILLEM DE KOONING, *Woman*, 1942, pencil, 7½ x 5″ (19.1 x 12.7 cm.), Allan Stone Gallery, New York.

Fig. 320. WILLEM DE KOONING, *Untitled*, 1949, black enamel on verso of Bruning graph paper, 27⅞ x 29⅞″ (70.8 x 75.9 cm.), Museum of Fine Arts, Boston, Sophie M. Friedman Fund.

Fig. 321. WILLEM DE KOONING, *Woman*, 1952, pencil and pastel, 21⅜ x 16″ (54.3 x 40.6 cm.), Collection of Mr. and Mrs. Stephen D. Paine, Boston.

Fig. 322. WILLEM DE KOONING, *Woman*, 1961, brush and ink, 23¹¹⁄₁₆ x 18¹¹⁄₁₆″ (60.1 x 47.4 cm.), The Hirshborn Museum and Sculpture Garden, Smithsonian Institution, Washington, D.C.

CHAPTER 14: DRAWING TODAY: MANY DIRECTIONS

Fig. 323. JASPER JOHNS, *Target with Faces*, 1958, pencil wash, 16¼ x 12½″ (41.3 x 31.8 cm.), Private Collection.

Fig. 324. JASPER JOHNS, *Flag*, 1958, pencil and graphite wash, 7½ x 10⅜″ (19.1 x 26.4 cm.), Collection of Mr. and Mrs. Leo Castelli, New York.

Fig. 325. JASPER JOHNS, *0 Through 9*, 1961, charcoal and pastel, 54 x 45″ (137.2 x 114.3 cm.), Collection of Robert C. Scull, Corona, New York.

Fig. 326. ROBERT RAUSCHENBERG, *The Mona Lisa*, 1960, mixed media and rubbing, 22¾ x 28¾″ (57.8 x 73.0 cm.), Collection of Robert C. Scull, Corona, New York.

Fig. 327. ROBERT RAUSCHENBERG, *Canto XXXI*, from the series *Dante: Inferno*, 1959–60, red and graphite pencil and gouache, 14½ x 11½″ (36.9 x 29.2 cm.), The Museum of Modern Art, New York, Anonymous Gift.

Fig. 328. LARRY RIVERS, *Frank's French Money*, 1962, crayon and pencil, 12¾ x 14¼″ (32.4 x 36.2 cm.), Private Collection.

Fig. 329. ROY LICHTENSTEIN, *Drawing for Cathedral Series*, 1969, ink wash, 28 x 42″ (71.1 x 106.7 cm.), Private Collection.

Fig. 330. LARRY RIVERS, *Self Portrait*, 1953, pencil and colored chalk, 28½ x 21″ (72.4 x 53.3 cm.), The Art Institute of Chicago, Gift of Mr. and Mrs. Edwin Bergman.

Fig. 331. ANDY WARHOL, *Mao*, 1973, pencil, 81¼ x 42¼″ (206.4 x 107.3 cm.), Private Collection.

Fig. 332. ROBERT INDIANA, *The American Eat*, 1962, frottage in conté crayon, 25 x 19″ (63.5 x 48.3 cm.), Collection of Richard Brown Baker, New York.

Fig. 333. JIM DINE, *Toothbrush and Tumbler Holder*, 1962, India ink, wash and aluminum screw, 29 x 23″ (73.7 x 58.4 cm.), Private Collection.

Fig. 334. JIM DINE, *Twenty Hearts*, 1970, watercolor, 44 x 34″ (111.8 x 86.4 cm.), Collection of Mr. and Mrs. Louis S. Myers, Akron, Ohio.

Fig. 335. CLAES OLDENBURG, *Study for the Image of the Buddha Preaching*, 1967, pencil, 30⅛ x 22⅛″ (76.5 x 56.2 cm.), The Museum of Modern Art, New York, Gift of Mr. and Mrs. Richard E. Oldenburg.

Fig. 336. CLAES OLDENBURG, *Proposed Colossal Monu-ment for the Battery, New York: Vacuum Cleaner (View from the Upper Bay)*, 1965, charcoal and wash, 23 x 29″ (58.4 x 73.7 cm.), Collection of Jonathan D. Scull, New York.

Fig. 337. WAYNE THIEBAUD, *Rabbit*, 1966, pastel, 15 x 20″ (38.1 x 50.8 cm.), Allan Stone Gallery, New York.

Fig. 338. SAUL STEINBERG, *Hero and Monster*, 1966, pen and ink, 19 x 25″ (48.3 x 63.5 cm.), Chermayeff & Geismar Associates, Inc., New York.

Fig. 339. LEONARD BASKIN, *Ugolino and Anselmo, Canto XXXIII*, 1968, ink, 26 x 20″ (63.0 x 50.8 cm.), Collection of Mr. and Mrs. John E. Marqusee, London.

Fig. 340. ANDREW WYETH, *The Apron*, 1967, pencil and watercolor, 22 x 28″ (55.9 x 71.1 cm.), Private Collection.

Fig. 341. ANDREW WYETH, *Garret Room*, 1962, watercolor and dry brush, 17½ x 22½″ (44.5 x 57.2 cm.), Private Collection.

Fig. 342. ANDREW WYETH, *Farm Wagons*, 1964, pencil, 19½ x 39⅜″ (49.5 x 100.0 cm.), Private Collection.

Fig. 343. ANDREW WYETH, *The Mill*, 1958, watercolor and dry brush, 12 x 22¼″ (30.5 x 56.5 cm.), Private Collection.

Fig. 344. LEO DEE, *Paper Landscape*, 1972, silverpoint, 35⅛ x 26″ (89.2 x 66.0 cm.), Yale University Art Gallery, New Haven, Connecticut, Purchased with the Aid of Funds from the National Endowment for the Arts and the Susan Morse Hilles Matching Fund.

Fig. 345. WALTER MURCH, *Study for "The Birthday,"* 1963, pencil, wash and crayon, 23 x 17½″ (58.4 x 44.5 cm.), Whitney Museum of American Art, New York, Neysa McMein Purchase Award.

Fig. 346. THEO WUJCIK, *Portrait of Ed Moses*, 1973, silverpoint, 21 x 26″ (53.5 x 66.0 cm.), Collection of Richard Brown Baker, New York.

Fig. 347. AL LESLIE, *Constance Pregnant Almost 4 Months*, 1970, charcoal and pencil, 30 x 40″ (76.2 x 101.6 cm.), Collection of Mr. Robert C. Scull, Corona, New York.

Fig. 348. RICHARD ESTES, *Woolworth's America*, 1974, gouache on board, 16 x 20″ (40.6 x 50.8 cm.), Private Collection, New Haven, Connecticut.

Fig. 349. CHUCK CLOSE, *Self Portrait*, 1968, pencil, 29⅛ x 23″ (74.0 x 58.4 cm.), Collection of Mr. and Mrs. Stephen D. Paine, Boston.

Fig. 350. VIJA CELMINS, *Ocean Image*, 1970, graphite and acrylic spray, 14¼ x 18⅞″ (36.2 x 47.9 cm.), The Museum of Modern Art, New York, Mrs. Florence M. Schoenborn Fund.

Fig. 351. LEE BONTECOU, *Untitled*, 1963, pencil, soot and muslin, 24 x 18″ (61.0 x 45.7 cm.), Collection of the Artist.

Fig. 352. EDWARD RUSCHA, *Wax*, 1967, gunpowder, 14½ x 23″ (36.8 x 58.4 cm.), The Museum of Modern Art, New York, Lester Avnet Fund.

Fig. 353. WILLIAM T. WILEY, *Victory Guardians*, 1973, watercolor, brush, felt tipped pen, indelible pencil, pen and ink, 22⅜ x 30″ (56.7 x 76.0 cm.), The Museum of Modern Art, New York, Grant from the National Endowment for the Arts and Allade, Inc..

Fig. 354. JOHN FAWCETT, *Felix and the Cats*, 1972, pen and ink and collage on board, 30 x 22″ (76.2 x 55.9 cm.), Yale University Art Gallery, New Haven, Connecticut, Purchased with the Aid of Funds from the National Endowment for the Arts and the Susan Morse Hilles Matching Fund.

Fig. 355. ELLSWORTH KELLY, *Avocado*, 1967, pencil, 29 x 23″ (73.7 x 58.40 cm.), Collection of the Artist, New York.

Fig. 356. RICHARD SERRA, *Untitled*, 1972, lithographic crayon, 37¾ x 49¾″ (95.9 x 126.4 cm.), Whitney Museum of American Art, New York, Gift of Susan Morse Hilles.

Fig. 357. CY TWOMBLY, *Before the Battle*, 1963, mixed media, 19¾ x 27½″ (50.2 x 69.9 cm.), Collection of Mr. Ivan Karp, New York.

Fig. 358. DOROTHEA ROCKBURNE, *Neighborhood*, 1973, vellum, colored and graphite pencil on white wall, 16′ long (487.7 cm.), Private Collection.

Fig. 359. CHRISTO, *Valley Curtain (Project for Rifle, Colorado)*, 1971, mixed media, 28 x 22″ (71.1 x 55.9 cm.), Collection of Mr. and Mrs. Stephen D. Paine, Boston.

Fig. 360. ROBERT SMITHSON, *Spiral Jetty*, 1970, earthwork, Great Salt Lake, Utah.

Photo Credits

Oliver Baker, New York: 259
E. Irving Blomstrann, New Britain, Ct: 236, 261, 291
Brenwasser, New York: 33, 45, 143, 223, 224, 339
Rudolph Burckhardt, New York: 323, 324, 326, 351, 357
Geoffrey Clements, Staten Island, N.Y: 73, 248, 254, 255, 283, 296, 297, 306, 307, 310, 317, 345, 355, 356
Bill Finney, N.H: 199
Gianfranco Gorgoni, New York: 360
Helga Photo Studio, Montclair, N.J: 252
Scott Hyde, New York: 96, 97, 98, 99, 130, 174, 187, 234
Bruce C. Jones, New York: 331
Malcolm Lublimer, Los Angeles: 330
Mathews: 335, 350
Richard Merrill, Saugus, Mass: 20, 70
Morris, Paris: 7
Motts Photographic Center, Columbus, Ohio: 268
Otto E. Nelson, New York: 207, 208, 328

Eric Pollitzer, New York: 318, 325, 336, 338, 347
Walter Rosenblum, Long Island City, N.Y: 240
Nathan Rubin, New York: 358
Edward Saxe Studio, Hartford, Ct: 215
John D. Schiff, New York: 206
Walter Scott, Stockbridge, Mass: 272
Soichi Sunami: 312
Joseph Szaszfai, Branford, Ct: 10, 21, 22, 24, 25, 27, 40, 54, 81, 83, 84, 85, 86, 87, 88, 95, 101, 116, 121, 129, 135, 136, 154, 167, 170, 173, 188, 194, 197, 214, 216, 242, 258, 260, 273, 275, 309, 319, 333, 344, 346, 354
Taylor and Dull, New York: 241
Herbert P. Vose, Wellesley, Mass: 104, 132, 293, 305, 349, 359
A. J. Wyatt: 13

*All other photographs courtesy of the owners.

Bibliography

A. GENERAL BIBLIOGRAPHY

1. REFERENCE

American Art Annual, vols. 1–37, Washington, D.C., 1898–1948 (after 1948, *American Art Directory,* New York).

American Association of Architectural Bibliographers, *Index of American Architectural Drawings Before 1900,* compiled by James H. Grady, Frederick D. Nichols and William B. O'Neal, Charlottesville, Va., 1957.

Benjamin, Samuel G.W., *Art in America: A Critical and Historical Sketch,* New York, 1880.

Brown, Milton, *American Painting from the Armory Show to the Depression,* Princeton, 1955.

Clement, Clara, and Laurence Hutton, *Artists of the Nineteenth Century and Their Works,* Boston, 1879 and 1884; reprint ed., St. Louis, 1969.

Constable, William George, *Art Collecting in the United States of America: The Outline of a History,* London and New York, [1964].

Cowdrey, Mary Bartlett, *American Academy of Fine Arts and American Art Union,* 2 vols., New York, 1953.

Craig, James H., *The Arts and Crafts in North Carolina, 1699–1840,* Winston-Salem, N.C., 1965.

Cummings, Thomas S., *Historic Annals of the National Academy of Design,* Philadelphia, 1865; reprint ed., New York, 1971.

De Tolnay, Charles, *History and Technique of Old Master Drawings: A Handbook,* New York, 1943; reprint ed., New York, 1972.

Dolloff, Francis W., and Roy L. Perkinson, *How to Care for Works of Art on Paper,* Boston, 1971.

Dow, George Francis, *The Arts and Crafts in New England, 1704–1775,* Topsfield, Mass., 1927; reprint ed., New York, 1967.

Drawing Society, *Approaches to Drawing: A Collector, Philip Hofer; A Curator, Jacob Bean; An Artist, Gabor Peterdi; Three Lectures Presented at the Metropolitan Museum of Art, 1961–62,* New York, 1963.

Drepperd, Carl W., *American Drawing Books,* New York, 1946 (reprint from the *New York Public Library Bulletin* 49, no. 11, November, 1945, pp. 795–812).

Dunlap, William, *A History of the Rise and Progress of the Arts of Design in the United States,* 3 vols., New York, 1834; reprint ed., New York, 1969.

Encyclopedia; or a Dictionary of Arts, Sciences, and Miscellaneous Literature, 18 vols., Philadelphia, 1798.

Fielding, Mantle, *Dictionary of American Painters, Sculptors and Engravers,* New York, 1965.

Frankenstein, Alfred, *After the Hunt: William Harnett and Other American Still-Life Painters, 1870–1900,* rev. ed., Berkeley, 1969.

Gerdts, William, *The Great American Nude,* New York, 1974.

———, and Russell Baker, *American Still-Life Painting,* New York, 1971.

Gettens, Rutherford J., and George L. Stout, *Painting Materials: A Short Encyclopedia,* New York and London, 1942.

Gottesman, Rita Suswein, *The Arts and Crafts of New York, 1726–1776,* New York, 1937.

———, *The Arts and Crafts of New York, 1777–1799,* New York, 1954.

———, *The Arts and Crafts of New York, 1800–1804,* New York, 1965.

Graves, Algernon, *A Dictionary of Artists Who Have Exhibited Works in the Principal London Exhibitions from 1760–1893*, London, 1901.

———, *A Century of Loan Exhibitions, 1813–1912*, 5 vols., London, 1913; New York, n.d.

Groce, George C., and David H. Wallace, *The New-York Historical Society's Dictionary of Artists in America, 1564–1860*, New Haven, 1957.

Hardie, Martin, *Water-Colour Painting in Britain*, 3 vols., London, 1968.

Hartmann, Sadakichi, *A History of American Art*, 2 vols., Boston, 1902.

Hunter, Dard, *Papermaking in Pioneer America*, Philadelphia, 1952.

Hunter, Sam, *American Art of the Twentieth Century*, New York, 1972.

Isham, Samuel, and Royal Cortissoz, *The History of American Painting*, New York, 1943.

Lancour, Harold, *American Art Auction Catalogues, 1785–1942: A Union List*, New York, 1944.

Lucas, S.T., "A Bibliography of Water Color Painting and Painters," thesis submitted for Fellowship of Library Association, England, 1965.

McCoy, Garnett, *Archives of American Art: A Directory of Resources*, New York, 1972.

McKay, George L., *American Book Auction Catalogues, 1713–1934: A Union List*, New York, 1937.

Meisel, Max, *A Bibliography of American Natural History*, 3 vols., Brooklyn, 1924–1929.

National Academy of Design Exhibition Record, 1826–1860, 2 vols., New York, 1943.

National Academy of Design Exhibition Record, 1861–1900, ed. by Maria Naylon, 2 vols., New York, 1973.

Novak, Barbara, *American Painting of the Nineteenth Century*, New York, 1969.

O'Neal, William B., *Jefferson's Fine Arts Library*, Charlottesville, Va., 1956.

Plenderleith, Harold James, *The Conservation of Prints, Drawings and Manuscripts*, Oxford, 1937.

Pope, Arthur, *The Language of Drawing and Painting*, Cambridge, Mass., 1929.

Prime, Alfred Coxe, *The Arts and Crafts in Philadelphia, Maryland, and South Carolina. Vol. I: 1721–1785; Vol. II, 1786–1800*, Topsfield, Mass., 1929 and 1932; reprint ed., New York, 1969.

Reynolds, Graham, *A Concise History of Watercolor*, New York, 1971.

Richardson, Edgar P., *Painting in America*, New York, 1956 and 1965.

Rose, Barbara, *American Art Since 1900*, New York, 1967.

Rosenberg, Jakob, *Great Draughtsmen from Pisanello to Picasso*, Cambridge, Mass, 1959.

Ruskin, John, *The Elements of Drawing*, London, 1857; reprint ed., intro. by Lawrence Campbell, New York, 1971.

Sandler, Irving, *The Triumph of American Painting*, New York, 1970.

Simoni, John Peter, "Art Critics and Criticism in Nineteenth Century America," Ph.D. dissertation, Ohio State University, 1952.

Stokes, Isaac Newton, *Iconography of Manhattan Island, 1498–1909*, New York, 1915–1928.

Strictly Academic: Life Drawing in the Nineteenth Century, exhibition catalogue, University Art Gallery, State University of New York, Binghamton, 1974.

Tuckerman, Henry T., *Book of the Artists: American Artist Life*, New York, 1867; reprint ed., New York, 1966.

Watrous, James, *The Craft of Old-Master Drawings*, Madison, Wisc., 1957.

Welker, Robert Henry, *Birds and Men: American Birds in Science, Art, and Literature, 1800–1900*, Cambridge, Mass., 1955.

2. AMERICAN DRAWINGS

American Drawings, exhibition catalogue, Solomon R. Guggenheim Museum, New York, 1964.

American Drawings (mostly lent by John Davis Hatch, Jr.), exhibition catalogue, Mills College Art Gallery, Oakland, Calif., 1942.

American Drawings of the Sixties: A Selection, exhibition catalogue, New School for Social Research Art Center, New York, 1970.

American Drawings, Pastels and Watercolors, Part I: Works of the Eighteenth and Early Nineteenth Centuries, exhibition catalogue, Kennedy Galleries, New York, 1967.

American Drawings, Pastels and Watercolors. Part II: Works of the Nineteenth Century, 1825–1890, exhibition catalogue, Kennedy Galleries, New York, 1968.

American Landscape Drawings from the Collection of John Davis Hatch, exhibition catalogue, Berkshire Museum, Pittsfield, Mass., 1966.

Ashton, Dore, "Contemporary American Drawing," *Arts* 39, no. 7 (April 1965), pp. 26–31.

Baur, John I.H., "Portfolio of American Drawings," *Art in America* 49, no. 4 (Fall, 1961), pp. 64–73.

Bolton, Theodore, *Early American Portrait Draughtsmen in Crayons*, New York, 1923; reprint ed., New York, 1970.

Callow, James T., *Kindred Spirits: Knickerbocker Writers and American Artists, 1807–1855*, Chapel Hill, N.C., 1967.

Catalogue of the Collier Collection of Original Drawings and Paintings by Distinguished American Painters and Illustrators, exhibition catalogue, Art Association of Indianapolis, John Herron Art Institute, Indianapolis, Ind., 1907.

Catalogue of the Loan Exhibition of Brooklyn Art Treasures and Original Drawings by American Artists,

exhibition catalogue, Brooklyn Institute of Arts and Sciences, Brooklyn, N.Y., 1924.

The Civil War: A Centennial Exhibition of Eyewitness Drawings, exhibition catalogue, essay by William P. Campbell, National Gallery of Art, Washington, D.C., 1961.

A Decade of American Drawings, 1955–65, exhibition catalogue, Whitney Museum of American Art, New York, 1965.

Dessins américaines du XVIIIᵉ siècle à nos jours, exhibition catalogue, Musée des Beaux Arts, Rouen, [1960?].

The Drawing Society National Exhibition, 1965, exhibition catalogue, October House, New York, 1965.

The Drawing Society National Exhibition, 1970, exhibition catalogue, American Federation of Arts, 1970.

Drawings, exhibition catalogue, Lyman Allyn Museum, New London, Conn., 1936.

Drawings by American Artists, from the Collection of John Davis Hatch, Jr., exhibition handlist, University Art Gallery, University of Pittsburgh, Pittsburgh, Pa., 1938.

Drawn from Nature/ Drawn from Life: Studies and Sketches by Frederic Church, Winslow Homer and Daniel Huntington from the Collection of the Cooper-Hewitt Museum of Decorative Arts and Design, Smithsonian Institution, exhibition catalogue, Ithaca College Museum of Art, Ithaca, N.Y., 1971.

Drepperd, Carl W., *Early American Prints*, New York, 1930.

The Düsseldorf Academy and the Americans: An Exhibition of Drawings and Watercolors, exhibition catalogue, The High Museum of Art, Atlanta, Ga., 1972.

Early Prints and Drawings of California, from the Robert B. Honeyman, Jr., Collection, exhibition catalogue, Los Angeles County Museum, Los Angeles, 1954.

Exhibition of Drawings by American Artists Past and Present from the Collection of John Davis Hatch, Jr., exhibition catalogue, Phillips Memorial Gallery, Washington, D.C., 1937.

Fink, Louis Marie, and Joshua C. Taylor, *Academy: The Academic Tradition in American Art*, exhibition catalogue, National Collection of Fine Arts, Smithsonian Institution, Washington, D.C., 1975.

French in America, 1520–1880, exhibition catalogue, Detroit Institute of Arts, Detroit, 1951.

Goetzmann, William H., *Army Exploration of the American West*, New Haven, 1959.

Hatch, John Davis, Jr., "Graphic Techniques Used by Our Early American Artists: An Exploratory Study," in *American Drawing Annual VIII*, exhibition catalogue, Albany Institute of History and Art, Albany, N.Y., 1948.

————, "Question of American Draughtsmanship,"

American Collector 11, no. 1 (February 1942), pp. 6–7+.

Hayes, Bartlett H., *American Drawings*, New York, 1965.

————, *The American Line, One Hundred Years of Drawing*, exhibition catalogue, Addison Gallery of American Art, Phillips Academy, Andover, Mass., 1959 and 1961.

Johnson, Una E., *Golden Years of American Drawings, 1905–1956*, exhibition catalogue, The Brooklyn Museum, Brooklyn, N.Y., 1957.

————, *Twentieth Century Drawings. Part I: 1900–1940; Part II: 1940 to the Present*, New York, 1964.

Kent, Norman, ed., *Drawings by American Artists*, New York, 1947.

Krauss, Rosalind, *Line as Language: Six Artists Draw*, exhibition catalogue, Art Museum, Princeton University, Princeton, N.J., 1974.

Marzio, Peter, "The Art Crusade: A Study of American Drawing Books and Lithographs, 1830–1860," Ph.D. dissertation, University of Chicago, 1969.

Miller, Jo, *Drawings of the Hudson River School, 1825–1875*, exhibition catalogue, The Brooklyn Museum, Brooklyn, N.Y., 1969.

————, "Drawings of the Hudson River School: The First Generation. Part I," *Connoisseur* 175, no. 702 (August 1970), pp. 303–9.

————, "Drawings of the Hudson River School: The Second Generation. Part II," *Connoisseur* 175, no. 703 (September 1970), pp. 47–55.

National Parks and the American Landscape, exhibition catalogue, essay by William A. Truettner and Robin Bolton-Smith, National Collection of Fine Arts, Smithsonian Institution, Washington, D.C., 1972.

One Hundred Contemporary American Drawings, exhibition catalogue, intro. by Dore Ashton, University of Michigan Museum of Art, Ann Arbor, Mich., 1965.

One Hundred and Fifty Years of American Drawing, 1780–1930, from the Collection of John Davis Hatch, Jr., exhibition catalogue, Lawrence Art Museum, Williams College, Williamstown, Mass., 1965.

Paul Magriel Collection: One Hundred Years of American Drawing, exhibition catalogue, University of Texas Art Museum, Austin, Tex., 1964.

Pennell, Joseph, *Pen Drawing and Pen Draughtsmen*, London and New York, 1889; New York, 1921.

Pilgrim, Dianne H., *American Impressionist and Realist Paintings and Drawings from the Collection of Mr. and Mrs. Raymond J. Horowitz*, exhibition catalogue, Metropolitan Museum of Art, New York, 1973.

Plagens, Peter, "The Possibilities of Drawing," *Artforum* 8, no. 2 (October 1969), pp. 50–55.

Recent American Drawings, exhibition catalogue, Rose Art Museum, Brandeis University, Waltham, Mass., 1964.

Richardson, Edgar P., "What is the American Line? U.S. Draftsmen from the Early Colonies to the Sec-

ond World War," *Art News* 47, no. 3 (May 1948), pp. 16–19+.

Rose, Bernice, *Drawing Now*, exhibition catalogue, Museum of Modern Art, New York, 1976.

Rossiter, Henry P., "Academic Drawings in the M. & M. Karolik Collection," *Antiques* 82, no. 4 (October 1962), p. 295.

Slatkin, Charles E., and Regina Shoolman, *Treasury of American Drawings*, New York, 1947.

Smith, F. Hopkinson, *Outdoor Sketching, Scammon Lectures given at the Art Institute of Chicago, 1914*, New York, 1915.

Solomon, Elke M., *American Drawings, 1963–1973*, exhibition catalogue, Whitney Museum of American Art, New York, 1973.

————, *Recent Drawings*, exhibition catalogue, American Federation of Arts, 1975.

Steinberg, Leo, "Month in Review," *Arts* 30, no. 8 (May 1956), pp. 46–48.

Sullivan, Margaret, "The Trend Toward American Drawings," *Prints* 7, no. 4 (April 1937), p. 204.

Taft, Robert, *Artists and Illustrators of the Old West, 1850–1900*, New York, 1953.

Three-Dimension into Two-Dimension: Drawing for Sculptor, exhibition catalogue, New York Cultural Center, New York, 1973.

Williams, Herman W., Jr., *The Civil War: The Artist's Record*, exhibition catalogue, Corcoran Gallery of Art, Washington, D.C., and Museum of Fine Arts, Boston, 1961–2.

3. AMERICAN WATERCOLORS

American Watercolors, 1850–1972, exhibition catalogue, Birmingham Museum of Art, Ala., and Mobile Art Gallery, Mobile, Ala., 1972.

American Watercolors, Drawings and Prints, 1952: A National Competitive Exhibition, exhibition catalogue, Metropolitan Museum of Art, New York, 1952.

Amerikanische Meister des Aquarells, exhibition catalogue, The Albertina, Vienna, 1949.

L'Aquarelle contemporaine aux Etats-Unis, exhibition catalogue, Musée des Beaux-Arts, Besançon, 1955.

Art in New England, A Contemporary Watercolor Exhibition, exhibition catalogue, Addison Gallery of American Art, Phillips Academy, Andover, Mass., 1939.

Art Triumphs in Watercolor, 2 vols., Boston, 1891 and 1893.

Breuning, Margaret, "Contemporary Water-color Painters," *International Studio* 83, no. 345 (January 1926), pp. 21–26.

Carson, Marian Sadtler, "Early American Water-color Painting," *Antiques* 59, no. 1 (January 1951), pp. 54–56.

Catalogue of a Collection of Water-Color Drawings, Loaned to the Pennsylvania Academy of the Fine Arts, exhibition catalogue, Pennsylvania Academy of the Fine Arts, Philadelphia, [1877?].

Catalogue of an Exhibition of Water Colors by American Artists, exhibition catalogue, Fine Arts Academy—Albright Art Gallery, Buffalo, N.Y., 1921.

Condit, Charles, *Painting and Painters' Materials*, New York, 1893.

Curry, Larry, *Eight American Masters of Watercolor*, exhibition catalogue, Los Angeles County Museum of Arts; published New York, 1968.

Ennis, George Pearse, "American Water-color Painting of Today," *London Studio* 5, no. 3 (March 1933), pp. 160–69.

An Exhibition of Water-Colors by American Artists, exhibition catalogue, Newark Museum, Newark, N.J., 1912.

Fabri, Ralph, *History of the American Water Color Society: The First Hundred Years*, New York, 1969.

Gallatin, Albert Eugene, *American Water-Colourists*, New York, 1922.

Gardner, Albert Ten Eyck, *A History of Water Color Painting in America*, New York, 1966.

Gervasè, Frank, "A History of the American Water Color Society, 1866–1950," unpublished manuscript, collection of Archives of American Art, Washington, D.C.

Goodrich Lloyd, *American Watercolor and Winslow Homer*, Minneapolis, 1945.

A Historical Collection of Pictures in Watercolor by American Artists, assembled by Gustav H. Buech, Esq., of Brooklyn, exhibition catalogue, The Art Institute, Chicago, n.d.

A History of American Watercolor Painting, exhibition catalogue, intro. by Alan Burroughs, Whitney Museum of American Art, New York, 1942.

Hitchcock, Ripley, *Some American Painters in Watercolors*, New York, 1890.

Johnson, C. Stuart, "Watercolor Painting in America," *Munsey's Magazine* 8, no. 6 (March 1893), pp. 637–44.

Lee, Sherman E., "A Critical Survey of American Watercolor Painting," Ph.D. dissertation, Western Reserve University, 1941.

O'Hara, Eliot, *Watercolor at Large: Nineteen Chapters on the Renaissance of Watercolor with Thirty Illustrations, Two in Full Color*, New York, 1946.

————, *Watercolor Faces Forth*, New York, 1938.

————, and Shirley Putnam O'Hara, "Watercolor Painting in the United States," *The Old Water-Colour Society's Club 27th Annual Volume*, London, 1949.

Richardson, Edgar P., "Watercolor, the American Medium?," *Art News* 44, no. 5 (April 15, 1945), pp. 20–2+.

Scholl, Phoebe K., "A Study of the Styles and Techniques of Some Outstanding Recent American Watercolor Painters," Ph.D. dissertation, Columbia University, 1970.

Seligmann, Herbert J., "Some American Water Color-ists," *Nation* 113, no. 2944 (December 7, 1921), pp. 686–88.

"Significant American Watercolor Work," *Craftsman* 16, no. 5 (August 1909), pp. 510–20.

A Special Loan Exhibition of Contemporary American Water Colors, exhibition catalogue, Metropolitan Museum of Art, 1941.

Ten American Masters of Watercolor, exhibition catalogue, Andrew Crispo Gallery, New York, 1974.

Three American Masters of Water Color: Marin, Demuth, Pascin; A Loan Exhibition from the Ferdinand Howald Collection of the Columbus Gallery of Fine Arts, exhibition catalogue, Cincinnati Art Museum, Cincinnati, O., 1969.

Twentieth Century American Watercolors, exhibition catalogue, Bowdoin College of Art, Brunswick, Me., 1973.

Two Hundred Years of Watercolor Painting in America, An Exhibition Commemorating the Centennial of the American Water Color Society, exhibition catalogue, Metropolitan Museum of Art, New York, 1966–67.

Tyrell, Henry, "American Aquarellists, Homer to Marin," *International Studio* 74, no. 294 (September 1921), pp. xxvii–xxxvi.

Watercolor, U.S.A.: A Survey of Watercolor, U.S.A., from 1870 to 1946, exhibition catalogue, Walker Art Center, Minneapolis, Minn., 1946.

Whitaker, Frederic, "Watercolor, the American Medium," *American Artist* 26, no. 6 (June 1962), pp. 64–75+

Wolfe, John, *Oil Paintings and Water Color Drawings*, auction catalogue, Henry H. Leeds and Co., New York, December 22, 1863.

4. FOLK AND COUNTRY ART

American Primitive Watercolors, exhibition catalogue, intro. by Mary C. Black, Smithsonian Institution Traveling Exhibition Service, in cooperation with the Abby Aldrich Rockefeller Folk Art Collection, 1964–1965.

Andrews, Edward Deming, "Shaker Inspirational Drawings," *Antiques* 48, no. 6 (December 1945), pp. 338–41.

———, and Faith Andrews, *Visions of the Heavenly Sphere: A Study in Shaker Religious Art*, Charlottesville, Va., 1969.

Black, Mary C., "American Primitive Painting," *Art in America* 51, no. 4 (August 1963), pp. 64–82.

———, and Jean Lipman, *American Folk Painting*, New York, 1966.

Borneman, Henry S., *Pennsylvania German Illuminated Manuscripts: A Classification of Fraktur-Schriften and an Inquiry into their History and Art*, Norristown, Pa., 1957; New York, 1973.

"Calligraphy: Why Not Learn to Write?," exhibition

catalogue, American Museum of Folk Art, New York, 1975.

Lichten, Frances, *Fraktur: The Illuminated Manuscripts of the Pennsylvania Dutch*, Philadelphia, 1958.

Lipman, Jean, and Alice Winchester, *The Flowering of American Folk Art, 1776–1876*, exhibition catalogue, Whitney Museum of American Art, New York, 1974.

Little, Nina Fletcher, *The Abby Aldrich Rockefeller Folk Art Collection*, Boston, 1957.

M. & M. Karolik Collection of American Water Colors and Drawings, 1800–1875, vol. II, Boston, Museum of Fine Arts, 1962.

Nineteenth-Century Folk-Painting: Our Spirited National Heritage, Works of Art from the Collection of Mr. and Mrs. Peter Tillou, exhibition catalogue, The William Benton Museum of Art, University of Connecticut, Storrs, 1973.

One Hundred and One American Primitive Water Colors and Pastels from the Collection of Edgar William and Bernice Chrysler Garbisch, exhibition catalogue, intro. by William P. Campbell, National Gallery of Art, Washington, D.C., 1966.

Pennsylvania German Fraktur and Color Drawings, exhibition catalogue, Pennsylvania Farm Museum of Landis Valley, Lancaster, Pa. 1969.

Savage, Gail, and Norbert H. Savage and Esther Sparks, *Three New England Watercolor Painters*, exhibition catalogue, The Art Institute of Chicago, 1974.

Shelley, Donald A., *The Fraktur-Writing or Illuminated Manuscripts of the Pennsylvania Germans (Pennsylvania German Folklore Society Publications 23)*, Allentown, Pa., 1961.

Weiser, Frederick S., *Fraktur, Pennsylvania German Folk Art*, Ephrata, Pa., 1973.

———, "Piety and Protocol in Folk Art: Pennsylvania German Fraktur Birth and Baptismal Certificates," in Ian M.G., Quimby, ed., *Winterthur Portfolio* 8, Charlottesville, Va., 1973.

5. ILLUSTRATION

Armstrong, Regina, "Representative American Women Illustrators," *Critic* 36, no. 5 (May 1900), p. 417–30; no. 6 (June 1900), pp. 520–29; 37, no. 1 (July 1900), pp. 43–54; no. 2 (August 1900), pp. 131–41.

Bolton, Theodore, *American Book Illustrators*, New York, 1938.

A Century of American Illustration, exhibition catalogue, Brooklyn Institute of Arts and Sciences, Brooklyn, N.Y., 1972.

Coffin, William A., "American Illustration of Today," *Scribner's Magazine* 11, no. 1 (January 1892), pp. 106–117; no. 2 (February 1892), pp. 196–205; no. 3 (March 1892), pp. 333–49.

The Golden Age of American Illustration, 1880–1914, exhibition catalogue, Delaware Art Museum, Wilmington, Del. 1972

Green Samuel M., "An Introduction to the History of American Illustration from its Beginnings in the Late Seventeenth Century to 1850," Ph.D. dissertation, Harvard University, 1938–39.

Hamilton, Sinclair, "Early American Book Illustrations and Wood Engravings, 1670–1870. A Catalogue of a Collection of American Books Illustrated for the Most Part with Woodcuts and Wood Engravings," unpublished manuscript. Princeton University, [1958?].

Hoeber, Arthur, "A Century of American Illustration," *Bookman* 8 (November 1898–February 1899), pp. 213–19; 316–24; 429–39; 506; 540–48.

Murrell, William, *A History of American Graphic Humor. Vol. I: 1747–1865,* New York, 1933.

———, *A History of American Graphic Humor. Vol. II: 1865–1938,* New York, 1938.

Nevins, Allan, and Frank Weitenkampf, *A Century of Political Cartoons: Caricature in the United States from 1800 to 1900,* New York, 1944.

Pennell, Joseph, *The Illustration of Books, A Manual for the Use of Students,* New York, 1895.

Pitz, Henry C., *The Brandywine Tradition,* Boston, 1969.

———, *A Treasury of American Book Illustration,* New York, 1947.

Reed, Walt, ed., *The Illustrator in America, 1900–1960s,* New York, 1966.

Slythe, R. Margaret, *The Art of Illustration,* London, 1970.

Sullivan, Edmund J., *The Art of Illustration, 1750–1900,* New York, 1921.

Weitenkampf, Frank, *American Graphic Art,* New York, 1912.

———, "Nineteenth Century History in Illustrated Weeklies," *Art in America* 45, no. 4 (Winter, 1957–58), pp. 28–31.

———, "Political Caricature in the United States in Separately Published Cartoons: An Annotated List," *New York Public Library Bulletin* 56, no. 3 (March 1952), pp. 107–38; no. 4 (April 1952), pp. 187–96; no. 5 (May 1952), pp. 218–53; no. 6 (June 1952), pp. 285–99; no. 7 (July 1952), pp. 359–70; no. 9 (September 1952), pp. 473–76; no. 10 (October 1952), pp. 510–28; no. 11 (November 1952), pp. 557–79; no. 12 (December 1952), pp. 620–34.

Wheeler, Monroe, ed., *Modern Painters and Sculptors as Illustrators,* New York, 1936.

6. PASTELS

Fisher, S. Melton, "The Art of Painting in Pastel," *Magazine of Art* 27, no. 1 (January 1903), pp. 145–48; no. 4 (April 1903), pp. 294–95.

Harrison, Birge, "The Case of Pastel," *Art and Progress* 6 (1915), pp. 154–57.

Hinson, Mary Alice, "The American Pastel Revival: Fashion and Style," unpublished paper, Yale University.

Pilgrim, Dianne H., "The Revival of Pastels in Nineteenth-Century America," unpublished article.

Schmiegel, Karol A., "Pastel Portraits in the Winterthur Museum," *Antiques* 107, no. 2 (February 1975), pp. 323–31.

Studies and Finished Work in Pastel, Water Color, and Tempera, exhibition catalogue, City Art Museum, St. Louis, Mo., 1897.

Warren, William Lamson, "Connecticut Pastels, 1775–1820." *Bulletin of the Connecticut Historical Society* 24, no. 4 (October 1959), pp. 97–128.

7. CATALOGUES OF PUBLIC COLLECTIONS

Boston. Museum of Fine Arts, *Catalogue of Paintings and Drawings in Water Color,* Boston, 1949.

Boston. Museum of Fine Arts, *M. & M. Karolik Collection of American Water Colors and Drawings, 1800–1875,* 2 vols., intro. by Henry P. Rossiter, Boston, 1962.

Brooklyn. Brooklyn Museum, Tschudy, Herbert B., *Catalogue of the Water Color Paintings, Pastels and Drawings in the Brooklyn Museum,* Brooklyn, 1932.

Brunswick, Me. Bowdoin College Museum of Art, *Catalogue of the Bowdoin College Art Collections. Part I: The Bowdoin Drawings,* Brunswick, Me., 1885.

Buffalo. Albright-Knox Art Gallery, *Drawings and Watercolors from the Albright-Knox Art Gallery,* Buffalo, N.Y. 1967.

Cambridge, Mass. Fogg Art Museum, Harvard University, *American Art at Harvard,* Cambridge, Mass., 1972.

Chicago. The Art Institute of Chicago, *Drawings, Old and New,* compiled by Carl O. Schniewind, Chicago, 1946.

Detroit. Detroit Institute of Arts, *Paintings in the Detroit Institute of Arts, A Checklist,* Detroit, 1967.

Lawrence, Ka. University of Kansas Museum of Art, *American Drawings and Watercolors from the Collection of the University of Kansas Museum of Art,* Lawrence, Ka., 1973.

Minneapolis, Minn. Walker Art Center, *John T. Baxter Memorial Collection of American Drawings,* Minneapolis, Minn., 1949.

New London, Conn. Lyman Allyn Museum, *Complete List of American and European Drawings, Paintings and Watercolors in the Collection of the Lyman Allyn Museum,* New London, Conn., 1966.

New York. Metropolitan Museum of Art, *Tapestries, Water-color Paintings, Drawings, Etchings, etc.,* New York, 1892.

Philadelphia. The Historical Society of Pennsylvania, *Paintings and Miniatures at the Historical Society of Pennsylvania*, rev. ed., compiled by Nicholas B. Wainwright, Philadelphia, 1974.

Philadelphia. Penrose, Boies, *Prints and Drawings in the Collection of the Historical Society of Pennsylvania*, Philadelphia, 1942.

Providence, R.I. Museum of Art, Rhode Island School of Design, *Selection 1: American Watercolors and Drawings (Bulletin of the Rhode Island School of Design* 58, no. 4, January, 1972).

Raleigh, N.C. North Carolina Museum of Art, *A Catalogue of Drawings and Watercolors*, Raleigh, 1969.

Salem, Mass. Brewington, M.V. and Dorothy, *The Marine Paintings and Drawings in the Peabody Museum*, Salem, 1968.

Santa Barbara, Calif. The Santa Barbara Museum of Art, *Drawings: The Collection of the Santa Barbara Museum of Art*, Santa Barbara, Calif., 1970.

Tucson, Ariz. University of Arizona Museum of Art, *The C. Leonard Pfeiffer Collection*, Tucson, Ariz., n.d.

Tucson, Ariz. The University of Arizona Museum of Art, *The Edward Joseph Gallagher III Memorial Collection*, Tucson, Ariz., 1964.

Tucson, Ariz. The University of Arizona Museum of Art, *The Gallagher Memorial Collection: Paintings, Watercolors, Drawings and Sculpture*, Tucson, Ariz., n.d.

Tulsa, Okla. Thomas Gilcrease Institute of American History and Art, *The Art of the Old West, from the Collection of the Gilcrease Institute*, selections and text by Paul A. Rossi and David C. Hunt, Tulsa, 1971.

Utica, N.Y. Munson-Williams-Proctor Institute, *Paintings, Drawings and Sculptures in the Munson-Williams-Proctor Institute*, Utica, N.Y., 1961.

Washington, D.C., National Collection of Fine Arts, *Catalogue of the Gellatly Collection*, Washington, D.C., 1954.

Wichita, Ka. Wichita Art Museum, *Catalogue of the Roland P. Murdock Collection*, Wichita, 1972.

Williamstown, Mass. Sterling and Francine Clark Art Institute, Haverkamp-Begemann, Egbert, et al., *Drawings from the Clark Art Institute*, 2 vols., New Haven and London, 1964.

Winterthur, Del. Henry Francis Du Pont Winterthur Museum, Sommer, Frank H., *Pennsylvanian German Prints, Drawings and Paintings: A Selection from the Winterthur Collections*, Winterthur, Del., 1965.

Worcester, Mass. Worcester Art Museum, *Art in America, 1830–1950, Paintings, Drawings, Prints and Sculpture from the Collection of the Worcester Art Museum*, Worcester, Mass., 1969.

B. ARTISTS' BIBLIOGRAPHY

ABBEY, EDWIN AUSTIN (1852–1911)
Edwin Austin Abbey, 1852–1911, exhibition catalogue, Yale University Art Gallery, New Haven, 1973.

ALBRIGHT, IVAN LE LORRAINE (b. 1897)
Sweet, Frederick A., *Ivan Albright: A Retrospective Exhibition*, exhibition catalogue, The Art Institute of Chicago, 1964.

ALEXANDER, FRANCESCA (1837–1917)
Alexander, Constance Grosvenor, *Francesca Alexander, A Hidden Servant*, Cambridge, Mass., 1927.

ALLSTON, WASHINGTON (1779–1843)
Outlines and Sketches by Washington Allston, engraved by I. and J.W. Cheney, Boston, 1850.
Richardson, Edgar P., *Washington Allston, A Study of the Romantic Artist in America*, Chicago, 1948.

ANSHUTZ, THOMAS (1851–1912)
Thomas Anshutz, 1851–1912, exhibition catalogue, Graham Galleries, New York, 1963.

AUDUBON, JOHN JAMES (1785–1851)
Dwight, Edward H. *Audubon: Watercolors and Drawings*, exhibition catalogue, Munson-Williams-Proctor Institute, Utica, N.Y., and The Pierpont Morgan Library, New York, 1965.
The Original Water-Color Paintings by John James Audubon for "The Birds of America", intro. by Marshall B. Davidson, New York, 1966.

BARTLETT, WILLIAM H. (1809–1854)
William H. Bartlett and His Imitators, exhibition catalogue, The Arnot Art Gallery, Elmira, N. Y., 1966.

BARTRAM, JOHN (1699–1777)
Diary of a Journey through the Carolinas, Georgia and Florida, from July 1, 1765–April 10, 1766, annotated by Francis Harper, Philadelphia, 1942 (*Transactions of the American Philosophical Society*, n.s. 33, pt. 1, December, 1942, pp. 1–120).

BARTRAM, WILLIAM (1739–1823)
Ewan, Joseph, ed., *William Bartram: Botanical and Zoological Drawings, 1756–1788; Reproduced from the Fothergill Album in the British Museum (Natural History)*, Philadelphia, 1968 (*Memoirs of the American Philosophical Society* 74, 1968).
Fagin, N. Bryllion, *William Bartram, Interpreter of the American Landscape*, Baltimore, 1933.

BASKIN, LEONARD (b. 1922)
Baskin, Leonard, *Baskin, Sculpture, Drawings and Prints*, New York, 1970.
Drawings for the Iliad, Leonard Baskin, exhibition catalogue, The Art Institute of Chicago, 1962.

BELLOWS, ALBERT FITCH (1829–1883)
Bellows, Albert Fitch, *Watercolor Painting: Some Facts and Authorities in Relation to Its Durability*, 1868.

Catalogue of Oil Paintings, Water-colors, Black and White Drawings, Etchings, Pen and Ink Sketches, auction catalogue, Ortgies and Co., New York, February, 1884.

BELLOWS, GEORGE (1882–1924)
George Bellows: A Retrospective Exhibition, exhibition catalogue, National Gallery of Art, Washington, D.C., 1957.
Morgan, Charles H., *George Bellows, Painter of America,* New York, 1965.

BENNETT, WILLIAM JAMES (1789–1844)
De Silva, Ronald Anthony, "William James Bennett: Painter and Engraver," Master's thesis, Winterthur, 1970.

BENSON, FRANK WESTON (1862–1951)
Frank W. Benson, Edmund C. Tarbell: Exhibition of Paintings, Drawings and Prints, exhibition catalogue, Museum of Fine Arts, Boston, 1938.

BENTON, THOMAS HART (1889–1975)
Craven, Thomas, *Thomas Hart Benton,* New York, 1939.

BIERSTADT, ALBERT (1830–1902)
Hendricks, Gordon, *Albert Bierstadt, Painter of the American West,* New York, 1973.

BINGHAM, GEORGE CALEB (1811–1879)
Bloch, E. Maurice, *The Drawings of George Caleb Bingham with a Catalogue Raisonné,* Columbia, Mo., 1975.

BIRCH, THOMAS (1779–1851)
Gerdts, William H., *Thomas Birch, 1779–1851: Paintings and Drawings,* exhibition catalogue, Philadelphia Maritime Museum, Philadelphia, 1966.

BIRCH, WILLIAM RUSSELL (1755–1834)
The City of Philadelphia, 1798–1800, drawn and engraved by Wm. Birch and Son, Springfield Cottage near Nefthammy Bridge on the Bristol Road, Pa., 1800.

BLAKELOCK, RALPH ALBERT (1847–1919)
Ralph Albert Blakelock, 1847–1919, exhibition catalogue, New Jersey State Museum, Trenton, N.J., and Sheldon Memorial Art Gallery, Lincoln, Neb., 1975.

BLASHFIELD, EDWIN HOWLAND (1848–1936)
Blashfield, Edwin Howland, *Mural Painting in America,* New York, 1913.
The Works of Edwin Howland Blashfield, intro by Royal Cortissoz, New York, 1937.

BLOOM, HYMAN (b. 1913)
Sadik, Marvin, *The Drawings of Hyman Bloom,* exhibition catalogue, Museum of Art, University of Connecticut, Storrs, Conn., 1968.

BLUM, ROBERT F. (1857–1903)
Robert F. Blum, 1857–1903: A Retrospective Exhibition, exhibition catalogue, Cincinnati Art Museum, Cincinnati, O., 1966.

BLUME, PETER (b. 1906)
Peter Blume in Restrospect: Paintings and Drawings, 1925–1964, exhibition catalogue, The Currier Gallery of Art, Manchester, N.H., 1964.

BLYTHE, DAVID GILMOUR (1815–1865)
Miller, Dorothy, *The Life and Work of David G. Blythe,* Pittsburgh, 1950.

BODMER, KARL [*sic* Carl] (1809–1893)
Carl Bodmer Paints the Indian Frontier: A Traveling Exhibition, exhibition catalogue, Smithsonian Institution, Washington, D.C., 1954.
Wied-Neuwied, Alexander Philip, Prince von, *Travels in the Interior of North America, 1832–1834,* London, 1843.

BONTECOU, LEE (b. 1931)
Lee Bontecou, exhibition catalogue, Museum of Contemporary Art, Chicago, 1972.

BRADFORD, WILLIAM (1823–1892)
William Bradford, 1823–1892, exhibition catalogue, De Cordova Museum, Lincoln, Mass., and New Bedford Whaling Museum, New Bedford, Mass., 1969.

BRADLEY, WILL H. (1868–1962)
Wong, Roberta Waddell, *Will H. Bradley, American Artist and Craftsman,* exhibition catalogue, Metropolitan Museum of Art, New York, 1972.

BRICHER, ALFRED THOMPSON (1837–1908)
Alfred Thompson Bricher: Exhibition of Thirty-five Original Pen and Ink and Wash Drawings, exhibition catalogue, Clayton and Libertore Art Gallery, Bridgehampton, N.Y., 1971.
Brown, Jeffrey, *Alfred Thompson Bricher, 1837–1908,* exhibition catalogue, Indianapolis Museum of Art, Indianapolis, 1973.

BROWN, GEORGE LORING (1814–1889)
George Loring Brown: Landscapes of Europe and America, 1834–1880, exhibition catalogue, Robert Hull Fleming Museum, Burlington, Vt., 1973.

BURCHFIELD, CHARLES (1893–1967)
Baur, John I.H., *Charles Burchfield,* exhibition catalogue, Whitney Museum of American Art, New York, 1956.
The Drawings of Charles Burchfield, New York, 1968.

CALYO, NICOLINO (1799–1884)
"Cries of New York," *Connoisseur* 90, no. 376 (December 1932), pp. 420–421.

CARMIENCKE, JOHANN HERMANN (1810–1867)
Johann Hermann Carmiencke, Drawings and Watercolors, exhibition catalogue, National Collection of Fine Arts, Smithsonian Institution, Washington, D.C., 1973.

CASSATT, MARY (1845–1926)
Breeskin, Adelyn D., *Mary Cassatt; A Catalogue Raisonné of the Oils, Pastels, Watercolors, and Drawings,* Washington, D.C., 1970.

CATESBY, MARK (1679–1749)

Comstock, Helen, "An 18th Century Audubon," *Antiques* 37, no. 6 (June 1940), pp. 282–284.

CATLIN, GEORGE (1796–1872)

McCracken, Harold, *George Catlin and the Old Frontier*, New York, 1959.

CHAPMAN, JOHN (1808–1889)

Chapman, John Gadsby, *The American Drawing Book: A Manual for the Amateur and Basis of Study for the Professional Artist, Especially Adapted to the Use of Public and Private Schools as well as Home Instruction*, New York, 1847 and 1864.

John Gadsby Chapman, Painter and Illustrator, exhibition catalogue, National Gallery of Art, Washington, D.C., 1962.

CHASE, WILLIAM MERRITT (1849–1916)

Roof, Katherine, *The Life and Art of William Merritt Chase*, New York, 1917.

Chase Centennial Exhibition, Commemorating the Birth of William Merritt Chase, November 1, 1849, exhibition catalogue, John Herron Art Institute, Indianapolis, 1949.

William Merritt Chase, exhibition catalogue, The Art Galleries, University of California, Santa Barbara, 1964.

CHRISTO (b. 1935)

Alloway, Lawrence, *Christo*, London, 1969.

CHRISTY, HOWARD CHANDLER (1873–1952)

The Christy Book of Drawings: Pictures in Black and White and Color by Howard Chandler Christy, New York, 1908.

CHURCH, FREDERIC EDWIN (1826–1900)

Frederic Edwin Church, exhibition catalogue, National Collection of Fine Arts, Smithsonian Institution, Washington, D.C., 1966.

Huntington, David C. *The Landscapes of Frederic Edwin Church: Vision of an American Era*, New York, 1966.

CLOSE, CHUCK (b. 1940)

Nemser, Cindy, "An Interview with Chuck," *Artforum* 8, no. 5 (January 1970), pp. 51–55.

Three Realists: Close, Estes, Raffael, exhibition catalogue, Worcester Art Museum, Worcester, Mass., 1974.

COLE, THOMAS (1801–1848)

Merritt, Howard S., *Thomas Cole*, exhibition catalogue, Memorial Art Gallery of the University of Rochester, Rochester, N.Y., 1969.

Noble, Louis L., *The Life and Works of Thomas Cole, N.A.*, New York, 1853; new edition, ed. by Elliot Vesell, Cambridge, Mass., 1964.

Rodriguez, Oswaldo, "Three Essays in the Art of Thomas Cole," Master's thesis, Yale University, 1975.

Seaver, Esther, *Thomas Cole: One Hundred Years Later*, exhibition catalogue, Wadsworth Atheneum, Hartford, Conn., and Whitney Museum of American Art, New York, 1949.

COLMAN, SAMUEL (1832–1920)

The Art Collections of the Late Samuel Colman . . ., auction catalogue, Anderson Galleries, New York, April 19–20, 1927.

Colman, Samuel, *Nature's Harmonic Unity, A Treatise on its Relation to Proportional Form*, ed. by C.A. Coan, New York, 1912.

COPLEY, JOHN SINGLETON (1738–1815)

John Singleton Copley, 1738–1815, exhibition catalogue, essay by Jules D. Prown, National Gallery of Art, Washington, D.C., 1965.

Prown, Jules D., "An 'Anatomy Book' by John Singleton Copley," *Art Quarterly* 26, no. 1 (Spring, 1963), pp. 31–46.

———, *John Singleton Copley*, 2 vols., Cambridge, Mass., 1966.

CROPSEY, JASPER F. (1823–1900)

Talbot, William S., *Jasper F. Cropsey, 1823–1900*, exhibition catalogue, National Collection of Fine Arts, Smithsonian Institution, Washington, D.C., 1970.

DARLEY, FELIX OCTAVIUS CARR (1822–1888)

Bolton, Theodore, "The Book Illustrations of Felix Octavius Carr Darley, with Catalog," *Proceedings of the American Antiquarian Society* 61, pt. 1 (April 1951), pp. 137–82; reprint ed., New York, 1952.

Weitenkampf, Frank, "Illustrated by Darley," *International Studio* 80, no. 334 (March, 1924), pp. 445–49.

DAVIES, ARTHUR B. (1862–1928)

Arthur B. Davies: A Centennial Exhibition, exhibition catalogue, Munson-Williams-Proctor Institute, Utica, N.Y., 1962.

DAVIS, STUART (1894–1964)

Goossen, E.C., *Stuart Davis*, New York, 1959.

Stuart Davis Memorial Exhibition, 1894–1964, exhibition catalogue, National Collection of Fine Arts, Smithsonian Institution, Washington, D.C., 1965.

DE KOONING, WILLEM (b. 1904)

Hess, Thomas B., *Willem de Kooning Drawings*, Greenwich, Conn., 1972.

Larson, Philip, and Peter Schjeldahl, *De Kooning: Drawings/ Sculpture*, exhibition catalogue, Walker Art Center, Minneapolis, Minn., 1974.

Rosenberg, Harold, *Willem de Kooning*, New York, 1974.

DEMUTH, CHARLES (1883–1935)

Allana, Pamela E., "Watercolor Illustrations of Charles Demuth," Ph.D. dissertation, Johns Hopkins University, 1970.

Ritchie, Andrew C., *Charles Demuth,* exhibition catalogue, Museum of Modern Art, New York, 1950.

DEWING, THOMAS WILMER (1851–1938)

Ely, Catherine Beach, "Thomas W. Dewing," *Art in America* 10, no. 5 (August 1922), pp. 224–29.

DICKINSON, EDWIN (b. 1891)

Goodrich, Lloyd, *The Drawings of Edwin Dickinson,* New Haven and London, 1963.

DIEBENKORN, RICHARD (b. 1922)

Drawings, exhibition catalogue, Department of Art and Architecture, Stanford University, Stanford, Calif., 1965.

DINE, JIM (b. 1935)

Jim Dine Designs for a Midsummer Night's Dream. Selected from the Drawings and Prints in the Collection of the Museum of Modern Art, exhibition catalogue, intro. by Virginia Allen, Museum of Modern Art, New York, 1968.

Gordon, John, *Jim Dine,* exhibition catalogue, Whitney Museum of American Art, New York, 1970.

DOUGHTY, THOMAS (1793–1856)

Goodyear, Frank H., Jr., *Thomas Doughty,* exhibition catalogue, Pennsylvania Academy of the Fine Arts, Philadelphia, 1973.

DOVE, ARTHUR G., (1880–1946)

Haskell, Barbara, *Arthur Dove,* exhibition catalogue, San Francisco Museum of Art, San Francisco, 1974.

Rich, Daniel Catton, *Paintings and Water Colors by Arthur G. Dove,* exhibition catalogue, Worcester Art Museum, Worcester, Mass., 1961.

DUNLAP, WILLIAM (1766–1839)

William Dunlap, Painter and Critic; Reflections on American Painting of a Century Ago, exhibition catalogue, Addison Gallery of American Art, Phillips Academy, Andover, Mass., 1939.

DURAND, ASHER B. (1796–1886)

A.B. Durand, 1796–1886, exhibition catalogue, intro. and catalogue by David Lawall, Montclair Art Museum, Montclair, N.J., 1971.

DU SIMITIÈRE, PIERRE, EUGÈNE (c. 1736–1784)

Donaghy, Elizabeth, "Pierre Eugène Du Simitière, Unsuccessful Artist and Natural Historian in Revolutionary America," Master's thesis, Winterthur, 1970.

Du Simitière, Pierre Eugène, *Books, Pamphlets, Newspapers, Prints, Drawings, and So On (The American Museum), Sold at Du Simitière's Late Dwelling House,* broadside, Philadelphia, March 10, 1785.

DUVENECK, FRANK (1848–1919)

Duveneck, Josephine W., *Frank Duveneck: Painter-Teacher,* San Francisco, 1970.

Exhibition of the Work of Frank Duveneck, exhibition catalogue, Cincinnati Art Museum, Cincinnati, O., 1939.

EAKINS, THOMAS (1844–1916)

Goodrich, Lloyd, *Thomas Eakins: His Life and Work,* New York, 1933.

Hendricks, Gordon, *Life and Work of Thomas Eakins,* New York, 1974.

Hoopes, Donelson F., *Eakins Watercolors,* New York, 1971.

Parry, Ellwood C., III, and Maria Chamberlain-Hallman, "Thomas Eakins as an Illustrator, 1878–1881." *American Art Journal* 5, no. 1 (May 1973), pp. 20–45.

EDMONDS, FRANCIS WILLIAM (1806–1863)

Mann, Maybelle, "Francis William Edmonds: Mammon and Art," *American Art Journal* 2, no. 2 (Fall, 1970), pp. 92–106.

ESTES, RICHARD (1901–1973)

Three Realists: Close. Estes, Raffael, exhibition catalogue, Worcester Art Museum, Worcester, Mass., 1974.

EVERGOOD, PHILIP (1901–1973)

Lippard, Lucy R., *The Graphic Work of Philip Evergood,* New York, 1966.

FARNY, HENRY F. (1847–1916)

Henry F. Farny and the American Indian, exhibition catalogue, Cincinnati Art Museum, Cincinnati, O., 1943.

Taft, Robert, "The Pictorial Record of the Old West. X. Artists of Indian Life: Henry F. Farny," *The Kansas Historical Quarterly* 18, no. 1 (February 1950), pp. 1–19.

FARRER, HENRY (1843–1903)

Catalogue of Watercolors and Etchings by the Late Henry Farrer and of His Important Collection of Oriental Art, auction catalogue, American Art Association, New York, February 4–7, 1907.

FEININGER, LYONEL (1871–1956)

Hess, Hans, *Lyanel Feininger,* New York, 1961.

FISHER, ALVAN (1792–1863)

Johnson, Charlotte Buel, "The European Tradition and Alvan Fisher," *Art in America* 41, no. 2 (Spring, 1953), pp. 79–87.

Vose, Robert C., Jr., "Alvan Fisher, 1792–1863: American Pioneer in Landscape and Genre," *Bulletin of the Connecticut Historical Society* 27, no. 4 (October 1962), pp. 97–129.

FRANCIS, SAM (b. 1923)

Sam Francis, exhibition catalogue, Albright-Knox Art Gallery, Buffalo, N.Y., 1972.

FRASER, CHARLES (1782–1860)

A Charleston Sketchbook, 1796–1806: Forty Watercolor Drawings of the City and Surrounding Country, Including Plantations and Parish Houses, intro. and notes by Alice R.H. Smith, Charleston, S.C., 1940.

GIBSON, CHARLES DANA (1867–1944)

Drawings and Paintings of Charles Dana Gibson, exhibition catalogue, The Virginia Museum of Fine Arts, Richmond, Va., 1943.

GLACKENS, WILLIAM (1870–1938)

Glackens, Ira, *William Glackens and the Ashcan Group*, New York, 1957.

William Glackens in Retrospect, exhibition catalogue, St. Louis Art Museum, St. Louis, Mo., 1966.

GORKY, ARSHILE (1904–1948)

Jordan, Jim M., *Gorky: Drawings*, exhibition catalogue, M. Knoedler and Co., New York, 1969.

Joyner, Brooks, *The Drawings of Arshile Gorky*, exhibition catalogue, J. Millard Tawes Fine Art Center, University of Maryland, College Park, Md., 1969.

Seitz, William C., *Arshile Gorky: Paintings, Drawings, Studies*, exhibition catalogue, Museum of Modern Art, New York, 1962.

GRAVES, MORRIS (b. 1910)

Rubin, Ida E., ed., *The Drawings of Morris Graves*, Boston, 1974.

GROSZ, GEORGE (1893–1959)

Hess, Hans, *George Grosz*, New York, 1974.

GUSTON, PHILIP (b. 1913)

Ashton, Dore, *Philip Guston*, New York, 1960.

HABERLE, JOHN (1853–1933)

Haberle Retrospective Exhibition, exhibition catalogue, The New Britain Museum of American Art, New Britain, Conn., 1962.

HALE, LILIAN WESTCOTT (1881–1963)

Berry, Rose V.S., "Lilian Westcott Hale—Her Art," *Magazine of Art* 18, no. 2 (February 1927), pp. 59–70.

HAMILTON, JAMES (1819–1878)

Jacobowitz, Arlene, *James Hamilton, 1819–1878, American Marine Painter*, exhibition catalogue, The Brooklyn Museum, Brooklyn, N.Y., 1966.

HARNETT, WILLIAM MICHAEL (1848–1892)

Frankenstein, Alfred, *After the Hunt: William Harnett and Other American Still-Life Painters*, Berkeley, 1969.

HART, GEORGE O. "POP" (1868–1933)

George O. "Pop" Hart, 1868–1933, exhibition catalogue, The Newark Museum, Newark, N.J., 1935.

HARTLEY, MARSDEN (1877–1943)

Feininger-Hartley, exhibition catalogue, Museum of Modern Art, New York, 1944.

McCausland, Elizabeth, *Marsden Hartley*, Minneapolis, 1952.

HARVEY, GEORGE (1800/01–1878)

100 Years Ago in North America: Watercolor Drawings by George Harvey, exhibition catalogue, Kennedy Galleries, New York, 1940.

Shelley, Donald A., "George Harvey and His Atmospheric Landscapes of North America," *New-York Historical Society Quarterly* 32, no. 2 (April 1948), pp. 104–13.

HASELTINE, WILLIAM S. (1835–1900)

Water Colors by William S. Haseltine, exhibition catalogue, Addison Gallery of American Art, Phillips Academy, Andover, Mass., 1931.

HASSAM, CHILDE (1859–1935)

Childe Hassam, 1859–1935, exhibition catalogue, University of Arizona Museum of Art, Tucson, Ariz., 1972.

HEADE, MARTIN JOHNSON (1819–1904)

Stebbins, Theodore E., Jr., *The Life and Works of Martin Johnson Heade*, New Haven, 1975.

HENRI, ROBERT (1865–1929)

Homer, William Inness, *Robert Henri and His Circle*, Ithaca and New York, 1969.

HENRY, EDWARD LAMSON (1841–1919)

McCausland, Elizabeth, *The Life and Work of Edward Lamson Henry*, Albany, N.Y., 1945.

HILL, JOHN WILLIAM (1812–1879)

Hill, John Henry, *John William Hill, An Artist's Memorial*, New York, 1888.

John William Hill (1812–1879), John Henry Hill (1839–1922), exhibition checklist, Washburn Gallery, New York, 1973.

HOFMANN, HANS (1880–1966)

Greenberg, Clement, *Hofmann*, Paris, 1961.

HOMER, WINSLOW (1836–1910)

Cooke, Hereward Lester, "Winslow Homer's Water-Color Technique," *Art Quarterly* 24, no. 2 (Summer, 1961), pp. 169–94.

Foster, Allen Evarts, "Checklist of Illustrations by Winslow Homer in *Harper's Weekly* and Other Periodicals," *New York Public Library Bulletin* 40, no. 10 (October 1936), pp. 842–52.

———, "A Checklist of Illustrations by Winslow Homer Appearing in Various Periodicals," *New York Public Library Bulletin* 44, no. 7 (July 1940), pp. 537–39.

Gardiner, Albert Ten Eyck, *Winslow Homer, American Artist: His Life and Work*, New York, 1961.

Goodrich, Lloyd, *Winslow Homer*, New York, 1944.

———, *Winslow Homer*, exhibition catalogue, Whitney Museum of American Art, New York, 1973.

Hoopes, Donelson F. *Winslow Homer Watercolors*, New York, 1969.

HOPPER, EDWARD (1882–1967)

Goodrich, Lloyd, *Edward Hopper*, New York, 1971.

———, *Edward Hopper: Selections from the Hopper Bequest*, exhibition catalogue, Whitney Museum of American Art, New York, 1971.

HOVENDEN, THOMAS (1840–1895)

Livesey, Helen Corson, "The Life and Works of Thomas Hovenden, N.A.," Archives of American Art, New York (Typescript of paper read before the Plymouth Meeting Historical Society, February 22, 1955).

HUGE, JURGAN FREDERICK (1809–1878)

Lipman, Jean, *Rediscovery: Jurgan Frederick Huge (1809–1878)*, New York, 1973.

HUNT, WILLIAM MORRIS (1824–1879)

Hunt, William Morris, *Talks on Art*, Boston, 1875.

Knowlton, Helen M., *Art-Life of William Morris Hunt*, London and Boston, 1899.

KNOWLTON, DANIEL (1816–1906)
Drawn from Nature/Drawn from Life, exhibition catalogue, Ithaca College Museum of Art, Ithaca, N.Y., 1971.

INDIANA, ROBERT (b. 1928)
Robert Indiana, exhibition catalogue, intro. by John W. McCoubrey, Institute of Contemporary Art of the University of Pennsylvania, Philadelphia, 1968.

INMAN, HENRY (1801–1846)
Bolton, Theodore, "Henry Inman, an Account of His Life and Work," *Art Quarterly* 3, no. 4 (Autumn, 1940), pp. 353–75.
———, "Catalogue of the Paintings of Henry Inman," *Art Quarterly* 3, no. 4 (Autumn, 1940), Supplement, pp. 401–18.

INNESS, GEORGE (1825–1894)
Works by George Inness: The Collection of Mrs. Jonathan Scott Hartley Including . . . His Entire Collection of Water-Colors, auction catalogue, American Art Association, New York, March 24, 1927.
Ireland, Le Roy, *The Works of George Inness, An Illustrated Catalogue Raisonné*, London, 1965.

JARVIS, JOHN WESLEY (1780–1840)
Dickson, Harold E., *John Wesley Jarvis*, New York, 1949.

JOHNS, JASPER (b. 1930)
4 [Vier] Amerikaner: Jasper Johns, Alfred Leslie, Robert Rauschenberg, Richard Stankiewicz, exhibition catalogue, Kunsthalle, Bern, 1962.
Jasper Johns Drawings, exhibition catalogue, Arts Council of Great Britain, London, 1974.
Kozloff, Max, *Jasper Johns*, New York, 1972.

JOHNSON, EASTMAN (1824–1906)
Johnson, Eastman, *Catalogue of Finished Pictures, Studies, and Drawings*, auction catalogue, American Art Association, New York, February 26, 1907.
Hills, Patricia, *Eastman Johnson, Retrospective Exhibition*, exhibition catalogue, Whitney Museum of American Art, New York, 1972.

JOHNSTON, DAVID CLAYPOOLE (1798–1865)
Johnson, Malcolm, *David Claypoole Johnston, American Graphic Humorist, 1789–1865*, exhibition catalogue, American Antiquarian Society, Luneberg, Vt., 1970.
———, "David Claypoole Johnston, the American Cruikshank," *Antiques* 102, no. 1 (July 1972), pp. 101–7.

JOHNSTON, HENRIETTA (active 1709–1729)
Middleton, Margaret Simons, *Henrietta Johnston of Charles Town, South Carolina, America's First Pastellist*, Columbia, S.C., 1966.
Rutledge, Anna Wells, "Who Was Henrietta Johnston?," *Antiques* 51, no. 3 (March 1947), pp. 183–85.

KATZ, ALEX (b. 1947)
Sandler, Irving, and Bill Birkson, eds., *Alex Katz*, New York, 1971.

KELLER, ARTHUR I. (1867–1924)
Figure Studies from Life, intro. by James B. Carrington, New York, 1920.

KELLY, ELLSWORTH (b. 1923)
Goosen, E.C., *Ellsworth Kelly*, exhibition catalogue, Museum of Modern Art, New York, 1973.
Waldman, Diane, *Ellsworth Kelly: Drawings, Collages, Prints*, Greenwich, Conn., 1971.

KENT, ROCKWELL (1882–1971)
Kent, Rockwell, *This is My Own*, New York, 1940.
Rockwell Kent—The Early Years, exhibition catalogue, Bowdoin College Museum of Art, Brunswick, Me., 1969.
Rockwell Kent, Watercolors, Drawings, Sketches and Graphics, sale catalogue, Parke-Bernet, Inc., New York, 1972.

KLINE, FRANZ (1910–1962)
Gordon, John, *Franz Kline, 1910–1962*, exhibition catalogue, Whitney Museum of American Art, New York, 1968.

KRIMMEL, JOHN LEWIS (1787–1821)
Naeve, Milo Merle, "John Lewis Krimmel: His Life, His Art, and His Critics," Master's thesis, Winterthur, 1955.

KUHN, WALT (1880–1949)
Painter of Vision: Walt Kuhn, exhibition catalogue, University of Arizona Art Gallery, Tucson, Ariz., 1966.

LA FARGE, JOHN (1835–1910)
Catalogue of Works by John La Farge, exhibition catalogue, Durand-Ruel Galleries, New York, 1895.
Cortissoz, Royal, *John La Farge, A Memoir and A Study*, Boston and New York, 1911.
Weinberg, Helen Barbara, "John La Farge: The Relation of His Illustration to His Ideal Art," *American Art Journal* 5, no. 1 (May 1973), pp. 54–73.

LANE, FITZ HUGH (1804–1865)
Paintings and Drawings by Fitz Hugh Lane at the Cape Ann Historical Association, Gloucester, Mass., 1974.

LEBRUN, RICO (1900–1964)
Rico Lebrun Drawings, Berkeley, 1961.
Seldis, Henry J., *Rico Lebrun (1900–1964): An Exhibition of Drawing, Painting and Sculpture*, exhibition catalogue, Los Angeles County Museum of Art, Los Angeles, 1967.

LE MOYNE DE MORGUES, JACQUES (d. 1588)
Bushnell, David J., Jr., "Drawing by Jacques Le Moyne De Morgues of Saturioua, a Timucua Chief in Florida, 1564," *Smithsonian Miscellaneous Collections* 81, no. 4 (1928).
Lorant, Stefan, *The New World: The First Pictures of America, Made by John White and Jacques Le*

Moyne and Engraved by Theodore de Bry, New York, 1946.

LEVINE, JACK (b. 1915)
Getlein, Frank, *Jack Levine*, New York, 1966.

LE WITT, SOL (b. 1928)
"All Wall Drawings," *Arts Magazine* 46, no. 6 (February 1972), pp. 39–44.

LICHTENSTEIN, ROY (b. 1923)
Roy Lichtenstein: Drawings and Prints, intro. by Diane Waldman, New York, 1969.

LINDNER, RICHARD (b. 1901)
Ashton, Dore, *Richard Lindner*, New York, 1970.

LUKS, GEORGE (1867–1933)
George Luks, 1867–1933, An Exhibition of Paintings and Watercolors Dating from 1889–1931, exhibition catalogue, Munson-Williams-Proctor Institute, Utica, N.Y., 1973.

MARIN, JOHN (1870–1953)
Reich, Sheldon, *John Marin Drawings, 1886–1951*, exhibition catalogue, Utah Museum of Fine Arts, University of Utah, Salt Lake City, 1969.
———, *John Marin: A Stylistic Analysis and Catalogue Raisonné*, Tucson, Ariz., 1970.

MARSH, REGINALD (1898–1954)
Laning, Edward, *The Sketchbooks of Reginald Marsh*, Greenwich, Conn., 1973.

MARTIN, AGNES (b. 1921)
Linville, Kasha, "Agnes Martin: An Appreciation," *Artforum* 9, no. 10 (June 1971), pp. 72–73.

MARTIN, HOMER DODGE (1836–1897)
Hamilton, Sinclair, "Homer Martin as Illustrator," *New Colophon* 1, pt. 3 (July 1948), pp. 256–63.

MAURER, ALFRED HENRY (1868–1932)
McCausland, Elizabeth, *Alfred H. Maurer*, New York, 1951.

MAYER, FRANCIS BLACKWELL (1827–1899)
Heilbron, Bertha L., ed., *With Pen and Pencil on the Frontier in 1851; The Diary and Sketches of Francis B. Mayer*, St. Paul, Minn., 1932.

MILLER, ALFRED JACOB (1810–1874)
Descriptive Catalogue of a Collection of Watercolour Drawings by Alfred Jacob Miller (1810–1874) in the Public Archives of Canada, Ottawa, Canada, 1951.
Ross, Marvin C., *The West of Alfred Jacob Miller, from the Notes and Watercolors in the Walters Art Gallery*, Norman Okla, 1951 and 1968.

MOORE, CHARLES HERBERT (1840–1930)
Mather, Frank J., *Charles Herbert Moore, Landscape Painter*, Princeton, 1957.

MORAN, THOMAS (1837–1926)
Gerdts, William H., *Thomas Moran, 1837–1926*, exhibition catalogue, University of California Picture Gallery, Riverside, Calif., 1963.

Thomas Moran: Drawings and Watercolors of the West, from the Collection of the Cooper-Hewitt Museum of Design, exhibition catalogue, Washburn Gallery, New York, 1974.
Wilkins, Thurman, *Thomas Moran, Artist of the Mountains*, Norman, Okla., 1966.

MOTHERWELL, ROBERT (b. 1915)
Carmean, E.A., Jr., *The Collages of Robert Motherwell, A Retrospective Exhibition*, exhibition catalogue, The Museum of Fine Arts, Houston, Tex., 1973.
O'Hara, Frank, *Robert Motherwell: With Selections from the Artist's Writings*, exhibition catalogue, Museum of Modern Art, New York, 1965.

MOUNT, WILLIAM SIDNEY (1807–1868)
Cowdrey, Bartlett, and Hermann Warner Williams, Jr., *William Sidney Mount, 1807–1868, An American Painter*, New York, 1944.
Drawings and Sketches by William Sidney Mount, 1807–1868, in the Collections of the Suffolk Museum and Carriage House at Stony Brook, Long Island, N.Y., Stony Brook, L.I., N.Y., 1974.

MURCH, WALTER (1907–1967)
Walter Murch, A Retrospective Exhibition, exhibition catalogue, Museum of Art, Rhode Island School of Design, Providence, R.I., 1966.

MURPHY, J. FRANCIS (1853–1921)
Clark, Eliot, *J. Francis Murphy*, New York, 1926.

NAST, THOMAS (1840–1902)
Gutman, Walter, "An American Phenomenon," *Creative Art* 98, no. 3 (September 1929), pp. 670–72.
Keller, Morton, *The Art and Politics of Thomas Nast*, New York, 1968.

NEWMAN, BARNETT (1905–1970)
Hess, Thomas B., *Barnett Newman*, exhibition catalogue, New York, 1971.

O'KEEFFE, GEORGE (b. 1887)
Georgia O'Keeffe Drawings, intro. by Lloyd Goodrich, New York, 1968.
Goodrich, Lloyd, and Doris Bry, *Georgia O'Keeffe*, exhibition catalogue, Whitney Museum of American Art, New York, 1970.

OLDENBURG, CLAES (b. 1929)
Baro, Gene, *Claes Oldenburg, Drawings and Prints*, London and New York, 1969.
Rose, Barbara, *Claes Oldenburg*, exhibition catalogue, Museum of Modern Art, 1970.

PARRISH, MAXFIELD (1870–1966)
Ludwig, Coyle, *Maxfield Parrish*, New York, 1973.

PEALE, CHARLES WILLSON (1741–1827)
Sellers, Charles Coleman, *Charles Willson Peale*, New York, 1969.

PEALE, REMBRANDT (1778–1860)
Peale, Rembrandt, *Graphics: The Art of Accurate Delineation*, Philadelphia, 1850, 1854, and 1859.

Artist's Sale of Original Paintings, Engravings, Pencil Sketches, etc., and Other Property, auction catalogue, M. Thomas and Sons, Philadelphia, November 18, 1862.

PEALE, TITIAN (1799–1885)

Poesch, Jessie, *Titian Ramsay Peale, 1799–1885, and His Journals of the Wilkes Expedition*, Philadelphia, 1961.

PEARLSTEIN, PHILIP (b. 1924)

Philip Pearlstein: Zeichnungen und Aquarelle, die Druckgraphik, exhibition catalogue, Städliche Museen, Berlin, 1972.

PENNELL, JOSEPH (1860–1926)

Pennell, Elizabeth Robins, *The Life and Letters of Joseph Pennell*, 2 vols., Boston, 1929.

PETERDI, GABOR (b. 1915)

Prints and Drawings by Gabor Peterdi, exhibition catalogue, Cleveland Museum of Art, Cleveland, O., 1962.

POLLOCK, JACKSON (1912–1956)

Rose, Bernice, *Jackson Pollock: Works on Paper*, New York, 1969.

Wysuph, C.L., *Jackson Pollock: Psychoanalytic Drawings*, New York, 1970.

PRENDERGAST, MAURICE (1859–1924)

Rhys, Hedley Howell, *Maurice Prendergast, 1859–1924*, exhibition catalogue, Museum of Fine Arts, Boston, 1960.

Sawyer, Charles H., *Paintings and Watercolors by Maurice Prendergast*, exhibition catalogue, M. Knoedler and Co., New York, 1966.

PYLE, HOWARD (1853–1911)

Morse, Willard S., and Gertrude Brinckle, *Howard Pyle: A Record of His Illustrations and Writings*, Wilmington, Del., 1921; reprint ed., Detroit, 1969.

Howard Pyle, Diversity in Depth, exhibition catalogue, Delaware Art Museum, Wilmington, Del., 1973.

RANNEY, WILLIAM T. (1813–1857)

Grubar, Francis, *William Ranney, Painter of the Early West*, exhibition catalogue, Corcoran Gallery, Washington, D.C., 1962.

RAUSCHENBERG, ROBERT (b. 1925)

Rauschenberg—XXXIV Drawings for Dante's Inferno, commentary by Dore Ashton, New York, 1964.

Solomon, Alan R., *Robert Rauschenberg*, exhibition catalogue, The Jewish Museum, New York, 1963.

RAY, MAN (b. 1890)

Langsner, Jules, *Man Ray*, exhibition catalogue, Los Angeles County Museum of Art, Los Angeles, 1966.

REMICK, CHRISTIAN (1726–?1782)

Cunningham, Henry Winchester, *Christian Remick, An Early Boston Artist*, Boston, 1904.

REMINGTON, FREDERIC (1861–1909)

Hassrick, Peter H., *Frederic Remington: Paintings, Drawings, and Sculpture in the Amon Carter Museum and the Sid W. Richardson Collections*, New York, 1973.

RICHARDS, WILLIAM TROST (1833–1905)

Ferber, Linda S., *William Trost Richards, American Landscape and Marine Painter, 1833–1905*, exhibition catalogue, The Brooklyn Museum, Brooklyn, N.Y., 1973.

Works by William Trost Richards, auction catalogue, American Art Association, New York, December 16, 1885.

RIMMER, WILLIAM (1816–1879)

Bartlett, Truman H., *The Art Life of William Rimmer, Sculptor Painter and Physician*, Boston, 1882; reprint ed., New York, 1970.

Rimmer, William, *Elements of Design*, Boston, 1864 and 1879.

——, *Art Anatomy*, Boston, 1877.

RINDISBACHER, PETER (1806–1834)

Josephy, Alvin M., Jr., *The Artist was a Young Man: The Life Story of Peter Rindisbacher*, Fort Worth, Tex., 1970.

RIVERS, LARRY (b. 1923)

Hunter, Sam, *Larry Rivers*, New York, 1969.

Selle, Carol, *Larry Rivers: Drawings, 1949–1969*, exhibition catalogue, Art Institute of Chicago, Chicago, 1970.

ROBINSON, BOARDMAN (1876–1952)

Christ-Janer, Albert, *Boardman Robinson*, Chicago, 1946.

Ninety-Three Drawings, intro. by George Biddle, Colorado Springs, 1937.

ROBINSON, THEODORE (1852–1896)

Baur, John I. H., *Theodore Robinson, 1852–1896*, Brooklyn, N.Y., 1946.

Theodore Robinson, 1852–1896, exhibition catalogue, intro. by Sona Johnston, The Baltimore Museum of Art, Baltimore, Md., 1973.

ROSENQUIST, JAMES (b. 1933)

Tucker, Marcia, *James Rosenquist*, exhibition catalogue, Whitney Museum of American Art, New York, 1972.

ROTHKO, MARK (1903–1970)

Selz, Peter, *Mark Rothko*, New York, 1961.

RUSCHA, EDWARD (b. 1937)

Edward Ruscha/(Ed-Werd Rey-Shay)Young Artist, exhibition catalogue, Minneapolis Institute of Arts, Minneapolis, Minn., 1972.

RUSSELL, CHARLES M. (1864–1926)

Renner, Frederic G., *Charles M. Russell: Paintings, Drawings and Sculpture in the Amon G. Carter Collection*, Austin, 1966.

SAINT-MÉMIN, CHARLES BALTHAZAR JULIEN FÉVRET DE (1770–1852)

Quarré, Pierre, *Un descendant d'une grande famille de Parlementaires bourguignons: Charles-Balthazar-Julien Févret de Saint-Mémin, artiste, archéologue,*

conservateur du Musée de Dijon, exhibition catalogue, Musée de Dijon, Dijon, 1965.

SARGENT, JOHN SINGER (1856–1925)

Drawings by John Singer Sargent in the Corcoran Gallery of Art, selected and edited by Ellen Gross and James Harithas, Alhambra, Calif., 1967.

Hoopes, Donelson F., Sargent Watercolors, New York, 1970.

Ormond, Richard, John Singer Sargent: Paintings, Drawings, Watercolors, London, 1970.

Spassky, Natalie, John Singer Sargent: A Selection of Drawings and Watercolors from the Metropolitan Museum, exhibition catalogue, Metropolitan Museum of Art, New York, 1971.

SERRA, RICHARD (b. 1939)

Richard Serra, exhibition catalogue, Pasadena Museum of Modern Art, Pasadena, Calif., 1970.

SHAHN, BEN (1898–1969)

Soby, James Thrall, Ben Shahn: His Graphic Work, New York, 1957.

Shahn, Bernarda Bryson, Ben Shahn, New York, 1972.

SHARPLES FAMILY

Knox, Katherine McCook, The Sharples: Their Portraits of George Washington and His Contemporaries, New Haven, 1930.

SHAW, JOSHUA (c. 1777–1860)

Shaw, Joshua, A New and Original Drawing Book, Philadelphia, 1816.

———, Picturesque Views of American Scenery, Philadelphia, 1820–21.

SHEELER, CHARLES (1883–1965)

Charles Sheeler, exhibition catalogue, essays by Martin Friedman, Bartlett Hayes and Charles Millard, National Collection of Fine Arts, Smithsonian Institution, Washington, D.C., 1968.

SHINN, EVERETT (1873–1953)

De Shazo, Edith, Everett Shinn, 1876–1953: A Figure in His Time, New York, 1974.

Everett Shinn, 1873–1953, exhibition catalogue, New Jersey State Museum, Trenton, N.J., 1973.

SLOAN, JOHN (1871–1951)

Sloan, John, assisted by Helen Farr, Gist of Art, New York, 1939.

John Sloan, 1871–1951, exhibition catalogue, National Gallery of Art, Washington, D.C., 1971.

SMITH, DAVID (1906–1965)

Fry, Edward F., David Smith, exhibition catalogue, Solomon R. Guggenheim Museum, New York, 1969.

SMITH, F. HOPKINSON (1838–1915)

Catalogue of an Exhibition of Water Colors and Charcoal Drawings by F. Hopkinson Smith, exhibition catalogue, Fine Arts Academy-Albright Art Gallery, Buffalo, N.Y., 1915.

SMITH, JOHN RUBENS (1775–1849)

Smith, Edward S., "John Rubens Smith, An Anglo-American Artist," Connoisseur 85, no. 345 (May 1930), pp. 300–7.

Smith, John Rubens, A Key to the Art of Drawing the Human Figure, Philadelphia, 1831.

SOYER, MOSES (1899–1974)

Moses Soyer, Drawings, Watercolors, exhibition catalogue, American Contemporary Art Gallery, New York, 1972.

SOYER, RAPHAEL (b. 1899)

Foster, Joseph K., Raphael Soyer, Drawings and Watercolors, New York, 1968.

SPENCER, LILLY MARTIN (1822–1902)

Lilly Martin Spencer, 1822–1902: The Joys of Sentiment, exhibition catalogue, essay by Robin Bolton-Smith and William H. Truettner, National Collection of Fine Arts, Smithsonian Institution, Washington, D.C., 1973.

SPENCER, NILES (1893–1952)

Freeman, Richard B., Niles Spencer, exhibition catalogue, University of Kentucky Art Gallery, Lexington, Ky., 1965.

STEINBERG, SAUL (b. 1914)

Steinberg, exhibition catalogue, Museum Boymans van Beuningen, Rotterdam, 1967.

STELLA, JOSEPH (1877–1946)

Gerdts, William H., Drawings of Joseph Stella from the Collection of Rabin and Krueger, Newark, N.J., 1962.

Jaffe, Irma B., Joseph Stella, Cambridge, Mass., 1970.

STERNE, MAURICE (1878–1957)

Maurice Sterne: Drawings, New York, 1974.

STRICKLAND, WILLIAM (1788–1854)

Gilchrist, Agnes Addison, William Strickland, Artist and Engineer, 1788–1854, Philadelphia, 1950.

SULLY, THOMAS (1783–1872)

Biddle, Edward, and Mantle Fielding, The Life and Works of Thomas Sully (1783–1872), Philadelphia, 1921; reprint ed., Charleston, S.C., 1969.

Sully, Thomas, Hints to Young Painters and the Process of Portrait Painting, Philadelphia, 1873.

TAIT, ARTHUR FITZWILLIAM (1819–1905)

A.F. Tait, Artist in the Adirondacks, exhibition catalogue, The Adirondack Museum, Blue Mountain Lake, N.Y., 1974.

TANGUY, YVES (1900–1955)

Soby, James Thrall, Yves Tanguy, exhibition catalogue, Museum of Modern Art, New York, 1955.

TCHELITCHEW, PAVEL (1898–1957)

Kirstein, Lincoln, ed., Pavel Tchelitchew: Drawings, New York, 1947.

THAYER, ABBOTT H. (1849–1921)

Thayer, Gerald H., "Nine Pencil Drawings by Abbott H. Thayer," International Studio 74, no. 298 (January 1922), pp. ccx–ccxxvi.

White, Nelson C., Abbott H. Thayer, Painter and Naturalist, Hartford, Conn., 1951 and 1967.

THAYER, GERALD H. (1833–
 Thayer, Gerald H., *Concealing-Coloration in the Animal Kingdom*, New York, 1909.
THIEBAUD, WAYNE (b. 1920)
 Recent Works by Wayne Thiebaud, exhibition catalogue, E.B. Crocker Art Gallery, Sacramento, Calif., 1970.
TIFFANY, LOUIS C. (1848–1933)
 The Art Work of Louis C. Tiffany, New York, 1914.
TOBEY, MARK (b. 1890)
 Roberts, Colette, *Drawings by Mark Tobey*, New York, 1960.
 Tobey's 80: A Retrospective, exhibition catalogue, intro. by Betty Bowen, Seattle Art Museum, 1970.
TRUMBULL, JOHN (1756–1843)
 Jaffe, Irma B., *John Trumbull, Patriot-Artist of the American Revolution*, Boston, 1975.
TRYON, DWIGHT WILLIAM (1849–1925)
 Dwight W. Tryon: A Retrospective Exhibition, exhibition catalogue, Museum of Art, The University of Connecticut, Storrs, Conn., 1971.
 White, Henry, *The Life and Art of Dwight William Tryon*, New York, 1930.
TWACHTMAN, JOHN H. (1853–1902)
 Hale, John D,. "The Life and Creative Development of John H. Twachtman," Ph.D. dissertation, Ohio State University, 1957.
 John Henry Twachtman, 1853–1902: An Exhibition of Paintings and Pastels, exhibition catalogue, Ira Spanierman Gallery, New York, 1968.
TWOMBLY, CY (b. 1929)
 Delehanty, Suzanne, *Cy Twombly: Paintings, Drawings, Constructions, 1951–1974*, exhibition catalogue, Institute of Contemporary Art, University of Pennsylvania, Philadelphia, Pa., 1975.
VANDERLYN, JOHN (1775–1852)
 Lindsay, Kenneth C., *The Works of John Vanderlyn, from Tammany to the Capitol*, exhibition catalogue, University Art Gallery, State University of New York at Binghamton; pub., Boston, 1970.
VEDDER, ELIHU (1836–1923)
 Paintings and Drawings by Elihu Vedder, exhibition catalogue, Smithsonian Institution, Washington, D.C., 1966.
 Soria, Regina, *Elihu Vedder: American Visionary Artist in Rome (1836–1923)*, Rutherford, N.J., 1970.
WALKOWITZ, ABRAHAM (1878–1965)
 One Hundred Drawings by A. Walkowitz, intro. by Henry McBride, New York, 1925.
WALL, WILLIAM GUY (1792– after 1864)
 Shelley, Donald A., "William Guy Wall and His Watercolors for the Historic 'Hudson River Portfolio,'" *The New-York Historical Society Quarterly* 31, no. 1 (January 1947), pp. 25–45.
WARHOL, ANDY (b. 1930)

Coplans, John, *Andy Warhol*, New York, 1971.
 Masheck, Joseph, "Warhol as an Illustrator: Early Manipulations of the Mundane; Illustrations for 'Amy Vanderbilt's Complete Cookbook,'" *Art in America* 59, no. 3 (May–June 1971), pp. 54–9.
WATSON, JOHN (1685–1768)
 Morgan, John Hill, *John Watson, Painter, Merchant, and Capitalist of New Jersey, 1685–1768*, Worcester, Mass., 1941.
WEBER, MAX (1881–1961)
 First Comprehensive Retrospective Exhibition in the West of Oils, Gouaches, Pastels, Drawings and Graphic Works by Max Weber (1881–1961), exhibition catalogue, The Art Galleries, University of California, Santa Barbara, Calif., 1968.
WEIR, JULIAN ALDEN (1852–1919)
 J. Alden Weir, 1852–1919, Centennial Exhibition: Paintings, Drawings and Etchings, exhibition catalogue, American Academy of Arts and Letters, New York, 1952.
WEST, BENJAMIN (1738–1820)
 Kraemer, Ruth S., *Drawings by Benjamin West and His Son Raphael Lamar West*, exhibition catalogue, Pierpont Morgan Library, New York, 1975.
 Oedel, William T., "The American Sketchbook of Benjamin West," Master's thesis, University of Delaware, 1973.
WHISTLER, JAMES ABBOTT MCNEILL (1834–1903)
 Gallatin, Albert Eugene, *Whistler's Pastels and Other Modern Profiles*, London, 1913.
 Stubbs, Burns A., *Paintings, Pastels, Drawings, Prints, and Copper Plates by and attributed to American and European Artists, Together with a List of Original Whistleriana, in the Freer Gallery of Art*, Washington, D.C., 1948.
 Sutton, Denys, *Nocturne: The Art of James McNeil Whistler*, London, 1963.
WHITE, JOHN (active 1584–1593)
 Hulton, Paul, and David Beers Quinn, *The American Drawings of John White, 1577–1590, with Drawings of European and Oriental Subjects*, Chapel Hill, N.C., 1964.
WHITEFIELD, EDWIN (1816–1892)
 Norton, Bettina A., "Edwin Whitefield, 1816–1892," *Antiques* 102, no. 2 (August 1972), pp. 232–43.
WHITTREDGE, THOMAS WORTHINGTON (1820–1910)
 Baur, John I.H., ed., "The Autobiography of Worthington Whittredge, 1820–1910," *Brooklyn Museum Journal* 1 (1942), pp. 5–68.
 Worthington Whittredge: A Retrospective Exhibition of an American Artist, exhibition catalogue, Munson-Williams-Proctor Institute, Utica, N.Y., 1969.
WILLIS, EVELINE (fl. 1828)
 Pages from the American Memory Books of Eveline F. Willis, exhibition catalogue, intro. by Carl W. Drepperd, FAR Gallery, New York, 1945.

WILSON, ALEXANDER (1766–1813)
 Cantwell, Robert, *Alexander Wilson, Naturalist and Pioneer,* Philadelphia, 1961.
WINTER, GEORGE (b. 1917)
 The Journals and Indian Paintings of George Winter, 1837–1839, Indianapolis, Ind., 1948.
WYETH, ANDREW (b. 1917)
 Corn, Wanda, *The Art of Andrew Wyeth,* exhibition catalogue, M.H. DeYoung Museum, San Francisco, 1973.

Richardson, Edgar P., *Andrew Wyeth: Temperas, Watercolors, Dry Brush Drawings, 1938–1966,* exhibition catalogue, Pennsylvania Academy of Fine Arts, Philadelphia, 1966.
Andrew Wyeth, exhibition catalogue, intro. by David McCord, Museum of Fine Arts, Boston, 1970.
WYETH, NEWELL CONVERS (1882–1945)
 Allen, Douglas, and Douglas Allen, Jr., *N.C. Wyeth: The Collected Paintings, Illustrations and Murals,* New York, 1972.

Index